The McCrindle Gift

The McCrindle Gift
A Distinguished
Collection *of* Drawings
and Watercolors

MARGARET MORGAN GRASSELLI

ARTHUR K. WHEELOCK JR., *Editors*

With essays by

JOHN T. ROWE

FRANCIS RUSSELL

NATIONAL GALLERY OF ART, WASHINGTON

Produced by the Publishing Office
National Gallery of Art, Washington
www.nga.gov

Judy Metro, Editor in Chief
Chris Vogel, Deputy Publisher and Production Manager
Wendy Schleicher, Design Manager
Karen Sagstetter, Senior Editor
John Long, Assistant Production Manager
Sara Sanders-Buell, Permissions Manager

Edited by Nancy Green
Designed by Carolyn Eckert

Typeset in Ideal Sans and Centaur MT Std. Printed on 100 lb Opus Dull text by Capital Offset, Concord, New Hampshire

Frontispiece: John Singer Sargent, *Cairo* (detail), cat. 59
page x: Cornelis van Poelenburch, *The Prophet Elijah and the Widow of Zarephath* (detail), see page 185
pages 22 – 23: Hubert Robert, *A Roman Capriccio with the Pyramid of Gaius Cestius* (detail), cat. 33
page 164: François-Marius Granet, *A Cloister* (detail), see page 175

Library of Congress Cataloguing-in-Publication Data

National Gallery of Art (U.S.)
The McCrindle gift : a distinguished collection of drawings and watercolors / Margaret Morgan Grasselli and Arthur K. Wheelock Jr., editors ; with essays by John T. Rowe and Francis Russell. — 1st edition.

 pages cm

Includes bibliographical references and index.

ISBN 978-0-89468-377-0 (alk. paper)

1. Drawing — Exhibitions. 2. Watercolor painting — Exhibitions. 3. McCrindle, Joseph F. — Art collections — Exhibitions. 4. Drawing — Private collections — Washington (D.C.) — Exhibitions. 5. Watercolor painting — Private collections — Washington (D.C.) — Exhibitions. 6. National Gallery of Art (U.S.) — Exhibitions. I. Grasselli, Margaret Morgan, 1951 -, editor of compilation. II. Wheelock, Arthur K., Jr., editor of compilation. III. Title.

NC25.W3N353 2012
741.9074′753 — dc23 2012004938

Contents

DIRECTOR'S FOREWORD

THIS ENGAGING VOLUME AND EXHIBITION of drawings celebrates the extraordinary taste and collecting acumen of quite a remarkable individual, Joseph F. McCrindle. Joe, as he was known to his friends and colleagues, was raised in New York City in a family that had great appreciation for literature and the arts, and he immersed himself in these passions throughout his life, both as a publisher and as an art collector. His spacious home on Central Park West and his flat in Kensington in London were filled with works of art by some of the finest European and American masters. Some of these he had inherited, but most of them he bought on his travels to Europe, particularly England and Italy, or from New York dealers. He covered the walls of his homes with his treasured paintings and drawings, and those that he could not hang he crammed into closets and chests of drawers. Joe's wide-ranging tastes in art included portraits, figure studies, religious and mythological scenes, landscapes, and theatrical designs from the sixteenth to the twentieth centuries. The collection of drawings and paintings numbered well over two thousand works, but even so Joe had other collecting interests that he pursued just as avidly, including prints, rare books and manuscripts, and pre-Columbian sculpture.

Joe's collection was large, but his heart and his largesse were even greater. He felt strongly that the works of art and rare books

and manuscripts that he so enjoyed should be shared with museums that had nurtured his interests during his life. His patronage of American museums is legendary, and portions of his collection now reside in institutions both large and small from coast to coast. He and the foundation that he established, the Henfield Foundation (now the Joseph F. McCrindle Foundation) have also generously provided funds for museum projects, as well as for many of Joe's other interests, such as fellowships for young writers, musicians, and dancers.

Joe had a special attachment to the National Gallery of Art, and we are extremely grateful for his enormous generosity over the years, stretching back to 1991 at the time of the fiftieth anniversary of the National Gallery of Art, when he donated a wonderful painting by Luca Giordano. Since then he has greatly enriched the collection of Dutch art with a large number of gifts, including Jan de Bray's stunning double portrait of his parents, painted in 1664. Joe also gave the Gallery a remarkable painting by an artist whom he collected extensively, John Singer Sargent. A checklist of these paintings is included at the end of this catalogue.

This exhibition, however, specifically celebrates Joe's extensive gift of almost three hundred old master and modern drawings to the Gallery, all but two of which came after his death in 2008. This selection of

over seventy drawings and watercolors provides a wonderful overview of the range of works that constitute Joe's gift. It also gives an insight into the personal taste of the collector, who so enjoyed the unexpected and the unusual, and who admired works not because of the names of the artists attached to them but for the verve and rhythm of the line and, often, the whimsical nature of the subject or image.

Joe's extensive contributions to the National Gallery of Art include not only great works of art but also generous funding for our fellowship program. Indeed, we are delighted that many of the entries in this catalogue have been written by five former McCrindle fellows. We are grateful to Margaret Morgan Grasselli and Arthur K. Wheelock Jr. for conceiving and supervising this project and for their close collaboration with the team of catalogue authors. Thanks are also due to Francis Russell, deputy chairman of Christie's UK, who knew Joe well and kindly agreed to write about his collecting interests from an English perspective. Finally, we owe an enormous debt of gratitude to John T. Rowe who, both as a friend and adviser to Joe and as president of the Joseph F. McCrindle Foundation, has done much to help realize Joe's philanthropic wishes over the years. His personal account provides wonderful insights into a remarkable figure and a world now largely past, when a

lover of art could fulfill some of his greatest dreams and desires through the acquisition of drawings and paintings, and then, with equal enthusiasm, could bequeath the works to public collections and thus share them with future generations.

EARL A. POWELL III

ACKNOWLEDGMENTS

WE OWE OUR DEEPEST GRATITUDE TO a long list of colleagues who helped us as we pursued our study and publication of the McCrindle collection. First of all we thank our nineteen fellow authors, without whom this book could not have come into being. We enjoyed working with every one of them and value their contributions, many of which present important new scholarship. We especially appreciate the efforts of the five authors who were brought into this project specifically because they had served or were serving as Joseph F. McCrindle Fellows here at the National Gallery: Lars Kokkonen, Rozemarijn Landsman, Carolina Mangone, Julie Blake Shook, and Oliver Tostmann.

On behalf of the authors we thank a number of colleagues, scholars, and dealers from North America and Europe who responded readily to their queries on a wide variety of subjects: Stijn Alsteens, Carmen Bambach, Sheila Biddle, John Birmingham, Rosemarie Haag Bletter, Szilvia Bodnár, Babette Bohn, Philippe Bordes, William Breazeale, Barbara Brejon de Lavergnée, David J. Buch, Hugo Chapman, Noah Chasin, Andrew S. Ciechanowiecki, Gail S. Davidson, James Draper, Judson Feder, Christina Ferando, Peter Fuhring, Leslie and Johanna Garfield, Vic Gatrell, William Gelius, Clare Gesualdo, Laura M. Giles, William M. Griswold, Cathy Haill, Anita Haldemann, John O. Hand, Matthew Hargraves, Lee Hendrix, Gretchen A. Hirschauer, Dana Hiscock, Maria Hohmann, Herbert Karner, Armin Kunz, David Lachenmann, David Leavitt, Mary Levkoff, Evonne Levy, Carol Lewine, Alexandra Libby, Catherine Loisel, Emma Lucey, Ger Luijten, J. Patrice Marandel, Giorgio Marini, Andrew Martindale, Rachel McGarry, Bert Meijer, Pamela Morrison, Stephen M. Noonan, Roberta J. M. Olson, Georgina Pemberton, John Rice, Timothy Riggs, Paul Robertson, Heather Romaine, Betsy Jean Rosasco, Xavier Salomon, Salvador Salort-Pons, Livia Schaafsma, Marijn Schapelhouman, Peter Schatborn, Stephanie Schrader, Brian Sewell, Kevin Stayton, Stephen Tonkin, Mary Vaccaro, Caterina Volpi, Scott Wilcox, Linda Wolk-Simon, and Georgianna Ziegler and the staff of the Folger Shakespeare Library, Washington, DC.

Assisting us through the complexities of this project were many of our National Gallery colleagues, and we are grateful for their support. For his help in selecting the works for exhibition and for his strong commitment to this project, we thank Andrew Robison, Andrew W. Mellon Senior Curator of Prints and Drawings. We also thank the curatorial assistants — Jennifer Henel, Susanne Cook, Monica Alvano — who kept us on track with timely and unstinting support. We are indebted, in addition, to the associate and assistant

curators and interns in the division oof graphic arts, who performed many tasks associated with this project: Andaleeb Banta, Julie Blake Shook, Sarah Cantor, Ginger Hammer, Amy Johnston, Lars Kokkonen, Marie Ladino, Lara Langer, Colin Nelson-Dusek, Carlotta Owens, Charles Ritchie, Josephine Rodgers, and Stacey Sell. We also thank Nancy Yeide and Anne Halpern in the department of curatorial records and files, who maintained the paper and electronic files pertaining to the paintings, and exhibition officer Wendy Battaglino, who kept the object lists and budget in order.

Preparation of the drawings for exhibition has involved just about everyone in the Gallery's department of paper conservation under the leadership of Kimberly Schenck, including Marian Dirda, Michelle Facini, Linda Owen, Michelle Stein, Im Chan, and matter-framers Caroline Danforth, Shan Linde, Stephen Muscarella, Hugh Phibbs, and Jenny Ritchie. Painting conservator Cathy Metzger also helped with the repair of Jacob Johann Frey's work executed in oil on paper.

For their help with other exhibition details, we are grateful to Dodge Thompson, chief of exhibitions, Susan Arensberg, and Margaret Doyle. We are also greatly indebted to Patricia Donovan, senior development officer, for her many efforts on our behalf.

As always, the library staff under Neal Turtell and Lamia Doumato and the keepers of the Gallery's image collections under Gregory Most offered indispensable assistance to all the authors. We have enjoyed working with the congenial and able team of exhibition designers, Jamé Anderson, John Olson, and Stefan Wood and are grateful to Sally Freitag and Holly Garner-Ponce in the registrar's office and to the art handlers under Dan Shay and Joan Ganzevoort.

Working with the Gallery's publishing office under the direction of Judy Metro and Chris Vogel was, as always, a rewarding experience. Karen Sagstetter and John Long served as project coordinators and diplomatically kept us on deadline. We thank our editor Nancy Green for her light and intelligent touch and her keen eye for detail and consistency, and Carolyn Eckert for her handsome catalogue design.

Photographing all 295 McCrindle drawings offered its own special challenges for an imaging department that is always in high demand, but all the photography was completed with time to spare by Ricardo Blanc, Adam Davies, Lea Ingold, and Greg Williams, under the capable supervision of Lorene Emerson and with the assistance of David Applegate, Peter Dueker, and Emily Smith. Keeping track of the National Gallery images and gathering the comparative figures and the necessary permissions fell to Ira Bartfield, Kate Mayo, Sara Sanders-Buell, and Mariah Shay, to whom we extend our warmest appreciation.

We second our director's thanks to John T. Rowe for all he has done for the National Gallery in his efforts to carry out Joe McCrindle's wishes regarding the disposition of his collection, and we express our own deep gratitude to him and the Joseph F. McCrindle Foundation for their support of this exhibition. We hope that everyone who knew Joe will be pleased with this book and the accompanying exhibition, and we trust that they will consider them both appropriate tributes to Joe's taste as a collector and fitting celebrations of his generous support of the National Gallery of Art.

MARGARET MORGAN GRASSELLI
and ARTHUR K. WHEELOCK JR.

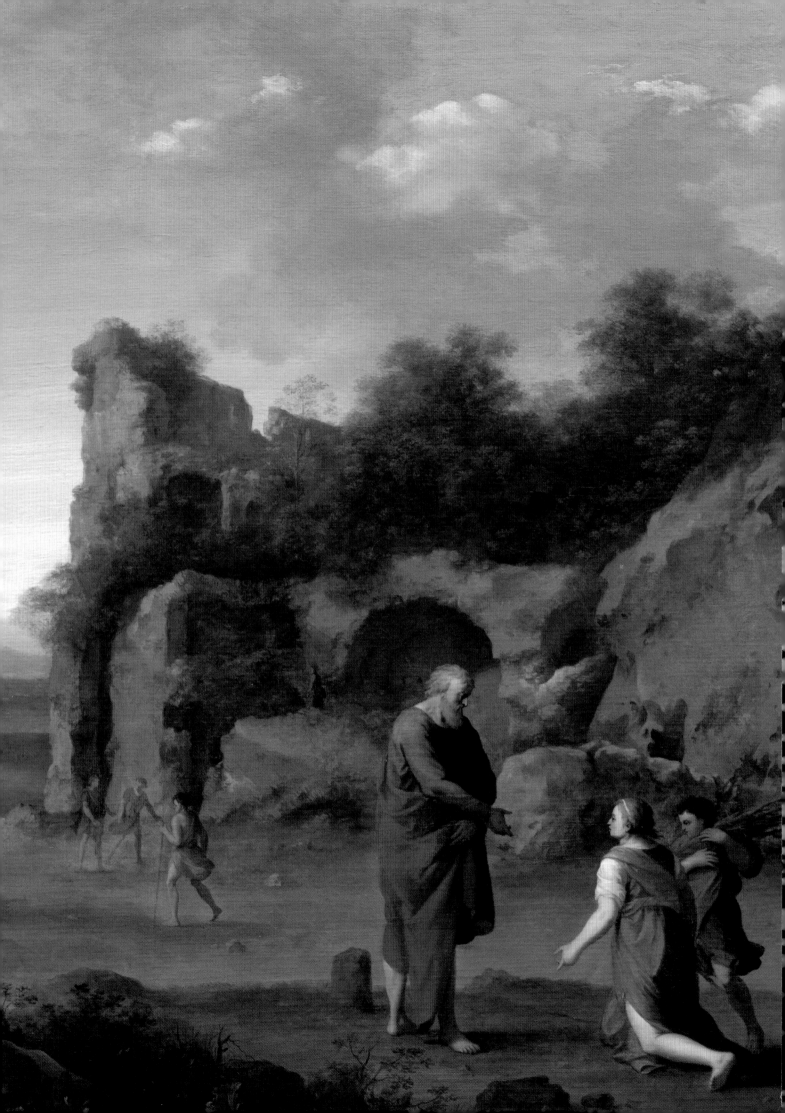

Joseph F. McCrindle
His Life and Philanthropy

JOHN T. ROWE

JOSEPH F. MCCRINDLE WAS SIMPLY JOE TO all who knew him: friends, colleagues, and even those who worked for him (fig. 1). Joe and I met in 1984 through a mutual friend because of my interest in the work of John Singer Sargent. Joe, whose collecting interests were remarkably broad, had assembled a number of fine Sargents, including six paintings, ten watercolors, and one drawing, and he enjoyed sharing his enthusiasm for the artist with me. Though my field of study had been classical music (I had recently received a master's degree in the French horn), Joe invited me to catalogue his extensive art collection. The project developed into a long-lasting friendship that included a great deal of travel, focusing on museums, architecture, and music. These trips would be my art history education.[1]

My first introduction to Joe's world was his extraordinary home on Central Park West in Manhattan, with its expansive views of the park and city. It was overwhelming to see New York laid at one's feet. The massive roof of the Metropolitan Museum was easily visible and I could glimpse his boyhood home across the park on Fifth Avenue. Joe's nine-room residence turned out to be one of the best investments he ever made. After his death in 2008, the sale of the apartment provided substantial financial windfalls for the charitable organizations he supported.

Upon entering the apartment, one was immediately struck by the number of art works that lined the walls, with dozens of drawings and scores of paintings hung frame to frame. The works on paper were displayed on a rotating basis in the front hall and dining room, where the light levels were low, while the paintings hung Salon-style throughout the rest of his home. Anchoring the foyer was Luca Giordano's

FIG. 1
Joseph McCrindle, Ireland, c. 1980

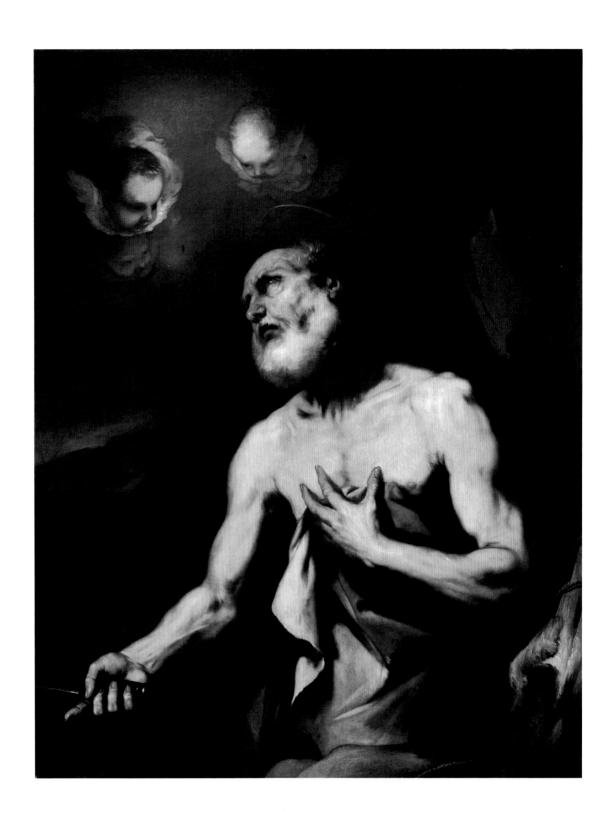

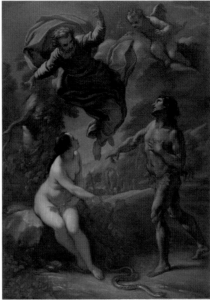

sensitive portrayal of the *Martyrdom of Saint Bartholomew*, a painting that had been in Joe's family for over a hundred years (fig. 2). Joe's favorite Sargent, *Pavement, Cairo* (see page 20, fig. 9) hung above the fireplace in the living room. Nearby was Pierre Subleyras's penetrating *Head of an Apostle (Youthful Self-Portrait, or Portrait of a Man)* (fig. 3), while Benedetto Luti's *The Expulsion from Paradise* anchored the adjacent study (fig. 4). The works of art hanging on the wall, however, only represented a fraction of his collection. In fact, the number of works in Joe's home was staggering. Most of the matted drawings were stored in custom-built filing cabinets, while certain closets were crowded with framed drawings and solander boxes filled with even more drawings. The two adjoining maids' rooms had been converted into storage areas for framed drawings.

Pictures were Joe's true focus and what his friends gravitated toward when he entertained. Although his feelings about entertaining were paradoxical (he was nervous in the role of host yet he excelled at it), he had a great many dinner parties and relished the company of art historians, curators, writers, musicians, publishers, and friends both young and old. The guest lists were remarkably varied. One evening, for example, he brought together Mayor John Lindsay, who was a childhood friend, and William Burroughs, a writer whose work Joe had published.

One reason Joe may have enjoyed the company of friends so much was that he loved stories. Comfortable in French, English, Italian, and German, he was a voracious reader from an early age and a great story-teller; over the years he relayed many anec-dotes from his life. He was well aware of how fortunate he had been to have had an upbringing that included travel and a first-rate education, particularly during the Great Depression when most people experienced such financial difficulties. The source of this financial security was his maternal grandfather, Joseph Fuller Feder, a savvy Wall Street man and stock investor, while his grandmother, Edith Mosler Feder, provided him great emotional support and introduced him to the world of art and culture.

Joe's childhood was not always easy despite his family's wealth (fig. 5). His mother, Odette, who was born to Joseph and Edith Feder in New York City in 1900, married Major John Ronald McCrindle (known to his family as Jack) in 1921.[2] Joe was born in New York on March 27, 1923. His parents' marriage, however, was unhappy, and the McCrindles divorced in 1924. After the divorce, Odette moved to France, where

she subsequently married Count Guy du Bourg de Bozas, by whom she had a son, Joe's half-brother, Antoine du Bourg. Joe stayed in New York and lived with his maternal grandparents in the family's elegant Stanford White mansion at 973 Fifth Avenue.[3]

Edith Mosler and Joseph Fuller Feder moved separately to New York City in the 1890s and married there in 1899 (figs. 6 and 7). Both families were from Cincinnati, to which their ancestors had emigrated in the 1850s from Germany and Silesia (a region now largely in southwestern Poland). The Mosler family, headed by Gustave Mosler, owned the Mosler Safe Company in Cincinnati, but Joe's great-grandfather, Henry Mosler, was not involved in the family business. He followed another path and decided to become an artist, studying painting in Düsseldorf, Munich, and Paris. His artistic merits were later recognized by the French state, which bought his painting *Le Retour* for the Luxembourg Museum, the first painting by an American to be purchased by the French government.[4] A contemporary of Winslow Homer, Mosler was also a successful Civil War artist.[5]

Because of her father's artistic career, Edith Mosler Feder was raised primarily in Paris. In addition to painting, Henry Mosler collected pictures, three of which were at the time attributed to Jusepe de Ribera. These he passed down to Edith, and they hung in the Stanford White house when Joe was growing up.[6] Photographs of interiors from the early 1920s show a decor that could be described as baronial (fig. 8). Pieces of Renaissance furniture, some of which were nineteenth-century reproductions, were interspersed with tapestries and sculpture. Later in the 1920s, Stéphane Boudin, from Maison Jansen in Paris, transformed the interior decor to eighteenth-century French. Joe subsequently eschewed "Fine French Furniture" as too formal. An early refusal to his grandmother was a defiant "no" against allowing her to send Monsieur Boudin to decorate his dorm rooms at Harvard. He later also refused her offer of a Nicolas de Largillierre painting as a gift, perhaps for the same reason. Joe seemed to prefer English furniture, and purchased

many pieces from country antique shops. He enjoyed mixing these with his more important family heirlooms.

Mrs. Feder was the dominant force in Joe's life and remained so until her death in 1960. She collected paintings, drawings, and rare books and her enthusiasm for literature and art had a lasting impact on Joe.[7] As a boy, Joe attended auction sales with her; he would bid on works, most likely following his grandmother's lead. She was an assiduous collector of English silver, antiquarian books, autographs, and letters—all of which Joe inherited—and it was from her that he developed his love of collecting ephemera such as stamps.[8] His grandmother always supported Joe's love of books, and during the 1930s she gave him an allowance of two hundred dollars a year to purchase first editions and antiquarian books. After Joe's death, the McCrindle Foundation gave selections from Joe's library to the New York Public Library and to the Morgan Library & Museum, which also received his collection of autographs and letters.[9]

Joe's diary of a trip to France in 1931 reflects his early interest in collecting:

JUNE 3 —In the morning mademoiselle and I went on the quai where they sell old books and pictures and stamps all along the river Seine for quite a long way. Well, I saw some books for 1 franc apiece, among them was a Catholic prayer book in a terrible state, some of the leaves were almost torn. I bought it, [but] mademoiselle was furious, she told me to exchange it. I went back to the dealer and exchanged it for a guide of Dieppe written in 1905. Then I spied an envelope with 2,000 stamps. . . . On the way home we saw a beautiful old church called St Germain des Près. We went inside. I was a little bit disappointed.

The young collector and connoisseur was fully formed at the age of eight.

Mrs. Feder had a particularly distinguished collection of drawings and paintings. She owned some fifty drawings, including works by Niccolò dell' Abate,[10] Guercino, Polidoro da Caravaggio, Louis Jean Desprez,[11] Jean François Millet, Crispijn van de Passe II, Giovanni Domenico Tiepolo, and a study after Peter Paul Rubens's Marie de' Medici

cycle in the Louvre.[12] The caliber of her paintings rivaled that of her works on paper. Aside from the Largillierre portrait,[13] she acquired important paintings by Jan de Bray and Cornelis Jonson van Ceulen (see page 184). Happily all three pictures are now reunited and hang in the National Gallery of Art in Washington. She also owned a signed Rachel Ruysch and the three paintings attributed to Ribera that she had inherited from her father. It is now recognized that Luca Giordano painted one of these, *Martyrdom of Saint Bartholomew* (see fig. 2), the work that held pride of place in Joe's Central Park West apartment.[14] Joe eventually donated this painting to the Fine Arts Museums of San Francisco.

The 1920s and 1930s were the formative periods of collecting for the Feder family because that was when they began to purchase real estate, decorative arts, and antiques. Life must have been a bit of a whirlwind for the entire family as they shuffled between homes in New York, Charleston, Connecticut, Paris, and near Bayonne, France. In 1929 the Feders commissioned a 183.9-foot yacht, the *Kihna*.[15] The yacht could accommodate a captain and a crew of twenty-six and provided seven staterooms for the Feders and their guests.

In August 1930 the family set sail for four months, starting in England, moving along the coastline of France and down through the Mediterranean, making various stops in the Greek isles. Joe accompanied them and their guests every summer as they followed various itineraries until their last trip aboard the *Kihna* in 1939. He had a tutor and acknowledged that the extensive travel was a wonderful education, but he also admitted to being lonely and unhappy much of the time. Although the summer cruises were filled with his grandparents' and his mother's friends, whom he enjoyed very much, he was sometimes left behind with the crew while the adults made land excursions. When they were on board, he was often kept awake late into the night by the noisy revelers above deck.

Until 1940, when France was invaded by Germany, the Feders spent part of every year in Paris. They owned a double house with Odette and her family at 216 Boulevard Saint-Germain, which is where they were when France was occupied. The situation was dangerous for them because of their Jewish

FIG. 8
Interior of the residence at 973 Fifth Avenue, New York, early 1920s

heritage. Although they were practicing Episcopalians, they feared that the Nazis would come after them nonetheless. They commandeered vehicles and on May 10, 1940, the entire family made a mass exodus to Lisbon, Portugal, to await a boat to the United States. Despite the traumatic circumstances, Joe was always fond of the time they spent in Portugal. Years later he was able to revisit Coimbra, the university town with its wonderful library, where they had stayed.

Back safely in New York after the family's frantic trip to Portugal, Joe continued his studies at St. Paul's School in Concord, New Hampshire. Although he excelled academically, he was still lonely and unhappy. Unlike most boys his age, he preferred the resources of the library to the football field. Joe went on to attend Harvard University and graduated in the class of 1944.

After graduation Joe joined the army, but Harvard had not prepared him for basic training at Fort Dix (fig. 9). In a letter to his grandmother dated June 13, 1944 ("une véritable journée d'enfer"—a veritable day in hell), he describes one sergeant as "a psychopathic case, I think almost a sadist" who "stormed and ranted and yelled about the most minute trivialities." A fellow soldier, "fascinated as they all are by my speech," subjected him to "the most objectionable and rather patronizing curiosity about which I could do nothing."

Mercifully, his intellect and the language skills he acquired during his years abroad soon became evident and he was selected for the Office of Strategic Services (OSS) and sent to London to work as a translator for the duration of the war. He lived much of the time at his own expense at the Ritz, but this arrangement caused some consternation with officers and he eventually moved to a shared flat.

After returning home from the war, Joe entered Yale Law School and graduated with the class of 1948. Although he worked briefly in a law firm, he was not content; because of his love of books, especially fiction, he decided to take a position with Morrow Publishing in New York. Joe soon became an independent literary agent and went on to represent such young writers as

Philip Roth, John McPhee, and Walter Clemons. In 1959, partly to help such writers publish their work, he founded the *Transatlantic Review*. The journal later published pieces by John Updike, Joyce Carol Oates, William Trevor, Paul Bowles, and V. S. Pritchett, as well as art by Jean Cocteau, Eugene Berman, Larry Rivers, and Mervyn Peake. Joe remained editor and publisher of the *Review* until 1977, when it ceased publication. Joe subsequently donated the papers of the *Transatlantic Review* to the Special Collections Library at Rutgers University.

To fund the *Transatlantic Review* and other charitable giving, Joe established the Henfield Foundation in 1959.[16] In 1980 he began awarding yearly Henfield Prizes in fiction to young writers. Sue Miller, Harriet Doerr (later a National Book Award winner), Walter Mosley, Ann Patchett, Ethan Canin, A. M. Holmes, and Mona Simpson have been among the recipients of this prize.[17] The Joseph F. McCrindle Foundation (formerly the Henfield Foundation) subsequently made annual awards to three graduate writing programs, with the winners selected by each program. The directors of the Foundation have recently established Henfield Prizes in Fiction at five graduate writing programs across the country. These include Columbia University, University of Virginia, University of Michigan, University of Iowa, and University of California, Irvine.

Beginning in the 1950s, Joe spent a good deal of time in London. This was also a period of intensive worldwide travel, for which London served as an opportune base. London was home to the offices of the *Transatlantic Review*, and it was also the best place to purchase old master drawings and paintings. An early mentor was his friend Brian Sewell, at the time an expert in the old master drawings department at Christie's. Brian advised him on the purchase of a number of works of art, including his Sargents. Joe would spend weekends in Winchelsea, near Rye, and Brian often accompanied him, the car filled with dogs. There were many picture dealers in that part of England, and the two of them enjoyed looking for treasures in country antique shops. They also made trips

FIG. 9
Portrait of Joseph McCrindle
in the Army, mid-1940s

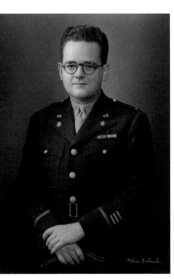

to Charleston to meet Duncan Grant, an artist whose work Joe collected.

Princeton, New Jersey, was for Joe the American counterpart to Winchelsea. He loved the university and its fine art museum. Allen Rosenbaum, the director, was a close friend. Joe enjoyed the opportunity to meet university scholars as well as those at the Institute for Advanced Study. Joe's intellectual community also included his curator, Frederick den Broeder, who would join him for weekends, and a number of budding (and today noteworthy) art historians who rented the room above his garage.[18]

In the 1960s and 1970s Joe generally spent January and February in Rome, where he became involved in the American Academy, later serving as a trustee from 1980 to 1994. The American Academy appealed greatly to his interest in scholarship and the arts. Rome was also the location of one of his favorite dealers, Carlo Sestieri, who was in partnership with his brother, Marcello. Joe enjoyed spending time with Carlo and his wife Giovanna at their lovely home in the Old Ghetto, on the Piazza Margana. During these years Joe was very active as a collector. His grandmother had died in 1960 and, although he was always rather careful about how he spent his money, he could buy what he liked. Aside from works of art, Joe purchased the spacious Kensington Court flat in the early 1970s and, at about the same time, the apartment on Central Park West. These residences provided ample room to absorb the inheritance from his grandmother and to hang and store his growing art collection.[19]

The main focus of Joe's collection of paintings was the Italian school of the seventeenth and eighteenth centuries, and he collected in depth. For example, he owned three works each by Corrado Giaquinto (fig. 10), Luca Giordano, and Salvator Rosa, as well as five by Francesco de Mura and two each by Ubaldo Gandolfi, Giovanni Battista Gaulli (called Il Baciccio), and Benedetto Luti. He had fine examples by a wide range of other Italian artists, including: Marco Benefial, Giacinto Brandi, Niccolò Codazzi, Sebastiano Conca, Francesco Furini, Antonio Galli (called Lo Spadarino),

Francesco Montelatici (called Cecco Bravo), Pietro Antonio Novelli, Matteo Rosselli, Andrea Sacchi, Giovanni Battista Salvi da Sassoferrato, Francesco Solimena, Lodovico Stern, and Francesco Trevisani.

He also owned a number of Dutch and Flemish paintings, including those that he had inherited from his grandmother. Over the years he acquired paintings by Abraham Bloemaert, Joos van Cleve (see page 18, fig. 7), Gaspar de Crayer, Nicolaes Maes, Claes Cornelisz Moeyaert, Cornelis van Poelenburch, and Willem Reuter.

FIG. 10
Corrado Giaquinto,
The Lamentation, oil on canvas,
Ackland Art Museum,
Chapel Hill, NC, Gift of
Joseph F. McCrindle

Joe's collection of drawings extended from the sixteenth to the twentieth centuries, with a focus on the Italian baroque. Nevertheless, it was a wide-ranging collection and includes a multitude of schools, primarily British, French, and American. In fact, nearly a quarter of the works on paper in his collection were from the British school, many of which he acquired in London. These include groups of drawings by Robert Polhill Bevan (see cats. 64, 65), Hercules Brabazon Brabazon (see cats. 56, 57), George Cruikshank, Edward Lear (see cat. 51), and Thomas Rowlandson (see cat. 43). When he was in Paris he tended to buy French drawings, including examples by Jean-Louis Forain, Lodovico Pissarro, and Théophile Alexandre Steinlen, whereas he gravitated toward works by Jean Cocteau, Rockwell Kent, and Pavel Tchelitchew (see cats. 66, 67) when he was in New York. Joe was also interested in stage design and costume

studies, and he collected works by Alexandre Benois, Eugene Berman, Robert Caney (see cats. 54, 55), and John Piper (see cat. 70). This interest in stage and set design certainly derived from his great love for—and encyclopedic knowledge of—the opera.

Joe did not spend lavishly to acquire works for his collection. Ten thousand dollars was the most money he ever spent on a drawing (a double-sided work formerly attributed to Fragonard that he bequeathed to the Cleveland Museum of Art) or a painting (the Pompeo Batoni portrait now in Washington (see page 15, fig. 4). He seemed to have few regrets regarding his collection except that he wished he "could have afforded an Emil Nolde watercolor." He once told me with humor, and a bit of regret, that he had refused the gift of a drawing of shoes that Andy Warhol had once offered him. He passed up a number of buying opportunities because he felt that the prices were too high. For example, four grisaille studies for Sargent's Boston Public Library murals were offered to him for a sum that would later be considered ridiculously low.

By the time I met Joe in the 1980s, his collecting days were mostly behind him, although he continued to purchase pre-Columbian art (primarily Colima dogs) and the occasional drawing, painting, or piece of English silver. The market for old master drawings and paintings had changed dramatically and Joe simply refused to pay what he considered outrageously high prices.

Joe began giving art works to museums in the 1960s. His first donations were to the Minneapolis Institute of Arts, largely because of his friendship with the noted scholar of eighteenth-century Italian art Anthony Clark, who was first a curator and then director of the museum. Tony Clark helped Joe refine his taste in Italian art, specifically eighteenth-century Roman art, and advised him to purchase the marvelous portrait of a gentleman by Batoni (see page 15, fig. 4). Joe's friendship with Duncan Robinson, director of the Yale Center for British Art, also prompted early gifts to that institution.

Aside from personal friendships, Joe also was aware of how his donations could enhance a museum's collection. For example, he thoughtfully donated Gaetano Gandolfi's drawing of *King David* to the Nelson-Atkins Museum in Kansas City (fig. 11) to reunite it with a related oil sketch in that collection. The Philadelphia Museum of Art received Bartolomeo Pinelli's *The Dioscuri* (see page 17, fig. 6) to go with a group of Roman late eighteenth- and early nineteenth-century drawings he had also left to that institution. Finally, he gave the Getty an outstanding drawing by Jean-Baptiste Greuze, *Old Woman with Arms Outstretched*, because, as he said:

FIG. 12
Jean-Baptiste Greuze, *Old Woman with Arms Outstretched (Study for "The Neapolitan Gesture")*, 1756, black and white chalk with stumping, on faded blue paper, The J. Paul Getty Museum, Gift of Joseph F. McCrindle

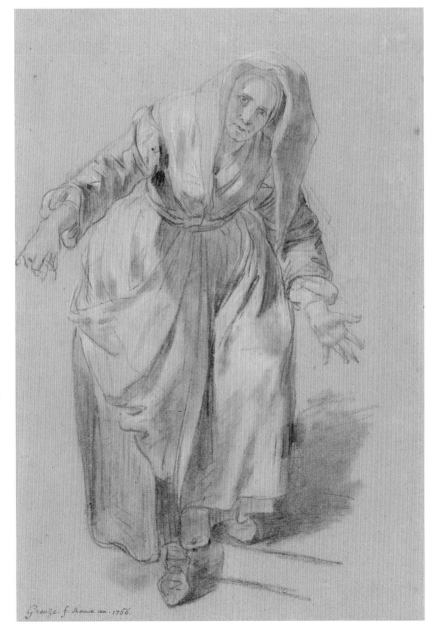

"The Getty needs drawings" (fig. 12). The McCrindle Foundation donated Joe's fine *Portrait of Murat, King of Naples* by Antoine-Jean Baron Gros to the Walters Art Museum. Its selection by the curators at the Walters helped to enrich that museum's excellent collection of nineteenth-century French art.

Joe made his first gift to the National Gallery of Art in 1991 in honor of its fiftieth anniversary celebration. His Giordano, *Diana and Endymion*, was the first painting by that artist to enter the Gallery's collection. Over the years, Joe's relationship with the Gallery grew, partly due to his friendship with Arthur Wheelock, curator of northern baroque

paintings. If one were to reflect on Joe's gifts to Washington, one might surmise that he focused his collecting on the Northern School. While he did present important paintings by De Bray, Jonson van Ceulen, and Philips Wouwerman (see pages 184, 185), the most moving picture he gave to the Gallery is surely *Saint Francis in Prayer* by Bernardo Strozzi (fig. 13). Many of Joe's finest paintings are now at the National Gallery of Art because he felt deeply that donating to the nation's museum was a great honor.

Five years before his death in 2008, it became obvious that Joe was not going to be able to travel and entertain as he had in the past. The effects from a series of small strokes had taken their toll, and he eventually acceded to suggestions and, later, demands that he needed care at home. His caregivers helped to stabilize his health, and he was able to make a few trips, including visits to Washington, D.C., and two round-trip voyages to England on the *Queen Mary 2*. Joe appreciated any excuse to get out of the apartment, but the transatlantic crossings brought back his earliest happy memories and enabled him to see his remaining friends in London and the pictures in his flat. On one of these trips he was able to visit the Courtauld Gallery, where he could view, with great satisfaction, Il Baciccio's *Portrait of Gian Lorenzo Bernini*, which he had donated to that institution in 2003 (fig. 14).

Joe did not start out with, or, for that matter, ever have a wish list of artists to collect. He bought what he liked and he bought a great deal. Years later scholars would say he probably should have bought less and refined his collection, but he was pleased with its character. In part because he chose to disperse his collection widely and not give it to a single institution, it is quite difficult to gauge the collection's ultimate significance.[20] He chose to make a wide impact with little concern about the difficulty that would make in ascertaining his overall legacy.

Joe worked on his will extensively during the latter years of his life, yet less than 20 percent of the collection was specifically listed in the document. During Joe's last two years in the New York apartment

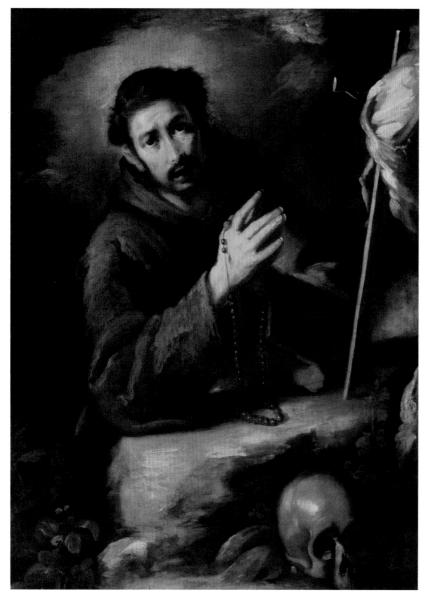

FIG. 13
Bernardo Strozzi, *Saint Francis in Prayer*, c. 1620/1630, oil on canvas, National Gallery of Art, Gift of Joseph F. McCrindle, 2002

much remained on the walls, but virtually everything listed in the will was put on loan at the various legatee institutions. It was a sad period, but it was also exciting to see that what he had determined in his will was becoming real. After Joe's death at home on July 11, 2008, works of art not listed in his will became the property of his Foundation. When the board of directors of the Foundation met after Joe's death, I made the case that we should give away any art work that museums would like to have rather than sell them to raise funds for the Foundation. In this way the Foundation sought to honor Joe's lifelong dedication to philanthropy. It was no small endeavor coordinating with curators from over twenty museums to

choose works from the vast reserves still left in the apartment, but the process has now been successfully completed.

Joe's most lasting legacy will be the gift and bequest of his eclectic and compelling art collection to over forty institutions in the United States, England, and the Netherlands. This generosity, however, goes hand in hand with his funding—either through bequests or gifts from the Foundation—of scholarships, internships, travel grants, fellowships, writing prizes, and support of social-justice organizations. He was an amazing person, quick of mind and delightful to be with, who gave back to society far in excess of the many benefits he received from his privileged background.

FIG. 14
Giovanni Battista Gaulli
(Il Baciccio), *Portrait of Gian Lorenzo Bernini*, c. 1675,
oil on canvas, The Courtauld Gallery, London, Gift of Joseph F. McCrindle in memory of Professor Anthony Blunt

NOTES

1. In writing this essay, I am grateful for the assistance of Sheila Biddle, John Birmingham, Andrew S. Ciechanowiecki, Gail S. Davidson, James Draper, Judson Feder, Leslie and Johanna Garfield, Clare Gesualdo, Laura M. Giles, Margaret Morgan Grasselli, William M. Griswold, John O. Hand, Jennifer Henel, Gretchen A. Hirschauer, Dana Hiscock, David Leavitt, Carol Lewine, Alexandra Libby, J. Patrice Marandel, Andrew Martindale, Rachel McGarry, Pamela Morrison, Stephen M. Noonan, Timothy Riggs, Paul Robertson, Andrew Robison, Betsy Jean Rosasco, Xavier Salomon, Salvador Salort-Pons, Brian Sewell, Caterina Volpi, Arthur K. Wheelock Jr., Scott Wilcox, and Linda Wolk-Simon.

2. Odette Feder's husband's family was of Scottish descent and included an apothecary and a doctor who practiced in British colonial Jamaica. Major McCrindle, however, followed another path and became a World War I flying ace, serving under General Sir Edmund Allenby in Mesopotamia. He later became a lawyer in Britain and a managing director of British Airways.

3. The Feders purchased the Henry Cook house at 973 Fifth Avenue in 1919. It abutted the neighboring Payne Whitney house (now the Office of Cultural Services, French Embassy). These attached houses were Stanford White's last designs and were completed in 1902–1905. Census records indicate that in 1920 the Feders lived in the house with their daughter and nine servants. See Gray 2011.

4. Joe later gave an autograph replica of the painting to the Skirball Museum in Los Angeles, a museum founded by his cousin, Audrey Skirball Kenis.

5. *Harper's Weekly* also recognized Henry Mosler's work and published a number of his Civil War drawings in 1861–1863. Mosler's Civil War sketchbooks and many other works were given to the Archives of American Art in Washington. Joe also bequeathed one of Henry Mosler's self-portraits to the National Portrait Gallery in Washington. The most comprehensive source on Mosler's life and production is Los Angeles 1995

6. An inventory entitled "Joseph Fuller Feder Collection, 973 Fifth Avenue," listing the works of art and furniture, is undated but was probably conducted in the early 1920s. It tantalizingly mentions a Federico Barocci *Betrothal of Saint Catherine* in the dining room, along with two of the Riberas. Joe never mentioned a painting by Barocci so this may well have been sold before he was aware of it.

7. Joe's grandfather, Joseph Feder, did not seem to share his wife's enthusiasm for paintings. Although he did assert on one occasion that he collected paintings by Lucas Cranach, none are known to have been owned by the family. He did collect oriental carpets and published a catalogue of them. Joe always felt a little sorry for him. Both his wife and daughter spoke fluent French and his wife made most of the purchases, and Joe suspected that Mr. Feder felt left out. Joe's mother, Odette, was not a collector like her mother, and many of her pictures were given to her by her parents. Through her third marriage, to George Monroe Moffett, she retained lifetime interest in a major Grant Wood, a Van Gogh, and a Renoir. Joe was amused at her distaste for modern art.

8. Like many youngsters, Joe was passionate about his stamp collection and was heartbroken to find out in early adulthood that his grandmother had sold it off in one of her purges.

9. The Morgan Library & Museum's holdings from the McCrindle Foundation include more than three hundred letters and autographs from authors such as Gustave Flaubert, Marcel Proust, and Jean-Jacques Rousseau.

10. *Funeral of Mausolus, King of Halicarnassus* (sold Christie's, New York, January 25, 2005, lot 116, by Joe's brother).

11. *Interior of Saint Peter's Illuminated* (bequeathed by Joe to the Cooper-Hewitt Museum, New York).

12. *Envy* (bequeathed by Joe to the Ackland Art Museum, Chapel Hill, NC). The Van de Passe **II**, *Parable of Lazarus and the Rich Man* was bequeathed by Joe to the Morgan Library & Museum; Millet's pastel, *Portrait of Louis Alexandre Marolle*, was given by Joe to Princeton University Art Museum.

13. Joe declined *The Grand Dauphin of France and His Tutor, Jacques-Bénique Bossuet* as a gift and subsequently Mrs. Feder sold it to French & Co. It later entered the National Gallery as a gift from the Kress Collection. The painting is no longer thought to depict the dauphin and is now titled *Portrait of a Young Man and His Tutor*.

14. One of the other Ribera paintings, a *Greek Sage*, has retained its attribution and is now in the Kress Collection at the University of Arizona Museum in Tucson. The other painting, a *Saint Jerome* (sold to French & Co. by Joe's grandmother and purchased by Detroit Institute of Art), is based on the version in the Real Academia de Bellas Artes de San Fernando, Madrid.

15. The Feders commissioned the 575-ton vessel in September 1929 from Camper & Nicholsons, Limited, Yacht Builders (Gosport and Southampton) at the cost of £71,500 and had it decorated by Maison Jansen, Paris.

16. The Foundation continued to make charitable gifts after the *Transatlantic Review* was shut down.

17. John Birmingham, chairman of the McCrindle Foundation, and Joe read all of the submissions, which by the early 2000s had become a daunting task for Joe.

18. Joe was also attached to the Brooklyn Museum, and from 1969 through 1974 he served on the Governing Committee (precursor to the museum's Board of Trustees). He made a number of gifts from the estate of Mrs. Feder to the costume collection, which is now housed within the Costume Institute at the Metropolitan Museum of Art.

19. Joe's mother predeceased Mrs. Feder, and his brother, Tony du Bourg, inherited her estate.

20. The Suida-Manning Collection, now in the Blanton Museum of Art at the University of Texas, Austin, is a comparable collection formed over two generations, but, in contrast to Joe's collection, it remains largely intact. The Mannings and Joe were friends and Joe was very familiar with the areas of strength in their holdings and must have felt a bit of kinship.

Joseph F. McCrindle
An Impression

FRANCIS RUSSELL

JOSEPH MCCRINDLE WAS A SELF-EFFACING man, and only his friends were aware of both the extent of the collections he assembled and the strength of his wish that these should pass to appropriate institutions. I came to know him in or soon after 1972, when I began to work at Christie's, London; although he had a house in Princeton and an apartment in New York, and traveled widely, he made regular visits to his successive London establishments, a house in Edwardes Square, subsequently a flat in Kensington Court, and, of course, the house he bought at Winchelsea in the 1960s.

Joe's work on the *Transatlantic Review* meant that he had many friends among the

writers he had encouraged in London. He regularly visited the salerooms, and made his rounds of the dealers. Brian Sewell was his particular mentor, but Joe had the conviction of his own tastes and interests. London was the jumping-off point for frequent European forays to Italy—particularly to Rome, where his friend Milton Levine was a fellow of the American Academy—to France, and to Amsterdam, forays during which sorties to museums, to exhibitions, and, especially in Paris and Rome, to dealers were the norm. There was a Jamesian quality to the pattern of Joe's life, and his selection of Winchelsea seems almost to echo the novelist's decision to live in the neighboring Cinque Port, Rye. Significantly, Joe maintained his membership in Brooks's, most elegant of London clubs, to which he was elected in 1948, when such establishments were more exclusive than they subsequently became, and where he regularly asked me to lunch with him. But he felt more at ease, perhaps, in his larger, and therefore more anonymous, New York clubs, the Century Association and the Racquet Club.

Joe was largely brought up by his maternal grandmother, Mrs. Joseph Fuller Feder, daughter of the painter Henry Mosler. She was a cosmopolitan figure, as much at home in Paris as in New York. Mrs. Feder was a discriminating collector and later bequeathed to Joe wonderful works of art, among them drawings by Polidoro da Caravaggio (fig. 1) and Crispijn van de Passe II, works that he

would in turn donate to the Metropolitan Museum of Art and the Morgan Library & Museum. Her example encouraged him to start collecting early books at the age of eight and can be seen to have drawn him toward both drawings and pictures.

Mrs. Feder had inherited a number of pictures from her father, including Nicolas de Largillierre's *The Grand Dauphin of France and His Tutor, Jacques-Bénique Bossuet* (now titled *Portrait of a Young Man and His Tutor*), which Joe decided not to accept as a gift from his grandmother (it is now in the National Gallery of Art, Kress Collection). The rejection implies his want of interest in the Grand Manner of European portraiture that appealed so strongly to many Americans of his grandmother's generation. Recently the picture was joined at Washington by two other pictures of Mrs. Feder's that Joe gave to the National Gallery of Art—Jan de Bray's wholly affectionate yet austere double portrait of his parents and Cornelis Jonson van Ceulen's suave portrait of the poet, Anna Maria van Schurman (see page 184).

From books and stamps it was natural to graduate to drawings and pictures. While never violently rich, Joe was in the happy position of being able to buy at a time when prices in many of the areas to which he was drawn were not exorbitant. He came into his own as a collector in the 1960s; by the time I knew him, his walls were already full to overcrowding. His pace of acquisition eased in the later 1970s, when the

FIG. 2
Interior from Mrs. Feder's Sherry-Netherland apartment (Jan de Bray painting on the wall), 1950s

FIG. 3
Interior from Mrs. Feder's Sherry-Netherland apartment (Jonson van Ceulen painting on the left), 1950s

statistics of the art market were beginning to change and prices for old master drawings rose beyond his comfort level. Joe bought much less thereafter, but he developed an interest in pre-Columbian material, which he subsequently gave to the Cincinnati Art Museum. He also began collecting prints and acquired more than 350, forming a collection that ranges from an important suite of engravings by the sixteenth-century master Maerten van Heemskerck to a selection of works by the contemporary French artist Erik Desmazières. He later gave this collection to the Ackland Art Museum, University of North Carolina at Chapel Hill. Shortage of space had already led him to place pictures on long-term loan in the institutions he favored, notably the Art Museum, Princeton University. Visitors to his own establishments, however, had plenty to see.

The uncompromising brick façade of Kensington Court in London may not have prepared the visitor for Joe's somewhat dark flat: the hall, densely hung with pictures and drawings; his study and adjacent drawing room; the corridor lined with old master drawings that led to further rooms; the kitchen, with the beautiful picture of flints that was the connoisseur Eliot Hodgkin's first exhibit at the Royal Academy, where Joe had acquired it. The pictures suggested the range of his enthusiasms: old masters, portraits, views—often of places of interest to him. In time the finer pictures were taken to New York, and so the London visitor might be forgiven for underestimating his host's discrimination.

The New York apartment revealed Joe's interests much more clearly. The entrance led to a large central hall, thickly hung with drawings and pictures. For those aware of Joe's instinctive sympathy with an earlier American generation's understanding of Europe, the bank of Sargent watercolors came as no surprise. Opposite these was what was in my view the most satisfying of Joe's many eighteenth-century Roman pictures that reflected the interest in these rekindled by that most genial and enthusiastic of scholars, Anthony (Tony) Clark, whom

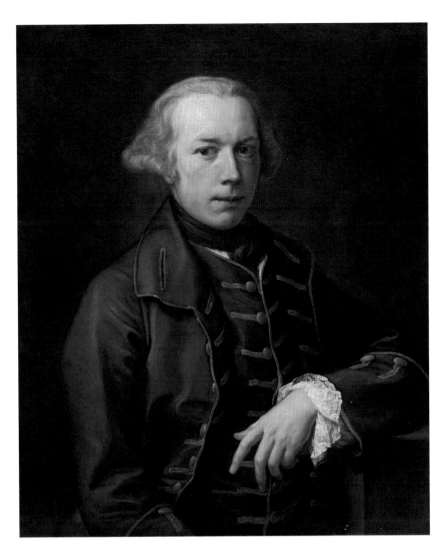

Joe had come to know through the Levines: an exceptionally sensitive portrait of a gentleman by Pompeo Batoni, which has now passed to the National Gallery of Art (fig. 4). Other settecento pictures, many purchased from the Roman dealer Carlo Sestieri, were placed near this portrait, and in the adjacent drawing room with its breathtaking views out over Central Park. Also in the drawing room was part of Joe's library, including his collection of first editions of Sir Walter Scott.

I, too, was interested in Scott; at the age of twelve, I had bought a first edition of *Rob Roy*, without realizing that I was descended from that tempestuous hero's sister. On leaving Oxford I prepared an iconography of Scott. Some years later I told Joe of my

FIG. 4
Pompeo Batoni, *Portrait of a Gentleman*, c. 1762, oil on canvas, National Gallery of Art, Gift of Joseph F. McCrindle, 2004

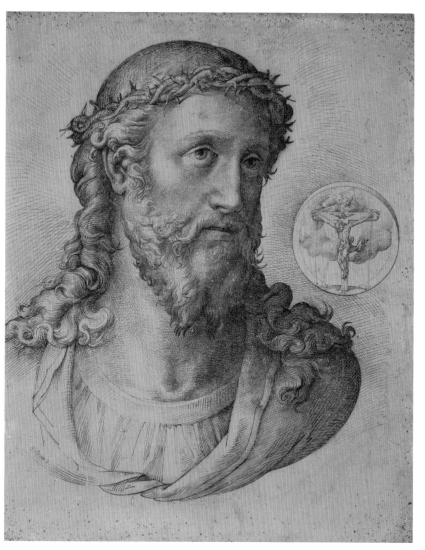

to the New York Public Library and the Morgan Library & Museum. The Morgan was also the beneficiary of a large collection of letters and manuscripts. Few visitors saw the service room that was appropriated as a storehouse for racks of framed drawings. The very number of these was eloquent. Joe enjoyed buying. He liked making regular purchases: he was not afraid of bargains; and he instinctively understood that even relatively minor things can cast a revealing light on the age in which these were created.

Joe liked the company of those who were appreciative, and had many allies in the ranks of art historians and museum curators. But unlike some collectors, he never gave one the sense that he regarded either collecting or presenting what he had collected as the means of a social or intellectual progression. There is often a degree of narcissism in exhibitions of private collections, not least of drawings. In Joe's case that was most emphatically not the case. When an exhibition of a selection of his drawings was held at the Art Museum, Princeton University (*Old Master Drawings from the Collection of Joseph F. McCrindle*, 1991), he knew how much preparing it pleased his friend, Frederick den Broeder, who wrote the catalogue. Joe was, I think, genuinely surprised to realize how many fine sheets he had brought together. There were, perhaps, few trophy drawings in that exhibition, but there was much of interest in the areas that most appealed to Joe.

Italy was strongly represented in Joe's collection of over two thousand drawings. He owned a characteristic landscape by that gifted amateur, Gherardo Cibo (cat. 5). He had a fine Bartolomeo Passarotti (fig. 5), good examples of Paolo Farinati and Niccolò Martinelli, il Trometta, a beautiful study for a miracle of Saint Zenobius by Ciro Ferri (cat. 21), and a characteristic *Head of a Bearded Man* by Benedetto Luti, which has now most appropriately followed Tony Clark's drawings collection to Philadelphia with forty-four of the McCrindle drawings. Joe had a particular interest in Naples and Rome, with sheets by Luca Giordano, Francesco Solimena, and Corrado Giaquinto, while his fine Bartolomeo Pinelli, also now at the Philadelphia Museum

frustration at being unable to trace the most ambitious of Sir Edwin Landseer's portraits of Sir Walter, which Knoedler's had sold to a client in Rhode Island in 1927. The obvious people in Newport and the Social Register had failed me. Joe did not. He recognised the purchaser's name as that of the grandmother of a university contemporary, and within a day had arranged for me to see the picture in the apartment of his friend's aged mother. Joe was almost as excited as I was! Nor did he forget my interest in Scott, but I only learned that he had bequeathed his Scott collection to me when he was too ill to comprehend my gratitude.

There were books throughout the apartment, many of which have now passed

of Art (fig. 6), implies a sympathy with Italian neoclassicism. Of his early Dutch drawings the finest was perhaps Maerten van Heemskerck's *Satan Challenges God to Remove His Protection from Job*, which has now found an appropriate home in Washington (see cat. 3), while his Jean-Baptiste Greuze (see page 9, fig. 12) has passed to the Getty Museum.

Joe, whose standards had been informed by the drawings he inherited from his grandmother, made the vast majority of his own acquisitions in London—no fewer than thirty at Colnaghi's, where he, like other collectors, was constructively encouraged by James Byam Shaw. But, significantly, the drawings he bought there were drawn from the boxes of which collectors were given the run rather than from the annual exhibitions that Byam Shaw selected with such care.

Long after the latter ceased to be involved with the firm, Byam Shaw told me that he had liked the way Joe had chosen things that he personally liked.

Colnaghi's had a unique place in the London old master drawings world, but in the 1960s large numbers of sheets were available, often sold in bundles by the auction houses. There was, therefore, a role for knowledgeable specialist dealers of taste, among them Yvonne ffrench and Wynne Jeudwine, who exhibited together in the rooms of the Alpine Club and whom Joe knew. With time, of course, the dealers from whom Joe bought regularly came to sense what would appeal to him, none more clearly perhaps than Carlo Sestieri in Rome. But seeing Joe working through the boxes during views at King Street at a time when he was much less active as a buyer in

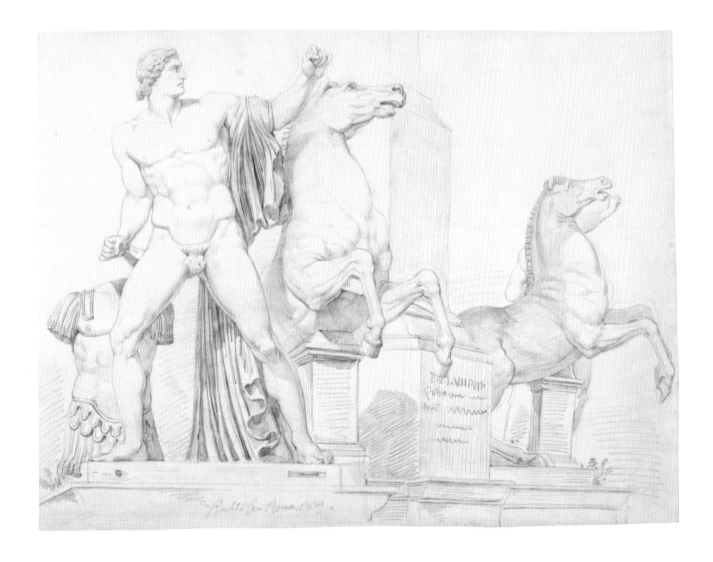

the field, I sensed that he really preferred to find things for himself, and that he was not particularly bothered whether others endorsed his taste or not.

The Princeton exhibition did not include drawings by English or American artists, but Joe was an assiduous collector in these fields too. John Singer Sargent was by no means the only artist of whom Joe built up a significant holding. It is not difficult to understand why

he also bought drawings by Edward Lear, of which a group have now passed to the National Gallery of Art (see cat. 51 and pages 170–171). He was drawn to Jean-Louis Forain, and, among twentieth-century draftsmen, to Pavel Tchelitchew (see cats. 66, 67 and pages 165–166), Rockwell Kent (see page 165), and Robert Polhill Bevan (cats. 64, 65 and page 166).

Den Broeder's catalogue and the exhibition at the National Gallery of Art, a

selection drawn from Joe's gift of 295 drawings to the Gallery, offer a microcosm of his extensive collection of drawings. These catalogues, however, do not reflect his interest in paintings, which numbered about 320 works from the American, Dutch, English, Flemish, and Italian schools. The quality of the works is evident: thirteen of these pictures are now in the National Gallery of Art (see pages 184–185). Among Joe's pictures, the Italian baroque was strongly represented, with fine works by Bernardo Strozzi (see page 10, fig. 13), Salvator Rosa, Francesco Furini, Giovanni Battista Gaulli (called Il Baciccio) (see page 11, fig. 14), Francesco Solimena, and Corrado Giaquinto, whose *Lamentation* (see page 7, fig. 10) and *Christ at the Column* have gone respectively to the Ackland Art Museum, Chapel Hill, and the Legion of Honor, Fine Arts Museums of San Francisco, as well as portraits of unidentified sitters by Pompeo Batoni (see fig. 4) and Pierre Subleyras (see page 3, fig. 3). The earliest of the major northern pictures was a respectable version of Joos van Cleve's *Saint Jerome in His Study* (fig. 7), while excellent examples of Nicolaes Maes, Cornelis van Poelenburch, and Philips Wouwerman (fig. 8) have passed to the National Gallery of Art.

It is not surprising that Joe responded to Benjamin West, another American who gravitated to Europe. West's *Angel of the Resurrection* (now at the Brooklyn Museum of Art) exemplifies the qualities that made him *the* religious painter of late-eighteenth-century England. Joe's handful of pictures by West was balanced by his splendid holding of watercolors and paintings by Sargent, including the *Seaside Landscape*, at the Corcoran Gallery of Art, which exemplifies the artist's bravura in his observation of nature, and *Pavement, Cairo*, at the National Gallery of Art (fig. 9), which reminds us that the painter was, like Joe himself, an appreciative sightseer. Joe placed Sargent's *Study for "Gassed Soldiers"* (fig. 10) on long-term loan at the Yale Center for British Art and by bequest it is now in their permanent collection.

Joe considered the future of his possessions for many years and made generous use of the tax concessions that have contributed so greatly to the growth of American

FIG. 8
Philips Wouwerman, *Battle Scene*, c. 1645/1646, oil on panel, National Gallery of Art, Washington, Gift of Joseph F. McCrindle in memory of Frederick A. den Broeder, 2000

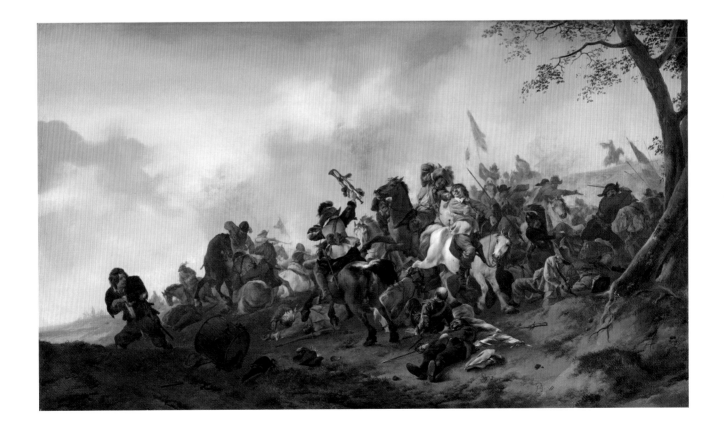

museum collections. He knew that his things did not merit preservation en bloc and would contribute most if carefully distributed among the institutions he favored. When I first knew him, Princeton—which was to receive the Joos van Cleve—was, I think, the principal institution Joe had in mind. But in time his horizons widened. He was delighted to realize that many of his British pictures and drawings, particularly those of the twentieth century, would fill gaps in the holdings of the Yale Center for British Art, where he found a congenial and appreciative director in Duncan Robinson. Works by Walter Sickert, Duncan Grant, David Bomberg, and artists of the Camden Town Group thus found an

appropriate home at Yale. Later gifts from the collection range from a portrait of Tobias Smollett, formerly attributed to Francis Hayman, and two pictures by that most exacting of Victorian landscapists, John Brett, to works by Max Beerbohm, Sir William Orpen, Henry Scott Tuke, William Peploe, Eliot Hodgkin, and John Minton.

Naturally, Joe always planned that most of the collection should pass to American institutions. He had, however, also a strong sense of his link with England. When it became possible for him to channel works of art there through the National Art Collections Fund in a tax-efficient way via the Lutece Foundation, Joe was keenly interested.

His first gift was a landscape by Anthonie van Croos, his second a picture by Duncan Grant. We had already talked about a few other, more significant works that had no counterparts in the National Gallery in London. But the arrogant and unsympathetic attitude of the then-director of the National Art Collections Fund caused Joe to lose interest. Subsequently, however, he presented Baciccio's portrait of Bernini to the Courtauld Institute of Art in memory of Anthony Blunt (page 11, fig. 14).

Illness clouded the last years of Joe's life. He faced this period with calm courage and knew that he was fortunate in friendship. With the help of John Rowe, who understood his wishes so well, he ensured that works from his collections were gradually distributed to the institutions in which they would contribute most. The pace of donations quickened, but they were carefully considered. Thus, pictures by Sargent were given to six museums: the National Gallery of Art and Corcoran Gallery of Art in Washington, Princeton University Art Museum, North Carolina Museum of Art, Philadelphia Museum of Art, and Saint Louis Art Museum. After Joe's death, large groups of both drawings and pictures were carefully placed. Eight drawings passed to the Metropolitan Museum of Art, three hundred seventy-six to the Pierpont Morgan Library, and a large group to the Museum of Fine Arts, Boston. The Sterling and Francine Clark Art Institute at Williamstown received forty-six drawings, including twelve by Jean-Louis Forain. Groups of drawings by Forain, Théophile Alexandre Steinlen, and Pavel Tchelitchew went to the New Orleans Museum of Art, while varied groups of studies have passed to the University of Michigan Museum of Art and the Minneapolis Institute of Arts. Nine northern drawings were presented to the Teylers Museum at Haarlem, for which Joe had a particular affection. The pictures and drawings that remained in Kensington Court, which were not on the whole of museum quality (although he gave one drawing to the British Museum), were sold for the benefit of the Friends of Friendless Churches, a

body that has done so much valuable work preserving religious buildings in Great Britain.

When I was helping Gervase Jackson-Stops to select pictures for the *Treasure Houses of Britain* exhibition held at the National Gallery of Art in 1985–1986, we went to see an old friend of mine who was to be a generous lender. After a time he turned to Gervase and observed: "I do like shopping, don't you?" Joe most certainly did, as we sense when we realize how much he bought and in so many differing, if sometimes overlapping, areas of interest. He loved the places where he shopped and he liked the dealers to whom he returned. But above all he would have been gratified to know that his possessions can now give pleasure, and perhaps instruction, to a wide audience. Joe was in personal matters a modest man, but he knew instinctively that his drawings and pictures would prove to be of enduring value.

FIG. 10
John Singer Sargent,
Study for "Gassed Soldiers," 1918,
charcoal and graphite, Yale
Center for British Art, Bequest
of Joseph F. McCrindle

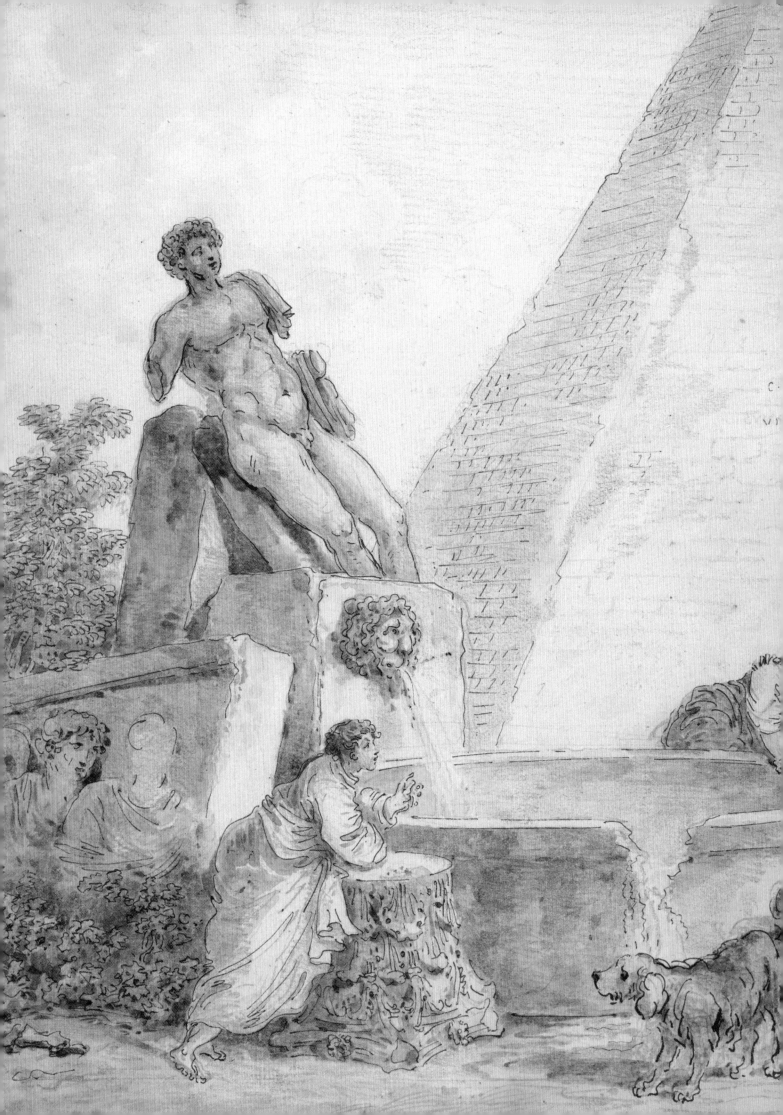

Catalogue

NOTE TO THE READER

All of the works of art are from the collections of and must be credited to the National Gallery of Art, Washington.

The catalogue is arranged in approximate chronological order, by the date of each drawing. Works by a single artist are generally grouped together.

Dimensions are given in millimeters, height preceding width. Unless otherwise stated, dimensions indicate the entire sheet. If the paper is unusually shaped (not a square or a rectangle), the maximum dimension is given and the shape is described. Measurements for works in other media are given in centimeters.

Unless otherwise indicated, all drawings are on laid paper of varying shades of white or off-white.

Watermarks found in the paper are described briefly and, whenever possible, are noted as related to watermarks catalogued in Briquet, Churchill, or Heawood (see bibliography). Undeciphered or fragmentary watermarks are noted as such.

References to "Lugt" in the provenance indicate the presence of a collector's mark on the drawing itself or on the mount. If a mark is catalogued in Lugt (see bibliography), the pertinent Lugt number is given.

In references to literature, exhibition catalogues are abbreviated by the city and date of the exhibition's first presentation. Other books and articles in periodicals are abbreviated by the author's or authors' last name(s) and the date of publication. Full citations for the abbreviated literature and exhibition references are given in the bibliography, beginning on page 186.

Provenance is given in chronological order; the means of transfer between owners is not always specified, nor are gaps in the ownership history noted.

CONTRIBUTORS

ABB Andaleeb Badiee Banta

DB Daniella Berman

JB Jonathan Bober

DC Deborah Chotner

MD Margaret Doyle

MMG Margaret Morgan Grasselli

GCH Ginger Crockett Hammer

GDJ Gregory D. Jecmen

ARJ Amy R. Johnston

LK Lars Kokkonen

RL Rozemarijn Landsman

LL Lara Langer

CM Carolina Mangone

AR Andrew Robison

JR Josephine Rodgers

SS Stacey Sell

JBS Julie Blake Shook

OT Oliver Tostmann

Parmigianino

PARMA 1503–1540 CASALMAGGIORE

I

The Flaying of Marsyas,
1526/1530

pen and light brown ink with
brown wash, heightened
with white gouache, incised;
with later additions by at
least one other hand, in
pen and dark brown and
black ink, heightened with
a different white gouache
on brown paper, 165 × 141
(all four corners trimmed to
create an oval shape)

Joseph F. McCrindle
Collection 2010.93.14

INSCRIPTIONS verso:
upper left, in graphite,
Flaying Marsyas; center,
Perino del Vaga, 1500–1547/
Photographed by BM/LGD

PROVENANCE L. G. Duke;
to P. & D. Colnaghi & Co.,
Ltd., on April 12, 1955 (stock
number A20841 on verso);
sold to Joseph F. McCrindle,
New York, June 18, 1958;
gift to NGA in 2010

LITERATURE Princeton
1991, no. 10 (attributed to
Bernardino Campi); Banta
2012, 49–58

FIG. 1
Antonio Fantuzzi,
after Parmigianino, *Apollo*
Overseeing the Flaying of Marsyas,
c. 1545, etching, Bibliothèque
Nationale, Paris

THE TALE OF THE GOD APOLLO
punishing the satyr Marsyas after besting
him in a musical contest comes from
Ovid's *Metamorphoses* (VI, 382–400). For his
impertinence in challenging a god, Marsyas
was condemned by Apollo to be skinned
alive. Here Apollo, standing gracefully at
right, directs another figure to flay Marsyas,
who is hanging upside down from a tree.
Scattered on the ground are the instruments
used in the contest: Apollo's lyre and
Marsyas's panpipes.

In spite of an earlier attribution to
Bernardino Campi (1522–1595), this sheet
proves to be a drawing by Parmigianino
that has been partially hidden by later
retouching. The heavy-handed dark brown
and black inks on the figures' contours and
a second campaign of white heightening
throughout this sheet obscure immediate
association with the work of this major
mannerist artist. Yet the drawing's obvious
correspondence to an etching from c. 1545
by Antonio Fantuzzi (c. 1510–1550 or after)
after Parmigianino's invention clarifies it as
the finished preparatory design, heretofore
assumed to be lost (fig. 1).[1] Looking past the
later interventions, one notes the willowy
contour lines and fine, long parallel hatchings
in lighter brown ink, as well as the elongated,

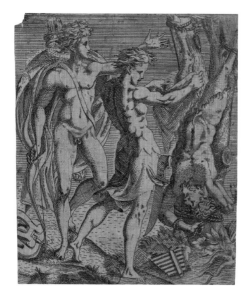

elegant forms typical of Parmigianino's
draftsmanship. Raking light reveals extensive
stylus markings throughout the sheet that
indicate compositional pentimenti; these,
together with specific details present in the
drawing but not found in the print, confirm
that this drawing was the primary design
for it.

This sheet may relate to a group of oval
sketches depicting scenes from the legend
of Marsyas, which Parmigianino probably
executed during his last years in Rome, before
the city's sack by imperial forces in 1527, or
directly afterward, when the artist fled to
Bologna.[2] In shape and style it is close to two
examples in the Musée du Louvre, Paris, that
depict *Minerva Throwing the Pan Pipes into the Water*
and *A Man Expressing Surprise*, particularly in
the dynamic delineation of the drapery and
the figures' graceful yet expansive gestures.[3]
The Uffizi has an initial sketch of the *Flaying*
of Marsyas composition that was later refined
and elaborated in the present drawing.[4]

It has been pointed out that the antique
sculpture of *Apollo Belvedere* likely served as
the model for the Apollo in Parmigianino's
series of drawings treating the Marsyas
theme.[5] The orientation of the figure of
Apollo in the McCrindle sheet is in reverse
to the sculpture's stance, but would appear
in a print in the same direction as the statue.
In his appropriation of the antique source,
Parmigianino artfully transformed the raised
arm of the sculpted Apollo into a gesture
that commands Marsyas's punishment. — ABB

1 Zerner 1969, no. 76b. See also Wyss 1996, 103, 107, fig. 79.
 Many thanks to Lara Langer, who directed my attention to
 this print.

2 See Gnann 2007, 1: 99–100; 2: nos. 606–615, and Popham
 1971, 1: no. 390; 2: pls. 129–131.

3 Inv. 6412*bis* and 6433; reproduced in Gnann 2007, 2:
 nos. 609, 614.

4 Inv. 13583F, red chalk with pen and brown ink; Gnann 2007,
 2: no. 613.

5 Gnann 2007, 100; Carmen C. Bambach in London 2000,
 under cat. no. 78.

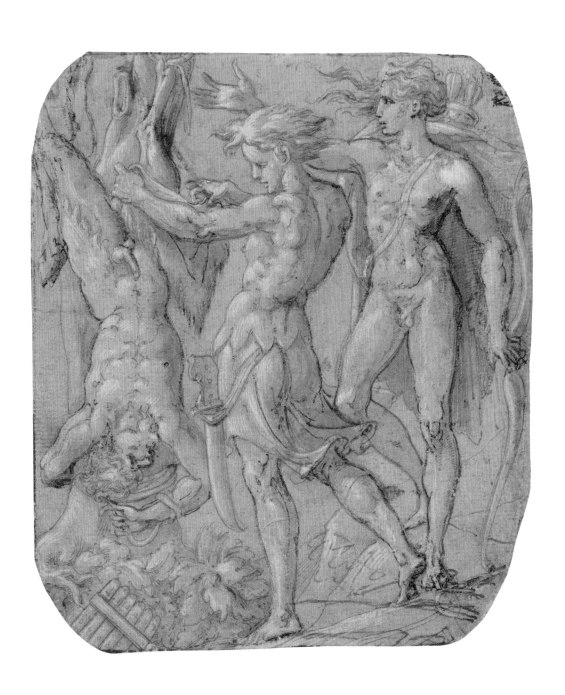

Polidoro da Caravaggio

CARAVAGGIO C. 1499 – 1543 MESSINA

2

Fleeing Barbarian,
early 1520s

black chalk, 179 × 122

Joseph F. McCrindle
Collection 2010.93.10

INSCRIPTIONS lower right,
in pen and brown ink,
Padre Resta's inventory
number, *i.91*; upper left,
by an unknown hand,
no. 94; on the Richardson
mount, lower center,
in pen and gray ink,
Giulio Romano; lower right,
in pen and brown ink,
by Richardson, *P. Resta.*

PROVENANCE Padre
Sebastiano Resta
(1635 – 1714), Milan (Lugt
2992); Jonathan Richardson
Sr. (1665 – 1745), London
(Lugt 2183); F. Abott,
Edinburgh (Lugt 970); sale,
Sotheby's, London, March
12, 1963, lot 118; Joseph F.
McCrindle, New York; gift to
NGA in 2010

LITERATURE Princeton
1991, no. 2; Leone de Castris
2001, 35, 39, 483, no. D 182,
fig. 23

POLIDORO CALDARA, KNOWN AS Polidoro da Caravaggio for the north Italian town where he was born, was the most independent and idiosyncratic of Raphael's followers. He entered the master's workshop in Rome around 1515, and his participation in its collective projects is distinguished by eccentricity and energy. In the mid-1520s Polidoro developed a new kind of decoration for palace façades with scenes from Roman history painted in grisaille imitating antique low-relief sculpture. Enlivened by dynamic composition and bold characterization, these were admired for nearly two centuries and were copied by almost every artist who went to Rome, thus ensuring the lasting strength of Polidoro's reputation.

Polidoro's drawings, deviating from Raphael's example and often strikingly pictorial, are a primary expression of his naturalistic instinct and unbridled temperament. The present study is an unusual manifestation of his essential early interest in re-creating antique form. Full-length, costumed as a barbarian, and compressed within a single plane, this figure relates generally to relief sculpture and, in its abrupt movement and oversized extremities, to figures in the great narrative relief of Trajan's Column (Rome, AD 113). Polidoro's drawing, however, is more complicated and animated than any antique precedent: the barbarian runs in one direction while looking backward and is rendered essentially in profile but with his torso turned to the front. The resulting double tension lies midway between a classical *contrapposto* and the *figura serpentinata* of full mannerism. This type of figure was common in Polidoro's re-creations *all'antica*, and moreover often acts as the fulcrum of his illusionistic friezes. Indeed, it is tempting to imagine that the present drawing was conceived in preparation for one of his façade decorations,[1] but one cannot point to a specific corresponding figure in them.

Within Polidoro's oeuvre, the McCrindle drawing is equally unusual in handling and technique. His graphic habits can be discerned in the figure's loose construction and impulsiveness, though neither is as pronounced or obviously eccentric as is typical in his work. Similarly recognizable are the patchwork hatching and its implication of modulated light, but here it lacks the extreme vagueness of surface or density of atmosphere that pervade his typical red chalk studies. The use of black chalk in the McCrindle drawing is exceptional in Polidoro's work; the restrained, small-scale *Madonna and Child* in the British Museum offers the only significant example in this technique among hundreds of his surviving drawings.[2] Rather than serving to exclude Polidoro's authorship, however, this choice of medium is suited to both the appropriation of an antique source and a potential function *all'antica*. As much as the choice of motif, such adaptation of style to context suggests that this drawing is a very early effort, still close to the fundamental lessons learned from Raphael and probably made amid his collaborations with the master's other followers in the early 1520s. — JB

1 Pierluigi Leone de Castris (Leone de Castris 2001, 35) suggests that the drawing was "perhaps for one of the first façades painted with Roman histories," but then states without qualification that it was "preparatory for a façade decoration" (483, no. D 182).

2 Inv. 1958-12-13-5; Leone de Castris 2001, no. D 138.

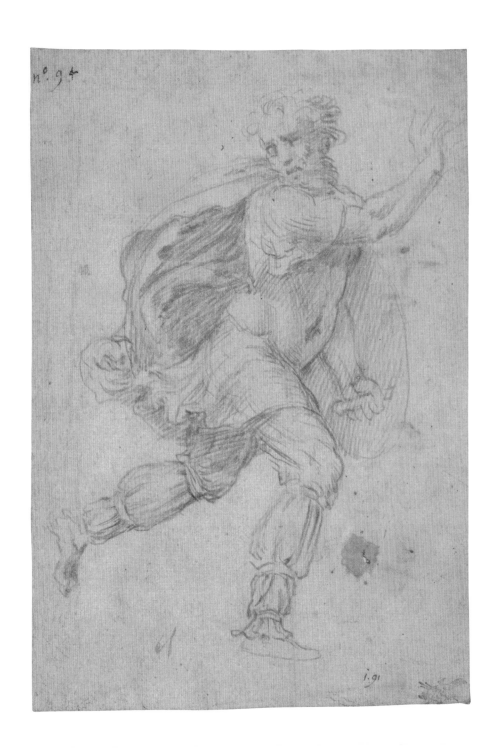

Maerten van Heemskerck

HEEMSKERK 1498 – 1574 HAARLEM

3

Satan Challenges God to Remove His Protection from Job, 1562

pen and brown ink over traces of graphite, incised for transfer, 191 × 246

Joseph F. McCrindle Collection 2010.93.23

INSCRIPTIONS signed in a cloud at lower right, in pen and brown ink, *M. Heemskerck inventor*; dated on another cloud, *1562*; and numbered on a third, *4*; verso: center, in graphite, in old Dutch script, *Historie van Job / no 30 — van Heemskercke*

PROVENANCE P. & D. Colnaghi & Co., Ltd., London, 1958; Joseph F. McCrindle, New York; gift to NGA in 2010

LITERATURE Princeton 1991, no. 73; *New Hollstein* 1993, pt. 1: 140, under no. 164; Harris 1994, 68; *New Hollstein* 2001, pt. 1: 89, under no. 60

AN EXCEPTIONALLY TALENTED AND prolific painter and draftsman, Maerten van Heemskerck made this drawing in preparation for one of a series of eight prints depicting the biblical story of Job (Job 2: 1–6).[1] This drawing, the fourth in the set, shows Satan daring the Lord to remove his sheltering hand from Job, his most faithful human servant. God, seated amid clouds and surrounded by his heavenly host, accepts the challenge, allowing Satan to smite Job with boils. But Job's faith remains unwavering. In the drawing he is shown in the lower right corner, seated in front of the ruins of what used to be his home, his arms folded in prayer and acceptance.

Called "Van Heemskerck" after his place of birth, Maerten trained with a local artist before joining the workshop of Jan van Scorel (1495–1562) in Haarlem. He then traveled to Rome in 1532, where he studied both antiquities and contemporary works of art. In the McCrindle drawing, a result of this journey is visible in the muscular bodies of the foreground figures and in the pose of God the Father, all of which recall works of Michelangelo (1475–1564).[2]

After settling in Haarlem, Van Heemskerck became increasingly involved in the production of prints, creating an extraordinarily large number of drawings that were meant to be engraved. He often depicted biblical and moralizing subjects, and many

of the final prints were captioned with poems by the eminent scholar Hadrianus Junius (1511–1575), another member, along with Van Heemskerck, of the Haarlem cultural elite.[3]

As this drawing reveals, Van Heemskerck rivaled the meticulousness and virtuosity of a printmaker in his handling of the pen. The profusion of lines varies from light touches of great delicacy to dark, strongly accentuated arcs. Many of the strokes are short and crisp, drawn close together and carefully modulated to shape clouds, draperies, and bodies with the utmost precision. To transfer the drawing to the copperplate, the drawing was incised with a stylus; fortunately, the image remained unspoiled. Although the (reversed) engraving was the final, finished product of the printing process (fig. 1), Van Heemskerck's preparatory drawing was no less admirable as a complete work of art. The artist's justifiable pride in it is indicated by his prominent signature. — *RL*

1 The prints are catalogued in *Illustrated Bartsch* 56, no. 5601; Hollstein 8, nos. 256–263; *New Hollstein* 1993, pt. 1: nos. 161–168; and *New Hollstein* 2001, pt. 1: nos. 57–64. Philips Galle (1537–1612) made the first set of prints of the Job series in 1563. Three other drawings for the suite are in the Museum Boijmans Van Beuningen, Rotterdam (see Hoetink 1961, pls. 6–8); two are in the National Galleries of Scotland, Edinburgh (one reproduced in Washington 1990, no. 48); and one is in the Centraal Museum, Utrecht (see Utrecht 1964, no. 167, fig. 4).

2 Frederick A. den Broeder (in Princeton 1991, 164) noted the similarity between the pose of God in Heemskerck's drawing and Michelangelo's sculpture of *Moses* (reproduced here on page 46).

3 For the relationship between Van Heemskerck and Junius, see Veldman 1974, 35–54.

Northern Italian school, late 16th century

4

*Salome with the Head
of Saint John the Baptist,*
c. 1580

pen and brown ink with
brown wash and black chalk,
heightened with white
gouache on blue paper,
squared for transfer in black
chalk, 424 × 477 (torn and
made up at upper right)

Joseph F. McCrindle
Collection 2010.93.18

INSCRIPTION lower right,
in graphite, *Taddeo Zuccaro
(Milani)/dom de Milan*

PROVENANCE Nicholas
Lanier (1588–1666),
London (Lugt 2885); Sir
Peter Lely (1618–1680),
London (Lugt 2094);
Hans Calmann, London;
Joseph F. McCrindle, New
York; gift to NGA in 2010

LITERATURE New Haven
1974, no. 39 (as Raffaellino
da Reggio?); Princeton 1991,
no. 34 (as North Italian,
Lombardy)

THIS COMPOSITION DEPICTS AN
unusual transitional moment in Saint John
the Baptist's martyrdom, with the central
figure of Salome carrying aloft the Baptist's
head apparently fresh from the execution,
for presentation to an unseen King Herod
and his wife, Salome's mother. Flanked by
disengaged and elaborately dressed soldiers
occupying the foreground as well as bustling
maidservants in the background, all mere
bystanders to the narrative, Salome is pre-
sented here as a heroic bearer of a sacred relic
for the viewer to venerate. The virtuosic
representation of figures not integral to the
narrative, however, competes with the devo-
tional tenor of the subject, making the viewer
equally aware of the draftsman's artistry.

Though squared for transfer onto a
larger canvas or a wall prepared for fresco,
this bravura drawing has yet to be connected
to any known painting or commission or
convincingly attributed to a specific artist.
While the ornate, body-conscious armor of
the muscular soldiers is typical of the man-
nerist style of Rome or Florence, the female
figures clad in billowing, diaphanous garments
are more indebted to the soft, expressive
style of Federico Barocci (c. 1526–1612), the
Urbino painter who influenced artists from
Rome to Milan. The deep, almost exaggerated
shading and the distinct, striated highlights
also recall the attention to surface that was
characteristic of Lombard artists of the later
sixteenth century.

Rarely does a drawing as rich and
ambitious as this *Salome* so persistently defy
attribution. Various artists from central
and northern Italy have been tentatively
associated with the work. The early collector's
annotation at lower right attributing it to
the Roman mannerist Taddeo Zuccaro
(1529–1566) was dismissed by London
dealer Hans Calmann when he purchased
the drawing. He favored the master's less
famous follower, Raffaellino da Reggio
(1550–1578),[1] whose emphasis on shading

with a strong sense of relief and preference
for compositions in diagonal recession are
loosely similar to the McCrindle drawing.
In 1991 Frederick A. den Broeder pursued
a clue offered by the latter part of the
inscription (*dom de Milan*) and suggested that
the drawing was made by an artist aware of
the Roman-Florentine tradition but working
in a local idiom in northern Italy.[2] Following
a critical survey of potential candidates from
the Veneto, Ferrara, and Lombardy, Den
Broeder cautiously advanced an attribution
to Camillo Procaccini (1551–1629) working
in about 1580, because Procaccini had worked
at the Milan Cathedral and may have spent
time in Rome.[3] While there are no direct
stylistic equivalents to the McCrindle sheet
among Procaccini's drawings, there are many
similarities: the use of exaggerated shading
and striated highlights, the representation
of space, the elegantly clad soldiers, and
the figure types suggest an artist who was
working in Procaccini's Lombard milieu and
was also fluent in the artistic tradition of
Rome. — CM

1 Noted in Princeton 1991, 86, no. 34.

2 Frederick A. den Broeder in Princeton 1991, 86.

3 Den Broeder in Princeton 1991, 86–87. Den Broeder's
 other candidates included Giuseppe Porta, also called
 Giuseppe Salviati (1520–1575), Domenico Mona
 (c. 1550–1602), Giuseppe Meda (active before 1565–
 after 1580), Ambrogio Figino (c. 1548–1608), and
 Giambattista Crespi, called il Cerano (1575–1633).

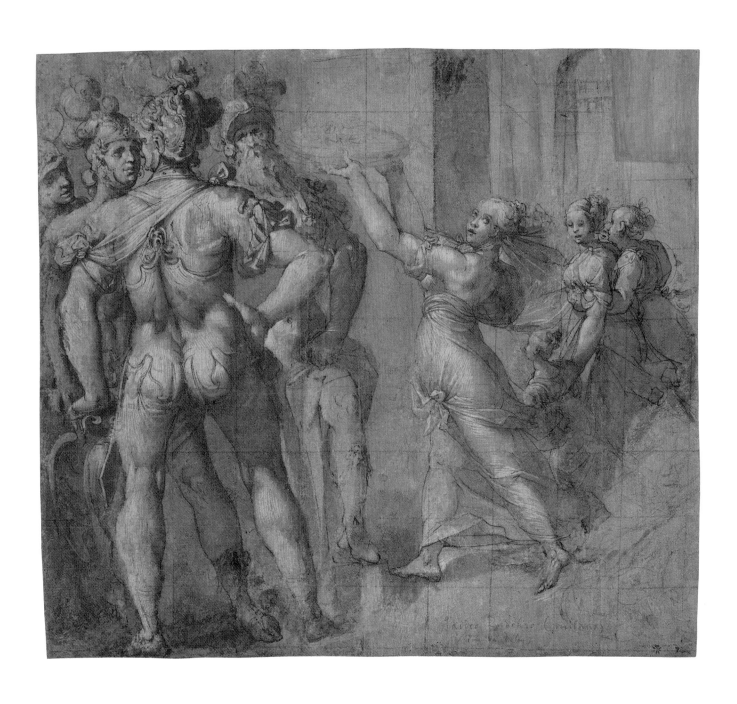

Gherardo Cibo

GENOA 1512 — 1600 ROCCA CONTRADA

5

Hilly Landscape with Ships, c. 1570

pen and brown ink with brown wash, heightened with white gouache on blue paper, 215 × 290

Joseph F. McCrindle Collection 2010.93.13

INSCRIPTION numbered at upper left, in pen and brown ink, 3

PROVENANCE possibly Daniel Gardner;[1] A. Bruce Thompson (part of an album sold at Sotheby's, London, April 27, 1960, lots 1–12); Helene C. Seiferheld, New York; Joseph F. McCrindle, New York; gift to NGA in 2010

LITERATURE Bolten 1969, 143, no. 115; New Haven 1974, no. 29; Princeton 1991, no. 9; Harris 1994, 68

ONE OF THE MOST PROLIFIC ITALIAN landscape draftsmen of the sixteenth century was the Genoese nobleman, scientist, and amateur artist Gherardo Cibo; about 150 landscape drawings by him are now known. It was not until 1989, however, that his authorship of these works was discovered, based on similarities with the background landscapes included in some botanical illustrations that are securely attributed to him.[2] As the McCrindle drawing shows, Cibo's view of nature has little in common with the bucolic landscapes of Domenico Campagnola (1500–1564), the classicizing views of Polidoro da Caravaggio (c. 1499–1543), or any other works by his professional Italian contemporaries. In fact, it is more closely connected to the style of landscape executed by northern artists, recalling to a certain extent the *Weltlandschaft* (world landscape) that was popular among such Netherlandish artists as Pieter Bruegel (c. 1525 / 1530–1569), Joachim Patinir (c. 1485–1524), and Hieronymus Cock (c. 1510–1570). Having traveled to the Netherlands in 1540, Cibo would have certainly known and was undoubtedly inspired by the works of these artists.[3]

Like many other Cibo drawings, the McCrindle sheet owes its charm to its fanciful character and its lively execution. It depicts a modest building, perhaps a monastery, set into the side of a forested hill that borders a rocky coast.[4] In spite of its small size, the drawing hums with activity — fishing boats float below the cliffs and figures walk along a hillside path. Typical of Cibo's hand are the rapidly sketched trees with quick loops suggesting masses of foliage; the rich hatchings reinforced by washes that create dark areas of shadow; the deft strokes of white gouache that suggest bright, flickering sunlight. Adding to the boldly visual effect of the drawing is the blue paper support — found also in many other drawings by Cibo — that gives appropriate color to both the water and the sky while also serving as the middle tone for the rest of the scene.[5]

Cibo was descended from an old noble family and was groomed to work at the papal court. He received a humanist education and became one of the leading botanists of his time, illustrating scientific publications with innumerable renderings of flowers and plants. That Cibo would eventually be regarded as one of the most delightful and original Italian landscapists of the sixteenth century is an unexpected reward for this *gentil' huomo* who never received classical training as an artist and who may well have regarded his activities as a landscape draftsman as little more than a pleasurable distraction. — OT

1 See Bolten 1969, 135, n. 1.

2 The identification of Cibo as the artist responsible for these landscape drawings was made by Arnold Nesselrath in the mid-1980s. See Nesselrath 1993 and San Severino Marche 1989. Prior to that the drawings had been thought to be the work of a different amateur, Ulisse Severino da Cingoli; see Bolten 1969.

3 Another Cibo drawing in the National Gallery of Art, *Rocky Landscape with a Natural Arch* (inv. 2007.111.58), seems to have been inspired in part by a print by Hieronymus Cock. See Washington 2011, no. 10. Other drawings influenced by Cock's works are cited in Washington 2011, 33, n. 4.

4 The building in the McCrindle drawing bears a strong resemblance to a church sketched by Cibo on the verso of another sheet. See San Severino Marche 1989, 71 (location unknown).

5 The *Rocky Landscape with a Natural Arch* mentioned in note 3 is also on blue paper.

Italian school, possibly Florentine or Roman, late 16th or early 17th century

6

A Partially Skinned Rat, 1580 / 1630

two shades of red chalk with traces of black chalk, 153 × 224

Joseph F. McCrindle Collection 2009.70.26

INSCRIPTIONS lower left, in pen and brown ink: *21*; on the mount, lower right, in pen and brown ink, *An Animal by Parmegiano*; lower right, in graphite, *71*; lower left, in graphite, *Colnaghi* (partially erased); on verso of mount, upper center, in pen and brown ink, *TT* [or *JJ* or *II*, or *JT*?]; center, in graphite, *4 / Parmeggiano*

PROVENANCE George John Spencer, 2nd Earl Spencer (1758 – 1834), Althorp (Lugt 1531); sale, Thomas Philipe, London, June 14, 1811, no. 530, as by Parmigianino: "A camelion [*sic*] — red chalk, stumped — vigorously executed." Robert Clermont Witt (1872 – 1952), London (Lugt 2228b); P. & D. Colnaghi & Co., Ltd., London (inv. no. A 5435 on verso of mount); Joseph F. McCrindle, New York; Joseph F. McCrindle Foundation, 2008; gift to NGA in 2009

FIG. 1
Filippo Napoletano,
Study of an Animal's Skull,
c. 1620, red chalk,
Palais des Beaux-Arts de Lille

THIS UNUSUAL DRAWING OF A RAT, WITH its fur partially shaved and the flesh removed from its skull, is equal parts intriguing and mystifying. Although it bears a nineteenth-century attribution to Parmigianino (1503 – 1540), the drawing's graphic physiognomy has little in common with that artist's work. While Parmigianino was known to draw animals from life, there is a certain rigidity of line and robustness of three-dimensional form in this drawing that excludes it from the Parmese master's oeuvre.[1] Furthermore, there may be the hand of a second artist present in the drawing, particularly along the darker, reinforced contours of the rat's haunches on the right side. To whom the sheet's authorship can be reassigned and from what region it hails remain open questions.

The precise handling and the explicit, almost sculptural presentation of the rat's anatomy suggest a semiscientific and certainly analytic intent on the artist's part. As interest in the natural world and the sciences proliferated throughout the sixteenth and seventeenth centuries, many artists across Europe contributed illustrations to compendiums of nature and recorded the contents of *wunderkammern,* or cabinets of natural curiosities, compiled by learned aristocrats and amateur scientists alike through the early modern period.[2] It is possible that this drawing relates to this type of protoscientific environment, although it

does not bear the hyperdetailed appearance that characterizes the work of an artist who has been engaged to record every aspect of a natural specimen. Instead, the delicate attention to the fall of light and shade, and the careful arrangement of the rat's body against background elements — as if to create a setting of sorts — point to aesthetic concerns that surpass a purely clinical record of appearances.

While a secure attribution for this somewhat macabre drawing remains to be found, it has striking affinities with the subject and style of drawings of animal skeletons by Filippo Napoletano (1589 – 1629).[3] A peripatetic artist working in Rome from 1614 to 1617 and then at the Medici court in Florence until 1622, Napoletano published a series of etchings, *Incisioni di diversi scheletri di animali* (1620 – 1621), for which he made studies of animal skeletons, including a pen-and-ink drawing of a rat (Musée du Louvre, Paris, inv. 17641).[4] His red chalk drawing of an animal's skull — perhaps a wolf's — shares the long parallel strokes that the artist of this sheet uses to delineate both the rat's body and the background forms (fig. 1). Perhaps the present drawing's author — if not Napoletano himself — was an artist similarly interested in the unflinching observation and investigation of natural forms. — *ABB*

1 See Di Giampaolo and Cingottini 2007, 60 – 61; Gnann 2007, 1: nos. 802, 805, 806.

2 See Grinke 2006, 13 – 16.

3 Chiarini 2007, 396, 410, 434, figs. 226 – 228, 270, 324.

4 Chiarini 2007, 434, fig. 324.

French or Italian school, late 16th or early 17th century

Head of a Man,
1580 / 1610?

black and red chalk, 84 × 66

Joseph F. McCrindle
Collection 2009.70.164

INSCRIPTIONS verso:
lower left, in graphite,
Matam; lower center, *192*
(encircled)

PROVENANCE Jacques
Auguste Boussac
(1885 – 1962), Paris
(Lugt 729b; sale, Paris,
Galeries Georges Petit,
May 10 – 11, 1926, lot 98, ill.);
Mrs. Joseph Fuller Feder,
New York; to her grandson,
Joseph F. McCrindle, New
York; Joseph F. McCrindle
Foundation, 2008; gift to
NGA in 2009

THIS PORTRAIT OF A HANDSOME YOUNG man, the smallest drawing included in this survey of the McCrindle collection, is a mystery. It was sold in 1926 as the work of Theodor Matham (1605 / 1606 – 1676) and was subsequently attributed to his father, Jacob Matham (1571 – 1631), the name under which it was recorded in Joseph McCrindle's collection. The technique of the portrait, however, is more sensitive and refined than that of either Matham; both preferred to work with the pen and were deeply immersed in the northern mannerist tradition.[1] Unlike these artists, the draftsman who made this drawing used the black chalk with utmost delicacy, subtly enhancing the work with some controlled touches of red for the man's lips, his complexion, and the corners of his eyes.

Unfortunately, it is impossible at this point to say who did draw this charming portrait. The work itself offers almost no clues about either the artist's or the sitter's identity. It focuses entirely on the man's face, framed by a few locks of cropped hair, with no neckwear, hat, or jewelry to suggest his nationality, his station in life, or when he lived. Only the brief indication of the hair, just a couple of inches long and swept up from the forehead and away from the face, seems to suggest a date in the late sixteenth or early seventeenth century.[2] The overall aesthetic does not appear to be Dutch or Flemish; there might be a closer relationship to artistic currents in Italy and France.[3] Furthermore, the small scale and unfinished state make it a challenge to recognize a particular master's hand.

By the end of the sixteenth century, a tradition of portraiture in all media had been well established, from monumental and life-size likenesses intended for political or propaganda purposes to small miniatures, both painted and drawn, that served a more private and personal function. Though the McCrindle drawing is not a fully finished work — in the sense that the hair and the top of the head are left incomplete — it belongs to the latter group, the array of portraits that were easily portable and were usually intended as gifts for loved ones. It may not share the high degree of finish usually associated with portrait miniatures, but it is unlikely that it was made in preparation for a work in another medium — a painting, an engraving, or a medal. It seems instead to have been made as an independent work, perhaps as a gift from the artist to a friend or even as a memento for the artist to keep. Certainly the frankness of the sitter's glance and the sensitive rendering of the drawing suggest that the sitter and draftsman knew each other well. — RL

1 Two compositional drawings by Jacob Matham in the collection of the National Gallery (inv. 1971.44.3 and 1943.3.5862), for example, show how markedly different his drawing technique and aesthetic were from those of the artist who made the McCrindle portrait. Images are available at *www.nga.gov*.

2 Many French portrait drawings of men from that period — all rendered in chalk but generally more highly finished and formal in presentation — are reproduced in Adhémar 1973.

3 A drawing by François Quesnel (1543 – 1619) of *Robert Josset, Embroiderer to King Henry III* (Adhémar 1973, 158, no. 257, reproduced in black and white on the cover), shows some qualities of handling that are reminiscent of the McCrindle portrait and may suggest a French origin for it.

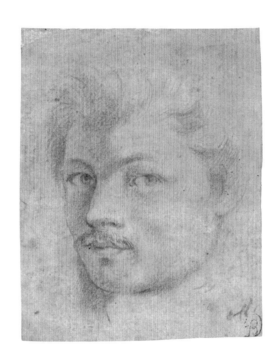

Lazzaro Tavarone

GENOA 1556 – 1641 GENOA

8

*The Blessed in Paradise
with the Virgin and
Saint John the Baptist
before God, c. 1590*

pen and brown ink with
brown wash over black
chalk, 227 × 202

Joseph F. McCrindle
Collection 2010.93.26

PROVENANCE Yvonne
ffrench, London, 1961
(as Cambiaso); Joseph F.
McCrindle, New York;
gift to NGA in 2010

LITERATURE Princeton
1991, no. 26

LAZZARO TAVARONE WAS ONE OF THE
most prolific artists working in Genoa during
the first half of the seventeenth century.
As an assistant in the workshop of Luca
Cambiaso (1527 – 1585), Tavarone learned the
fundamentals of large-scale decorative fresco
painting and in 1583 followed his teacher to
Spain, where Cambiaso had been contracted
to decorate the interior of the Escorial palace
for Philip II. Upon his return to Genoa
in 1592, Tavarone became an exceptionally
successful practitioner of fresco decoration
in the city's churches and palaces. Known for
his sumptuous, brightly colored compositions
with illusionistic architectural elements and
life-size figures, he made many preparatory
drawings in pen and ink and accomplished
figure studies in chalk on prepared papers.

This sheet is probably a compositional
study for one of Tavarone's fresco cycles,
although the commission for which it was
made remains debatable. Mary Newcome
has connected this drawing with a fresco of
Paradise that Tavarone painted in the 1630s in
the now-destroyed vault of the refectory of
Santa Maria in Passione (Genoa), known only
from photographs that show it in a severely
damaged state.[1] While the composition of
this drawing generally corresponds to the
remnant of the fresco, the style of the sheet
suggests that it was executed at an earlier
point in Tavarone's career, when he was
mirroring Cambiaso's practice of depicting
figures largely in terms of geometric shapes.
The blocky, faceless forms developed in thick
pen lines and wash recall those populating
the drawings of Cambiaso's later career, such
as the National Gallery of Art's *Martyrdom of
Saint Lawrence*.[2] Jonathan Bober concurs that
the McCrindle sheet is by Tavarone, and has
suggested that the drawing may date from
an earlier point in the artist's production,
closer to the period when he worked under
Cambiaso at the Escorial.[3] This seems the
more logical assessment since the Santa
Maria in Passione frescoes date to a later

point in Tavarone's life, and it would be odd
for him to return at the end of his career
to a Cambiaso-esque style in his designs
for that decoration. Furthermore, other
preparatory drawings by Tavarone from
this campaign of frescoes do not employ
a similarly geometric depiction of figures.[4]
Unfortunately, Tavarone's graphic work
from his time as Cambiaso's assistant has yet
to be fully distinguished from that of his
master, largely because Tavarone so strongly
appropriated Cambiaso's geometric approach
to figures and compositional structure.

In any case, this drawing is significant
in its clarity of form and fine condition.
Although its specific relationship with
Tavarone's painted work remains to
be determined, it nevertheless serves as a
starting point in the navigation of the
as-yet-uncharted territory of this important
artist's early career. — *ABB*

1 Princeton 1991, 70, under no. 26. For a reproduction of the
 Paradise fresco, see Newcome 1982a, 34, fig. 10.

2 Inv. 1971.80.2; reproduced at *www.nga.gov*. For numerous
 other reproductions of drawings by Cambiaso, see Austin
 2006.

3 Conversation, November 23, 2010.

4 See Newcome Schleier 1990, 207, figs. 9 and 10; Genoa 2009,
 nos. 4, 5, 18, and 19.

Giovanni Balducci

FLORENCE 1550/1560–AFTER 1631 NAPLES

9

A Battle on a Bridge,
c. 1600

pen and brown ink with
blue wash over black chalk,
squared for transfer in
black chalk; watermark:
fleur-de-lys atop three hills
within a circle surmounted
by initial M (Briquet 11933
and 11937; Heawood 1620);
sheet 265 × 392 (the four
corners cut off), image
216 × 336

Joseph F. McCrindle
Collection 2010.93.17

PROVENANCE sale,
Sotheby's, London, July 1,
1936, one of eleven drawings
in lot 95 (as Belisario
Corenzio); Sir Robert Witt
(his inventory number,
2789J, inscribed at lower left
in graphite); Anthony Blunt;
Brian Sewell, London, 1968;
Joseph F. McCrindle; gift
to NGA in 2010

LITERATURE London 1964,
no. 8 (as Corenzio);
Vitzthum 1965, 405 (as
Corenzio); Bean and Turčić
1982, 66, under no. 54
(as Corenzio); Princeton
1991, no. 27 (as Corenzio);
Di Giampaolo 1992, 332;
New York 1992, under
no. 22; Harris 1994, 69

THIS HANDSOME SHEET WITH ITS
delicate blue washes and refined pen lines
belongs to a group of eleven drawings that
were sold together in 1936 with an attribution
to the Neapolitan painter Belisario Corenzio
(c. 1560–c. 1653).[1] In 1982, however, Silvana
Musella Guida first suggested that the group
was instead the work of the Florentine artist
Giovanni Balducci, called il Cosci.[2] That
attribution has since gained the support of
a number of scholars, most notably Mario
di Giampaolo, and is now generally regarded
as fixed.[3]

In addition to sharing the distinctive
combination of brown ink and blue wash,
all the drawings in the group are coherent
in execution, with figures that are elegantly
formed and almost balletic in their gestures
and movements. Each of the sheets is also
squared for transfer in black chalk, although
no final project is known; presumably these
were made in preparation for a series of
paintings, or possibly for a set of tapestries.

One of the drawings in the group, now
in the collection of the Courtauld Gallery,
London, bears an inscription in Italian
identifying the scenes depicted as "historic
deeds of His Highness Prince John of
Austria upon his arrival in Naples."[4] In the
1936 auction catalogue they were called *Scenes
from the Life of Don John of Austria, and relating
to the Battle of Lepanto, 1571.* None of these
drawings, however, show the sea battle proper
from 1571, by far Don Juan's most brilliant
victory as a military leader. It is questionable,
therefore, whether these compositions, which
mainly involve warriors on horseback and
on foot, have anything to do with either Don
Juan or his military accomplishments. The
McCrindle sheet, in any case, stands apart
from the others in the group because it is
the only one that depicts a scene *all'antica*,
with all the soldiers wearing Roman cuirasses
and helmets. It more likely represents a
scene from ancient history, perhaps the
famous battle at the Milvian Bridge in 312,

with Constantine the Great as the rider on
the rearing horse defeating his adversary
Maxentius. The same subject was drawn
by Balducci—in a sketchier style with a very
different composition—on a sheet in the
Uffizi.[5] — OT

1 Three of the drawings in the series are in the Courtauld
 Gallery (numbered by Robert Witt, who acquired all eleven
 drawings in 1936, with his inventory numbers 2789A, 2789B,
 and 2789C), and two are in the Metropolitan Museum
 of Art, New York (Witt nos. 2789H [?]; 2789I). One was
 on the art market in 1992 (no. 2789F), at which time the
 last four were reported to be in the collection of Jacques
 Fryszman in Boulogne-Billancourt, Paris (New York 1992,
 under no. 22).

2 Musella Guida, 1982, 44.

3 See Di Giampaolo 1992, 329–334; Harris 1994, 69;
 New York 1992, no. 22.

4 Inv. D.1952.RW.2789.L. The drawing is reproduced (as
 Corenzio) at *http://www.artandarchitecture.org.uk/images/
 gallery/54b28bb0.html.*

5 Inv. 646 F. Reproduced in Di Giampaolo 1992, fig. 14.

2789 J.

Matthäus Gundelach

HESSEN C. 1566 – 1653 / 1654 AUGSBURG

10

The Assumption and Coronation of the Virgin, 1615 or before

pen and brown and black ink with stumped graphite over graphite; watermark: pinecone in a shield (close to Briquet 2119; Augsburg, 1600); 343 × 229

Joseph F. McCrindle Collection 2009.70.1

INSCRIPTION dated at bottom right corner (by the artist?), *1615*

PROVENANCE Martin & Sewell, London, 1970; Joseph F. McCrindle, New York; Joseph F. McCrindle Foundation, 2008; gift to NGA in 2009

FIG. 1
Hans Rottenhammer, *The Coronation of the Virgin,* 1602, oil on copper, Germanisches Nationalmuseum, Nuremberg

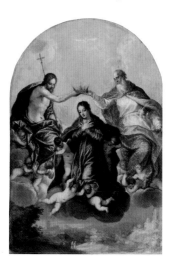

MATTHÄUS GUNDELACH WAS A LEADING artist in the German transition from mannerism to baroque. He practiced from 1593 in Prague at the courts of the Emperors Rudolph II and Matthias, but left c. 1615 for Stuttgart and southern Germany, and by 1617 had settled permanently in Augsburg. Like those of his fellow artist Hans Rottenhammer in Augsburg, Gundelach's figures during the second decade of the century became more weighty and strongly modeled, their gestures more classic than theatrical; while his compositions could be populous, each figure is clearly delineated.

When this drawing came to the Gallery, it was attributed to Hans von Aachen (1552 – 1615). Its quality is certainly high, but its style does not sufficiently match Von Aachen's; rather, the composition evokes works of the period from southern Germany. Szilvia Bodnár suggested that we consider whether the drawing might be related to Matthäus Gundelach. Further study confirmed this idea, which was also strengthened by the identification of the watermark as a pinecone that seems to be set inside a shield, signifying an early seventeenth-century Augsburg paper.[1] Several distinctive characteristics connect the drawing closely with others by Gundelach, especially the frequently elongated and almost double-jointed wrists,[2] as well as the attractively fluffy and flowing locks of hair, often parted in the middle.[3] The attribution is clinched by the distinctive treatment of the profile of the angel at far right, an exact parallel to the executioner's profile in Gundelach's *Beheading of Saint Catherine* in Augsburg and a reverse twin of a figure in the background of his *Minerva and the Muses on Mount Helicon,* now in Princeton.[4] The drawing shows early stages of Gundelach's development toward more robust figures and controlled gestures. Although the inscription is not clearly by the artist's hand, 1615, or slightly earlier, is a reasonable date for the work.

The subject of the McCrindle drawing would be appropriate for a painting, print, or book illustration, but its size, grand scale, and arched top make it more likely a study for a church altarpiece. That this and other strongly Catholic subjects were treated by the Protestant Gundelach reflects the remarkable religious tolerance of Augsburg. Gundelach stresses the Marian aspect of the image to an extreme, giving God the Father a bishop's miter, God the Son a king's diadem, but the Virgin Mary an emperor's crown. There is one recorded Gundelach painting of the subject, probably finished by 1614 and now in the former Capuchin cloister church in Haslach, Germany.[5] However, its composition is quite different, dominated by a lower register with numerous figures centered on an oversize portrait of the kneeling donor, Graf Christoph II von Fürstenberg. Gundelach's colleague Rottenhammer painted at least three Coronations: c. 1595, now in London; 1602, closest to Gundelach's drawing, now in Nuremberg (fig. 1); and the 1606 altar in Munich. In the winged putti supporting the clouds at bottom, Gundelach's composition shows the influence of Titian's famous 1516 Frari altarpiece *The Assumption of the Virgin,* probably mediated by Rottenhammer's 1602 painting, and the upper register of Gundelach's angels may have been developed from Cornelis Cort's 1576 engraved *Coronation of the Virgin* after the Zuccari.[6] — AR

1 While not the same, it is closest to Briquet 2119.

2 See examples in *The Rape of Proserpine* in Nuremberg (Nuremberg 1992, no. 55) and *Joseph and Potipher's Wife* in Berlin (Stuttgart 1979, no. F14).

3 See examples in *Bathsheba at the Bath* in Braunschweig, *Joseph and Potipher's Wife* in Berlin, *Venus and Mars* in Göppingen (Stuttgart 1979, nos. F13, F14, F15), and *The Entombment of Saint Catherine* in Augsburg (Augsburg 1987, no. 19).

4 See Augsburg 1987, no. 18 and Princeton 1982, no. 39.

5 See Göller 1931, 99 – 113 and Bender 1981, 159 – 163.

6 *New Hollstein* 2000, 2: 102, no. 100.

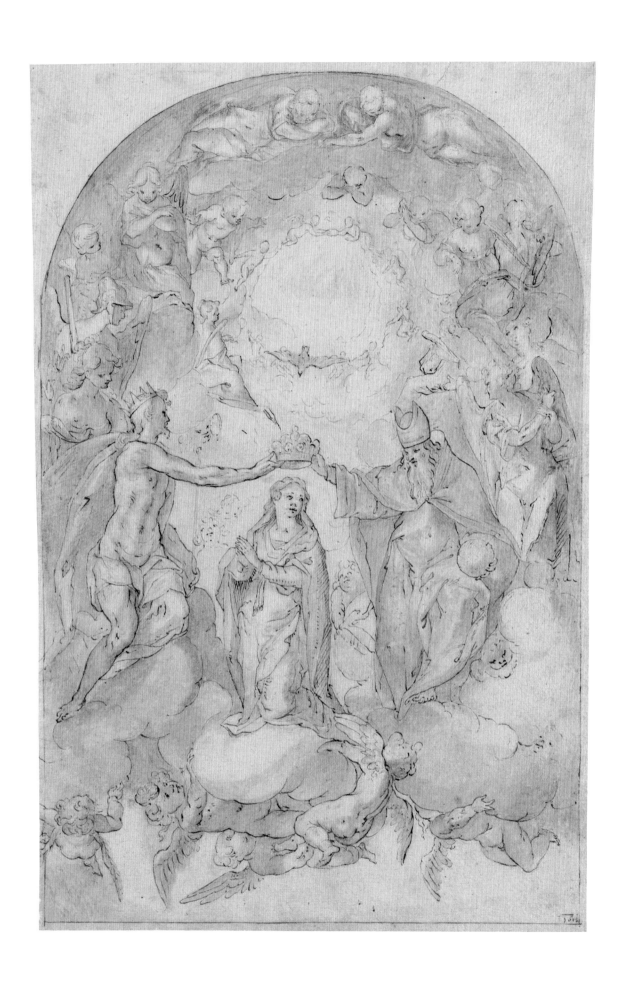

Jacopo Palma il Giovane

VENICE 1544 – 1628 VENICE

II

Madonna and Child in Glory with Saints John the Baptist, Stephen, and Lawrence, 1620 / 1628

pen and brown ink with brown wash, heightened with white gouache over graphite; watermark: three-pronged fork in a circle; 326 × 229

Joseph F. McCrindle Collection 2010.93.16

INSCRIPTIONS initialed by the artist, lower right, on the grill, *I.P.*; lower left, in pen and brown ink, *di Palma Giovane*; verso: upper right, in graphite, *Giacomo Palma*

PROVENANCE W. R. Jeudwine, London, 1962; Joseph F. McCrindle, New York; gift to NGA in 2010

LITERATURE Princeton 1991, no. 20

FIG. 1
Jacopo Palma il Giovane, *Madonna and Child in Glory with Saints John the Baptist, Stephen, and Lawrence,* 1620 / 1628, oil on canvas, parochial church of Nozza, near Vestone, Brescia

BORN INTO A VENETIAN FAMILY OF painters, the most famous of whom was his great-uncle Palma Vecchio (c. 1480 – 1528), Palma Giovane came of age during the last years of Titian (c. 1490 – 1576) and entered into direct competition for important commissions with the aging Jacopo Tintoretto (1518 – 1594). After the latter's death, Palma became the most esteemed artist in Venice, enjoying secular and ecclesiastical patronage in northern Italy and abroad.

Palma's *Madonna and Child in Glory with Saints John the Baptist, Stephen, and Lawrence* dates to this later period. Although it has not been previously noted, the McCrindle drawing is a preparatory study, with only minor compositional differences, for the altarpiece in the presbytery of the parochial church of Nozza near Vestone, Brescia, dedicated to Saints Stephen and John the Baptist (fig. 1).[1] The overall theme—a *sacra conversazione* (holy conversation) in which various saints commune with the Virgin and infant Christ—is common to Palma's work from 1600 onward. Also characteristic is his reuse of figural motifs from his own repertoire: the

Baptist's pose echoes figures in at least twenty other paintings and drawings,[2] as do the poses of Saint Stephen and Saint Lawrence. Since more than forty *sacre conversazioni* are now attributed to Palma, he may have turned to this formulaic compositional type in order to satisfy the increased demand that accompanied his later fame.

The consecration of the church on October 23, 1600, furnishes the earliest date for the McCrindle sheet, but the painting may well date from the 1620s, in the last years of the artist's life.[3] Indeed, the style of the drawing—marked by the hasty quality of the line and the smooth sweeps of shadow contrasted against passages of flickering highlights—is characteristic of Palma's late period.[4] Rare in his drawings, however, is the inclusion of his initials, *I.P.*, seen here in the spaces of Saint Lawrence's grill.[5] Although Palma signed the final altarpiece, the rare mark of authorship in the study suggests that he valued the drawing itself as a work of art in its own right. — CM

1 Ivanoff and Zampetti 1980, 593, nos. 407 and 718, fig. 1; Mason Rinaldi 1984, 149, no. 600, fig. 685.

2 See, for example, Mason Rinaldi 1984, figs. 423, 712, 716.

3 Based on the lack of innovation in the painting, Stefania Mason Rinaldi (Mason Rinaldi 1984, 149), dated the altarpiece to c. 1620 / 1628.

4 Compare, for example, the *Madonna and Child in Glory with Saints Jerome, Stephen, and Carlo Borromeo* (Biblioteca Correr, Venice, inv. III 8527) for a painting documented to 1626 / 1627. Reproduced in Venice 1990, 86, no. 27.

5 Another signed drawing from late in Palma's career is the *Martyrdom of Saint Lawrence* in the Courtauld Gallery, London, which is inscribed *I.P.F. 1628 14 8tobre.* See Ivanoff and Zampetti 1980, 596, no. 432, 737, fig. 1.

Italian school, 17th century

12

River God, 1620 / 1650

black chalk, heightened
with white gouache on blue
paper, 195 × 157

Joseph F. McCrindle
Collection 2009.70.203

INSCRIPTIONS lower
center, in pen and brown
ink, *Rubens*; verso: center of
the mount, in graphite, *14*
(encircled) and *R – VI – A*ˣˣ,
and, in another hand below
that, *From the Lady Lucas
Collection*

PROVENANCE Lady Lucas
(according to inscription
on the verso of the mount);
Joseph F. McCrindle,
New York; Joseph F.
McCrindle Foundation,
2008; gift to NGA in 2009

FIG. 1
Michelangelo, *Moses,*
c. 1513–1515, marble, San Pietro
in Vincoli, Rome

THE RECLINING FIGURE IN THIS
drawing—presented grasping the stem of
an oar or rudder and clad in an animal
pelt—is a river god. A type established in
antiquity, river gods are traditionally
represented as aged men with long beards
who lounge on urns and sometimes hold oars
or other nautical implements.[1] These figures
are used to establish location in a variety of
subjects from myth and history as well as
in an array of genres from landscape to
allegory. Except on statuary or coins and
medals, river gods are rarely represented
independently. This one probably was
conceived as part of a larger painting: with
his back to the viewer and resting on his
arm, as he looks up sharply into an unseen
realm, he likely would have occupied the
lower left corner of a composition.
Sometimes river gods are accompanied by
an animal that establishes their identity
(for example, a tiger for the Tigris); though
such an attribute is missing in this drawing,
the novel inclusion of the pelt from an
animal with an unidentifiable feline visage
might have been intended as a clue to help
identify the river this god personifies.

 Although an early collector's attribution
to Peter Paul Rubens (1577–1640) has rightly
been rejected,[2] the heroic muscularity of the
river god, emphasized by the highlighted
contours of his back, shoulder, arm,
and hand, nonetheless recalls the three-
dimensional presence achieved by Rubens in
his black-and-white chalk drawings of male
nudes and antique statues.[3] The designer
of the McCrindle river god not only used
white highlights to shape the figure but also
to suggest a strong light source outside the
drawing, one which, as it illuminates the god's
back, simultaneously casts his frontal form
into shade. This latter part of the figure, its
legs awkwardly foreshortened and wrapped
in a pelt, is drawn more hastily and with less
attention to anatomical accuracy than the rest
of the form.

Created by an artist working in a spirit
similar to Rubens's studies of the human
form, this river god looks neither to a living
model nor to the antique for its inspiration
but to sixteenth-century statuary. The god's
upper body—particularly his bent right
hand caressing the strands of his beard, the
head turned sharply away and crowned in a
wreath that ends in two leafy prongs jutting
above the hairline—is a creative adaptation
of Michelangelo's sculpture of Moses (as it
would be seen from the far left) from the
Julius II tomb in the church of San Pietro in
Vincoli, Rome (fig. 1). This reference to
Michelangelo suggests that the river god was
created by an artist who worked or studied
in Rome and for a patron who would have
appreciated and recognized the inventive
allusion to the Renaissance master. — CM

1 On ancient depictions of river gods, see Rubinstein 1984,
 257–263.

2 The drawing entered the National Gallery collection
 with an attribution to Hans Rottenhammer (1564–1625),
 which has proven to be untenable.

3 On Rubens's drawing style, see Anne-Marie Logan and
 Michiel C. Plomp in New York 2005.

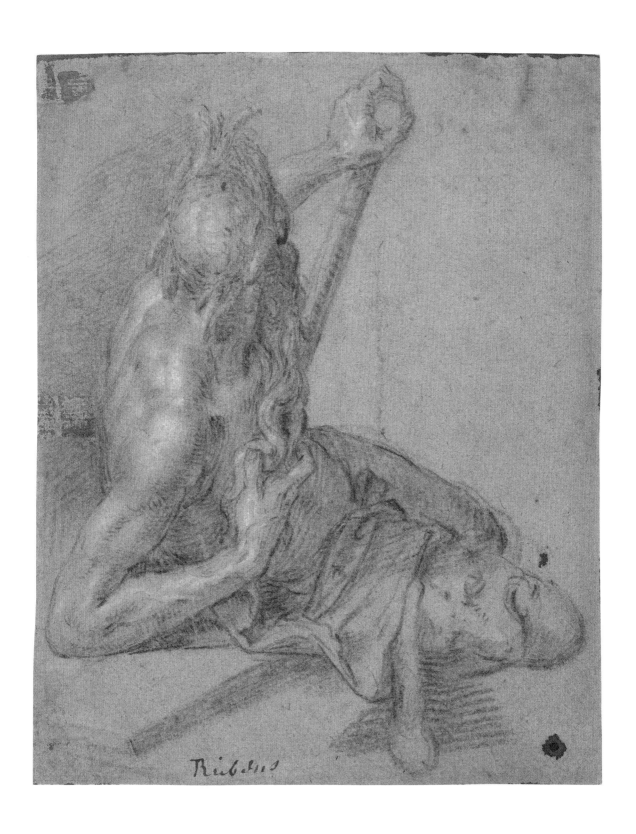

Bolognese school, 17th century

13

Saint Andrew,
1625 / 1650

red chalk with red and
brown wash, 230 × 90

Joseph F. McCrindle
Collection 2009.70.212

INSCRIPTION across the
bottom, in pen and brown
ink (faded), *Sopra Gialo,
Soto Cilestre*

PROVENANCE sale,
Sotheby's, London,
October 28, 1969, lot 27;
to P. & D. Colnaghi & Co.
Ltd. (inventory number in
graphite *D31177* on verso);[1]
purchased by Joseph
F. McCrindle, March 5,
1970; Joseph F. McCrindle
Foundation, 2008;
gift to NGA in 2009

THE FIGURE DEPICTED IS SAINT ANDREW,
identifiable by the object of his martyrdom,
the saltire (or decussate) cross. The brother
of Saint Simon Peter, Andrew was one of
Christ's first disciples to spread the Gospel
beyond the Holy Land. It is believed that
Andrew was condemned to death in the city
of Patras in western Greece during the reign
of Emperor Nero. Sentenced to be crucified,
Andrew refused to be put to death in the
same way as Christ and was instead bound by
ropes to an X-shaped cross.

The drawing of Saint Andrew is an
eloquent example of a baroque interpretation
of a draped standing figure, rooted in the
study of classical art and imbued with the
gravitas of an enlightened spirit. Andrew
and his cross fill the narrow compositional
space with a commanding presence and a
bold sense of monumentality. A thin border
of red chalk frames the saint, suggesting
that the final painting would occupy a
nichelike setting. Strong outlines fix the
figure's contours, while rhythmic parallel
hatchings — slightly blended by evenly
applied red wash — emphasize shaded areas
of the body, cross, and background. Blocks
of untouched paper suggest a strong light
source from the upper left of the compo-
sition. Perhaps intentionally, the artist
incorporates the creased fold at the bottom
of the paper — an imprint of the rope used
to hang the sheet to dry during the paper-
making process — as a kind of three-
dimensional ledge supporting the saint.

The McCrindle drawing was originally
attributed to the Bolognese artist Elisabetta
Sirani (1638–1665), daughter of Giovanni
Andrea Sirani (1610–1670), who had been a
pupil of Guido Reni (1575–1642).[2] Elisabetta
was trained in Reni's classicizing style and
was hailed in her time as one of its leading
masters. In her drawings she mainly worked
in a relatively spontaneous style that features
freely applied washes and pen lines over
chalk and dramatic light effects that convey

a sense of dynamic action — characteristics
that do not appear in the McCrindle *Saint
Andrew*.[3] The works by her father, on the other
hand, show some features that are closer in
handling to the McCrindle drawing — such
as blocked-out drapery folds and some
sketchiness in the delineation of the feet and
hands[4] — but again, the draftsmanship is
different enough to preclude an attribution
to him.

The influence of Guido Reni is still
evident, however, and the drawing in fact
comes remarkably close in many ways to a
painting, attributed to Reni himself, of a
prophet made for the Annunciation chapel
at the Palazzo del Quirinale, Rome, in 1610.[5]
The connections between the National
Gallery sheet and the works of Reni and his
closest adherents indicate that the drawing
was very likely produced by another, as-
yet-unidentified follower of the Bolognese
master. — *LL*

1 I am grateful to Colnaghi associate Livia Schaafsma
 for providing this provenance information (email
 correspondence, June 2011).

2 The attribution to Elisabetta Sirani goes back at least to
 1969; Colnaghi records list the drawing under her name.
 Professor Babette Bohn has noted that its style is not typical
 of either Elisabetta or her father (email correspondence,
 February 2011).

3 See, for example, Kurz 1955, 133–136, nos. 491–516, especially
 499–500.

4 Kurz 1955, 137, nos. 518, 524, 525.

5 See Bohn 2008, 23–24.

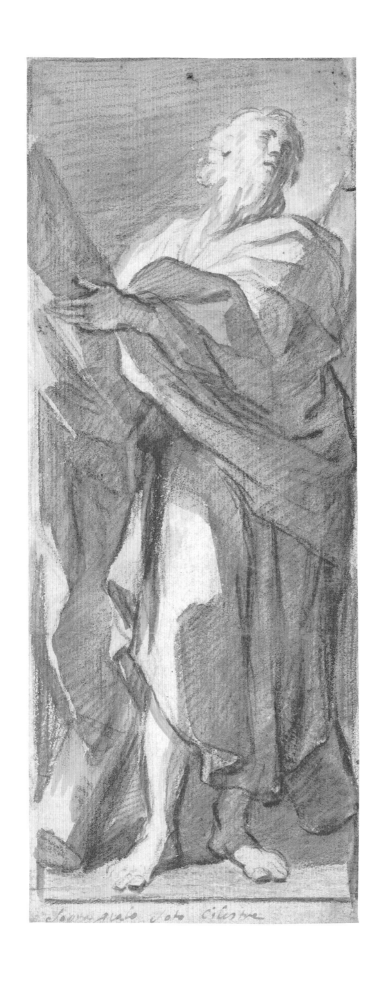

14

Ganymede and the Eagle,
Tobias and the Angel,
and the Annunciation,
mid-17th century;
verso *A Seated Nude*

pen and brown ink over
black chalk on light brown
paper; verso: red chalk,
heightened with white
chalk; watermark: kneeling
saint with halo and
holding a cross on a shield;[1]
404 × 250

Joseph F. McCrindle
Collection 2009.70.28.a/b

INSCRIPTIONS verso:
lower right, in pen and ink,
#599'. and by another hand,
in a different brown ink,
H[?]M: D: partially covering
an inscription in red chalk, *6*
di [?]; upper left, in graphite
[initials?]

PROVENANCE Galerie
Gerda Bassenge, sale April
23 / 27, 1968 (as anonymous
follower of Carlo Maratta);
purchased by P. & D.
Colnaghi & Co. Ltd., London
(inventory number on
recto, *D30554*); sold to
Joseph F. McCrindle on
November 22, 1968; Joseph
F. McCrindle Foundation,
2008; gift to NGA in 2009

WHEN JOSEPH MCCRINDLE PURCHASED
this sheet in 1970, it was considered to be
the work of an anonymous member of
the school of Carlo Maratta (1625–1713).[2]
Maratta was one of Rome's leading baroque
painters, who had been raised in the academic
practice that began with the founding of the
Carracci Academy in Bologna at the end of
the sixteenth century. This practice focused
on nude studies drawn from life, like the one
on the verso here, as the essential basis for
developing an artist's *invenzione*, and on pen
sketches like those on the recto to work out
compositional ideas.[3] Stylistically, however,
the drawings on both sides of the McCrindle
sheet seem to have more in common with
the spirit and style found in the works of
Carracci's Bolognese followers working in the
middle of the seventeenth century than with
those of Maratta and the members of his
Roman workshop.[4]

In the lively sketches on the recto, the
artist has allowed his pen to flow freely over
the page, jotting down ideas for three diverse
subjects: the mythological abduction of
Ganymede by Zeus disguised as an eagle and
the biblical stories of Tobias and the Angel
and the Annunciation. The artist displays
a remarkably assured control of the pen,
creating energetic curvilinear and straight
strokes to indicate movement and using thick
lines to create contours, while marking facial
features and body placement with short
jabs and blotches. The pen sketches are a
later expression of the drawing style of the
members of the Carracci family, especially
Annibale (1560–1609), as can be seen in such
examples by him as *Saint Margaret and the Dragon*
in the British Museum, London, and *Bacchus
Standing, Cup in Hand, and Next to a Goat* in
the Musée du Louvre, Paris.[5] Unfortunately,
no paintings or drawings have yet been
discovered that relate to any of the studies
on the McCrindle sheet.

In the study of a male nude on the verso,
the McCrindle artist follows the Carracci
example in emphasizing the placement of the
back and the bent leg, reinforcing a feeling
of tension in the body. The artist employed
another Carracci-like effect by rubbing the
red chalk to create dark shadows against
white chalk highlights. Furthermore, just as
the Carracci often repeated separate details
and motifs on the same sheet of paper, the
artist here has reconfigured the torso, head,
and foot in additional studies. Ultimately,
however, the McCrindle artist does not quite
replicate the Carracci's sophisticated and
confident handling of line and modeling
and instead produces a softer form with
less forceful contours and more restrained
modeling. The softness of this rendering
compared to the firmness of Ganymede's
body in the pen drawing on the recto could
suggest that two different artists worked on
this page, but in an unexpected connection
between the studies on front and back, the
outstretched arm and bent head of the red
chalk nude are repeated in reverse in the pen
figure of Ganymede. — LL

1 See Prosperi Valenti Rodinò 1995, 168–169, nos. 26, 30, for
similar watermarks.

2 I am grateful to Livia Schaasfsma at Colnaghi for
tracking down the records relating to this object
(email correspondence, May 2011).

3 Robertson 2008, 71–72. See also Pigozzi 2001, 18–21.

4 Catherine Loisel affirms the attribution to a northern
Italian artist working in the mid- to late seventeenth century,
possibly in Bologna (email correspondence, April 2011).
See Bjurström, Loisel, and Pilliod 2002, nos. 1702–1703.

5 British Museum, London, inv. 1990,0519.7; Musée du
Louvre, Paris, inv. 7182 recto. Reproductions can be found
at *http://www.britishmuseum.org/research/search_the_collection_
database.aspx* and *http://arts-graphiques.louvre.fr/fo/visite?srv=rom*
respectively.

Pieter de Jode the Elder

ANTWERP 1570 — 1634 ANTWERP

15

*Saint Bernard of
Clairvaux with
the Instruments of
the Passion, c. 1625*

pen and brown ink with
gray and brown wash and
black chalk, incised for
transfer, 318 × 204

Joseph F. McCrindle
Collection 2009.70.12

PROVENANCE Prosper
Henry Lankrink (1628 –
1692), London (Lugt 2090);
P. & D. Colnaghi & Co.
Ltd., London (as Abraham
Bloemaert); Joseph F.
McCrindle, New York,
1966; Joseph F. McCrindle
Foundation, 2008; gift to
NGA in 2009

ALTHOUGH THIS DRAWING ENTERED
the collection of Joseph F. McCrindle and
came to the National Gallery as the work
of Abraham Bloemaert (1566–1651), it
is now attributed with confidence to the
Flemish artist Pieter de Jode the Elder.[1] Like
his father and first teacher, Gerard de Jode
(1509 / 1517–1591), Pieter was an engraver
and publisher. After further training with
Hendrick Goltzius (1558–1617) in the
northern Netherlands, followed by trips to
Rome and Paris, he established himself in
Antwerp, where he enjoyed a successful career
as a designer and maker of prints, excelling
especially at book illustration.

De Jode frequently executed prints with
religious subjects, including several saints.
Saint Bernard of Clairvaux (1090–1153),
depicted here, was the first abbot of the
Order of the Cistercians and a Doctor of the
Church. He was responsible for establishing
a solid foundation for the enduring success
of the order; Cistercian monks are often
referred to as Bernardines in his honor. He
was canonized in 1174, just twenty-one years
after his death.

In this drawing Saint Bernard is depicted
as an old man, his wrinkled face and aged
hands beautifully and sensitively rendered.
He is surrounded by the instruments of
Christ's Passion and other symbols relating
to the events leading up to and following the
Crucifixion. The most prominent of these
is the cross, which refers to one of Bernard's
most important undertakings, his preaching
in favor of a second Crusade (1146–1149).
In his attempts to raise popular enthusiasm
for the cause, he stressed the recovery of the
cross as the surest, most direct path to the
attainment of a state of grace.

In De Jode's drawing, the small sign
at the top of the cross bearing the Latin
acronym INRI (standing for Jesus of
Nazareth, King of the Jews) is written in
reverse, an indication that this drawing
was intended to be engraved. The lines
are indented, which confirms that the
composition was indeed transferred onto a
copper plate, but the engraving has yet to be
found.[2]

Although the drawing was made in
preparation for a print, it can also be admired
as a finished work of art in itself. The care
with which De Jode worked and reworked
this drawing with a variety of tools shows
that he made an effort to produce a piece that
was not only functional but also laudable.
Already in the seventeenth century it was
owned by the painter and discriminating
collector Prosper Henry Lankrink, whose
mark is visible at lower center on the edge of
the open book.[3] — RL

1 The attribution to Pieter de Jode the Elder was first
 suggested in July 2010 by Hugo Chapman and David
 Lachenmann (note in the object file). Ger Luijten suggested
 the same in 2011, and both Stijn Alsteens and Marijn
 Schapelhouman agreed (correspondence and conversation
 with the author).

2 Three other examples of drawings made by De Jode as
 models for engravings but for which the prints are not
 known are in the Rijksprentenkabinet, Amsterdam, all
 reproduced in Schapelhouman 1989, nos. 39, 43, 44.

3 For more information on Lankrink see Grove 1996, 18:
 748, and Lugt 2090.

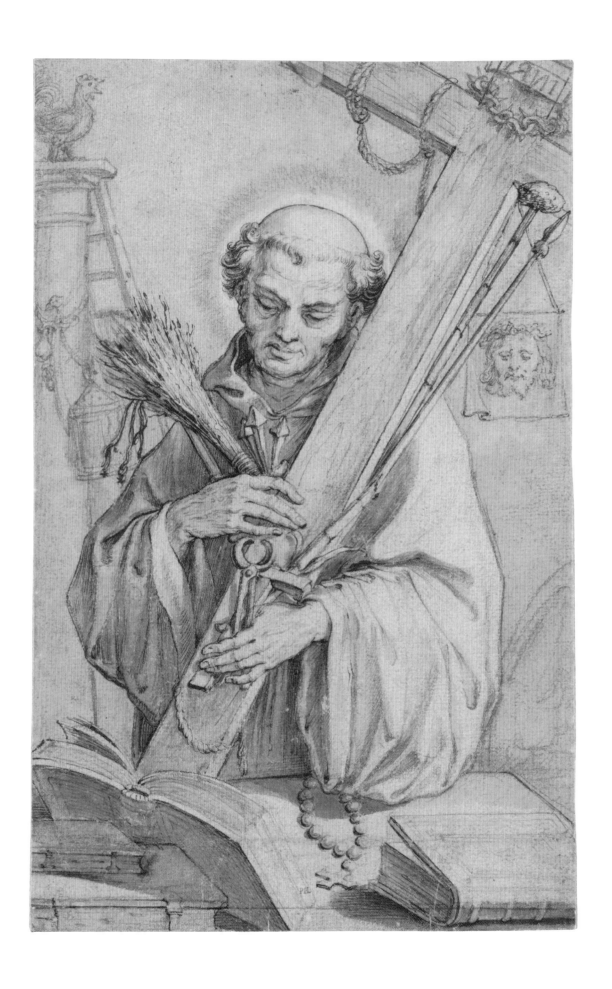

Remigio Cantagallina

BORGO SAN SEPOLCRO 1582/1583 – 1656 FLORENCE

Pecchio, 1630s

pen and brown ink over
faint traces of graphite
within a border line by the
artist, 152 × 224

Joseph F. McCrindle
Collection 2009.70.88

INSCRIPTION by the
artist, lower left, in pen and
brown ink, *Pecchio*.

PROVENANCE Dr. Henry
Wellesley (Lugt 1384;
sale, Sotheby's, June 30,
1866, lot 954, as Jacopo
Ligozzi); Sir David Kelly (not
in Lugt); sale, Hodgson's,
London, November 26,
1954, lot 596; Helene C.
Seiferheld, New York, 1960s;
Joseph F. McCrindle, New
York; Joseph F. McCrindle
Foundation, 2008; gift to
NGA in 2009

REMIGIO CANTAGALLINA WAS ONE OF the most important landscape draftsmen and printmakers working in seventeenth-century Florence. Little is known about the artist's early training, but his first documented works, a series of landscape etchings, date from 1603. Arriving in Florence sometime before 1608, Cantagallina was briefly in the studio of court artist and architect Giulio Parigi (1571–1635), where he produced prints after Parigi's designs. Also in Parigi's studio at the same time were Jacques Callot (1592–1635) and Stefano della Bella (1610–1664), both of whom might have been taught printmaking by Cantagallina.[1] Nature and the world around him were favorite subjects for Cantagallina; he was one of the first artists working in the beginning of the seventeenth century to reject the late-mannerist view of nature as fantastic and imaginary in favor of a deep interest in scenes from daily life. Although they follow a conventional formula, Cantagallina's landscapes were often drawn on the spot, as this one might have been. An inscription written by the artist himself names the far-off town as Pecchio, possibly identified with modern day Apecchio, located not too far from Tuscany in the province of Pesaro and Urbino in the Marche region.[2]

The insistently striated technique in the McCrindle sheet is characteristic of Cantagallina's hand. Equally typical of his work is the composition, in which the lightly drawn vista revealing a town nestled in a valley is theatrically framed on each side by darkly drawn trees with rounded foliage and twisting trunks. The foreground plane, however, appears more pronounced and detached and its stroke heavier and more automatic than in many of the artist's drawings, and the possibility that this could be the work of another hand should certainly be considered. In his discussion of the important group of landscapes by Cantagallina in the Uffizi, Florence, Marco Chiarini noted that the hands of Cantagallina's followers still need

to be distinguished from his own.[3] Similarly, in cataloguing the significant group in the Louvre, Paris, Catherine Monbeig Goguel relegated the sheets of manifestly inferior quality to his "entourage."[4] In this context, Baldinucci's comments about the three brothers Cantagllina, all pupils of Giulio Parigi, merit special attention, for while he described Remigio as "famous" for his pen landscape drawings, he termed Giovan Francesco "excellent" for his work in the same genre.[5] However, until the various hands are more clearly defined, it seems sensible to retain for this drawing the traditional attribution to Remigio.

The drawing most likely came from an album once owned by Dr. Henry Wellesley of Oxford (1791–1866) and by Sir David Kelly, which was inscribed *Vedute di Toscana d'Iacopo Ligozzi* (Views of Tuscany by Jacopo Ligozzi) and contained 105 drawings, today mostly attributed to Cantagallina.[6] After the album was sold in London in 1954, it was broken up, and drawings from it are now scattered.[7] Two other Cantagallina drawings came to the National Gallery in the McCrindle gift, including another fine landscape (see Other Drawings, page 179). — GDJ

1 For the printmakers working in the Parigi workshop, including Cantagallina, Callot, Della Bella and Ercole Bazzicaluva (c. 1610–1661 or after), see Spina 1983.

2 This identification was brought to the author's attention by William Breazeale, curator, Crocker Art Museum, Sacramento (conversation, January 2011).

3 Florence 1973, 35 (under no. 36).

4 Viatte and Monbeig-Goguel 1988, 2: nos. 130–148. None of the drawings rejected by Monbeig Goguel show the same kind of execution as the McCrindle sheet presented here.

5 Baldinucci 1845–1847, 4: 142.

6 The album is described in Parker 1956, 568.

7 Two are in the Ashmolean Museum, Oxford (see Parker 1956, no. 802 and Macandrew 1980, no. 802-2). Two others are in the Morgan Library & Museum, New York: *Large Oak Tree with Roots Exposed* (copy after Girolamo Muziano) (inv. 1984.54); and *Tuscan Landscape* (inv. 1966.5).

Pier Francesco Mola

COLDRERIO 1612 – 1666 ROME

17

*Caricatures of
Clerics and Priests,*
1640s or 1650s (?)

pen and brown ink,
141 × 186 (irregularly torn
and repaired)

Joseph McCrindle
Collection 2009.70.171

INSCRIPTION lower right,
in pen and brown ink
(by the artist?), *Mola/amico*

PROVENANCE Joseph
F. McCrindle, New York;
Joseph F. McCrindle
Foundation, 2008;
gift to NGA in 2009

THIS WITTY SHEET OF CARICATURE sketches is the work of Pier Francesco Mola, one of the most talented artists in mid-seventeenth-century Rome. He gained considerable public success through important commissions from the pope, other high-ranking churchmen, and noble families, and also prospered through his work on smaller, more intimate cabinet paintings. He drew regularly in preparation for his paintings and also made studies for his own pleasure. Among the latter is a considerable group of rapidly sketched caricatures, like the one presented here, in which he lampooned friends and contemporaries with biting humor. Presumably intended for private entertainment, such drawings allowed Mola — like his fellow artists Gian Lorenzo Bernini (1598 – 1680) and Guercino (1591 – 1666) who also exploited the liberties of this informal genre — to depict the *comédie humaine* of the Eternal City.

Depicted here are seven ecclesiastics, all shown in profile, a perspective that allowed Mola to focus on the characteristic features of his subjects. He accentuated singular traits, distinctive gestures, or sartorial details and exaggerated individual features into absurd forms. Several figures, presumably friends and acquaintances of the artist appear more than once in his caricatures: the left-most priest here (in the bottom corner, behind the priest with the goatee beard and long, horizontally stretched nose) appears on three other sheets.[1] Mola might have been fascinated by this sinister-looking cleric's prominent chin, aquiline nose, and deep-set eyes. Although the two figures at lower left are separated somewhat from the other five on the page, the whole scene seems to involve some sort of welcoming ceremony, with one figure at left being greeted by all the others, who turn toward him. At the center the only figure shown in full length stretches out his right arm toward the pig-nosed man at left and looks attentively at him. This central man

is dressed differently from the others, who all wear attire that is obviously clerical. He, too, seems to be a priest — his hat is probably a reduced version of the *capello romano* or *saturno,* a round-brimmed hat that priests once regularly wore as part of their informal street attire. His outer garment, however, is partially tucked informally into the belt at his waist as if it were a classical tunic. Followed by a suite of three minor priests, he appears to be the ranking member of the group, although his exact status within the church is not clear. A similar scene can be found in a drawing at Oxford.[2]

The distinctive appearance and personality that mark each of the figures drawn here make this a remarkably humorous and entertaining ensemble. Mola's wit is evident in every detail, especially in the contrasting sizes and shapes of his victims and their different qualities of expression. With such caricatures Mola proved to be a highly original and talented witness of his own times. — OT

1 Pier Francesco Mola, *Caricature of a Cleric Whipping a Child,* 256 x 190, Teylers Museum, Haarlem, inv. N.H. 115 (reproduced in Lugano 1989, 279, iii.94); *Caricature of Two Prelates,* Musée des Beaux-Arts et d'Archéologie, Besançon, inv. D 1939; *Caricature of an Ecclesiastic,* 135 x 156, Musée du Louvre, Paris, inv. 8450bis, verso (image available at *http://arts-graphiques. louvre.fr/fo/visite?srv=rom*).

2 Pier Francesco Mola, *Caricature of One Man Showing a Painting to Another with Several Observers,* 183 x 264, Ashmolean Museum, Oxford, inv. KTP 915 (reproduced in Lugano 1989, 289, III.112).

Francesco Allegrini

GUBBIO C. 1615 — AFTER 1679 ROME (?)

*Two Figures Fishing in
a Landscape*, c. 1650

pen and brown ink with
brown wash over traces
of black chalk; watermark:
six-pointed star in a circle
(similar to Heawood 3878);
192 × 252

Joseph F. McCrindle
Collection 2009.70.11

PROVENANCE Joseph
F. McCrindle, New York;
Joseph F. McCrindle
Foundation, 2008; gift to
NGA in 2009

THIS LUSH AND WOODED LANDSCAPE,
with a small stream winding its way into
the distance, belongs to the period in the
first half of the seventeenth century, when
the genre of landscape drawing came into
its own in Italy. The interest in representing
and interpreting the experience of nature
gained prominence first in Bologna under
the leadership of the Carracci family but
thereafter, under the influence of artists who
traveled there from the north, Rome became
the center of this activity.

The landscape drawings of native Italian
artists, like this one by Francesco Allegrini,
show the profound effect that the drawings
of the many northern immigrants had on
their work.[1] In the McCrindle sheet, for
example, the dark trees in the foreground,
drawn mainly with the brush and framing
the deeper view in the center, have many
similarities with those in the works of
Claude Lorrain (1604/1605—1682), while
the twisting forms of the tree trunks are
comparable to types found in drawings by
Paul Bril (1554—1626).[2]

The many distinctly northern qualities
of *Two Figures Fishing in a Landscape* explain
why it has recently been suggested that it
could be the work of a Flemish or Dutch
draftsman.[3] The attribution to Allegrini has
been sustained, however, by comparisons
with other works attributed to him; especially
close in subject matter, style, composition,
and even size is a drawing in a private
collection in Basel, Switzerland.[4] Allegrini's
bold and abundant use of several gradations
of wash is found in both drawings, giving
similar qualities of depth and unity to
the scenes. Although the Basel drawing
features less of the hatching that Allegrini
used to give body and texture to some of
the shadowed forms in the McCrindle
composition,[5] the figures in both sheets are
handled in similar fashion and the clumps
of foliage are sketched with the same types
of loosely stroked scallops.

Francesco Allegrini was born in
Gubbio in Umbria, north of Rome, and was
initially taught there by his father Flaminio
(1587?—1663?). At an early age he moved to
Rome, where he was apprenticed to Cavaliere
d'Arpino (1568—1640) and where he spent
most of his career.[6] Allegrini was a versatile
artist, mostly known for his decorative
frescoes, altarpieces, and battle scenes. The
majority of his drawings depict figures, but
as the McCrindle sheet shows, he was no less
skilled in rendering landscape. — *RL*

1 Hermann Voss first noted these qualities in Allegrini's
 landscape drawings in Voss 1924, 18. Marcel Roethlisberger
 pointed to specific similarities between landscape drawings
 of Allegrini and Claude Lorrain in Roethlisberger 1987,
 265, 268.

2 For many examples of landscape drawings by Claude and
 Bril, see San Francisco 2006, 56 and Ruby 1999.

3 In 2009, Bert Meijer noted resemblances to the work of
 Joos van Liere (c. 1520—1583) (notes in the object file).
 For the work of Van Liere, see Haverkamp-Begemann
 1979, 17—28. Interesting comparisons can also be made
 with works from the circle of Bril and by the Dutch artist
 Herman van Swanevelt (c. 1600—1655), but ultimately
 these are more superficial than substantive and do not
 support a change of attribution to either of those
 northerners or their followers.

4 *Landscape with Figures*, pen and brown ink with brown wash,
 200 x 261. Reproduced in Roethlisberger 1987, pl. 24b.

5 Allegrini often sketched landscapes and trees with similar
 hatching in pen only (Roethlisberger 1987, pls. 20a, 20b,
 21b, 22a).

6 The watermark in this sheet of paper indicates a Roman
 origin in the first half of the seventeenth century. See
 Heawood 3878.

Ercole Procaccini il Giovane

MILAN 1605–1675/1680 MILAN

*Christ Appearing
to the Four Marys,*
mid-1600s (?)

red chalk with red wash,
heightened with white
gouache, 256 × 228

Joseph F. McCrindle
Collection 2009.70.21

PROVENANCE C. R.
Mendez & Co., London;
P. & D. Colnaghi & Co. Ltd.
(as Venetian school,
late 17th century; inventory
number in graphite on
verso, center right: D28762
followed by letters CA,
erased), purchased July
22, 1965; to Joseph F.
McCrindle, April 20, 1966;
Joseph F. McCrindle
Foundation, 2008; gift to
NGA in 2009

ACQUIRED BY JOSEPH MCCRINDLE AS THE work of an unknown seventeenth-century Venetian artist, this drawing was tentatively attributed to the Genoese painter Bartolomeo Biscaino (1632–1657) after it entered the National Gallery's collection in 2009.[1] In 2010, David Lachenmann suggested an attribution to Ercole Procaccini il Giovane based on stylistic similarities with accepted drawings by Procaccini in the collections of the Biblioteca Ambrosiana, Milan, and the British Museum, London.[2]

Ercole was the grandson of Ercole the Elder (1520–1595), and the nephew of the most famous members of the Procaccini family, Giulio Cesare (1574–1625) and Camillo (1555–1629). Originally from Bologna, they operated a successful workshop at the same time as the Carracci founded their academy there in 1582.[3] In 1587 the Procaccini clan relocated to Milan, where their studio became an important center of artistic production in the Lombard region. The young Ercole trained with members of his family, including his father, Carlo Antonio (1571–1630), who was also a painter; he also studied briefly at the Accademia Ambrosiana when it first opened in 1621.[4]

For his drawings Ercole frequently used the combination of red chalk with red wash and white heightening that is found in the McCrindle sketch. Very similar in media and execution, for example, are two compositions in the British Museum, *The Crowning with Thorns* (inv. SL.5224.76) and *A Woman, Half-Length, with a Putto Handing Her a Palm* (inv. 1943,1113.145).[5] In all three drawings Procaccini produces sinuous contours accented by staccato touches of the chalk, often thickened by the flattened end of the stick, thereby giving a slight blotchiness to the drawings. Sanguine washes and touches of bright white highlights add to the visual richness of each scene and create a sense of dynamic movement. The influence of Ercole's uncles, especially Camillo, is evident in the swirling forms of the drapery and in the delicate hatchings that suggest the soft fall of shadow over the figures.

The tradition of depicting the risen Christ appearing to the three Marys dates to the Middle Ages, but here Procaccini shows him appearing to four women. This may be a conflation of various Gospels that describe the Virgin's companions on different occasions as Mary Magdalene, Mary of Cleopas, and Mary Salome.

This drawing is not affiliated with any known painting or fresco, but the low viewpoint suggests that it might have been made in preparation for a work placed high on a wall. Very little is known about Ercole's development as a draftsman, making it difficult to date the McCrindle drawing. Nevertheless, it is a significant addition to the artist's oeuvre as well as a fascinating reminder of the continuing impact of the Procaccini family in Milan through most of the seventeenth century. — LL

1 Livia Schaafsma provided the information regarding Colnaghi's acquisition and sale of the drawing (email correspondence, June 2011); Mary Newcome affirmed that the drawing is not Genoese in origin (email correspondence, March 2011), thus excluding Biscaino from consideration.

2 The most important collection of drawings by Ercole the Younger is in the Ambrosiana, Milan, which includes several drawings executed in red chalk with red wash and white heightening, especially nos. F254 inf. n. 1365; F254 inf. n. 1387; F235 inf. n. 1076. See Modena 1959, 113–115 and *www.italnet.library.nd.edu/ambrosiana*. For drawings in the British Museum, see *www.britishmuseum.org*. Other collections that include significant holdings of drawings by Ercole are the Uffizi, Florence, and the Accademia, Venice. See Nancy Ward Neilson's entry in Grove 1996, 25: 644; Abelli 1992, 359; Arfelli 1961, 472–473; and Ruggeri 1982, 140.

3 Neilson 1987, 133.

4 Arfelli 1961, 470; Neilson in Grove 1996, 644; Neilson 1987, 134.

5 See *www.britishmuseum.org/research/search_the_collection_database*. Another comparable drawing in the Ambrosiana is *A Putto Crowning a Man Wearing a Cuirass* (F254 inf. n. 1364 recto), also executed in red chalk and red wash on white paper, 140 × 275. See *www.italnet.library.nd.edu/ambrosiana*.

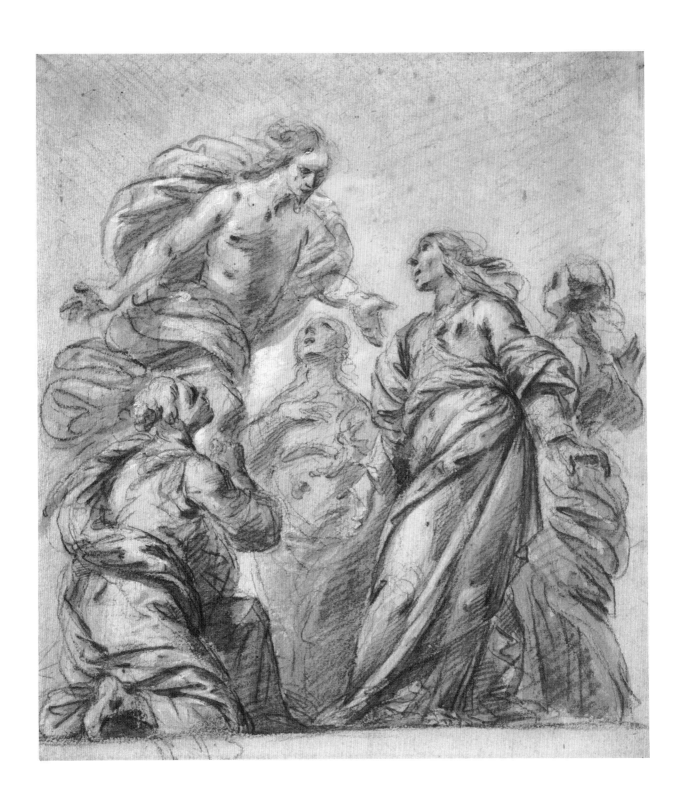

Cornelis Saftleven

GORINCHEM 1607 – 1681 ROTTERDAM

20

A Dog, 1660s (?)

black chalk with gray-brown
wash, 109 × 137

Joseph F. McCrindle
Collection 2009.70.211

PROVENANCE Joseph
F. McCrindle, New York;
Joseph F. McCrindle
Foundation, 2008;
gift to NGA in 2009

THIS CHARMING DRAWING CAPTURES
the playful character of a rather skinny, but
nevertheless energetic dog.[1] He has positioned
himself firmly on the ground, ready to jerk
on the unidentifiable object he clamps in
his jaw. With a few brisk touches of black
chalk, Cornelis Saftleven — not his brother
Herman to whom the drawing was previously
attributed — expresses the tension in the
dog's body, half crouching with his front
legs braced and his tail taut yet mischievously
pointing upward.

Validating the attribution to
Cornelis is a sketchbook, preserved in the
Rijksprentenkabinet in Amsterdam, signed
by him and filled with drawings of animals.[2]
Most of these are in a more finished state
than the McCrindle study, but stylistically
they show marked similarities to it, not
only in the graphic qualities of the chalk
strokes, but also in the way that the black
chalk is combined with wash, a technique
that Saftleven often used. Here, with a
combination of rapid, relatively light touches
of the chalk and a number of sharp, dark
accents, he sets out the animal's contours,
and then creates the texture of the fur and
the sense of a three-dimensional form in
motion with groups of short parallel strokes
alternating with loose curves. The result
is a remarkably spontaneous and animated
drawing.

As a member of a well-established
artistic family, Cornelis Saftleven must have
been well aware of the painting traditions in
the Netherlands. His father, grandfather, and
both of his younger brothers were artists.
He was born in Gorinchem, but his parents
soon thereafter moved to Rotterdam. Little
is known about Saftleven's life, though it
has been suggested he spent some time in
Antwerp. For most of his life, however, he
lived in Rotterdam, where he died in 1681.[3]

Saftleven was exceptionally versatile in
technique and choice of subject matter, but
animals feature prominently in his work.

Lions, owls, cats, dogs, and a broad variety
of other animals and otherworldly creatures
occupy his allegories, barns, and landscapes.
About five hundred drawings by Cornelis's
hand are known today, but hardly any of
them can be directly linked to his paintings.
It is not surprising, then, that this dog from
the McCrindle sheet has not been found
in one of Saftleven's oils. It is likely that
he intended many of his drawings to be
independent works of art, for he frequently
signed and dated them, but the small scale
of this study and the lively freshness of the
jotting suggest that it was a sketch made for
his own pleasure, perhaps drawn on the spur
of the moment. — RL

1 I thank Marijn Schapelhouman and Arthur K. Wheelock
 Jr. for confirming the attribution to Cornelis Saftleven
 (conversations with the author).

2 Inv. RP-T-1990-158 (unpublished).

3 An early portrait, drawn by Anthony van Dyck (1599 – 1641),
 as well as seventeenth-century inventories indicating a
 collaboration of one (or both) of the Saftleven brothers
 with Peter Paul Rubens (1577 – 1640) and David Teniers the
 Younger (1610 – 1690), support the possibility that Cornelis
 Saftleven spent time in Antwerp. See James 1994, 135, 141.
 For a detailed biography and catalogue raisonné of Cornelis
 Saftleven's painted and drawn work, see Schulz 1978.

Ciro Ferri

ROME 1634 – 1689 ROME

*Saint Zenobius
Resuscitating a Child,*
c. 1665

black chalk, squared for
transfer in black chalk;
watermark: six mounds;
247 × 283

Joseph F. McCrindle
Collection 2010.93.19

INSCRIPTIONS verso:
upper center, in pen and
brown ink, *nº 7*, and below
that *Corto*; lower right, in
graphite, *47*; lower right,
in pen and brown ink,
Pietro da Cortona

PROVENANCE Baron
Milford (1744 – 1823),
Pembrokeshire (Lugt
2687); Anthony Blunt
(1907 – 1983), London;
Martin and Sewell, London,
1970; Joseph F. McCrindle,
New York; gift to NGA in
2010

LITERATURE London 1964,
no. 26; Vitzthum 1965, 405;
Edinburgh 1972, no. 48;
Davis 1982, 238; Princeton
1991, no. 49; Harris 1994, 68

FIG. 1
Ciro Ferri, *Saint Zenobius
Resuscitating a Child*, 1665, oil
on canvas, Kunsthistorisches
Museum, Vienna

WITH ITS DRAMATIC RENDERING OF
lights and shadows, well-orchestrated
display of emotions, and clear and broad
composition, this drawing is a fine example
of *cortonismo*, a grand-manner style stemming
from Pietro da Cortona (1596 – 1669). As
his pupil and main assistant, Ciro Ferri
worked with Cortona on numerous
prominent projects in Rome and Florence.
Because of their collaborations and Ferri's
capacity to emulate Cortona's style, it can
sometimes be difficult to separate their
hands; the present drawing was in fact once
considered to be the work of Cortona, as
an old inscription on the verso indicates.
Recent scholarship, however, has reassessed
Ferri as a master in his own right, and the
character and extent of his graphic oeuvre
have been more clearly defined.[1]

The drawing is well conceived,
with figures evenly distributed across the
composition and Saint Zenobius in the
center. Most striking is the stark contrast
between the forceful delineation of the
figures in the foreground and the much softer
lines marking the background, a hallmark
of Ferri's drawing style.[2] Characteristic of
his hand also are the sharp, sometimes
nervous lines that define the standing man
at right, as well as the long irregular strokes,
occasionally paired with finer hatchings,
that create a vibrant flow in the draperies and
give life to the forms.

Saint Zenobius (337 – 417) was the son
of a noble family of Florence who converted
to Christianity and dedicated his life to
service in the Church. He is credited with
evangelizing his native city and also with
performing several miracles in which he
revived people who had died. The scene here
involves a young child who was run over
and killed by a cart. His grieving mother has
brought the child to Zenobius, who prays
over him and brings him back to life.

Squared for transfer, Ferri's drawing
served as the final model for a painting that
was probably executed for the Stanza
dell'Udienza of Cardinal Leopoldo de'
Medici in 1665, now in the Kunsthistorisches
Museum, Vienna (fig. 1).[3] Ferri nevertheless
changed the central group in the canvas by
moving the dead boy closer to Saint Zenobius,
separating him from his mother and changing
her gesture. Most likely he did this because
the group formed by the middle-aged
kneeling man to the left of Saint Zenobius
and the mother and child in the McCrindle
drawing recall similarly posed figures on the
narrow side of Cortona's famous fresco of
Divine Providence at the Palazzo Barberini in
Rome.[4] Through the changes he made
in his painting, Ferri eventually arrived at a
composition that was less reminiscent of
his teacher, thus documenting his efforts to
present himself as an independent master
while also demonstrating his rich technical
abilities and his talent for innovation. — OT

1 Merz 2005, 225.

2 Paris 2011, 68.

3 Vitzthum 1965; the subject was long thought to represent
Saint Martin resuscitating a dead child, but Vitzthum
suggested that it was Saint Zenobius. Another sketch of
the composition (graphite and pen, 133 x 150) is in the
Istituto Nazionale per la Grafica, Rome (Album Odescalchi,
no. 48a), reproduced in Prosperi Valenti Rodinò 1997, 206.

4 Briganti 1962, pl. 130.

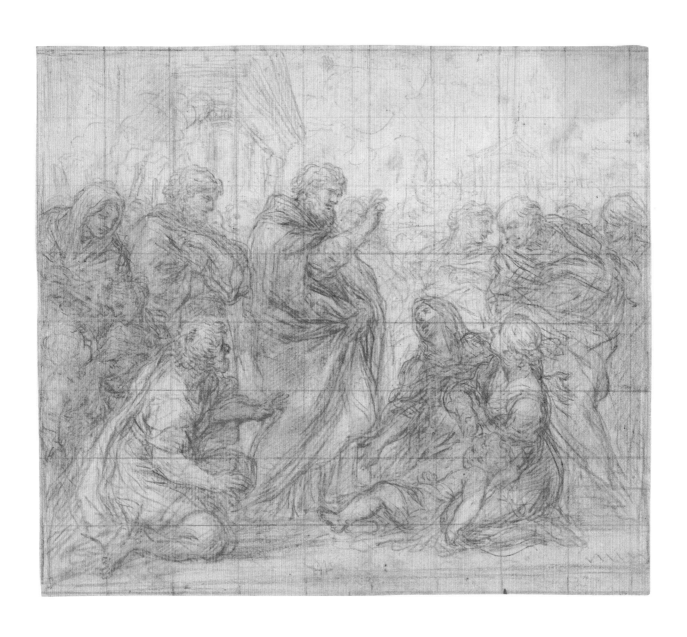

Domenico Piola 1

GENOA 1627–1703 GENOA

*Blessed Maria Vittoria
Fornari's Vision of
the Trinity*, c. 1670

pen and brown ink with
brown wash over graphite
with additions in black
chalk, 170 × 122

Joseph F. McCrindle
Collection 2009.70.192

INSCRIPTIONS on the
mount, lower right, in pen
and brown ink, *D. Piola*;
above that, in graphite,
64; verso of mount: upper
center, in graphite, *62/27*

PROVENANCE Lorna Lowe,
London, 1983; Joseph F.
McCrindle, New York;
Joseph F. McCrindle
Foundation, 2008; gift to
NGA in 2009

AS ONE OF THE LEADING ARTISTS active in Genoa during the latter half of the seventeenth century, Domenico Piola produced a considerable graphic oeuvre. His highly ornamental and dynamic style dominated the artistic scene in Genoa, not least due to his role as the head of a major family workshop, known as the Casa Piola, which included his brothers, three sons, and two sons-in-law. Together they took on numerous decorative projects incorporating drawing, painting, sculpture, and stucco work for various churches and private homes of the city's elite, essentially defining the baroque style in Genoese art.

The present sheet is typical of Domenico's draftsmanship, with its calligraphic lines and full, angular drapery underscored by areas of wash, all crafted into a diagonal composition. The artist determined the general layout of the compositional elements with thin, spidery strokes of graphite, most noticeable in the drapery folds of the three-headed figure of the Trinity. He followed with pen and brown ink, using two different types of lines — some stronger to establish the contours, others finer to create varying levels of detail — and brown wash to produce an almost sculptural three-dimensional quality. Despite the clarity and relatively finished aspect of the drawing, it appears that Domenico, or perhaps another artist in his workshop, returned to the sheet with a thicker black chalk to add an arc of fabric, or banderole, held over the Trinity's heads by flying putti.[1] The addition of the banderole strengthens the active diagonal of the original composition and frames the holy presence.

The iconography of this drawing is quite distinctive and finds a parallel in a print of the *Vision of the Blessed Maria Vittoria Fornari* engraved by Georges Tasnière (1632–1704) after a design by Domenico.[2] In the print, probably dating to the 1670s, the Blessed Maria Vittoria, the founder of the Turchine

order of Celestial Annunciades in Genoa, gazes upon a vision of the Trinity. Although the engraving displays the customary depiction of the Trinity as three separate elements (Christ, God the Father, and the dove of the Holy Spirit) instead of the triple-headed and triple-bodied figure in Domenico's drawing, it is obvious that the drawing represents the same visionary saint.[3] The far more elaborate nature of the Tasnière print makes it unlikely that the McCrindle drawing served as a study for the composition. However, the existence of both a drawing and a print of this Genoa-specific subject matter suggests that this hagiography was of interest to Domenico and his contemporaries and that it may have found expression in another as-yet-unidentified painted or sculptural form based on the McCrindle sheet. — ABB

1 Whether this revision was Domenico's or a colleague's is unknown, but the interactive and collaborative nature of the Casa Piola workshop may have encouraged such amendments to initial designs.

2 See Sanguineti 2004, 2: 498. For the print, see Newcome 1982b, 612.

3 The three-faced interpretation of the Trinity has precedents in Byzantine and medieval imagery but had increasingly fallen out of use until it was condemned as a heretical representation of the Trinity during the Counter-Reformation. See Réau 1955–1959, 2: 21–22.

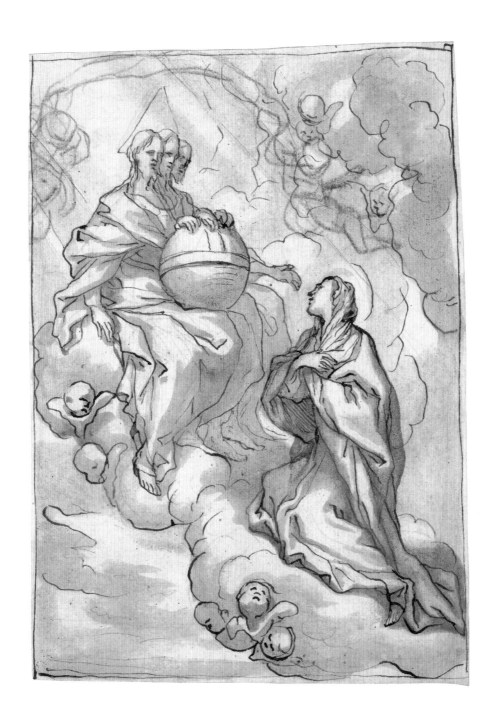

Raymond La Fage

LISLE-SUR-TARN 1656—1684 LYON

The Fall of Phaeton,
c. 1680

pen and brown ink over
graphite, 258 × 196

Joseph F. McCrindle
Collection 2009.70.151

INSCRIPTIONS numbered
at upper right, in pen and
brown ink, 44; lower left, *ce
dessin/provient du Cabinet
du Ranc.*; lower right,
Lafage fecit; lower center, in
graphite (partially erased),
Chute de Phaeton; verso:
center, in graphite, C:65/240

PROVENANCE probably
the painter Jean Ranc
(1674–1735), according
to the inscription; Joseph
F. McCrindle, New York;
Joseph F. McCrindle
Foundation, 2008; gift to
NGA in 2009

FIG. 1
Raymond La Fage, *Moses
Receiving the Tablets of the Law,*
c. 1680?, pen and brown
ink over black chalk,
Yale University Art Gallery,
New Haven

THE FALL OF PHAETON IS AN EXCELLENT
example of the spirited draftsmanship for
which the short-lived seventeenth-century
French artist Raymond La Fage was most
admired. Although he died at the age of
twenty-eight, La Fage had already established
himself as a draftsman of note, and his
drawings were collected assiduously both
before and after his death. According to
Pellegrino Antonio Orlandi, in his 1719
biography of the artist, "La Fage stupefied
Rome with his extraordinary style of drawing,
with few strokes and pure contours, with such
ferocity that he seems to make a mockery
of Michelangelo, Giulio Romano, and
Annibale Carracci."¹ Some decades later, the
collector and biographer Pierre-Jean Mariette
(1694–1774) praised La Fage as one of the
greatest draftsmen of all time, rivaling the
achievement of his Renaissance and baroque
predecessors.² After La Fage's early death
more than 225 prints after his drawings
were published, a testament to the enduring
reputation and appeal of his works.

At a young age, La Fage migrated to
Toulouse and later moved to Paris. By 1679
he found himself in Rome, where he
shared first prize in a drawing competition.
Even after his return to France in 1680, La
Fage remained deeply influenced by the
forms, shapes, and compositions of Roman
baroque art and architecture, as well as the
sixteenth-century sculptures of Michelangelo
(1475–1564). In *The Fall of Phaeton* one can see
echoes of such contorted and heavily muscled
figures as Michelangelo's sculpture of *Day*.³

Characteristic of La Fage's sketchiest
pen drawings is the nervous, rapid, almost
agitated quality of line found in *The Fall of
Phaeton.* According to Mariette, the artist
would have tossed off such a drawing with
complete spontaneity, executing "straight off
everything that his imagination suggested
to him."⁴ Numerous works jotted down in
this style are among the approximately three
hundred drawings by La Fage that survive.
Especially close is *Moses Receiving the Tablets of
the Law* at the Yale University Art Gallery,
which features an identical inscription to the
one at lower right on this sheet, apparently
in the same handwriting: *Lafage fecit* (fig. 1).
Also comparable are such drawings as *The
Ascension of Christ* at the British Museum,
London, and *The Holy Family with Saint Elizabeth
and Saint John the Baptist* at the Louvre, Paris.⁵

The myth of Phaeton's demise is best
known from the version recounted in the
second book of Ovid's *Metamorphoses,* in
which the half-mortal son of Helios, the
sun god, received reluctant permission from
his father to drive the chariot of the sun for
a day. Phaeton was unable to control the
powerful horses and scorched the earth with
the sun's heat. To prevent the destruction of
mankind, Zeus, king of the gods, threw a
lightning bolt that caused Phaeton to plunge
to his death. La Fage expertly captures the
scene with a flurry of quick strokes that
express the violent suddenness of the event
while including all the salient elements:
the terrified horses, the ornate chariot, and
the falling human just moments before his
obliteration. — DB

1 Orlandi 1719, 379, as translated in Sarasota 2006, 174.

2 Mariette 1851–1860, 3: 30.

3 Reproduced in Goldscheider 1996, pl. 180.

4 Mariette 1851–1860, 3: 31.

5 Reproductions can be found online on the websites of
 each institution at *http://www.britishmuseum.org/research/
 search_the_collection_database.aspx* and *http://arts-graphiques.louvre.
 fr/fo/visite?srv=rom*, respectively.

44

= Ce dessin provient
= du Cabinet de Rane.

Lafagefeit

Giuseppe Passeri

ROME 1654–1714 ROME

24

Aurora's Tryst with Time Interrupted, c. 1700

pen and brown ink with brown and red wash and red and black chalk, heightened with white gouache, 236 × 184

Joseph F. McCrindle Collection 2009.70.185

INSCRIPTION verso: center of the mount, in graphite, *Giuseppe PASSERI/Aurora*

PROVENANCE P. & D. Colnaghi & Co. Ltd., London, by 1961; Joseph F. McCrindle, New York; Joseph F. McCrindle Foundation, 2008; gift to NGA in 2009

LITERATURE London 1961, no. 67; Clifford 1976, 852, n. 4

THIS DRAWING, ALONG WITH A SHEET representing *Time Interrupting History* at the Suermondt-Ludwig Museum, Aachen, is one of two known designs by Giuseppe Passeri for the face of a night clock (*orologio notturno*).[1] A seventeenth-century Italian invention, night clocks featured rotating dials that were illuminated from behind with oil lamps so that the numbers would be visible in the dark. These luxury timepieces were often produced collaboratively: clockmakers fabricated the mechanisms, cabinetmakers created the architectural frames, sculptors contributed decorative elements, and painters designed the faces. In keeping with the prestige status of these objects, the painters who worked in the genre were among the most renowned artists of the period, including Passeri's teacher, Carlo Maratta (1625–1713), who painted the face of a clock that was given by an Italian cardinal to Louis XIV.[2]

Night clocks were typically decorated either with images of Mary and the saints or with allegories of time. The unusual subject of Passeri's drawing, identified here as *Aurora's Tryst with Time Interrupted*, belongs to the latter category.[3] In Roman mythology Aurora, goddess of the dawn, furnished the transition from night to day by flying across the sky every morning to announce the arrival of the sun. According to the Latin poets who expanded on the myth, Aurora took many mortal lovers, among them Tithonus. Wanting to be with him for eternity, Aurora asked Zeus to grant Tithonus immortality, but she forgot to ask that he also be given eternal youth. Thus, while Aurora remained ageless, she awoke each day to a lover who grew older and more decrepit.[4] Passeri takes license with this myth, substituting for Aurora's aged lover the winged figure of Time holding his sickle and hourglass. The romantic interlude interrupted, a recumbent and startled Time flails as Aurora is torn away from him by a putto who pulls her hair while the horses hitched to her chariot — their makeshift bed — plunge in alarm.

The energy of the composition is heightened by Passeri's densely layered drawing style. Hastily drawn red chalk lines visible throughout the scene seem to record the artist's initial schema, over which he has drawn more definite, if equally hurried, contour lines in brown ink. Using red and brown washes throughout the composition — in the sky, to suggest the hazy break of dawn; to color the foliage on the right; and to cast Time and one of the horses in shadow — Passeri gives depth and atmosphere to the page. Yet it is Aurora, her flesh bathed in white highlight, who is the focus of the image. She looks upward, beyond the putto, to the blank semicircular space, known as a chapter ring, that would eventually be occupied by the illuminated rotating numerals of the clock dial. Like the body of Aurora herself, the muted glow of the dial would have reminded the viewer of the soft light of dawn. — CM

1 The McCrindle drawing was mentioned as a study for a clock by Timothy Clifford (in Clifford 1976, 852, n. 4), but that identification was apparently lost until Hugo Chapman recognized its purpose anew in July 2010 during a visit to the National Gallery of Art. The Aachen sheet is reproduced in Graf 1995, 1: 397, fig. 252.

2 Clifford 1976, 852, n. 4.

3 The subject of the drawing was previously identified as Night fleeing before Morning. See London 1961, no. 67, where a note of uncertainty regarding the subject is indicated by the inclusion of a question mark; and Clifford 1976, 852, n. 4, where the question mark is omitted.

4 In seventeenth- and eighteenth-century representations of Aurora and Tithonus, the latter is generally portrayed as an aged man, recumbent and shielding his eyes from Aurora's blazing torch. See, for example, Francesco Solimena's 1704 painting, *Aurora Taking Her Leave of Tithonus*, at the J. Paul Getty Museum, Los Angeles (inv. 84.pa.65; reproduction available at *http://www.getty.edu/art/gettyguide/artObjectDetails?artobj=856*).

Italian school, late 17th or early 18th century

25

A Smiling Boy with Flowing Hair, c. 1700 (?)

red chalk; watermark: present but not deciphered; 224 × 176

Joseph F. McCrindle Collection 2009.70.170

INSCRIPTIONS verso of Richardson mount: upper left, in graphite, *H445*; upper center, in brown ink, *P.101./F.3/P.2./I* [or *J* (?)] (shelf numbers of Jonathan Richardson Sr.)

PROVENANCE Jonathan Richardson Sr. (1667 – 1745) (Lugt 2184); P. & D. Colnaghi & Co. Ltd., London, by 1977; Joseph F. McCrindle, New York; Joseph F. McCrindle Foundation, 2008; gift to NGA in 2009

LITERATURE London 1977, no. 59

THE ORIGINS OF THIS HUMOROUS drawing of a smiling boy remain almost a complete mystery, with virtually no clues pointing to the identity of the artist or the location where it might have been made. The study entered the McCrindle collection with an attribution to the circle of the Bolognese artist Giuseppe Maria Mitelli (1634 – 1718), a printmaker and draftsman known to have made a number of studies of highly animated characters with exaggerated facial expressions. Mitelli's drawing style, however, generally has a more studied, engraving-like quality that is quite different from the rapid, curvilinear lines that capture this boy's half-closed eyes, tooth-filled smile, and loose, wavy locks.[1] The differences are sufficient enough to cast doubt on an attribution even to a member of his circle. Such images capturing momentary expressions of laughing or smiling figures are more readily found among the works of a number of northern artists who experimented with facial contortions in their portraits and genre scenes, including Adriaen Brouwer (1605 – 1638), David Teniers the Younger (1610 – 1690), and Rembrandt van Rijn (1606 – 1669). The style of the McCrindle work, however, does not obviously tie it to the Dutch or Flemish school.

In contrast to cat. 17, a traditional caricature in which facial features are exaggerated in a comical way, this drawing captures the fleeting expression of a boy responding to something humorous. The artist is not mocking him but simply delights in recording his squinting eyes, broad smile, and puffed cheeks. The image is startling, however, mainly because such figures with open-mouthed smiles exposing their teeth are rarely depicted in old master paintings or drawings.

The McCrindle drawing was originally owned by the early eighteenth-century portraitist and collector, Jonathan Richardson Sr., whose collector's mark, the letter *R*, is stamped in the lower right corner of the sheet. With the help of his son, Jonathan Richardson Jr., he amassed an impressive collection of drawings. Although he collected broadly, his primary interest was Italian works, which may help point to an Italian origin for the McCrindle sheet. Regardless of where it was made, however, such a drawing might have had a special appeal for Richardson because of his own work as a portraitist and his interest in studying and capturing different qualities of facial expression.[2] For us, while we know almost nothing about this sketch of *A Smiling Boy,* it continues to be an intriguing object of curiosity and delight. — *LL*

1 See, for example, a red chalk drawing of *The Numerous Company of the Damned* in the British Museum, London; inv. 1899,0729.1; for a reproduction, go to *http://www. britishmuseum.org/research/search_the_collection_database.aspx.* Fantastic, exotic, and deformed figures are also found in many of Mitelli's prints, some of which are available for viewing at the same website.

2 For a number of Richardson's own portrait drawings, see Gibson-Wood 1994, 202 – 206.

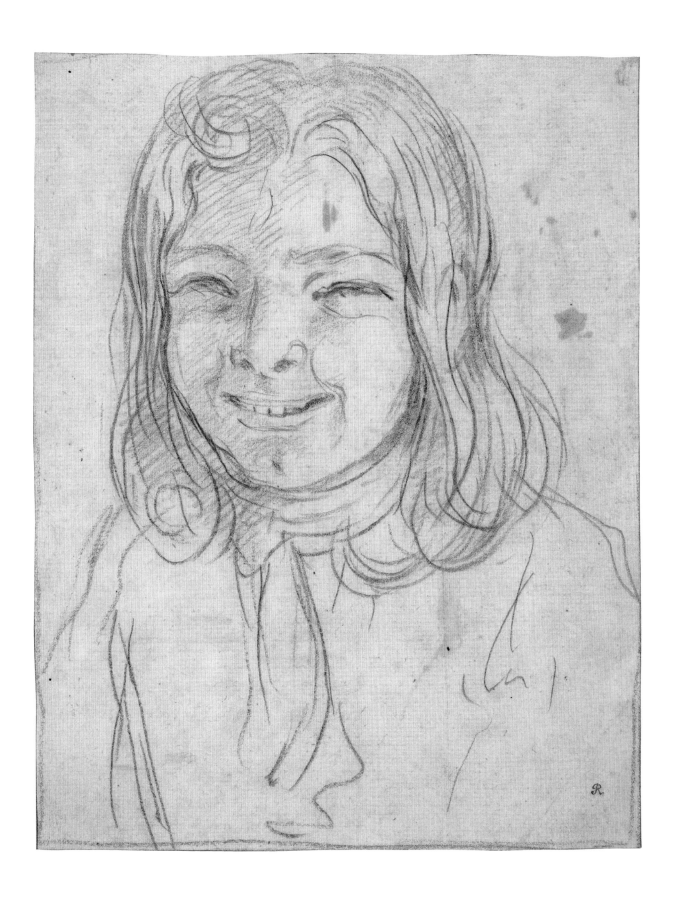

Abraham Genoels II

ANTWERP 1640—1723 ANTWERP

26

Landscape with a Natural Arch, c. 1718

pen and black ink with gray wash and watercolor over traces of graphite and red chalk, 139 × 189

Joseph F. McCrindle Collection, 2009.70.173

PROVENANCE P. & D. Colnaghi & Co. Ltd.; Joseph F. McCrindle, New York, purchased on August 17, 1966; Joseph F. McCrindle Foundation, 2008; gift to NGA in 2009

FIG. 1
Abraham Genoels II, *Rocky and Wooded Landscape with Figures*, 1718, pen and brown ink with gray wash and watercolor over red chalk, The Courtauld Gallery, London

THIS CHARMING LANDSCAPE FEATURING a natural rock arch has been attributed to various artists — Isaac de Moucheron (1667–1744) and Pieter Mulier I (1615–1670) among them — but it can now be firmly attributed to the Flemish artist Abraham Genoels II on the basis of its strong similarity to a drawing signed by him and dated 1718, today in the Courtauld Gallery, London (fig. 1).[1] The drawings share the same fluid technique and reveal similar compositional traits. In both works Genoels began by sketching out the basic design in chalk or graphite (graphite and red chalk for the McCrindle sheet and red chalk for the Courtauld piece), which he then carefully worked up in pen and ink with delicate, broad, and flowing applications of wash and watercolor. The loopy strokes Genoels characteristically employs for foliage are identical in both drawings. The classically arranged compositions are also similar in the way the dark trees and rocks frame panoramic views in the far distance; both drawings also depict figures traveling or resting in the landscape.

Painter, draftsman, and etcher, Genoels was a native of Antwerp but first made his reputation in France, where he worked at the Gobelins tapestry workshop and became a member of the French Academy in 1665 on the recommendation of Charles Le Brun (1619–1690). He returned to Antwerp in 1672, becoming a master of the Guild of Saint Luke, and in 1674 departed for Italy, where he spent eight years. There he joined the *Schildersbent* (the society of northern painters working in Rome), which gave him the name Archimedes (after the third-century BC Greek mathematician) because of his profound knowledge of perspective. On his return to Antwerp he taught popular courses on architectural geometry and perspective drawing to young students and was by all accounts a very successful artist.

The natural arch depicted in this drawing might have been inspired by the Col de Pierre Pertuis pass (from the Latin *petra pertusa*, meaning broken rock) in the Jura mountains, near Tavannes, Switzerland.[2] This natural rock tunnel was enlarged by the ancient Romans in the third century for a major road that was used for hundreds of years thereafter. — GDJ

1 The Courtauld drawing, *Rocky and Wooded Landscape with Figures* (inv. D.1952.RW.1078), was kindly brought to my attention by Stijn Alsteens, curator, Department of Prints and Drawings, at the Metropolitan Museum of Art, New York (correspondence with the author, June 10, 2011). The McCrindle sheet was attributed to Pieter Mulier when it was sold to McCrindle in 1966; at some point thereafter it acquired an attribution to Moucheron, under whose name it entered the National Gallery.

2 The possible source of inspiration was suggested by Peter Schatborn, former chief curator of the Rijksprentenkabinet, Amsterdam (correspondence with the author, April 14, 2011).

Daniel Marot the Younger

LONDON 1695–1769 THE HAGUE

27

*A Stage Set with a Statue
and a Palace*, 1730s (?)

pen and black ink with
gray wash over traces of
graphite, sheet 327 × 495,
image (inner border line)
304 × 470

Joseph F. McCrindle
Collection, 2009.70.25

PROVENANCE Joseph
F. McCrindle, New York;
Joseph F. McCrindle
Foundation, 2008;
gift to NGA in 2009

SEVERAL FEATURES OF THIS APPEALING, fully finished composition hint at its probable use as a design for a theater set: the trees that frame the view of the palace like coulisses; the stagelike breadth of the foreground space; the fanciful edifice, composed of a massive Gothic stone fortress decorated with baroque flourishes and, behind it, a more delicately defined palace with classical proportions and details; and, finally, the statuary suggestive of a mythological tale — the sort that provided material for countless theatrical productions in the eighteenth century. The identity of the female statue clothed in classical flowing robes is open to debate. Since she holds an arrow in her left hand and a leash in her right, with a dog barely visible behind her right leg, she could be Diana, who as a huntress always keeps both hound and weapon close by and is often associated with a woodland setting. However, the presence of Cupid grasping a bow above the fortress gate would suggest that she is Venus — and that the arrow she holds could have been taken from her son. As the goddess of love and beauty, Venus is rarely associated with the hunt, but she did appear to her son Aeneas in the guise of a huntress in the *Aeneid* (Book 1), and one of her human lovers was the hunter Adonis.

Regardless of the identity of the goddess represented by the statue, the play for which this stage decoration was designed must have involved a love story. The figure of Cupid positioned directly above a cartouche decorated with an image of his bow and arrowless quiver may even identify the building as the palace of Amor. The sculpture was added, however, after the massive wall of the fortress had already been drawn, for the lines defining the building's stone cornice continue across his wings, chest, and shoulders.[1] Interestingly, this Cupid appears to have two sets of small rounded wings rather than the feathered ones with which he is most often portrayed. If these are meant as butterfly wings, it is an unusual

choice (though one not completely without precedent), for it is Cupid's lover Psyche who is more traditionally associated with butterflies than Cupid himself.[2]

This drawing entered the National Gallery collection as the work of an unknown German artist, but Andrew Robison later suggested that the execution and conception could link it to the work of Daniel Marot, an idea that was refined by Peter Fuhring to Daniel Marot the Younger.[3] Like his father, for whom he was an assistant, the younger Marot was a draftsman and decorative painter who worked on garden design, architectural interiors and ornament, and stage sets. While the elder Marot was adroit at portraying figures, his son was less so, which may account for the awkwardness of the female statue. Marot junior was more gifted in rendering buildings and landscape, talents that are evident here in the deft handling of the trees and the charming intricacies of the palace's architectural details. — MD

1 This observation was made by Margaret Morgan Grasselli in conversation with the author on July 29, 2011.

2 I am grateful to David J. Buch for reminding me of this (email, June 15, 2011). Psyche's tie to the butterfly comes from her name, a Greek word for both soul and butterfly. See Brenner 1983, 82.

3 Robison's idea was first expressed in a conversation with Margaret Morgan Grasselli in February 2011. Fuhring, who called the Marot attribution "interesting," noted that it would more likely be Marot the Younger than his father in an email to the author on June 2, 2011. Fuhring also signaled another example of a stage set design with a palace and statues in a garden, which he had recently attributed to Marot the Younger, in the Biblioteca Nacional de España, Madrid (reproduced in García-Toraño Martínez 2009, 364, no. 502).

Pier Leone Ghezzi

ROME 1674–1755 ROME

Abbot Antonio Niccolini,
c. 1725

pen and iron-gall ink over
graphite, 306 × 218

Joseph F. McCrindle
Collection 2009.70.126

INSCRIPTION verso:
lower left, in pen and brown
ink, *Mr. L'Ab. Nicolini*

PROVENANCE From an
album acquired by Richard
Neville Neville (1717–1793)
in Paris in 1763; inherited in
1793 by Richard Aldworth
Griffin-Neville, 2nd
Baron Braybrooke; by
descent to Robin Henry
Charles Neville, 10th Lord
Braybrooke (sale, Sotheby
Parke Bernet, London,
December 10, 1979, no. 87);
Joseph F. McCrindle,
New York; Joseph F.
McCrindle Foundation,
2008; gift to NGA in 2009

A WELL-RESPECTED AND SUCCESSFUL history painter and portraitist in his own time, Pier Leone Ghezzi is now best known for the hundreds upon hundreds of highly entertaining caricatures he made of his contemporaries. With an unerring eye for the telling details of costume, physiognomy, carriage, and expression, the artist poked gentle fun at the patrons, friends, colleagues, chance acquaintances, foreign dignitaries, and tourists he met in the course of his work and social life in Rome. He has been called the first professional caricaturist, but most of his drawings appear to have been made for his own entertainment.[1] He certainly kept an astonishing number of them in his own possession, assembling nearly 1,400 renderings into eight substantial volumes between about 1730 and 1747. Calling them *Il Mondo Nuovo* (The new world), he sold the entire collection to Pope Benedict XIV in 1747 for a monthly stipend of twenty-five scudi.[2]

While Ghezzi kept so many drawings for himself, he also made numerous copies of them, presumably for the sitters or their friends. The present drawing of a Florentine abbot, Antonio Niccolini, is one such replica of a caricature in the Vatican albums.[3] According to Ghezzi's own inscription on the original drawing, the priest's brother, a knight of Malta, sat next to the artist at a dinner given in Rome by the French ambassador, Cardinal Melchior de Polignac, on April 4, 1725. Ghezzi befriended the knight and thereafter made individual caricatures of both him and his brother, that of the abbot dated May 20, 1725. The present repetition was probably made very shortly thereafter, most likely for a French patron, since the inscription on the verso gives an abbreviated form of the French version of the sitter's title, "Monsieur l'abbé." The drawing was one of 152 contained in two eighteenth-century albums that remained intact until 1979, when all the caricatures were sold.[4] Since almost all the sheets in those two volumes bore similarly brief inscriptions in French, and all of them were already in Paris by 1763, it is tempting to think that the patron for whom the copies were made was the Cardinal de Polignac himself or perhaps a member of his entourage.

The McCrindle drawing was executed in the insistently linear pen style that Ghezzi used for nearly every one of his caricatures. Adeptly manipulating the weight and width of each line, and spacing and massing the strokes with studied regularity, he created highly stylized yet visually appealing renderings that are unmistakably his work. The large majority of his figures are portrayed alone, in profile, and in the simplest of settings, as is the case here, but as formulaic as these drawings may at first seem, they are in no way repetitive or monotonous, but are instead remarkably individualized and endlessly entertaining. — MMG

1 See Clark 1963, 12.

2 Codice Ottoboniano Latino, nos. 3112–3119. The drawings were fully catalogued and discussed in detail, though with few illustrations, in Dorati da Empoli 2008.

3 Cod. Ottob. Lat. 3115, fol. 52. See Dorati da Empoli 2008, 210, no. 52, and the entry written by Antonella Pampalone in sale cat. Sotheby Parke Bernet, London, December 10, 1979, no. 87.

4 See sale cat. Sotheby Parke Bernet, London, December 10, 1979.

Giovanni Paolo Panini

PIACENZA 1691–1765 ROME

29

Saint Paul Preaching in Athens, 1734

pen and black and gray ink with gray wash over graphite, heightened with white gouache on tan prepared paper; watermark: Strasburg Lily with a double-pointed arrow below (similar to Churchill 406); 413 × 277

Joseph F. McCrindle Collection 2010.93.21

INSCRIPTIONS signed and dated at lower right, in pen and black ink, *I.P.P./1734*; on the altar, center right, *IGNOTO / DEO*; verso: lower left, in graphite, *2129N*

PROVENANCE Joseph F. McCrindle, New York; gift to NGA in 2010

LITERATURE Princeton 1991, no. 58; Harris 1994, 68

FIG. 1
Giovanni Paolo Panini, *Saint Paul Preaching in Athens*, 1731, oil on canvas, location unknown (ex coll. Carlo Sestieri, Rome)

GIOVANNI PAOLO PANINI, DURING MOST of his lifetime, had a quasi-monopoly on the production of paintings and drawings representing fanciful vistas of the ancient and modern buildings and monuments of Rome and its environs. He was a master at constructing pleasing architectural capriccios and filling them with innumerable lively figures; he also delighted in depicting the important festivals celebrated in contemporary Rome. With the assistance of a large workshop, he produced an impressive body of works, although the drawings have not yet been coherently explored.[1] Thanks to his close connections with Roman art schools and to his ties with the local French community of artists—he was named a member of the French Academy in Rome and taught optics to the students there, including Hubert Robert (cat. 33)—Panini played a highly influential role in the development of the capriccio and the encouragement of contemporary taste for cityscapes that combined the modern and antique worlds.

Saint Paul preaching in Athens is one of Panini's most frequently depicted motifs, featured in more than twenty paintings. Based on the New Testament book of Acts (17:22–23), this drawing shows the bearded apostle among the ruins of the Greek city, gesturing to an altar at right inscribed with the Latin phrase IGNOTO DEO and identifying that "unknown god" to his listeners as the Christian deity. With its combination of magnificent ancient architecture and lively figure groups, it proves a veritable showpiece for the artist's talents. The drawing was based on a painting of the same subject, dated 1731 (fig. 1), repeating the same general composition and several of the figures.[2] The lofty architectural setting of the painting is much reduced in the drawing, however, and the figures within it are enlarged, thus intensifying the drama of the scene and turning a fanciful capriccio into a history scene.[3]

Remarkable for the fine precision of the pen lines and the brilliantly adept handling of the white heightening and ink washes, this beautifully rendered drawing is a fine demonstration of Panini's skill as a draftsman. With works like this he was able to satisfy the demands of the newly burgeoning market for highly finished drawings that were sold, collected, and often displayed as works of art in their own right. — OT

1 For Panini's paintings, see Arisi 1986.

2 Oil on canvas, 73 x 61, signed and dated *I. P. Panini. Roma 1731*. See Arisi 1986, 338, no. 213.

3 At least one painted replica after the 1731 painting is also known. Oil on canvas, 76 x 64 cm, signed and dated: *I.P.P. 1737* (Victoria and Albert Museum, London). Reproduced in Arisi 1986, 348.

Andrea del Pozzo (circle of)

TRENTO 1642–1709 VIENNA

30

A Baldachin with a Painting of the Annunciation, c. 1708 or later

pen and brown ink over graphite on two joined sheets of paper, 414 × 207

Joseph F. McCrindle Collection 2009.70.194

INSCRIPTIONS upper left, in graphite (barely legible), --- *un angelo si vol[?]*; below that, in the same ink as the drawing, *per ordine composito*; upper right, in the same ink, *una croce/ligna* and, below that, *il padre eterno/sta nel mezzo/del arco*; lower right, in the same ink, *invention del fra A Pozzo/fatto a Vienna*

PROVENANCE Joseph F. McCrindle, New York; Joseph F. McCrindle Foundation, 2008; gift to NGA in 2009

AS THE INSCRIPTION "INVENTION OF brother A Pozzo/made in Vienna" situated at the lower right intimates, this drawing relates to a Viennese altar designed by the Italian Jesuit brother Andrea del Pozzo (1642–1709). Best known for his illusionistic ceiling painting in the Roman church of Sant'Ignazio, Pozzo worked primarily for the Jesuit order in Italy until around 1702/1703, when he was called by Emperor Leopold I to Vienna. He worked there for the Hapsburg court and various religious orders until his death. Among the most influential Italian artist-theorists of the period, Pozzo inspired numerous followers who disseminated his ideas throughout Europe.

This drawing of an ensemble uniting painting, architecture, and sculpture closely resembles an altar made by Pozzo in 1708/1709 for the Kirche am Hof.[1] The am Hof altar, though destroyed in the late eighteenth century, is known through a highly finished drawing from the 1730s by Salomon Kleiner

(1703–1761; fig. 1).[2] Both it and the McCrindle drawing represent altars similarly composed of almost the same architectural frameworks and sculptures.

The quick and confident sketch, combined with the differing subjects of the altar paintings at center — the Assumption in the am Hof drawing and the Annunciation in the McCrindle drawing — as well as the additional statuary in the latter sketch, could suggest this drawing is Pozzo's preliminary sketch for the am Hof altar, before the subject of the painting had been determined. On the other hand, the many Italian inscriptions, which describe the various formal components of the ensemble, do not resemble Pozzo's handwriting as it is known from official documents.[3] If these inscriptions were made by the same hand that created the drawing, they point to authorship by another Italian artist/architect working in Vienna around the beginning of the eighteenth century, possibly in Pozzo's studio. — *AR*

Hoch-Altar in der Kirche deren W.W. S.P.P.P. Jesuiter auf dem Hof in Wienn.

1 The Kirche am Hof is the Casa Professa (the chief or "professed" house) of the Jesuits in Vienna.

2 On the am Hof altar and the drawing, see Bösel 1996, 167–168.

3 Evonne Levy (in conversation with Julie Blake and Margaret Morgan Grasselli, spring 2010) and Herbert Karner (email of April 14, 2010, to Julie Blake) both expressed doubts about the attribution of this drawing to Pozzo. Levy also noted the discrepancies between Pozzo's handwriting and the inscriptions on the McCrindle sheet.

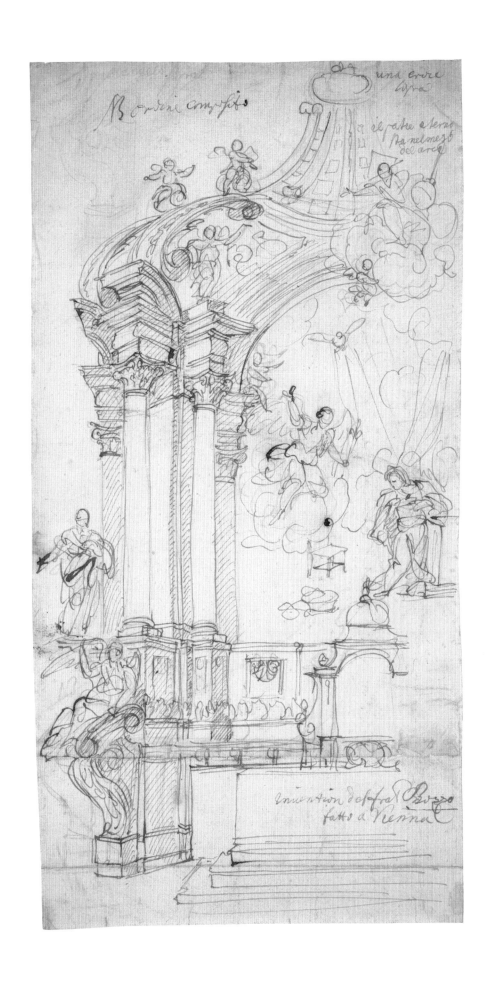

Agostino Masucci

ROME 1690–1768 ROME

31

Studies of an Apostle Guided by an Angel and the Adoration of the Shepherds, 1720 / 1750

album page with four drawings in various media; watermark: on the secondary sheet, a large, crowned armorial with a fleur-de-lys in the center and a tassel hanging below over the initials *J H & Z* (very similar to Heawood no. 1860; 1779, Bern, Switzerland); 461 × 294

Joseph F. McCrindle Collection, 2009.70.163.a–d

INSCRIPTIONS numbered at lower right in pen and brown ink, *388*; on the mount, lower center, in pen and brown ink, *Carlo Maratti*; verso: center, in graphite, *374* (scratched out)/*384*

PROVENANCE Sir Robert L. Mond (1867–1938), London (Lugt 2813a); sale, Christie's, London, July 7, 1959, lot 139; P. & D. Colnaghi & Co. Ltd., London (stock no. *A23760 CO* at lower right of mount in graphite); to Joseph F. McCrindle on November 26, 1959; Joseph F. McCrindle Foundation, 2008; gift to NGA in 2009

LITERATURE Borenius 1938, 36, no. 150 (1–4) (as follower of Carlo Maratta)

THE FOUR SMALL DRAWINGS MOUNTED ON this album page are all by Agostino Masucci, a native of Rome and one of the leading Italian classicizing painters of the eighteenth century.[2] Having trained first with Andrea Procaccini (1671–1734) and then with Carlo Maratta (1625–1713), Masucci pursued a successful career in Rome, with many commissions from noble, papal, and royal patrons. Among his many professional honors were his appointment as regent of the Congregazione dei Virtuosi al Pantheon in 1735 and his election as *principe* of the Accademia di San Luca in 1737. He produced mainly portraits and religious paintings and was much admired for his images of the Madonna and Child.[3]

The drawings consist of two pairs of studies for two different projects. Both of the chalk sketches, for example, show two bearded male figures — the same person in variant poses — holding a staff and following a winged angel who points toward a set of steps. Although no other context is provided, the scenes recall the story of Saint Peter being led out of prison by an angel (Acts 12:7–10). The chalk studies were produced on paper of the same manufacture and were probably executed within a short time of each other, but Masucci develops his black chalk figures with quick, jagged, short lines and several traces of pentimenti, while he uses the red chalk to create smoother contours and more subtle shading. No painting by Masucci relating to these sketches is known, but the draftsmanship is comparable to other known chalk drawings by his hand, such as *An Angel Supporting a Fainting Ecclesiastic* in the Musée du Louvre (inv. 17063), *Saints and an Angel* and *Figures Studies* on the recto and verso of a sheet in the Kupferstichkabinett, Berlin (inv. 21103), and *The Annunciation* (recto and verso) in the Ashmolean Museum, Oxford (inv. 1964).[4]

Both of the pen-and-ink studies represent ideas for an Adoration of the Shepherds, with each one including two shepherds kneeling before the Baby Jesus,

who is watched over by the Virgin Mary and Saint Joseph. Masucci creates the forms with blunt, choppy contour lines and uses short, parallel hatchings to suggest shadow and plasticity. He changes his mind as he draws, leaving some significant pentimenti, especially in the head of Joseph in the bottom sheet, where the dense concentration of acidic iron-gall ink has started to eat away the paper. Closely similar in handling are such pen drawings by Masucci as *Studies for the Education of the Virgin* in the Metropolitan Museum, New York (inv. 1972.118.12) and several in the Kupferstichkabinett, Berlin, including a small *Adoration of the Shepherds* (inv. 21099) that has much in common with the two McCrindle sketches.[5]

The watermark on the album sheet to which the four drawings are attached is datable to about 1779, suggesting that the studies were all mounted together in the late eighteenth century. The inscription identifying the artist as Carlo Maratta, even only such a short time after Masucci's death in 1768, is not entirely surprising because all four studies bear witness to Masucci's close adherence to his teacher's example and to the key role Masucci played in carrying Maratta's classicizing baroque style well into the middle years of the eighteenth century. — LL

1 Livia Schaafsma at Colnaghi's traced the firm's records pertaining to the purchase and sale of this drawing (email correspondence, July 2011).

2 I am grateful to Catherine Loisel, who confirms the attribution of all four drawings to Masucci (email correspondence, April 2011). I also thank William Breazeale for sharing his views on the attribution (email correspondence, April 21, 2011).

3 See Milan 1988, 88 and Clark 1967, 259–264.

4 For a reproduction of the Louvre drawing, go to *http://arts-graphiques.louvre.fr/fo/visite?srv=rom.* The Berlin drawings are reproduced in *Corpus Gernsheim,* nos. 52 168 and 52 169; for the Ashmolean studies, see *Corpus Gernsheim* 48 136 and 48 137.

5 For the New York drawing, see Bean and Griswold 1990, 146, no. 134; for the Berlin *Adoration,* see *Corpus Gernsheim* 52 154.

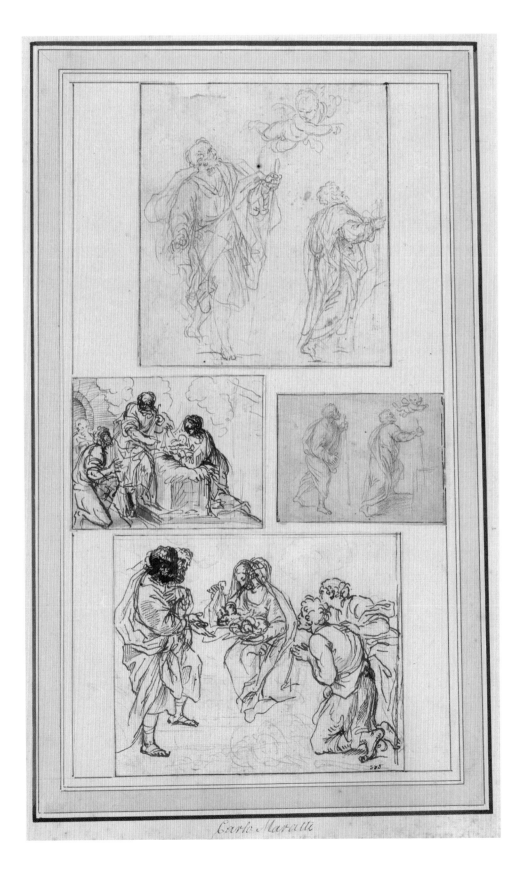

TOP *An Apostle Guided by an Angel*; black chalk; watermark: partial, six-pointed star within a circle, probably surmounted by a Latin cross (close to Briquet 6089); 154 × 140

CENTER LEFT *The Adoration of the Shepherds*; pen and brown ink with brown wash; 81 × 107

CENTER RIGHT *An Apostle Guided by an Angel*; red chalk; watermark: partial, six-pointed star within a circle, probably surmounted by a Latin cross (close to Briquet 6089); 71 × 94

BOTTOM *The Adoration of the Shepherds*; black chalk with pen and brown ink; 131 × 160

French school, mid-18th century

32

A Male Nude Seen from Behind, c. 1760

red chalk; watermark:
I.AFF [illeg]/AUVERGNE
and a bunch of grapes;
566 × 384

Joseph F. McCrindle
Collection 2009.70.113

INSCRIPTION upper right,
in graphite, N°4 (?)

PROVENANCE Joseph F.
McCrindle, New York
(as William Etty); Joseph
F. McCrindle Foundation,
2008; gift to NGA in 2009

ALTHOUGH THIS DRAWING ENTERED THE McCrindle collection as the work of the nineteenth-century British artist William Etty (1787–1849), the choice of red chalk for the medium and the overall style of execution place it instead within the life-drawing tradition that flourished in France in the 1700s. Such studies of the posed male nude — known as *académies* for the places where most of them were made — were a fundamental part of the training and development of every young French artist, and hundreds upon hundreds of these drawings have survived.[1] Many have well-supported attributions, as is the case with another study of this type by Carle Vanloo, also in the McCrindle collection (see Other Drawings, page 176), but a large number remain unattributed, in part because relatively few were signed, but also because very little research has been dedicated to the genre and to clarifying the production of individual artists.[2]

From the time the Académie royale de peinture et de sculpture was founded in Paris in 1648, life-drawing classes were held for two hours in the afternoon on every working day, a practice that remained uninterrupted until the French Revolution and the abolishment of the Académie in 1793. As many as 120 students could work at one time under the supervision of a professor, who was selected from among the most distinguished drafts-men in the Académie. Twelve members served in this capacity each year, each one posing the model, monitoring the life-drawing ses-sions, offering advice to the students, and even correcting their drawings, for a period of one month. The models customarily held the same pose over the course of three con-secutive classes — six hours per pose, two poses per week — and the students were expected to produce at least one drawing of each pose. Every three months they could submit their most successful work to a com-petition in which three prizes were awarded for the best life-drawings of the quarter.

The unknown artist responsible for the McCrindle study was clearly an accomplished young draftsman who was fully conversant with human anatomy and was well skilled in expressing qualities of light, surface, form, and space with his chalk. The pose is not particularly complex, but the ease with which the artist has situated the diagonal figure within the confines of the page, perfectly filling the available space from the top right to the bottom left corners, shows how advanced he must have been in producing this type of drawing. With luck, a signed drawing by the same artist will someday be found to help finally restore this work to the oeuvre of its proper master. — MMG

1 For the most recent discussion of the life-drawing tradition in France, see the essay by Emmanuelle Brugerolles and Camille Debrabant in Paris 2009, 20–75.

2 A counterproof of the McCrindle Vanloo drawing was published as the work of the artist in an exhibition catalogue that was intended to serve as a complete repertory of Vanloo's known artistic production; see Nice 1977, 175, no. 580.

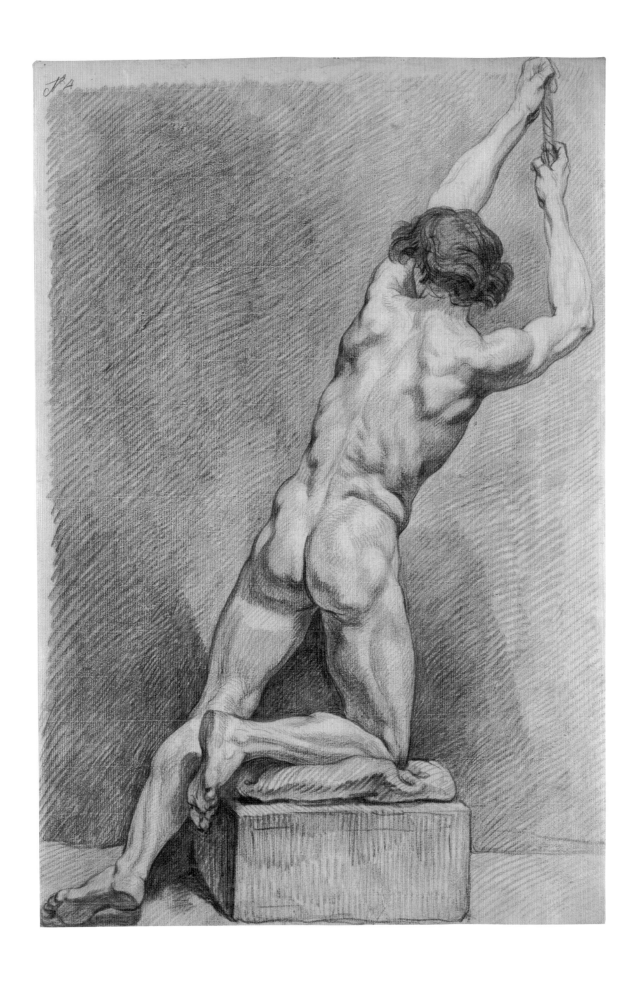

Hubert Robert

PARIS 1733 – 1808 PARIS

33

*A Roman Capriccio
with the Pyramid
of Gaius Cestius,*
1781 or later

pen and black ink with
brown and gray-brown
wash over black chalk
counterproof, 368 × 289

Joseph F. McCrindle
Collection 2009.70.199

INSCRIPTIONS on the
pyramid, in pen and black
ink, *IO M/C. VIT. SEXTIUS/
VIR EPULONUS*; dated in the
counterproof (in reverse),
1781

PROVENANCE P. & D.
Colnaghi & Co., Ltd.,
London; Joseph F.
McCrindle, 1961; Joseph
F. McCrindle Foundation,
2008; gift to NGA in 2009

FIG 1
Pyramid of Gaius Cestius,
c. 12 BC, Rome

HUBERT ROBERT WAS THE LEADING
eighteenth-century French painter of archi-
tectural capriccios, a subgenre of landscape in
which the artist extracted famous ruins,
landmarks, and sculptures from their normal
surroundings and set them into different
contexts to create imaginative new scenes.
Robert's favorite source materials for his com-
positions were the great monuments of ancient
and modern Rome, which he studied assidu-
ously for more than a decade when he was
living and working in Italy from 1754 to 1765.

In the present composition the steeply
sloped pyramid evokes the unmistakable form
of the tomb of the wealthy Roman praetor
(magistrate) Gaius Cestius, built about 12 BC
and then incorporated into the southern part
of the Aurelian Walls that were built around
Rome during the second half of the third
century AD (fig. 1). The same monument
appears prominently in a number of other
drawings and paintings by Robert made over
a span of many years.[1] Typical of Robert's
capriccios is the juxtaposition of the highly
recognizable pyramid with more generic
ruins, including a bas-relief, an overturned
Corinthian capital, a damaged statue, and a
cracked stone basin. Equally characteristic

is the way in which the artist has turned
these ancient fragments into a setting for
an everyday scene of modern life, with two
women collecting water at a fountain while a
young man addresses them and a dog cools
its paws in a puddle.

Underlying the pen and wash of
the present drawing is a light gray counter-
proof, essentially a monotype taken from
an original composition drawn in black
chalk by covering it with a dampened sheet
of paper and running the two together
through a press.[2] Robert frequently pulled
such counterproofs from his black or red
chalk studies, which resulted in somewhat
paler — and reversed — versions of his
compositions. Some of these counterproofs
Robert then reworked and embellished with
pen and ink and wash, as here, often making
subtle changes or more obvious enhancements
to the original study and thus creating in the
process new works that were quite different in
appearance from the initial chalk drawings.[3]
In this case, the original was made by Robert
in 1781 (the date appears in reverse on the
pyramid), and although the reworked version
could date from any time thereafter, it was
probably completed within a short time,
most likely in the early 1780s. — MMG

1 For just four examples see Méjanès 2006, nos. 37 and 43, for
 two drawings in the Louvre; and Cayeux 1985, 60 and 195
 for a painting and its preparatory drawing in the Musée de
 Valence. Robert seems always to have drawn and painted
 the pyramid with the apex broken off, even though the
 original pyramid is complete.

2 What appears to have been the original black chalk drawing
 (as seen in a poor reproduction with no dimensions given)
 was sold in Paris at Hôtel Drouot on June 25, 1923, lot 41.
 That work's current location is not known.

3 Two other examples of Robert drawings made over
 black chalk counterproofs are in the collection of the
 National Gallery of Art, *The Peasant Dance* and *Ruined Farm*
 (inv. 1963.15.26 and 1963.15.27); both are reproduced in
 Washington 1978, nos. 33, 34. Images are available at
 www.nga.gov.

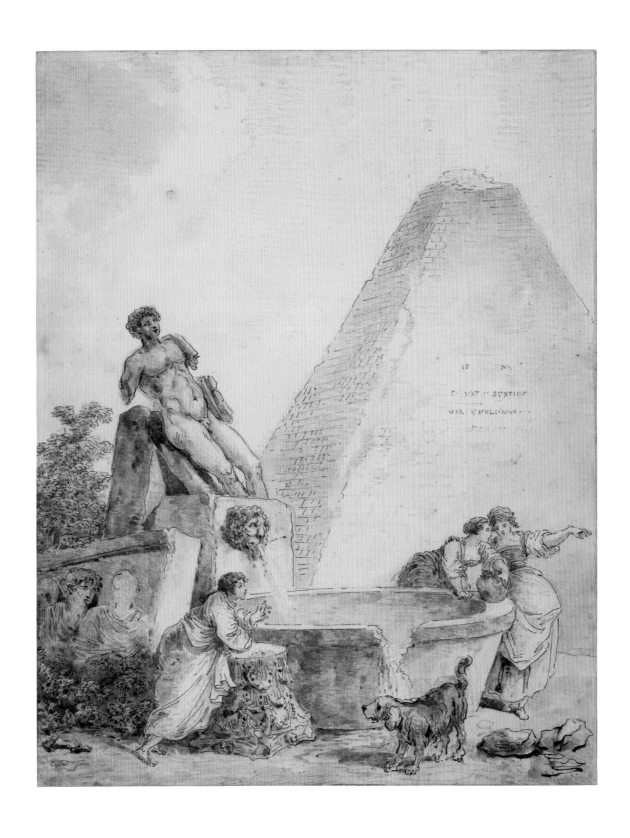

Pietro Antonio Novelli

VENICE 1729 — 1804 VENICE

34

Paulinus, Cardinal and Patriarch of Aquileia, Transfers His Seat to Grado, c. 1796

pen and black, gray, and brown ink with gray wash; watermark: IMPERIA surmounted by leaves (?); 218 × 282

Joseph F. McCrindle Collection 2009.70.178

INSCRIPTIONS signed at lower left, in pen and brown ink, *Pietro Ant Novelli dis.*; verso: right, in graphite, *7050/Seiferheld* and lower center (sideways) *403* (circled)

PROVENANCE Helene C. Seiferheld, New York; Joseph F. McCrindle, New York; Joseph F. McCrindle Foundation, 2008; gift to NGA in 2009

THIS WELL-IMAGINED COMPOSITION was drawn in preparation for one of a set of twenty-nine prints (plus an illustrated title page) of scenes from early Venetian history published in 1796/1797 as *Fasti Veneti o Collezione de' più illustri fatti della Repubblica Veneziana insino a Bajamonte Tiepolo* (Annals of Venice or collection of the most illustrious events of the Venetian Republic up to Bajamonte Tiepolo).[1] Pietro Antonio Novelli, the draftsman, painter, printmaker, and stage designer who was responsible for this sheet, made most of the drawings that served as models for the engravers; the rest were supplied by his contemporaries Francesco Galimberti (1755–1803/1804) and Giovanni Domenico Tiepolo (1727–1804). The majority of the images, including the one related to the McCrindle drawing, were engraved by Francesco del Pedro (1736/1740–1806). Each print was accompanied by an explanatory text whose author is thought to have been Francesco Boaretti (1748–1799), a Paduan scholar and priest who is known for his translations of Homer's *Iliad* and several ancient Greek plays into the Venetian dialect. The set was published by Giuseppe Picotti (1756–1835), who ran a thriving printing business in Venice.

In the scene presented here, Paulinus, cardinal and patriarch of Aquileia from 557 to 569, arrives on the island of Grado, situated in the Adriatic Sea west of Trieste, after Aquileia has been overrun by Lombard invaders in 568.[2] He brings with him the treasures of his church and quickly establishes a new see of Aquileia, which remains in Grado even after a rival patriarchate is restored in Aquileia. Centuries later, in 1451, the see of Aquileia in Grado would be merged with Castello to form the Archdiocese of Venice.

Novelli's well-developed talents as an illustrator are evident in the McCrindle drawing in the clarity of the scene and the liveliness of the rendering. The rather obscure subject was unrecognized until its connection with the print and the *Fasti Veneti* was discovered,[3] but Novelli did follow very closely the details of the story — except in the clothing, which is too modern for an event that took place in the sixth century. Typical of Novelli's draftsmanship is the attractive combination of fluid washes and parallel hatchings that he often used to give form and substance to his figures. Without being overly precise in his rendering, he created a richly detailed image that was clear enough to serve as the engraver's model but yet remained free enough in execution to remain handsomely pictorial in effect. — DB

1 The prints deal with events from Venetian history through 1310, when Bajamonte Tiepolo led a failed plot to overthrow the Doge and the Grand Council of Venice. Illustrations of many of the engravings, including the one made after the McCrindle drawing, are available at *http://www.lombardiabeniculturali.it.*

2 For more information about this episode in church history, see the *Catholic Encyclopedia* at *http://www.catholic.org/encyclopedia.*

3 In the McCrindle collection, the drawing was identified only as *A Venetian Scene*. I am grateful to Margaret Morgan Grasselli for discovering the print (personal communication, August 2011).

John "Warwick" Smith

IRTHINGTON 1749 – 1831 LONDON

35

Italian Coast Scene,
possibly 1776 / 1781

watercolor over graphite;
watermark: Strasburg Lily
with LVG below (similar
to Churchill 413, 414);
369 × 514

Joseph F. McCrindle
Collection 2009.70.184

INSCRIPTIONS verso:
lower left, in red chalk,
?J. Smith?; lower right,
in graphite, *Earl Warwicks
Collection*

PROVENANCE Earl of
Warwick (according to
the inscription on the
verso); unidentified
collector (stamped twice
with mark of a unicorn or
lion above a banderole
inscribed "tenax in fide";
not in Lugt); Thomas
Agnew & Sons, London;
Joseph F. McCrindle, New
York; Joseph F. McCrindle
Foundation, 2008; gift to
NGA, 2009

LITERATURE London 1962,
no. 141

FIG. 1
John "Warwick" Smith,
Isola Madre, Lago Maggiore, c. 1781,
watercolor and graphite,
Yale Center for British Art,
New Haven

JOHN "WARWICK" SMITH WAS THE SON of a gardener, whose employer was the sister of Captain John Bernard Gilpin and aunt of the picturesque theorist William Gilpin and the animal painter Sawrey Gilpin. Smith received his first drawing lessons from John, studied under Sawrey, and sketched in the countryside with William. While on a trip to Derbyshire in 1775, Sawrey introduced Smith to the wealthy aristocrat and amateur artist George Greville, 2nd Earl of Warwick (1746 – 1816), who was so impressed with Smith's drawings he paid for him to go to Italy the following year.[1]

Smith's sojourn in Italy lasted from 1776 to 1781. During that time, he benefited from the company of his fellow expatriates Thomas Jones (1742 – 1803), Francis Towne (1739 – 1816), and William Pars (1742 – 1782), to whom the present drawing was formerly attributed.[2] Together, these artists influenced each other's work and challenged one another to experiment. As a result, Smith was recognized in his day as a technical innovator in the use of watercolors, particularly for his Italian works. Some of these show a shift away from the traditional use of monochrome underpainting to the direct application of color washes onto the paper, which itself becomes an illuminant. Even if the present watercolor is unfinished, one can still see how Smith intended to spotlight the buildings and structures on the coast by reserving areas of white paper for highlights. As in his *Isola Madre, Lago Maggiore* (fig. 1),

Smith here achieved a vivid sense of depth and atmosphere by painting dark bands of color in the foreground to suggest water close by and then lightening the color bands to suggest greater distance, creating paler tones and increasingly allowing the white of the paper to show through.[3]

Smith's technique in his later works was considered mechanical and old-fashioned by such daring (and younger) watercolorists as J. M. W. Turner (1775 – 1851).[4] However, by the time Smith was made an associate of the Society of Painters in Water-Colours in 1805 (he served as the society's president in 1814, 1817, and 1818), he was regarded by many of his contemporaries as "an elder statesman of the art"[5] for the part he had played, in works like this one, in helping watercolor move beyond the tinted drawing tradition. — LK

1 Smith's sobriquet probably derives as much from a period spent living and working in Warwick as from his enjoyment of the 2nd Earl's patronage.

2 Exhibited by Agnew's in 1962 as the work of Smith, the watercolor was later attributed to Pars, who worked in a closely similar style. The inscription on the back indicating that the work was once in the Earl of Warwick's collection, however, points to Smith as the work's creator.

3 Scott Wilcox was the first to note the similarities between the two watercolors (email to Julie Blake, April 9, 2010, in the National Gallery of Art object file).

4 Farington *Diary,* 4: 1303 (November 17, 1799).

5 New Haven 2007, 268.

Carlo Labruzzi

ROME 1748 – 1817 PERUGIA

The Great Villa of the Quintilii on the Appian Way, 1789

watercolor over graphite; watermark: J Honig & Zoonen; 412 × 550

Joseph F. McCrindle Collection, 2009.70.150

INSCRIPTION upper center, in graphite, 70

PROVENANCE Sir Richard Colt Hoare (1758 – 1838); included in one of four albums alleged to have been found in a bombed-out house in London during the Second World War; John Manning, London, 1960; Joseph F. McCrindle, New York; Joseph F. McCrindle Foundation, 2008; gift to NGA in 2009

LITERATURE London 1960, no. 7, 8, or 9; Storrs 1973, no. 119

CARLO LABRUZZI WAS A PAINTER OF landscapes in the manner of Claude Lorrain (1604/1605–1682) and a member of the Accademia di San Luca in Rome, as well as a successful draftsman, engraver, and watercolorist. As such he was popular with British Grand Tourists in Italy, among whom he counted several patrons. One of these was Sir Richard Colt Hoare, an amateur artist and antiquarian to whom in 1788 Labruzzi dedicated a series of twelve etchings entitled *Figure Originali* (Original figures).[1] This astute move may have led to the artist's most important commission, for the following year Colt Hoare asked Labruzzi to accompany him as "companion and artist" on a journey from Rome to Brindisi along the Appian Way. Colt Hoare planned to publish an account of the Via Appia accompanied by a series of engravings of the classical monuments, villas, and tombs along the route. To this end he carefully transcribed classical inscriptions and took copious notes, while Labruzzi was enlisted to make drawings of the remains of classical antiquity they encountered along the way.[2]

Unfortunately, the trip was cut short by bad weather, and Labruzzi subsequently fell ill. Nevertheless, the artist had already produced some four hundred watercolor sketches. From these he would prepare more than two hundred finished sepia drawings to be used for engravings. Although the planned publication was never brought to fruition, twenty-four plates engraved by Labruzzi were issued in Colt Hoare's lifetime under the title *Via Appia illustrata ab urbe Roma ad Capuam*.[3]

The McCrindle drawing is one of the original watercolors produced by Labruzzi while on the journey. It depicts the ruins of the Great Villa of the Quintilii, built by the brothers Sextus Quintilius Valerianus Maximus and Sextus Quintilius Condianus Maximus in the course of the second century AD and confiscated and enlarged by Emperor Commodus (161–192).[4] It was so extensive

that, when first excavated, the site was thought to represent an entire town and was therefore referred to as *Roma Vecchia* (old Rome).

Depicted here is the *tepidarium*—a warm room from which bathers would pass into either a cold (*frigidarium*) or hot pool (*caldarium*)—of the bath complex of the villa, looking north from just beyond a stone wall in the direction of the Via Appia.[5] Labruzzi first sketched the scene in pencil, which is still visible, particularly in the background at left in the aqueduct that fed the baths. To this the artist then added watercolor, rendering the ruins in detail but executing the landscape loosely with broad strokes and squiggles. As a result the scene retains the freshness and immediacy of a work produced en plein air, while also expressing the monumentality and grandeur of the building rising above the sprawling countryside. — JBS

1 For the dedication see Stainton 1982, 462. A set of the prints is in the collection of the National Gallery of Art (inv. 1997.11.1).

2 Colt Hoare intended to follow the itinerary described by the Roman poet Horace in 38 BC. For more information on this project, see London 1960 and London 1996, under nos. 167–168.

3 A complete set is in the collection of the National Gallery of Art (inv. 1983.49.34).

4 For detailed descriptions and photographs of the ruins, see Rome 2003a, nos. 13.1–13.43.

5 Labruzzi completed several views of the site, including one in the collection of the Whitworth Art Gallery in Manchester painted from inside the *tepidarium* and showing two figures (in Manchester 1983, no. 27, not reproduced).

70

Philippe-Auguste Hennequin

LYON 1762–1833 LEUZE-EN-HAINAUT, NEAR TOURNAI

Achilles and Patroclus,
1784 / 1789

pen and brown ink, with
brown and brown-gray
wash; watermark: PRO
PATRIA (similar to Churchill
133 and 135); 205 × 319

Joseph F. McCrindle
Collection 2009.70.141

INSCRIPTIONS on
the mount below the
drawing, lower right, in
pen and brown ink, *phi.*
Aug. hennequin; verso
of mount: lower right, in
graphite, *Philippe Auguste*
Hennequ [cut off] / *Ecole*
Flamande / *1762 – 1833;*
above that, *81082*

PROVENANCE Frederick
den Broeder; bequeathed
to Joseph F. McCrindle,
New York, 2000; Joseph
F. McCrindle Foundation,
2008; gift to NGA in 2009

FIG. 1
Roman, *Sarcophagus with Reliefs*
Depicting the Slaughter of the
Children of Niobe (detail),
second century AD, Gallery of
the Candelabra, Vatican

PHILIPPE-AUGUSTE HENNEQUIN'S
interest in the legacy of classical antiquity is
reflected both stylistically and thematically
in his work throughout his career, particularly
in his known drawings, which compose only
a portion of those (well over a thousand)
apparently sold by his estate after his death.[1]
A distinguished history painter who garnered
acclaim during the First Empire, Hennequin
was one of the first students to enter the
studio of Jacques-Louis David (1748–1825),
training with the neoclassical master for
less than a year before moving on to the
Académie royale de peinture et de sculpture
in 1781. Early in his career an English patron
sponsored an extended stay in Rome, and
Hennequin spent the better part of six years
there from 1784 to 1790, admiring the ancient
statuary and ruins as well as the paintings
by great masters from Raphael and Titian to
Poussin and Claude.[2]

One of the objects that Hennequin
presumably studied during his Roman so-
journ was a second-century AD sarcophagus
representing in relief the story of Niobe,
whose hubris in boasting of her fertility
caused Apollo and Diana to slaughter all
fourteen of her children, the Niobids.
Hennequin based the two views of a dead
warrior here on two Niobids from the upper
frieze of the sarcophagus, where the dead
siblings are draped one on top of the other,
splayed out in a long row of limp bodies
(fig. 1).[3] The sarcophagus, which had been
unearthed from the grounds of a Roman villa

in 1777, was donated to the Vatican and put
on display, both accessible and well-known
to French artists at the time. David himself
drew from it.[4]

Unlike the crush of bodies on the
sarcophagus, Hennequin's two corpses are
shown as individual figures in full view.
The artist added shields and a grieving man,
presumably turning the study into an episode
from the *Iliad,* with Achilles mourning his
beloved companion Patroclus, who had been
felled by Hector.

Hennequin's interest in the Trojan War,
and Greek mythology in general, played
itself out in several paintings and numerous
drawings and lithographs. Although the
figures in this study do not connect precisely
to any known finished work, a much more
elaborate pen, ink, and wash depiction of
a dead warrior (possibly Patroclus) being
mourned was reproduced as a lithograph
in 1825.[5] The sparse outline style that
characterized much of neoclassical graphic
art (and was associated especially with
illustrations of Homeric legends) often
became more idiosyncratic and expressive
when taken up by Hennequin, as here where
the contoured bodies are described by
stylized lines that verge on abstraction in the
figures' hands and torsos. Typical of many
of his line drawings, deftly applied areas
of wash convey a sense of corporeality and
shadow. — MD

1 Benoit 1994, 119.

2 See Hennequin 1933, 94–95.

3 I am grateful to Philippe Bordes for alerting me to this
 reference (email correspondence, May 10, 2011). Bordes
 dates the drawing to Hennequin's early career because of the
 fluidity of the line; it also coincides with his time in Rome.

4 See the National Gallery of Art's drawing by David,
 Niobe and Her Daughter, 1775 / 1780, inv. 1998.105.1.n,
 reproduced on the National Gallery website, *www.nga.gov.*

5 Both drawing and print are reproduced in Benoit 1994, 190,
 245, d.218 and l.31.

Johann Heinrich Lips

KLOTEN 1758 – 1817 ZURICH

38

Two Nude Men,
late 1780s (?)

pen and brown ink with
brown and gray-brown wash
over graphite; watermark:
present but not deciphered;
335 × 227

Joseph F. McCrindle
Collection 2009.70.156

INSCRIPTION verso:
lower right, in graphite,
S 19598

PROVENANCE Joseph
F. McCrindle, New York;
Joseph F. McCrindle
Foundation, 2008; gift to
NGA in 2009

KNOWN TODAY AS AN ILLUSTRATOR AND printmaker, Johann Heinrich Lips was also a prolific and eclectic draftsman. Of the thousands of prints and drawings he made during his lifetime, he is best known for his illustrations of the works of Johann Wolfgang von Goethe (1749–1832) and Johann Caspar Lavater (1741–1801). Lips met the latter in 1772, soon after Lavater had begun the physiognomic studies that would make him famous, and the two became lifelong friends and collaborators. Lips played a crucial role in the publication of Lavater's book *Physiognomischen Fragmente zur Beförderung der Menschenkenntnis und Menschenliebe* (Essays on physiognomy, for the promotion of the knowledge and love of mankind) (1775–1778), drawing and then etching or engraving the many portraits and diagrams that illustrated Lavater's influential theories. Through Lavater, Lips made many of his most important connections, including literary and artistic figures such as Goethe, Henry Fuseli (1741–1825), and Daniel Chodowiecki (1726–1801). Despite recurrent battles with depression, Lips was impressively productive and peripatetic, teaching for a time in the academy in Weimar and traveling widely through Germany but spending much of his later career based in Zurich.[1]

As a young man, Lips studied at the academies in Mannheim and Düsseldorf in 1780–1781. There he made nude studies similar to this one: following the precedents set by French and Italian academic practices, German academies stressed the importance of drawing from live models.[2] German academic studies, like their more famous French counterparts (see, for example, cat. 32), were normally executed in chalk, and this pen-and-wash study is unusual. Although studies of single figures were more typical, double studies like this one were not uncommon. In mid-eighteenth-century Paris, for example, two models posed together once a month.[3] Though models were often posed

in fighting attitudes, the figures here were likely intended to evoke a scene from classical history, perhaps a warrior finding a dead companion.

Like many of Lips's drawings, this study is undated. The style, however, suggests that Lips made it not at one of the German academies but slightly later. In 1786 he moved to Rome and remained there until 1789, immersing himself in the study of Michelangelo. Not only had he received a commission to copy the Sistine ceiling, he also reported in a letter to Lavater that he was avoiding the heat of the Roman summer by escaping to the cool of the Sistine Chapel, where he marveled at the power of Michelangelo's figures.[4] The exaggerated heroic anatomy and dramatic foreshortening of the figures in this study seem to reflect a close study of the Sistine frescos. Moreover, the style of draftsmanship, with its sophisticated interplay of washes and sensitive contours, resembles that of a drawing Lips made near the end of his time in Rome.[5] Had he wanted to practice his life drawing, Lips would have had ample opportunity to work from live models in Rome, where artists of all nationalities were welcome at a variety of academies.[6] — SS

1 For a detailed biography, see Coburg 1989, 11–73. For other drawings by Lips, see Zurich 1990, 48–55 and 192–193.

2 For example, see Coburg 1989, 30.

3 Princeton 1977, 22.

4 Lips expressed the hope that exposure to Michelangelo would strengthen his own art and make him bolder. Cited in Coburg 1989, 35–36.

5 Le Claire 2010, no. 14.

6 Percy 2000, 461.

Roman school, late 18th or early 19th century

39

Aeneas in the Underworld,
1780/1820

pen and brown ink with
gray and gray-brown wash
over graphite, with brown
ink border line by the artist;
watermark: Strasburg Bend
& Lily (Churchill 429); sheet
352 × 440, image 306 × 397

Joseph F. McCrindle
Collection 2009.70.188

INSCRIPTIONS lower left,
in graphite, *B. Pinelli*, and
again, in a different
hand, lower center,
B. Pinelli; verso: upper left,
in graphite, *15*

PROVENANCE Joseph
F. McCrindle; Joseph F.
McCrindle Foundation,
2008; gift to NGA in 2009

THIS ROUGH SKETCH BETRAYS A CLOSE
reading of Virgil's *Aeneid* (Book VI, 440–
476). In the relevant passage, which occurs
during Aeneas's journey through Hades, the
Trojan warrior meets the shade of his former
lover Dido for the first time since her suicide.
Weeping, he begs her to stop and speak to
him, but she turns away without speaking. As
described by Virgil, the stab wound in Dido's
breast is still fresh. Aeneas's guide, the
Cumaean Sibyl, stands behind him holding
the Golden Bough, the token that allows him
to pass safely through the underworld. They
are surrounded by the restless shades of those
who died of unwise love.

Once attributed to the foremost Roman
artist of the neoclassical era, Bartolomeo
Pinelli (1781–1835), this drawing is instead
the work of an unknown artist working in
Rome at around the same time. While Pinelli
did use pen and ink with brown and gray
washes to depict classical scenes, his drawings
bear little resemblance to the handling found
in *Aeneas in the Underworld*. Even in his roughest
sketches, Pinelli's drawings display a clarity
and understanding of human anatomy very
different from the draftsmanship seen here.
The energetic pen work and swirling lines
of the McCrindle drawing bear a somewhat
closer resemblance to the work of Felice
Giani (1758–1823), an astonishingly prolific
artist of a slightly earlier generation. Giani
made hundreds of drawings of this type,
often depicting themes from classical litera-
ture or mythology. In its heavy contours,
lavish use of wash, and bravura technique,
Aeneas in the Underworld resembles Giani's
drawings, but the figural types are different
and the drawing lacks the calligraphic fluency
of Giani's draftsmanship.[1]

Giani ran an active workshop and
supervised the army of assistants necessary
to complete the many decorative cycles he
produced over the course of his career, and
this drawing may be the product of an artist
within his extensive circle.[2] Intriguingly,
among his many other activities, Giani ran
several private evening "academies," beginning
with the Accademia dei Pensieri (Academy
of ideas) in Rome.[3] Participants drew their
own interpretations of an assigned subject,
and the resulting sketches were displayed and
discussed by the entire company. One artist
who attended the sessions noted that it was
both "utile e bello" (useful and beautiful) to
see so many interpretations of a given subject
in one place.[4] Working from the imagination
was an important step in learning to draw;
the emphasis placed on the exercise of the
imagination is reflected in the name of the
academy. "Pensieri," the same participant
noted, refers to the first ideas roughed out
on paper by the artist.[5] While it is tempting
to imagine that this *Aeneas in the Underworld*
emerged from one of these sessions, or that
the artist was someone in the immediate
circle of Giani, the similarities to Giani's
work are too general to permit a specific
attribution at this time. — SS

1 I thank Roberta Olson at the New-York Historical
 Society for her generous help with this and other drawings
 related to Bartolomeo Pinelli in the McCrindle gift.
 On Pinelli's drawings, see Olson 2001a and Fagiolo and
 Marini 1983.

2 These artists have only occasionally been studied as
 individuals. See Olson 2001b, 427.

3 Ottani Cavina 1999, 1: 34–41.

4 Ottani Cavina 1999, 1: 35.

5 Ottani Cavina 1999, 1: 35.

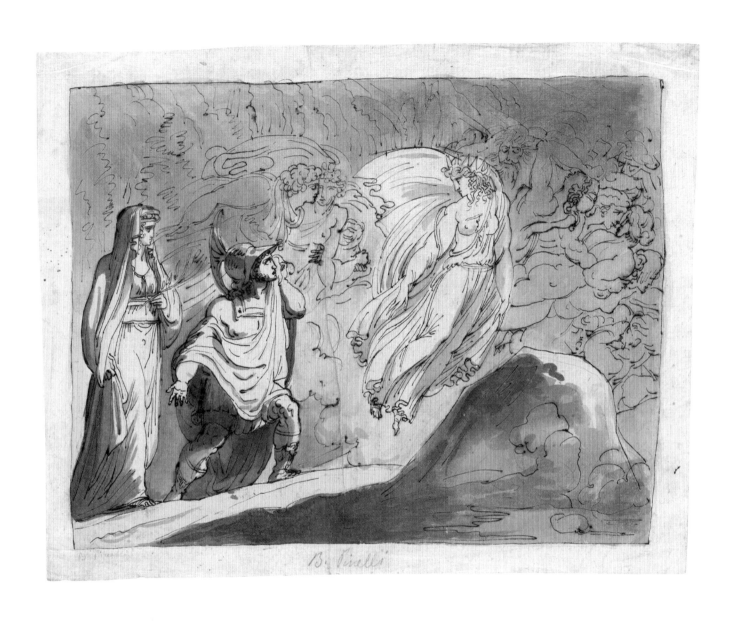

Felice Albites

ROME (?) C. 1778 – 1811 FLORENCE

40

*Saint John the Baptist
in the Wilderness,*
c. 1800

pen and brown ink over
traces of graphite on wove
paper, mounted on an old
album page; watermark:
animal head; 347 × 262

Joseph F. McCrindle
Collection 2009.70.9

INSCRIPTIONS lower
center, on a rock beside the
saint, in pen and brown ink,
the artist's monogram, *FA*;
lower left, in pen and dark
brown ink, *A del Magno*; on
album page, upper right,
in pen and red ink, *141*; on
the mount, lower left, in
pen and brown ink, *Felice
Albides Spagnolo fece.*; lower
right, *Acquisitato dal Sig.r
Gaetano Botticelli Pittore.*;
lower center, *S. Giovanni
Battista nel deserto.*; lower
right, in graphite, *Del Magno
Collection*; affixed at lower
left, a piece of red dymo
tape embossed *F16*

PROVENANCE Gaetano
Botticelli (according to
inscription on mount);
A. del Magno (according
to inscriptions on drawing
and mount); Joseph F.
McCrindle, New York;
Joseph F. McCrindle
Foundation, 2008;
gift to NGA in 2009.

DISPLAYING AN ENORMOUS DEGREE OF
graphic intensity, this striking drawing
depicts Saint John the Baptist living as an
ascetic in the wilderness. He is shown in
an energetically rendered grove of various
types of trees and vegetation from which a
lion wanders out into the background.
The figure of John the Baptist — dressed
in an animal skin, holding a staff with
a banderole that refers to his prophetic
role, and regarding the viewer with a
piercing gaze — has the classically idealized
appearance of an athletic youth.

The drawing's mount names the artist
but erroneously states his origin as Spanish.
Felice Albites was an architect active in
Rome — in 1795 he submitted designs for
a library for the triennial Concorso
Clementino competition of the Accademia
di San Luca — and in Florence, where he
trained at the Accademia di Belle Arti and
was later named a professor of architecture.[1]
He is also listed as a painter, sculptor, and
poet in the caption of an engraved portrait
by Raimondo Giarré.[2] Two pen-and-ink
drawings at the Uffizi, Florence, indicate
that Albites's figural graphic work reflects
the neoclassical style pervasive in central
Italy during the early nineteenth century.[3]
His figures are classically proportioned and
dispersed evenly throughout a geometrically
defined setting composed of carefully
arranged areas of light and shade. In com-
parison to these examples and the staid,
orderly drawings for his architectural designs,
the present sheet is clearly an exercise in
something entirely different.

In style and subject, this image draws on
both neoclassical and romantic concepts
circulating during the late eighteenth
and early nineteenth centuries. Its dramatic
presentation of a hermitic religious figure
staring intensely at the viewer from within a
vividly rendered landscape shares the stim-
ulating emotional effect found in the works
of such contemporaries as William Blake
(1757 – 1827), Benjamin West (1738 – 1820),
and Henry Fuseli (1741 – 1825). For Albites
the connection to these artists may have
come through his compatriot and fellow
academician Luigi Sabatelli (1772 – 1850),
who was active in Florence from 1795 until
1808 and frequently drew on works of
literature, philosophy, and art that empha-
sized representation of the "terrible" and
the "sublime" for his engravings.[4] The
Baptist's rigid features and blocky torso
have much in common with Sabatelli's
figural types, but the profusion of thickly
drawn lines on this sheet and the prominent
intertwined monogram — in the manner
of Albrecht Dürer or Albrecht Altdorfer —
suggest Albites also may have had an interest
in emulating German Renaissance woodcut
prints. — ABB

1 *Allgemeines Künstlerlexikon* 2005, 1: 135; Marconi et al. 1974, 1:
 nos. 933 – 937.

2 Duplessis et al. 1896 – 1911, 1: 38, no. 507.

3 *Episode from Ancient Roman History: The Return of Collatino to
 His Family*, inv. 12276 S; *Scene from the New Testament: Christ
 Resuscitating a Young Girl*, inv. 12277 S. Many thanks to Giorgio
 Marini for providing the author with illustrations of these
 unpublished drawings.

4 Spalletti 1991, 1: 292. For the artistic atmosphere of Italy
 during this period, see Roberta Olson in Washington 1980,
 11 – 14.

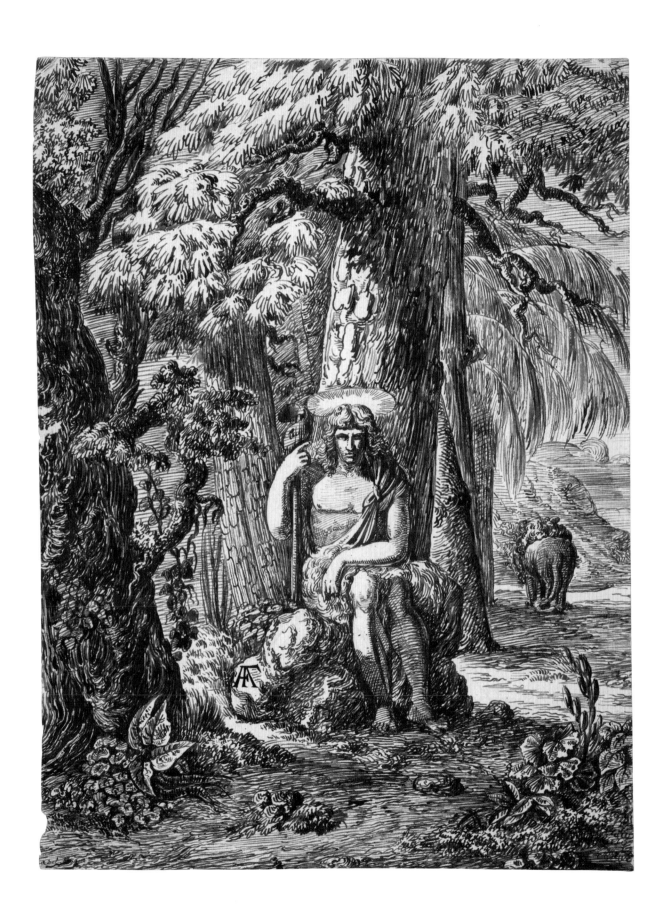

Pietro Gonzaga

LONGARONE, NEAR VENICE 1751—1831 ST. PETERSBURG

41

Egyptian Stage Design,
1800/1810

pen and brown ink with
brown wash over graphite,
197 × 238

Joseph F. McCrindle
Collection 2009.70.124

INSCRIPTIONS l114 on the
mount, lower right, in pen
and brown ink

PROVENANCE Joseph
F. McCrindle, New York;
Joseph F. McCrindle
Foundation, 2008; gift to
NGA in 2009

FIG. 1
Pietro Gonzaga, *Egyptian Stage
Design,* c. 1815, pen and brown
ink with gray and brown wash,
National Gallery of Art,
Gift of Frederick G. Schab,
in Honor of the Fiftieth
Anniversary of the National
Gallery of Art, 1991

THIS DRAWING ENTERED THE MCCRINDLE
collection as the work of Giovanni Galliari
(1746–1818), a member of the Milanese
family of stage designers, but the style
is more consistent with the art of his
contemporary, Pietro Gonzaga. The son of
a modest painter, Pietro moved to Treviso in
1767 to study with the Bibiena family, also
renowned for their scenography, and then
to Venice in 1769 to train with Giuseppe
Moretti (dates unknown) and Antonio
Visentini (1688–1782).[1] From 1772 to 1778,
Gonzaga worked with the Galliari, thus
explaining the similarities between his work
and that of Giovanni and other family
members. Thereafter, Gonzaga became an
independent artist and produced over sixty
set designs for various theaters in Italy. In
1792 he moved to Russia, having accepted
the invitation of Nikolai Yusupov, director
of pageantry for Catherine II, to work at the
court in Saint Petersburg.[2]

There Gonzaga published two treatises:
La musique des yeux et l'optique théâtrale (Music
for the eyes and theatrical optics) in 1800 and
*Information à mon chef ou éclaircissement convenable
du décorateur théâtral* (Information for my chief
or suitable explanation from the theatrical
decorator) in 1807.[3] In the autobiographical
Information à mon chef, Gonzaga stated that
the art of scenography had its own scale of
rhythms and chords, composed of colors and
lines that flowed together in harmony.[4] At
the same time, he believed, the scenery must
complement the stage action and produce a
unified visual experience for the viewer.

Gonzaga's scenes often featured complex
perspectival views and optical illusions to
create dramatic fantasy worlds that would
gain the instant attention of the audience.
Here he combined Egyptian motifs of a
pyramid and sculpted sphinxes with a
Venetian palace, several grand staircases, and
massive columns. The pictorial space, in which
buildings overlap and stairs lead nowhere, is
strongly structured yet starkly compressed. So
dominant are the architectural forms that one
hardly notices in the foreground the pool or
river that gently laps the bottom of the steps
and reflects the plinths supporting three
sphinxes. Typical of Gonzaga's work is the
bold combination of pen and ink with wash
that allows him to create an effect of bright
sunlight bathing the set.

The McCrindle drawing likely dates
to Gonzaga's Russian period, as comparisons
with several examples at the Hermitage
and the Museo Teatrale alla Scala in Milan
suggest.[5] Egyptian themes were very popular
at the turn of the nineteenth century,
particularly after the Napoleonic invasion of
Egypt in 1798. The Bibiena and the Galliari,
however, also incorporated ancient cities and
exotic places into their set designs before
that time and may have inspired Gonzaga
to include these elements in his scenes.
Ultimately, he developed several variations
of Egyptian themes in the early nineteenth
century, including another example in the
National Gallery's collection dating from
about 1815 (fig. 1).[6] — *LL*

1 Muraro 1967, 18.

2 For biographical details on Gonzaga, see Flora Jakovlevna
 Syrkina's entry in Grove 1996, 12: 914–915.

3 Muraro 1967, 15.

4 See Longarone 1986, 113–114.

5 Muraro 1967, nos. 54, 75, 76, and 86.

6 Inv. 1991.153.1. For other works by Gonzaga on Egyptian
 themes, see Longarone 1986, 62–63.

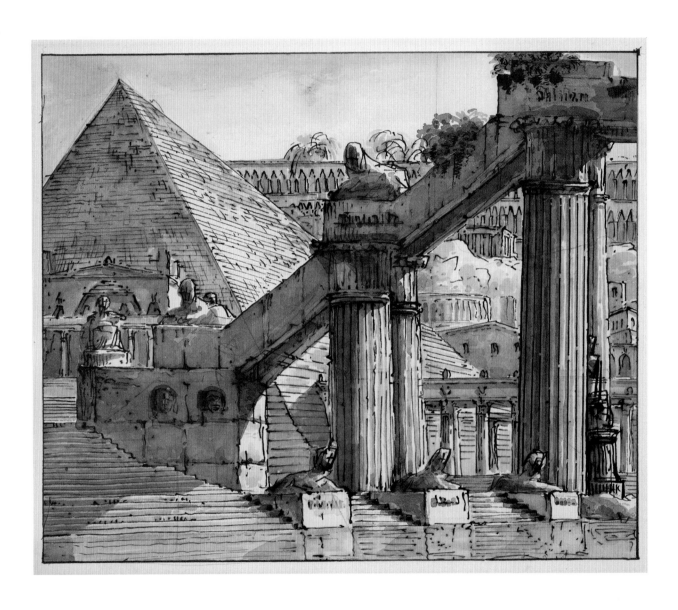

William Alexander

MAIDSTONE, KENT 1767–1816 MAIDSTONE

42

*A Chinese Peasant
Selling Betel,*
1793/1794

watercolor with pen and
black ink over graphite on
wove paper, 140 × 204

Joseph F. McCrindle
Collection 2009.70.10

INSCRIPTIONS by the
artist, upper right, in
graphite, *This Box filled with
a powdered lime to be / also
on the Table* [with a graphite
sketch of a box]; verso: by
the artist, at top, in graphite,
*Leaves of the Betel, resembling
the laurel leaf. / The Areka
Nuts are also on the Table
or Desk & look / White they
are something like a nutmeg
but have this / shape* [small
gumdroplike sketch] *— when
eaten these are wrapped / in
the betel leaf some of which so
wrapped are / also on the table*
[small sketch of an areca nut
partly enveloped in a leaf]

PROVENANCE P. & D.
Colnaghi & Co. Ltd.,
London; Joseph F.
McCrindle, New York;
Joseph F. McCrindle
Foundation, 2008; gift to
NGA in 2009

LITERATURE Storrs 1974,
no 16; Legouix 1980, 46

WILLIAM ALEXANDER'S QUIET CHILD-
hood in Maidstone gave little indication that
he would build a career on his depictions of
exotic subjects like the betel vendor shown
here. At the age of fifteen, he traveled to
London to begin his years as an apprentice.
Between 1782 and 1784, he worked for the
watercolorist Julius Caesar Ibbetson (1759–
1818).[1] Although Alexander moved on to
study at the Royal Academy, the connection
with Ibbetson proved crucial when the older
artist recommended his former apprentice
to serve as official draftsman to the British
embassy to China in 1792. Intended to
establish relations with the imperial court in
Beijing, this expedition was the first British
foray into mainland China. Alexander made
hundreds of studies of people and landscapes
during his two years with the embassy. He
later referred to them in the creation of
elaborate finished watercolors for exhibition
and for illustrations in several books about
China.

A Chinese Peasant Selling Betel appeared as
an aquatint illustration in *Picturesque
Representations of the Dress and Manners of the
Chinese,* published in 1814. According to the
official published account of the expedition,
betel leaf was wrapped around a paste of
powdered lime and areca nut, both shown
here, to create "a masticatory of a very
pungent taste, and in general use."[2] The
shallow box of lime, sketched separately in
the upper right of this drawing, appears
on the vendor's table in the finished aquatint;
a faint chalk outline is included in the
drawing to indicate the position of the box.
Alexander made multiple versions of many of
his drawings, and many of the more finished
studies like this one were made after his
return to England, based on rougher sketches
made on the voyage.[3] However, the notes on
both recto and verso of this sheet indicate
that in this case the artist was sketching from
life, jotting down reminders for later use.

Alexander ended his career as the first
Keeper of Prints and Drawings at the British
Museum. Selected for the post not for his
skills as a connoisseur but for his talent as a
draftsman, Alexander was expected to spend
only one day per week supervising the Print
Room, but four days drawing antiquities in
the collection in preparation for an ambitious
multivolume publication. He contributed
to a number of other books on a variety of
subjects, but he remains best known for the
work based on his time in China. — SS

1 For the most complete biographies of William Alexander,
 see Brighton 1981 and Legouix 1980.

2 Staunton 1797, 1: 295.

3 See, for example, Legouix 1980, nos. 2 and 3.

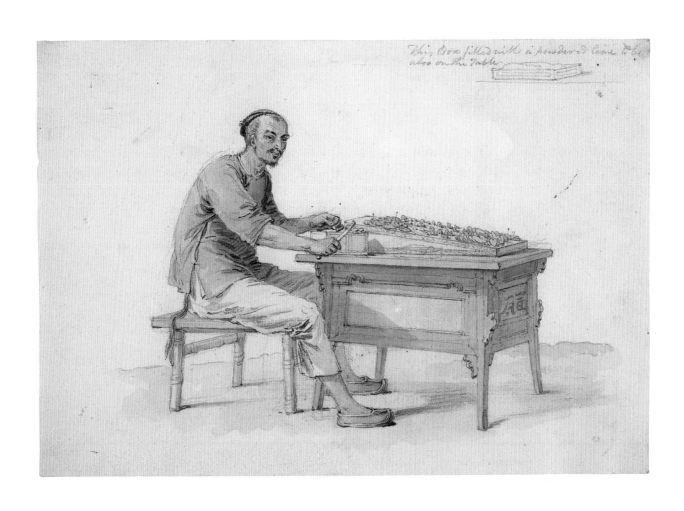

This Box filled with a powdered lime &c
also on the Table

Thomas Rowlandson

LONDON 1756–1827 LONDON

43

A Soldier's Widow,
possibly 1815/1820

watercolor with pen and
brown and gray ink and
sanguine wash over graphite
on wove paper, sheet 237 ×
193, image 165 × 133

Joseph F. McCrindle
Collection, 2009.70.206

INSCRIPTION across
bottom, in graphite (erased
but still legible), *A Soldier's
Widow*

PROVENANCE Joseph
F. McCrindle, New York;
Joseph F. McCrindle
Foundation, 2008; gift to
NGA in 2009

FIG. 1
Maria Gisborne, *The Soldier's
Widow* (after Samuel Wood-
forde), 1801, mezzotint, British
Museum, London

AN EXTREMELY PROLIFIC DRAFTSMAN,
Thomas Rowlandson produced an estimated
ten thousand drawings in a career spanning
nearly five decades. Trained in figure drawing
at the Royal Academy Schools and in Paris
in the 1770s, he worked for a time in London
as a portraitist, but turned to caricature as a
livelihood from the early 1780s. His humor-
ous drawings lampooning the life and people
around him were, as Robert Wark has put
it, "articles of commerce"[1] for Rowlandson,
bringing him quick money to finance his
penchant for high living and gambling.
According to his obituary in the *Gentleman's
Magazine*, Rowlandson had "been known, after
having lost all he possessed, to return home
to his professional studies, sit down cooly
[*sic*] to fabricate a series of new designs, and
to exclaim, with stoical philosophy, 'I have
played the fool; but,' holding up his pencils,
'here is my resource.'"[2]

Although caricature dominated
Rowlandson's commercial output from the
1780s, he continued to produce the occasional
portrait. As Vic Gatrell has observed, even
though it should be considered a portrait
rather than a caricature, the McCrindle
drawing reflects Rowlandson's "mounting
interest in the grotesque in the 1800s and
1810s,"[3] as well as his awareness of the then-
fashionable pseudoscience of physiognomy
and especially the writings of the Swiss
theologian Johann Caspar Lavater, whose
Physiognomische Fragmente (1775–1778; translated
into English as *Essays on Physiognomy,*
1789–1793) argued that character could be
read from facial features. With her coarse,
masculine face and off-putting stare,
Rowlandson's old widow seems to be almost
a different species—and certainly at a
different stage of widowhood—from the
attractive young woman depicted in Maria
Gisborne's mezzotint (fig. 1) after Samuel
Woodforde's untraced painting *The Soldier's
Widow*. While the latter's youth, beauty, and
vulnerability are meant to stir feelings of

sympathy in the beholder for her recent
loss, Rowlandson's burly old widow stares
challengingly out at the viewer and her
gnarled visage repels rather than invites
imaginative identification with her.

Seemingly uninfluenced by the innova-
tions of younger watercolorists, Rowlandson
worked within the eighteenth-century
tradition of the tinted drawing, in which
a sketch is drawn in graphite, outlined in
pen and ink, and then colored with flat and
transparent washes. In this case Rowlandson
appears at some point to have extended the
drawing by several centimeters in all directions
on the same sheet in order to add even more
bulk to the widow's already large frame.

A Soldier's Widow possibly dates from
around the same time as Rowlandson's
drawing of *A Sporting Cove* (c. 1815/1820;
Yale Center for British Art), which is similar
in style.[4] That Rowlandson was thinking of
the plight of soldiers' widows around this
time can be seen from his print *Land Stores*
(1812; Lewis Walpole Library), in which a
notice posted on a wall in the background
announces a "Voluntary subscription for a
Soldier's Widow—The smallest donation
will be greatfully [*sic*] received." There is also
a closely related (but unfortunately undated)
drawing by Rowlandson of *An Old Soldier's
Widow* in the collection of the Fine Arts
Museums of San Francisco.[5] — LK

1 Wark 1975, 25.

2 *Gentleman's Magazine* 97 (June 1827), 564.

3 Email of June 17, 2011, to the author (in the National
 Gallery of Art curatorial file).

4 Inv. B1977.14.368; image available at *http://britishart.yale.edu/
 collections/search.*

5 Possibly the same drawing identified by Joseph Grego
 as in the possession of A. H. Bates, Esq., Edgbaston,
 Birmingham, in Grego 1880, 2: 428.

Giuseppe Bernardino Bison

PALMANOVA 1762–1844 MILAN

44

Salome with the Head of Saint John the Baptist, 1825 / 1835

pen and brown ink with watercolor and brown-gray wash over black chalk, with touches of red chalk in Salome's lips and by her mouth; partial watermark: crescent moon; 287 × 240

Joseph F. McCrindle Collection, 2010.93.22

INSCRIPTIONS attached at lower right, small label with typescript, *by Bison*; verso: lower left, in graphite, 3/3/-

PROVENANCE Helene C. Seiferheld, New York; Joseph F. McCrindle, New York; gift to NGA in 2010

LITERATURE Washington 1980, no. 13; Princeton 1991, no. 70; Harris 1994, 68

GIUSEPPE BERNARDINO BISON ARRIVED IN Venice in 1777 and became a student of Anton Maria Zanetti (1706–1778) and of Costantino Cedini (1741–1811). There he was directly influenced by the aging rococo artists still living in the city, such as Pietro Longhi (c. 1701–1785) and Francesco Guardi (1712–1793), but he was perhaps more attracted to the graphic oeuvre of Giovanni Domenico Tiepolo (1727–1804). Bison's numerous imitations of Domenico's Punchinello series and his episodes from everyday life attest to the younger Tiepolo's influence on him.[1] In about 1800 Bison moved to Trieste and gained popularity during thirty years as a decorative painter there. In 1831 he relocated permanently to Milan, providing stage designs for several of north Italy's opera houses, especially the Teatro alla Scala.[2]

Although Bison's later paintings took on an increasingly romantic style, his graphic work retained an eighteenth-century Venetian interest in quick, delicate pen strokes enhanced with wash — and occasionally color — to emphasize the play of light. Here the neoclassically dressed figures are treated with a certain reserve in the handling of the lines, but the washes retain a tonality and luminosity that are strongly Tiepolesque in their visual effect. Roberta Olson has dated this drawing to Bison's Milanese period, citing the monumentality of the figures and similarities between the handling of the face of the young woman here and the treatment of another in a portrait study in the Brera, Milan.[3] Salome's face, however, also recalls a series of female studies Bison made when he was in Trieste.[4]

The subject presented here is Salome with the head of Saint John the Baptist on a silver charger. According to the New Testament Gospel of Mark (6:21–29), after Salome completed her famous dance on Herod's birthday and was granted any request, "she went forth, and said unto her mother, What shall I ask? And she said, The Head of John

the Baptist." The atrocity of the scene is only subtly indicated in the red-brown wash beneath the Baptist's disembodied head and through the penetrating expression of the bearded male figure behind Salome who may represent Herod or, more likely, the guard who carried out the beheading.[5] His expression and actions are ambiguous and so blended into the monochrome background that the viewer's eyes are quickly diverted back to the literal color in Salome's cheeks.

Bison's use of pure watercolor here is uncommon in his graphic work, but he employs it to great effect to enhance the femininity of the face and upper torso of Salome and to set her apart from the rest of the composition. She looks directly at the viewer with a demure expression, in unsettling contrast to the brutally severed head she bears. She does not look back at the head with either affection or remorse; she simply carries it as she would carry a centerpiece to a banquet.

In the later nineteenth and twentieth centuries, Salome's name came to connote the seductive femme fatale — in marked contrast to the seemingly innocent, almost chaste versions depicted by such earlier masters as Titian and Caravaggio and this Madonna-like incarnation imagined by Bison. — GCH

1 See Pignatti 1963, 56. For examples of Pulcinellata, see Rizzi 1976, nos. 19–20.

2 For biographical information about Bison, see Rizzi 1976.

3 See Washington 1980, 60. For the drawing at the Brera, see Beltrame-Quattrocchi 1969, fig. 7.

4 See Rizzi 1976, nos. 124, 130–131, for similar female studies from the Trieste period.

5 Roberta Olson identifies this figure as Herod (Washington 1980, 60). Domenico Tiepolo depicted both *The Banquet of Herod* and *The Head of John Presented to Salome* in his *New Testament* series (reproduced in Gealt and Knox 2006, nos. 100, 101). In Tiepolo's drawings, Herod's garb and that of his orientalized guards resemble the costume worn by Bison's male figure, but Herod is bearded and his soldiers are not.

by Bisson.

Gerhard Wilhelm von Reutern

GUT RÖSTHOF (NOW RESTU), NEAR WALK 1794–1865 FRANKFURT-AM-MAIN

45

Bernhard's Whooping Cough Face, probably mid- to late 1820s

pen and gray ink on wove paper, 161 × 90

Joseph F. McCrindle Collection 2009.70.196

INSCRIPTIONS upper right, in gray ink, *der 19*te *N.U.M./ u 22-*; lower right, *Bernhards Keuchhustens Gesicht*; verso: upper left, in graphite, *4*; lower center, *82*

PROVENANCE Joseph F. McCrindle, New York; Joseph F. McCrindle Foundation, 2008; gift to NGA in 2009

GERHARD WILHELM VON REUTERN TOOK up drawing with his left hand after losing his right arm as a young soldier in the Russian army, in the great battle against Napoleon's forces at Leipzig in 1813. Born and raised in the Baltic region of Livonia (then a Russian province, today encompassing parts of Estonia and Latvia), Reutern was the son of aristocratic parents of German origin. He had previously studied both the art of war and the art of drawing at the University of Dorpat (Tartu), where he matriculated at age fifteen in 1810. Destined for the army, he had dutifully signed up for a military science curriculum. However, to fulfill his own interests he also took lessons with the etcher and painter Karl August Senff (1770–1838), who had him copy John Flaxman's outline illustrations of Homer.[1] Reutern's decision to devote himself to art after being decommissioned was encouraged by Johann Wolfgang von Goethe, whom the injured soldier had first met while recuperating in Weimar. At a later meeting, Goethe praised Reutern's drawings for having a clear view of, and true feeling for, nature. He would find success, Goethe assured the artist, as long as he "continued to look at nature"—in other words, to draw directly from the world.[2] Reutern did in fact attain professional success, culminating with an appointment as court painter to Russian Emperor Nicholas I in 1837.

This intimate portrait was probably created in the mid- to late 1820s, around the time the artist was living with his in-laws in the small Hessian town of Willingshausen.[3] Like other pen-and-ink portraits of his from that period, it offers parallels to the work of Ludwig Emil Grimm (1790–1863), whom Reutern had enlisted in Willingshausen as a drawing tutor. The younger sibling of the literary brothers Jacob and Wilhelm, Grimm excelled at this type of tightly drawn portrait, which emphasizes the face and captures the sitter in a mood of sober realism

that eschews any hint of idealism. Here the primacy of line—every strand of hair recorded and parallel hatching used to model the face and clothing—creates an effect of precision reminiscent of the graphic work of Albrecht Dürer (1471–1528), whose drawings and etchings were venerated by many artists in Reutern's circle, especially Grimm.[4]

From the artist's inscription, it appears that the youth, identified only as Bernhard, is suffering from whooping cough, or pertussis. Throughout the nineteenth century, pertussis was among the major health threats to babies and small children; epidemics broke out annually all over Europe, killing thousands. For older children and adults the threat was less grave—as might be suggested by the sitter's attire, a caped overcoat that indicates he was out and about rather than convalescing at home. But even without the specter of death, the duration of pertussis, which can last for months, the severity of its character-istic paroxysmal cough, and the complications and other illnesses that often accompanied it made the disease one of the most dreaded in the era before a vaccine was available. — MD

1 See "Reutern" 1894, 295–296.

2 Reutern reported Goethe's inspiring words to his wife after visiting the writer in 1827. Although Goethe's primary interest lay in graphic art, the poet also urged the artist to paint. See "Reutern" 1894, 338.

3 London 1978, 12.

4 See Grimm's drawing showing Reutern and himself gathered with other artists around the tomb of Dürer on April 18, 1828, in commemoration of the three hundredth anniversary of the master's death (Germanisches Nationalmuseum, Nuremberg), reproduced in Koszinowski and Leuschner 1990, 1: 242, H 71.

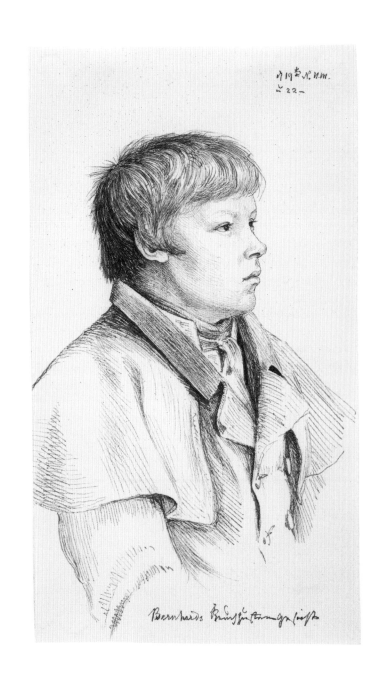

Jean Léonard Lugardon

GENEVA 1801 – 1884 GENEVA

46

A Young Benedictine
Monk Kneeling
(recto and verso),
after 1824

black chalk with stumping,
heightened with white
chalk on blue wove paper;
watermark: shell and initials
PM; 430 × 400

Joseph F. McCrindle
Collection 2009.70.13.a/b

PROVENANCE the artist's
studio (stamp J.L.L. in a
horizontal oval, lower right);
Joseph F. McCrindle,
New York; Joseph F.
McCrindle Foundation,
2008; gift to NGA in 2009

PREVIOUSLY UNATTRIBUTED, THIS drawing actually bears the tiny studio stamp of the Swiss artist Jean Léonard Lugardon and can now be returned to his oeuvre. Born in Geneva to French parents, Lugardon moved to Paris in 1820 and shortly thereafter entered the studio of Baron Antoine-Jean Gros (1771–1835).[1] Then, during a sojourn in Italy from 1823 to 1826, he met Jean-Auguste-Dominique Ingres (1780–1867), who counted Lugardon among his many students.

Upon his return to Geneva, Lugardon enjoyed considerable professional success. He profited especially from a new national desire for the creation and veneration of a lineage — artistic as well as historic — that was uniquely Swiss, a result of the reestablishment of Swiss independence with the Congress of Vienna of 1815. Many of Lugardon's canvases seek through their subject matter to connect with and cultivate this life-after-French-domination Swiss identity.[2] The artist remained in Geneva for the rest of his life, fulfilling important commissions and nurturing the establishment of a Swiss pictorial tradition focused on the portrayal of his nation's history.

Lugardon's interest in drawing was likely a result of his training. The schools of both Gros and Ingres stressed the importance of drawing, and Ingres encouraged his students to execute precise and numerous preparatory studies in advance of work on any canvas, a practice that was adopted by Lugardon. Indeed, the majority of his surviving works are drawings, with only a few paintings by him known.[3]

This large, handsome double-sided drawing was surely made in preparation for a painting, very likely celebrating an episode from Swiss history. Neither the painting nor the subject has yet been identified, however. The two large studies of the monk, shown with his head uncovered on the recto and hooded on the verso, are drawn with great simplicity and refinement, with fine strokes of black chalk setting the contours, delicately stumped shadows giving shape to the robes, and fresh touches of white chalk adding both color and light to the surfaces. Working out the dynamics of light and shadow falling over the form was of considerable interest to the artist, but the pose of the figure was also a concern — he varied the angles of the monk's arms and the tilt of his head not only in the two large-scale studies but also in a third study, on the recto, executed with multiple, overlaid contours showing variant poses. This drawing shows Lugardon to have been a sensitive and gifted draftsman, whose style and working practice were richly informed by the tradition of drawing he had inherited from his teachers. — DB

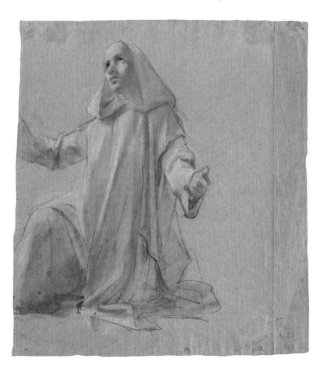

1 The most complete information available can be found in Buyssens 1991 and Montauban 1999.

2 Montauban 1999, 140.

3 See Montauban 1999 for several paintings; Buyssens 1991 reproduces a number of his drawings.

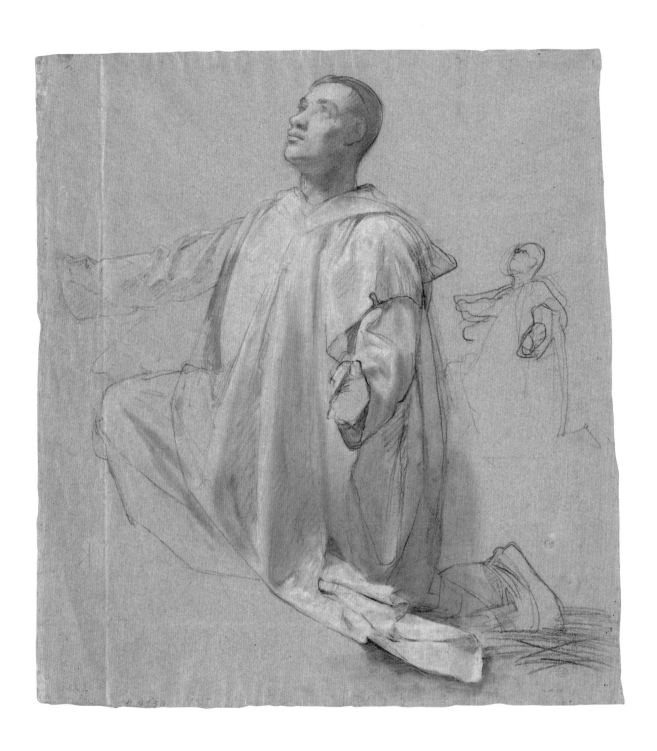

Ippolito Caffi

BELLUNO 1809 – 1866 LISSA

47

Interior of the Colosseum, c. 1843

watercolor over graphite on wove paper, 213 × 316

Joseph F. McCrindle Collection 2009.70.66

INSCRIPTIONS on mount at upper right, in pen and black ink, 5; verso of mount (now removed): in graphite, *Interno Colosseo*

PROVENANCE Joseph F. McCrindle, New York; Joseph F. McCrindle Foundation, 2008; gift to NGA in 2009

TRAINED LARGELY IN VENICE, IPPOLITO Caffi was steeped in that city's tradition of painting *vedute*, city views that featured well-known piazzas, monuments, buildings, attractions, and ruins. However, with his novel perspectives, interest in atmospheric effects, taste for capturing the varied qualities of natural and artificial light, and chronicling of extraordinary phenomena, he reshaped and modernized the *veduta* genre that had been defined by Canaletto (1697–1768) and other famed Venetian view painters of the previous century. Caffi's cityscapes reflect his frequent travels throughout Italy and Europe as well as his one-time tour of Greece, Turkey, Asia Minor, Palestine, Sudan, and Egypt. His Roman scenes, however, far surpass those of any other location.

This view of the Colosseum was painted during one of Caffi's numerous Roman residences.[1] Spotlighted by the late afternoon sun, the inner east wall of the ancient ruin is a craggy surface of shifting terra-cotta hues interspersed with green overgrowth. Deep shadow envelops the rest of the structure, casting into blue-brown darkness a portion of the earthen floor. Caffi's use of watercolor, which he deftly manipulates to create both translucent areas of illumination and more opaque areas of shadow, further heightens the tenebrous atmosphere. On the floor of the ancient structure stand modern Christian additions: a spare cross at center and fourteen aediculae representing the Stations of the Cross dispersed about the perimeter.[2] Declared a public church in 1749, the Colosseum is here peopled with pilgrims, tourists, and shade-seekers alike. As with many of his more popular subjects, Caffi executed numerous versions of the Colosseum's interior, typically altering the figures, changing the time of day and, with it, the type and quality of illumination. An oil painting in the Ca' Pesaro collection, Venice, signed by the artist and dated 1843, represents a nocturnal view of the

Colosseum from the same vantage point as the McCrindle watercolor, thus offering a possible date for the latter.[3]

The popularity of ruins as a subject of Caffi's scenes is attested by a second Caffi watercolor in the McCrindle collection, a bird's-eye view of the Roman Forum from atop the Colosseum (Other Drawings, page 179).[4] Probably painted during his last extended stay in Rome (1855–1857), when Caffi also executed numerous panoramas seen from the amphitheater's highest elevations,[5] this image has the clarity of a photograph — an emerging medium rivaling the market for painted *vedute*.[6] Yet the placid scene, like the rest of his watercolors, is more a plein-air impression than an archaeological document. — CM

1 Caffi was in Rome in 1832–1839, 1843, 1844–1845, 1855–1857.

2 On the eighteenth-century Christian additions to the Colosseum under Benedict XIV, see Corbo 1972.

3 Reproduced in Pittaluga 1971, no. 92, fig. 17.

4 The sky in this drawing was unfortunately completed by another, less adept artist whose handling of the sky in thick gouache has somewhat compromised Caffi's original image.

5 Examples are reproduced in Genoa 2006, 61, 192-193, no. 84; Belluno 2005, 169, no. 74; Venice 1979, figs. 21, 26.

6 On Caffi's friendship and rivalry with contemporary photographers in mid-nineteenth-century Rome, see the essays by Federica Pirani in Rome 2003b, 42–47; Belluno 2005, 72–85.

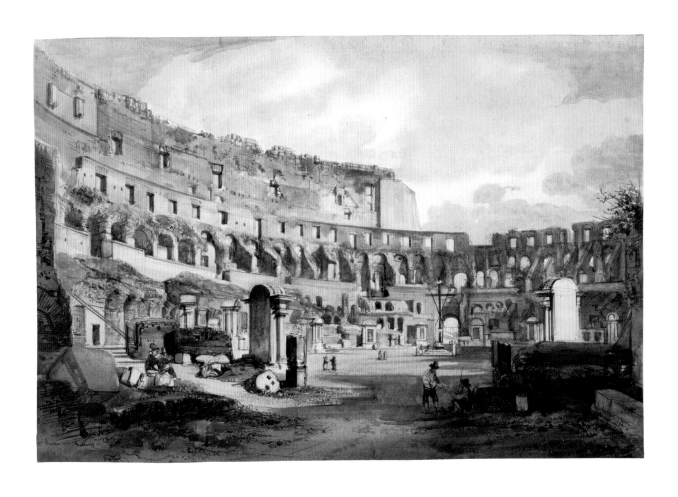

Johann Jakob Frey

BASEL 1813—1865 ROME

48

*Sun Breaking through
Clouds above the
Roman Campagna,*
1844 or after

oil on paper mounted on
a second sheet and then
on canvas, 290 × 440

Joseph F. McCrindle
Collection 2009.70.122

INSCRIPTION on stretcher,
upper right, in pen and black
ink, *13971*

PROVENANCE Joseph
F. McCrindle, New York;
Joseph F. McCrindle
Foundation, 2008; gift to
NGA in 2009

BORN IN BASEL, JOHANN JAKOB FREY
was the son of Samuel Frey (1785—1836), a
landscape painter and lithographer. After
rudimentary training with his father and
further studies with the Swiss historical
painter Hieronymus Hess (1799—1850),
Frey went to Paris and earned money
restoring paintings for local art dealers.
In his free time he honed his skills by
carefully copying seventeenth-century Dutch
landscapes at the Louvre. At the age of
twenty-one he went to Munich and entered
the artistic circle of Basel-born Emilie
Linder, a patron of young artists. In 1838,
with encouragement from Hess and funding
from Linder, Frey moved to Rome to join the
circle of German artists in residence there.[1]

Frey's career began to flourish in Italy,
and in 1842—1843 he was hired as the official
artist of an expedition with Egyptologist
Richard Lepsius (1810—1884). After touring
Egypt and Ethiopia, experiencing numerous
mishaps, and suffering increasingly poor
health, Frey left the expedition and made his
way back to Rome via Athens. Once reestab-
lished in Rome, he met with ongoing success
selling landscape paintings to tourists based
on his travel sketches and local studies. Frey
noted in his meticulous diary that his English
clients preferred his Italian landscapes, while
the Germans tended toward his Greek and
Egyptian views.[2] Unlike many of his compa-
triots who returned north after the revolu-
tions of 1848, Frey remained in Italy, married
a Roman woman, and painted landscapes
until he died of typhoid fever in 1865.

Like many of his contemporaries, Frey
frequently painted oil sketches en plein air.
These he brushed in rapidly on paper that
was later laid down on canvas. Like the
example in the McCrindle collection, most
of his oil sketches are unsigned and undated.[3]
Their subjects range from local attractions
such as the falls at Terni or the Villa Borghese
to remote, unidentifiable views of the Roman
campagna.[4] He took liberties with the details
of monuments and specific scenes, focusing
instead on the quality of light or on a passing
cloud or, in the case of his Egyptian scenes,
on a distant sandstorm. Many of these
sketches Frey executed solely outdoors, while
some he elaborated in the studio, allowing
him to exercise his imagination by combining
well-known natural and manmade elements
in a new way.

The dominant feature of the McCrindle
composition is the dynamic cloud-play that
partially conceals the sun. Frey thinly brushed
in the uncultivated terrain in the foreground,
an atmospheric haze over the middle ground,
and a mass of dark clouds set against a pale
sky. Although he may have begun this sketch
in situ, the layered pigments in the clouds
suggest that he returned to his studio to em-
bellish the details. The location depicted here
is not firmly established, but the sketch may
be loosely based on the Roman countryside
near Tivoli. The columned building set on the
cliff's edge at the left evokes Tivoli's circular
Temple of Vesta with its adjacent Temple of
the Sybil,[5] and the structures rising from the
valley mist below are reminiscent of the
Roman ruins along the Via Appia. The artist's
focus here, however, is less on archaeological
detail than on the serenity of the valley and
the promise of the southern sun. — GCH

1 For biographical information about Frey, see Virgilio 1980,
 16—17 and London 1974, 1—5.

2 For bibliographic information and commentary on Frey's
 sales and diary, see New York 1985, foreword, and London
 1974, 3.

3 See New York 1985 for a diverse sampling of Frey's oil
 sketches.

4 See New York 1985, nos. 16 and 17 for site-specific views,
 and nos. 12—15 for views of the Roman *campagna*.

5 See, for example, similar views of Tivoli painted by Richard
 Wilson (1714—1782) in the previous century: *Tivoli, Two
 Painters Surprised by a Storm,* 1752, National Gallery of Ireland,
 Dublin (reproduced in Paris 2001, 9); and *Tivoli,
 Temple of the Sibyl and the Campagna,* 1765 / 1770, Tate Britain,
 London (inv. T01706; image available at *http://www.tate.org.
 uk/collection/*).

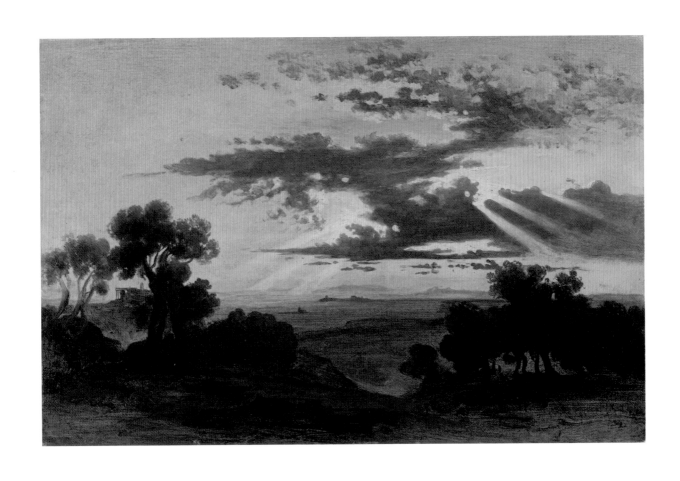

Constant Troyon

SÈVRES 1810 – 1865 PARIS

49

Cows and Sheep under Trees, c. 1850

charcoal and white chalk with touches of red chalk on blue-gray paper, 211 × 317

Joseph F. McCrindle Collection 2009.70.238

INSCRIPTIONS verso: lower center, in graphite, *262*; lower center margin, *Troyon*; lower right, along right margin (vertically), *R.K.*

PROVENANCE artist's atelier (stamped *C. T.* in red ink at lower left); unidentified collector (mark in black ink at lower right, *C.L.*; not in Lugt); Joseph F. McCrindle, New York; Joseph F. McCrindle Foundation, 2008; gift to NGA in 2009

THE SON AND GRANDSON OF PAINTERS of Sèvres porcelain, Constant Troyon first learned to draw at the factory as a child, tutored by a specialist in rendering flowers.[1] He moved from decorating ceramics to painting landscapes, eventually joining the ever-growing number of artists based in the village of Barbizon, who frequented the Forest of Fontainebleau in the 1830s to work in the open air. Troyon's friendship with Barbizon painters such as Théodore Rousseau (1812–1867) and Narcisse Diaz de la Peña (1808–1876) led him to adopt a naturalist approach to depicting the French countryside. In focusing on the simplicity of pastoral nature, Troyon rejected the idealized views of Italianate and classical landscapes that were more highly esteemed in French academic theory.

Although his landscapes earned him distinction and patronage, at the age of forty Troyon headed in a new direction, taking up the subject that would cement his reputation both during his lifetime and afterward: animals. His interest seems to have been piqued during a revelatory trip to the Netherlands, where he admired the work of seventeenth-century Dutch masters, especially Aelbert Cuyp (1620–1691) and Paulus Potter (1625–1654), both of whom specialized in painting livestock and rural life. Hardworking and prolific, Troyon became the foremost French *animalier* of the mid-nineteenth century. With the buying public clamoring for his large, impressive canvases, the artist enjoyed tremendous financial success.

This freely executed sketch of cattle and sheep gathered snugly beneath the protective embrace of trees gives a hint of Troyon's eye for composition, especially his noted ability to place animals comfortably into their bucolic surroundings. Rapidly drawn with charcoal and white chalk and just a few hints of red chalk, the drawing nevertheless conveys the sensation of a wider range of tone through the application of different touches and the use of the blue-gray paper. Troyon gained a reputation as an artist with a true understanding of animal anatomy and behavior and was praised for depicting what seemed to be real, breathing beasts. This ability becomes apparent here in the sheep and cattle that emerge out of a few quick strokes of chalk.

Troyon's experience as a landscape painter marked his depictions of animals and, for some nineteenth-century critics, this is what distinguished him from other specialists in the genre. A sensitivity to atmosphere, acquired during his days with the Barbizon painters, comes across here in the flickering effect of sunshine and shade, with white chalk marks dappled throughout the foliage and grass. The drawing has not been linked to any specific painting, but this type of scene — livestock gathered peacefully in a quiet rural setting with no shepherds or other figures around — is typical of Troyon's work. A very similar composition, albeit with a shepherdess, is found in *La Mare* (The pool) sold by the collector John W. Wilson in 1881.[2] — MD

1 Source material on Troyon is scarce; no monographs have been published since the early twentieth century. For the most detailed biography, see Hustin 1893; for a more recent assessment, see Müllerschön and Maier 2002, 332–340.

2 See illustration by Auguste André Lançon (1836–1887) in Hustin 1893, 75.

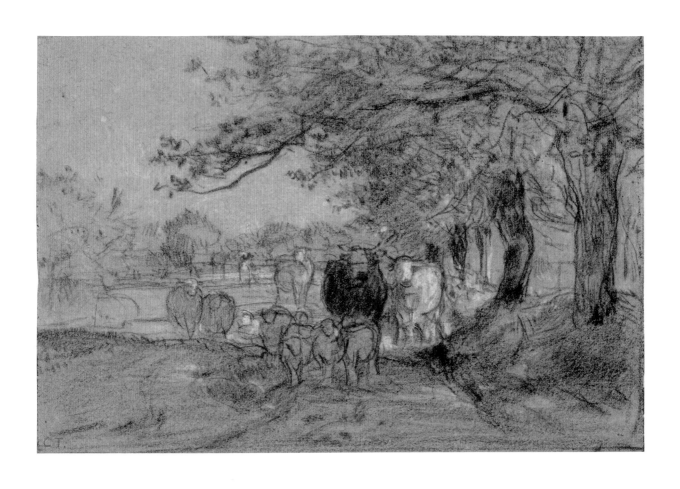

Gustave Doré

STRASBOURG 1832 — 1883 PARIS

50

Dwarf Musicians of Granada, 1861 / 1862

pen and black ink with light brown wash over graphite, 220 × 175

Joseph F. McCrindle Collection 2009.70.107

INSCRIPTIONS signed at lower left, in pen and black ink, *G Doré*; lower center, in graphite, *sous bristol*; on the mount, lower left, in graphite, *Nains musiciens de Grenade*

PROVENANCE Félix Bérthiault, bookseller (stamp on mat); Joseph F. McCrindle, New York; Joseph F. McCrindle Foundation, 2008; gift to NGA in 2009

FIG. 1
Jean François Prosper Delduc, *Ladies of Granada Listening to Itinerant Dwarf Musicians* (after Gustave Doré), 1864, wood engraving

GUSTAVE DORÉ WAS A TREMENDOUSLY prolific illustrator. He published his first lithographic album, *Les travaux d'Hercule*, at the age of fifteen and went on to illustrate some of the major works of western literature, ranging from the Bible and Dante's *Inferno* to *Don Quixote* and Balzac's *Les contes drôlatiques*. He was essentially a self-taught artist with an eccentric temperament who had great ambitions to succeed as a painter. Although he claimed that he made illustrations "just to pay for my paint and brushes . . . ,"[1] his paintings were generally rejected by the Parisian avant-garde and traditionalists alike. Work as an illustrator sustained him, however, and after the spectacular success of his Rabelais illustrations in 1854, he hired over forty wood engravers to make prints after his designs. His studio eventually produced over ten thousand engravings for more than 220 publications.[2]

Like many nineteenth-century Frenchmen, Doré was intrigued by the mystique of Spanish culture. He first visited Spain in 1855 with writers Théophile Gautier and Paul Dalloz. In 1861 – 1862, he returned with his friend, the collector and renowned Hispanist, Baron Jean-Charles Davilliers (1823 – 1883), making sketches as they toured the provinces. Davilliers later arranged for wood engravings after Doré's drawings to be published in the travel magazine *Tour du Monde* (1862 – 1873) and then in a bound compilation, *L'Espagne* (1874), which contained 309 of the 324 Spanish designs by Doré, including the print by Jean François Prosper Delduc (d. 1885) after the McCrindle drawing (fig. 1).[3]

Davilliers and Doré shared a fascination with the Spanish Romany, or Gypsies. Doré's began in his early childhood in Paris, where, after studying gymnastics, he mingled regularly with the street acrobats and participated in their performances.[4] Several prints in *L'Espagne* feature troupes of Gypsy performers, with dwarf musicians often included among them.

This lively little drawing, in a crisp linear style that could be easily translated into engraving, depicts two Gypsy dwarves: one plays a small stringed instrument in the guitar family[5] and the other plays a full-size tambourine, or *pandareta*. The figures are reproduced faithfully in the wood engraving by Delduc, but the print also includes a crowd of onlookers from all classes of Spanish society. The presence of these additional figures in the wood engraving and the fact that the drawing and print are oriented in the same direction suggest that an intermediary drawing was made to transfer the composition to the block. Alternatively, Doré may have drawn a reversed version of the image directly onto the block, something he is known to have done upon occasion.[6]

Doré's Spanish illustrations were criticized for being too detailed, but the exotic appeal of the scenes made them very popular in both France and Victorian England. In the end, they were reproduced in thirty different texts, including those by Émile Bégin, Alexandre Dumas, Théophile Gautier, and Edmondo de Amicis.[7] — GCH

1 See Simon 1989, 53.

2 See William R. Johnston's comments in Baltimore 2005, 212.

3 Fifty-five prints from *L'Espagne* after Doré's designs are reproduced in Forberg and Metken 1975, nos. 949 – 1003.

4 See Roosevelt 1885, 36.

5 The instrument depicted is smaller than a standard guitar and has f-holes in the soundboard instead of a central hole. According to an email (July 5, 2011) from Emma Lucey, this may be a *guitarillo* (a small guitar with four or five strings about the size of the *cavaquinho* or ukulele) or a *vihuela* (smaller than a guitar and an ancestor of the modern guitar). The f-holes, however, suggest a laud or *bandurria*, but the shapes of those instruments are different and do not support either identification. For images of all the instruments mentioned here, see *http://stringedinstrumentdatabase.11omb.com*.

6 See Roosevelt 1885, 238 – 239.

7 See Charnon-Deutsch 2004, 79.

Edward Lear

HOLLOWAY 1812–1888 SAN REMO

51

*Santa Maria della
Salute, Venice, at Sunset,*
1865 or later

watercolor and gouache
with pen and black ink over
graphite on wove paper,
115 × 177

Joseph F. McCrindle
Collection 2009.70.152

INSCRIPTION signed
at lower left, in violet
watercolor, *EL* (intertwined)

PROVENANCE J. S. Maas
& Co. Ltd., London, 1964;
Joseph F. McCrindle, New
York; Joseph F. McCrindle
Foundation, 2008; gift to
NGA in 2009

ALTHOUGH BEST KNOWN AS A WRITER OF
nonsense verse, Edward Lear was by
profession a landscape draftsman and painter.
An inveterate wanderer, he spent much of
his life abroad, traveling around southern
Europe, the Near East, and India, and
residing for long periods in Rome, Corfu,
Cannes, and San Remo. He first visited
Venice in 1857 and then again in November
1865, the second time to make studies for
an oil painting of the city commissioned by
Frances, Countess Waldegrave.[1]

During the second trip to Venice, Lear
made a number of on-the-spot sketches
in graphite depicting the church of Santa
Maria della Salute from different viewpoints.[2]
He annotated these sketches with location,
date, time (either early in the morning or
around sunset), the number of the drawing
in the series, and color notes. Some he later
elaborated in the studio using a procedure
he dubbed "penning out," in which he
applied ink lines and washes of color over
the graphite in a manner that harkened back
to the schematic tinted drawings of Francis
Towne (1739–1816).

In 1865, as he was working on the canvas
for Lady Waldegrave, Lear finished another
Venetian view, *Santa Maria della Salute, Venice, at
Sunset* (location unknown), based on some
of his sketches of the church. That painting
was purchased from the artist by the Brighton
collector Henry Willett in 1873.[3] Both the
McCrindle drawing and another sold at
Christie's in 2007[4] depict a purple-shadowed
(and oddly attenuated) Salute silhouetted
by a fiery sunset seen from roughly the
same position as the Willett picture. How-
ever, these brilliantly colored and highly
finished drawings, which are similar in size
and technique, lack annotations and are
stylistically quite unlike the "penned out"
drawings of the Salute dated November 1865.
Therefore, it seems likely that Lear produced
them both in the studio as finished works to
be sold.

As Briony Llewellyn has observed,
Lear's Venetian cityscapes are unusual in
his oeuvre because he had an "antipathy
towards urban subjects" and "was essentially
a painter of natural rather than man-made
landscape."[5] Lear himself complained in
1866 that "[t]hese Venetian scenes are no
delight to me" because, instead of mountains,
deserts, and forests, they depict "Man-
work—not God work."[6] Yet by bathing the
scene in the last glow of sunset and reducing
human figures to mere glyphs and the Salute
to a silhouette, the McCrindle drawing
demonstrates Lear's ambition to be not
merely a recorder of urban topography, but,
as he described himself, a "Painter of Poetical
Topography."[7] — *LK*

1 *The Grand Canal, Venice,* reproduced in London 1985, no. 59.
 The painting is still in the possession of the countess's
 descendants.

2 One example is reproduced in London 1985, no. 31; another
 was sold at Christie's, London, June 4, 2008, no. 29.

3 See London 1981a, no. 18, reproduced p. 28.

4 See sale cat. Christie's, London, June 5, 2007, no. 132.

5 London 1985, 152, no. 59.

6 Quoted by Briony Llewellyn in London 1985, 152, no. 59.

7 London 1985, 156, no. 63.

William Stanley Haseltine

PHILADELPHIA 1835 – 1900 ROME

52

Santa Maria a Cetrella, Anacapri, c. 1892

watercolor and gouache over graphite, 384 × 563

Joseph F. McCrindle Collection 2009.70.136

INSCRIPTION initialed at lower left, in pen and purple-red wash, *W.S.H.*

PROVENANCE Brian Sewell, London, 1979; purchased by Joseph F. McCrindle in 1979; Joseph F. McCrindle Foundation, 2008; gift to NGA in 2009

LIKE MANY ASPIRING YOUNG AMERICAN artists of his time, William Stanley Haseltine obtained much of his formal training as an artist from the School of Fine Arts in Düsseldorf, Germany. After returning to the United States in the fall of 1858, he enjoyed a successful career in New York, working alongside such important American landscapists as Frederic Edwin Church (1826 – 1900) and Albert Bierstadt (1830 – 1902). He was elected an associate of the National Academy of Design in 1860 and was made a full academician the following year. For the next several years his favored subjects were the rocky coasts of New England.[1]

By 1867, however, Haseltine had moved to Rome and become a part of the lively colony of artists living there. For the next three decades, his studio was an important stop for touring Americans, many of whom took home painted remembrances of their travels. Haseltine first visited the isle of Capri in 1858 and subsequently returned in 1865, 1868, 1870, and 1871. The dramatic location proved so fruitful that he included Caprese subjects in more than twenty-five exhibitions between 1859 and 1896, including those at the National Academy of Design, Pennsylvania Academy of Fine Arts, and the Paris Salon.[2]

At least three times Haseltine depicted the monastery of Santa Maria a Cetrella from approximately the same vantage point as the one seen here.[3] Located in Anacapri, the highest area on the island of Capri, and perched on Monte Solaro, the hermitage offers a panoramic view of much of the island. Its oldest parts date to the fourteenth century; a sacristy was added in the seventeenth century by Franciscan monks. In this view of Santa Maria a Cetrella, the artist uses watercolor in a tightly controlled manner, with the brushwork restrained rather than fluid. The extremely adept rendering of rock formations, a skill for which Haseltine was celebrated, is accomplished here by an intricate cross-hatching of strokes, usually blue-gray over red-brown. The thin, even blue of the sky is exceptionally delicate. To capture the white, sunstruck edges of the monastery's wall, Haseltine employed gouache. His use of that opaque, water-based paint may have been influenced by his knowledge of contemporary Italian watercolors, particularly those of a Naples group who employed tempera in their works. The formation of the Società degli Acquarellisti in Rome in 1875 gave the medium new prominence and perhaps encouraged Haseltine to produce highly finished watercolors such as this meticulous view.[4] — DC

1 Haseltine's *Narragansett Bay*, 1864, oil on canvas, a Rhode Island subject, was acquired by the National Gallery of Art in 2010 (Gift of Alexander M. and Judith W. Laughlin), reproduced at *www.nga.gov*.

2 See the chronology in San Francisco 1992, 159–207. The National Gallery of Art owns two paintings of Capri by Haseltine: *Marina Piccola, Capri* (1953.10.1), c. 1858, oil on paper, mounted on fabric; and *Natural Arch at Capri* (1989.13.1), 1871, oil on canvas. Both are reproduced at *www.nga.gov*.

3 The two others are *Anacapri* (Parrish Art Museum, Southampton, NY, oil on canvas, 1892?) and *Hilltop Monastery* (pencil, watercolor, and gouache on blue paper, formerly at Davis & Langdale, New York, reproduced in New York 1983; also at Hirschl & Adler, New York, in 1992).

4 See Andrea Henderson, "Haseltine in Rome," in San Francisco 1992, 39.

Henri-Joseph Harpignies

VALENCIENNES 1819–1916 SAINT-PRIVÉ

53

*Travelers on a Wooded
Path with a Border of
Whimsical Figures and
Monkeys,* 1895

watercolor and black ink
over black chalk on wove
paper, with gold paper
border and graphite
framing lines, 249 × 342
(inverted fan shape)

Joseph F. McCrindle
Collection 2009.70.135

INSCRIPTION initialed and
dated at lower left, in brush
and black wash, *H.h.95*

PROVENANCE Joseph
F. McCrindle, New York;
Joseph F. McCrindle
Foundation, 2008; gift to
NGA in 2009

OVER THE COURSE OF HIS EXCEPTIONALLY
long career, Henri-Joseph Harpignies
established himself as one of the most
prolific and successful French landscape
watercolorists of his time. Influenced early
on by the naturalism of the Barbizon School
and the classically composed works of Jean-
Baptiste Camille Corot (1796–1875), who
encouraged the younger artist at the
beginning of his career by purchasing some
of his compositions, Harpignies embraced a
neatly representational, tranquil, and generally
pleasing view of the world around him,
which evolved relatively little over the course
of his lifetime. His landscapes earned him
a measure of popularity that never waned and
also won for him several official distinctions,
including the Grande Médaille d'honneur
in 1897, the Grand Prix at the Exposition
Universelle of 1900, and membership in the
Légion d'honneur, culminating in his
appointment to the rank of Grand Officier
in 1911.

Both the overall format and the
composition of this charming watercolor set
it apart from Harpignies's normal landscape
production. Most unusual is its shape,
which has led in the past to its having been
identified as a fragment from a fan design. As
Andrew Robison recently observed, however,
the composition is oriented in the wrong
direction—upside-down—for a fan, and it
was probably made instead as a lampshade,
a type of work that Harpignies is known to
have done upon occasion.[1]

While the central landscape is rendered
in the artist's characteristic style—it is
marked by the poetic use of light, elegantly
sinuous trees, and silvery-green tonalities that
reflect the enduring influence of Corot—the
bright blue borders are drawn with unusual
verve and an unexpectedly quick, broken
touch. Closer examination reveals that most
of the dots and splotches of black ink are
actually amusing ideographs, mostly strolling
figures seen from behind, but one at right

depicts a frolicking, long-tailed monkey.
The border evokes in many ways the work of
the Nabi artists active in Paris in the 1890s,
most notably Pierre Bonnard (1867–1947)
and Édouard Vuillard (1868–1940), whose
paintings and color lithographs from that
period show a similar sense of patterning
and flattened space. It is surprising to see
Harpignies, whose art and style changed so
little over the years, responding so clearly
and immediately to a current trend in
contemporary art, but the juxtaposition of
the traditional landscape with these modern
touches adds unexpected notes of charm
and humor to the scene. — MMG

1 See the biographical note by Harley Preston in Grove 1996,
 14: 190 (also available online to subscribers through Oxford
 Art Online, *http://www.oxfordartonline.com/subscriber/article/
 grove/art/T036730?q=harpignies&article_section=all&search=ar
 ticle&pos=1&_start=1#firsthit*). Robison suggested that the
 drawing was a fragment from a design for a lampshade in
 conversation with the author, May 2010.

Robert Caney

[BIRTHPLACE UNKNOWN] 1847 – 1911 LONDON

54

*Stage Set with a
Statue of Saint
George Slaying the
Dragon*, 1870 / 1890

watercolor and gouache
with pen and black ink over
graphite, heightened with
white gouache on wove
paper, 250 × 345

Joseph F. McCrindle
Collection, 2009.70.81

INSCRIPTION initialed at
lower left, in pen and brown
ink, *RC*

PROVENANCE Joseph
F. McCrindle, New York;
Joseph F. McCrindle
Foundation, 2008; gift to
NGA in 2009

55

*Stage Set Consisting of
Painted Panels, Fabrics,
and Fans*, 1870 / 1890

watercolor and gouache,
graphite, black ink, and
metallic gold paint with
collage of colored velvets
and watercolored paper
cutouts on wove paper,
245 × 146

Joseph F. McCrindle
Collection, 2009.70.74

PROVENANCE Joseph
F. McCrindle, New York;
Joseph F. McCrindle
Foundation, 2008; gift to
NGA in 2009

ROBERT CANEY WAS A SCENIC ARTIST
active in London from the mid-1860s until
1905.[1] One of the principal set designers at
several theaters, including the famed Theatre
Royal, Drury Lane, Caney both designed and
painted scenery, as was customary at the time.
He worked primarily on pantomimes, which
had grown so popular that the Christmas
season entertainments routinely sold out,
and some continued their runs well into the
spring. Playbills prominently listed each scene
and credited the artists; scenery came to
surpass in importance even the actors and the
plot. In fact, the task of authors, known as
"arrangers," was to fit the text to the scenery,
effects, lighting, songs, and so on — not the
other way around.[2] One critic observed in
1882, "As a rule the playgoers of to-day want
to see and not to think."[3]

As the century progressed, pantomime
productions grew increasingly lavish, none
more so than those of Augustus Harris, the
famed manager of Drury Lane in the 1880s
and 1890s. Harris prided himself on pro-
ducing the most visually impressive shows.
His annual Grand Christmas Pantomimes ran
up to six hours, in part because long inter-
missions were required to transform the
elaborate scenes. No expense was spared and
production costs ran as high as £65,000 in
1887 (the equivalent of well over £3.2 million
today). This splendor was not lost on
audiences, who called for the scenic artists
(several were employed on each production)
to emerge after the show and receive their
applause. Contemporary reviews attest that
Caney was honored in this way, and critics
frequently singled him out for praise, com-
mending his "skilful [*sic*] and clever handling"
and declaring his work to be "artistically
designed and executed," "combining breadth
and delicacy," "magnificent," and "a triumph."[4]

The *Stage Set with a Statue of Saint George*,
one of fifteen drawings by Robert Caney
that came to the National Gallery in the

McCrindle gift (see Other Drawings, pages
167-168), is a fine example of the artist's rich
designs. Framed by columns and bright red
curtains, the scene features a grand central
monument topped by a dynamic statue
of Saint George with sword raised, about
to slay the dragon who cowers under the
hooves of the saint's rearing horse. The
scene is otherwise crowded with a jumble of
seemingly incongruous elements — statues
representing comedy and tragedy, a medieval
knight, a hunter, and exotic women holding
parrots; a relief depicting a mythological
chariot race; a brocade fabric or wall painting
featuring, among other things, pink flamingos
and rosy cherubs. The profusion has partly
to do with the emphasis on spectacle, but
may be further explained by the fact that
Victorian pantomimes routinely combined
disparate characters and stories in unexpected
and often bizarre fashion. The titles of such
productions reflect this: a typical example
is *Lady Godiva and Peeping Tom; or, Harlequin,
St. George and the Dragon of India, and the Seven
Champions*, a production Caney worked on
and for which the McCrindle drawing might
have been made.

In his *Stage Set Consisting of Painted Panels,
Fabrics, and Fans* (cat. 55, overleaf), Caney
invented an ornate cabinet inlaid with painted
or fabric panels depicting Japanese motifs and
decorated with geometric designs, collaged
fans, and a blue-and-white vase. The artist
has gone so far as to attach small swatches
of fabric to the drawing to indicate his
choices, a practice more frequently employed
by costumers but not uncommon for a stage
designer. In shape, color, and imagery the
piece clearly bears the influence of *Japonisme*.
Part of the larger aesthetic movement, the
"Cult of Japan" was simultaneously taken
up by painters, architects, and designers
for whom Japan represented a graceful and
harmonious antidote to the perceived ugliness
of an increasingly industrialized nation. In

the 1870s and 1880s *Japonisme* flourished and "Japanese or pseudo-Japanese motifs were applied to everything."[5]

Given the hundreds of actors crowding the stage, the blinding light of thousands of electric lamps, and the spectacular props and special effects that pantomimes featured—train crashes, real horses racing on treadmills, water scenes played out in an eight-thousand-gallon tank—the level of detail found in Caney's designs may seem surprising. Yet Harris described the set designers as "artists of the highest order" who went to great lengths to realize their visions.[6] Though it is not possible to precisely identify the productions for which these two works by Caney were made, they attest to the importance of scenery in nineteenth-century pantomimes and offer us a glimpse of their splendor. — *JBS*

1 I thank Cathy Haill and Heather Romaine for providing information about Robert Caney and graciously answering related queries, and Georgianna Ziegler and the staff of the Folger Shakespeare Library for making available their collection of nineteenth-century playbills.

2 This trend was not limited to pantomime—even Shakespeare's plays were drastically reduced. An 1873 Drury Lane production of *Antony and Cleopatra*, for example, reduced the number of scenes to twelve from the original thirty-three, and critics noted that the actors were "felt to be but the stopgaps of the representation, the aids and vehicles of the scene-painter and costumier." See Barrett 1988: 164.

3 As quoted in Booth 1981, 69.

4 "Christmas Entertainments," *London Illustrated News*, December 26, 1868, 642; "Christmas Entertainments," *London Illustrated News*, December 30, 1871, 638; "Prince's Theatre: Promenade Concerts," *Manchester Times*, March 27, 1875; "The Christmas Pantomimes," *Manchester Times*, January 1, 1876.

5 Spencer 1973, 21.

6 Harris 1889, 110–111.

Hercules Brabazon Brabazon

PARIS 1821–1906 OAKLANDS, SEDLESCOMBE

ALL HIS LIFE, HERCULES BRABAZON Brabazon thought of himself as an amateur artist, even though he had studied watercolor briefly in the 1860s under the British painters James T. Hervé d'Egville (c. 1806–1880) and Alfred Downing Fripp (1822–1895). Independently wealthy from an inheritance, for decades he felt no need to exhibit his works to the public. At the urging, however, of members of the New English Art Club (NEAC), who elected him a member in 1891, he exhibited his watercolors to the public for the first time at the age of seventy at the NEAC's exhibition that same year. His admirer and fellow NEAC member John Singer Sargent (1856–1925) induced a reluctant Brabazon to hold a solo exhibition of his drawings based on his travels in Europe, North Africa, the Middle East, and India at the Goupil Gallery in London in 1892. This and a series of

other exhibitions at Goupil's made Brabazon famous. In his day, he was hailed by some as establishing a critical link between J. M. W. Turner (1775–1851) and the impressionists because of the freedom of handling and fluid application of color in his landscapes.

Brabazon was such an admirer of Turner that he produced over four hundred of what C. Lewis Hind called watercolor "interpretations of this master."[1] These were not intended to be exact copies but rather translations that "give the essence of the picture as he saw it, with the omission of such details as did not interest him."[2] So, too, as Donelson Hoopes has pointed out, Brabazon's approach to landscape painting involved "subtle omission, that suggested more mood than description."[3] Sometimes, however, in the pursuit of simplified color harmonies Brabazon's omissions in his

56

Venetian Capriccio with a Campanile

watercolor and gouache over graphite on gray wove paper, 130 × 219

Joseph F. McCrindle Collection 2009.70.50

INSCRIPTION signed at lower right, in black chalk, *HBB*

PROVENANCE Davis and Long, New York; Joseph F. McCrindle, New York; Joseph F. McCrindle Foundation, 2008; gift to NGA in 2009

LITERATURE Flushing 1985, no. 12

Gondolas before a Palace on the Grand Canal in Venice

watercolor and black wash, heightened with white gouache on greenish-gray wove paper, 174 × 243

Joseph F. McCrindle Collection, 2009.70.52

INSCRIPTION VERSO: lower left, in graphite, *Grand Canal, Venice*

PROVENANCE Walker's Galleries, London, 1960; Joseph F. McCrindle, New York; Joseph F. McCrindle Foundation, 2008; gift to NGA in 2009

LITERATURE Flushing 1985, no. 13

Venetian views could be anything but subtle: in one case he omitted St. Mark's Campanile from a view of the Doge's Palace from the southeast,[4] and in a view of the church of Santa Maria della Salute he left out one of the church's towers.[5] After seeing the 1892 Goupil Gallery exhibition, the critic George Moore wrote that he could imagine Brabazon walking into St. Mark's Basilica in Venice only to ignore its rich architectural detail and ornamentation because "[i]t was his genius not to see these things"[6] but to see broad color effects.

In addition to his "interpretations," Brabazon is known to have painted capriccios, often including identifiable Venetian landmarks.[7] Because of the liberties he took with actual views, it is sometimes difficult to distinguish whether a particular work falls into one category or the other. Certainly the two McCrindle drawings included here show elements of both. Catalogue 56, for example, shows a distant view of an island containing an assortment of vaguely Venetian-looking buildings and structures, including a campanile and the dome of a church, a combination that suggests San Giorgio Maggiore. Since it departs significantly from actual views of that church, however, it is more likely that this is a product of Brabazon's imagination. With a remarkable economy of means, Brabazon has conjured up a vision of Venice using splashes of watercolor and dashes of gouache to great effect, playing off the transparency of the water and the emptiness of the sky against the opacity of the buildings and boats.

Gondolas before a Palace on the Grand Canal in Venice (cat. 57) presents a very different kind of scene. Instead of a more distant skyline, it shows a close-up view of an unidentified, and probably unidentifiable, palace nestled between other buildings with the canal opening up to the left. Unlike *The Pink Palace* (Tate Britain),[8] where touches of pink are used to call attention to a palazzo, Brabazon

here makes the palace stand out from its surroundings by painting the buildings around it salmon-pink while allowing the color of the paper to show through the façade of the palace itself. Moreover, whereas Brabazon left the upper half of the paper virtually untouched in *Venetian Capriccio with a Campanile* (cat. 56), here he has applied gouache so thickly that the sky appears more substantial than the palace itself. In addition, water and sky intermingle here; in contrast, the two realms are clearly demarcated in the other drawing. In many ways *Gondolas before a Palace* is a much more dreamlike picture, although both works reveal more imagination than observation.[9]

Brabazon's watercolors were so much enjoyed by Joseph McCrindle that he acquired more than seventy-five of them—plus two paintings—over the course of his collecting. Ten watercolors came to the National Gallery in the McCrindle gift (see Other Drawings, pages 166–167). — LK

1 Hind 1922, 148.

2 Hind 1922, 148. See also Hind 1912, 27–29.

3 Hoopes 1970, 15.

4 See sale cat. Duke's, Dorchester, England, November 2, 2006, no. 62.

5 See sale cat. Christie's, London, April 7, 2000, lot 70.

6 Moore 1893, 210. Moore also likened Brabazon's watercolors to music. Others did the same, perhaps aware Brabazon was also an accomplished pianist.

7 See sale cat. Christie's, London, April 7, 2000, lot 79.

8 Fenwick and Smith 1997, pl. 4.

9 A reviewer in *Athenaeum* 1905, 806, described a Brabazon watercolor interpretation of a Venetian scene by Francesco Guardi (1712–1793) as being "a dream memory of a Guardi."

John Singer Sargent

FLORENCE 1856—1925 LONDON

58

Spanish Church Interior,
c. 1880

watercolor, gouache, pastel,
and graphite on textured
wove paper, 368 × 265

Joseph F. McCrindle
Collection 2010.93.2

INSCRIPTIONS verso:
across top, in pen and black
ink, *By J. S. Sargent*; upper
left, in graphite, *V.O/(Trust)*;
center, in red crayon, *O/20*

PROVENANCE Violet
Ormond (Mrs. Francis
Ormond), 1925; her son,
F. Guillaume Ormond,
1955; his heirs, 1971;
sale, Christies, London,
November 12, 1976, lot 59;
Joseph F. McCrindle, New
York; gift to NGA in 2010

FIG. 1
Detail, infrared photograph
of cat. 58, showing the
graphite underdrawing with
the flagstaff at left

CELEBRATED AS ONE OF THE PREMIER
watercolorists of the twentieth century, John
Singer Sargent challenged the traditional
limitations of the medium. The boldness
and spirit of his works held a special appeal
for Joseph McCrindle, who demonstrated his
particular appreciation for Sargent's ability
and artistic importance by collecting ten
watercolors attributed to him, nine of which
are now in the National Gallery of Art (see
also cats. 59, 60 and page 165).[1] Taken as a
group, these nine reveal Sargent's sensitive
and exquisitely evocative mastery of the
watercolor technique.

Born to an expatriate American family
that traveled constantly throughout Europe,
Sargent was encouraged from a very young
age to pursue the arts. Early on he proved
adept at drawing and painting with water-
color, a skill that he honed throughout his
career. In a 1916 exhibition review, Kenyon
Cox (1856—1919), fellow artist and critic,
commented that the watercolors reveal
Sargent's personal side, in which he worked
"without any consciousness of obligation to
a public or of the necessity of making
himself understood."[2]

Sargent moved to Paris in 1874 to train
in the studio of Émile Carolus-Duran
(1837—1917), who, among other things,
encouraged his students to study the works
of the great seventeenth-century Spanish
master, Diego Velázquez (1599—1660).
Sargent was drawn to the complex tonal
values in Velázquez's paintings, and in the
autumn of 1879 he traveled to Madrid with
fellow students Edmond-Charles Daux
(1855—c. 1937) and Armand-Eugène Bach
(1850—1921). Museum records reveal that
Sargent spent days copying paintings at the
Prado.[3] Painstakingly reproducing the subtle
tones in Velázquez's paintings taught the
young artist principles of perspective, the
illusion of depth, as well as the passage of
light and dark in relation to shadows.

One of the watercolors Sargent com-
pleted during his period in Spain is this
rendering of the interior of an unidentified
church. Although the specific building is not
known, the plain stone structure and the
details of the altar are clearly Spanish in
style.[4] Inspired by the beauty, simplicity, and
depth of the space, Sargent punctuated the
darkness of the scene with faint highlights of
blue shadows that skim over the chapel walls
and flickers of light that reflect off gilded
frames and candleholders. Close examination
using infrared digital photography reveals
that he used an unexpectedly complex
technique, with layers of watercolor brushed
over an initial sketch of the church, pulpit,
and altar clearly drawn in gouache, pastel, and
graphite. Previously thought to be a crucifix,
the vertical form standing next to the pulpit
and blurred by the consuming darkness of
the middle ground actually turns out to be a
flagstaff (fig. 1).

The graphite underdrawing shows
how Sargent mapped the composition before
developing the aura of the church and its
spatial perspective with loose brushstrokes
and masterful gradations of color.[5] The
compositional structure and style echo
elements the artist was exploring in his oil
paintings in this same period, with the dark
void in the center of the picture plane, the
buff color of the wove paper, and the backlit
doorway creating an atmosphere that is both
tangible and evanescent. — JR

1 Also in the McCrindle gift is a Sargent oil made during
 the same visit to Egypt, *Pavement, Cairo*, 1891 (inv. 2006.121.1,
 reproduced, p. 20).

2 Cox 1916, 36.

3 Ormond and Pixley 2003, 632—640.

4 Ormond and Kilmurray 1998—, 4: 73.

5 See Marjorie Shelley in Herdrich and Weinberg 2000, 17, 23.
 The presence of pastel or black crayon dates the work to
 c. 1880 because these are media the artist only used in his
 early student years.

John Singer Sargent

FLORENCE 1856 — 1925 LONDON

59

Cairo, c. 1891

watercolor over graphite
on textured wove paper,
254 × 355

Joseph F. McCrindle
Collection 2010.93.7

INSCRIPTIONS signed at
lower right, in graphite,
John S. Sargent/Cairo; verso:
upper left, in pen and black
ink, *150 Cairo/J.S.S. Signed*,
and below that, in graphite,
E.S-; right, in red crayon,
6/37, and left center, in
graphite, *(3)*

PROVENANCE Emily
Sargent, 1925; Violet
Sargent (Mrs. Francis
Ormond), 1936; her
daughter Reine Ormond
(Mrs. Hugo Pitman), 1955;
Pawsey & Payne, London;
sale, Sotheby's, London,
December 13, 1961, lot 67
(as *Bethlehem*); bought by
Sir G. McKinnon; Albany
Gallery, London, 1967;
Hugh Ransom, London;
Brian Sewell, London;
Joseph F. McCrindle,
New York, c. 1972; gift to
NGA in 2010

SARGENT BEGAN HIS MOST AMBITIOUS project in 1890, when he was commissioned to complete a series of decorative murals known as the *Triumph of Religion* for the Boston Public Library Special Collections hall. Sargent was eager to show his versatility as an artist and to establish his reputation in a new genre. Originally he considered depicting scenes from Spanish literature, but in the fall of 1890 he changed his mind to focus on "illustrating certain stages of Jewish and Christian religious history."[1] In the winter of 1890 – 1891, in preparation for the murals, Sargent traveled to Egypt, Greece, and Constantinople, the cradle of the Judeo-Christian religions. Records indicating where, when, and how Sargent traveled throughout Egypt are limited, but the numerous drawings, such as this view near Cairo, show how the country and its history inspired his creativity.[2]

As the McCrindle drawing reveals, Sargent was captivated by this perspective of the Muhammad Ali mosque from behind a bastion wall, close to the eastern approach to the Cairo citadel, as the minarets emerge from the horizon.[3] He first used graphite lines to mark the horizon and the mosque on the page, then built up the composition with a vibrant interplay of controlled colors, reserved areas of white paper, translucent sweeps of thin wash, and more calligraphic accents of less diluted pigment. Through the most delicate manipulation of a limited palette of blues, yellows, and browns tinged with a few hints of pink and purple, Sargent evokes the heat and white sunlight of the Egyptian desert. The monochromatic values of the landscape inspired unusually subtle contrasts in Sargent's work, and the quality of the light led to experiments with looser forms and unique tonal values that had a lasting effect on his style.

In the context of the Boston Public Library mural project, one of the key objectives of Sargent's trip to the Near East was to create a signature style for the paintings. Instead of representing ancient gods and goddesses with conformist symbols and a conventional style, Sargent wanted to leave his own mark. In Egypt he was fascinated by the daily life of the native people and their seemingly timeless routines, such as irrigating the fields, carried out while living within miles of ancient ruins. In the Boston murals he modeled his images of pharaohs and religious icons on the modern-day Egyptians he encountered during his travels. At the same time, in brilliant watercolors such as *Cairo*, he demonstrated a new maturity in his artistic response to the Egyptian landscape, which was both personal and spiritual. — JR

1 See Promey 1999, 15.

2 Executed during the same trip was the painting *Pavement, Cairo*, 1891, also in the McCrindle gift (reproduced, p. 20).

3 See Ormond and Kilmurray 1998 –, 5: 234.

John Singer Sargent

FLORENCE 1856—1925 LONDON

60

Sir Neville Wilkinson on the Steps of the Palladian Bridge at Wilton House, 1904 / 1905

watercolor over graphite on wove paper, 254 x 355

Joseph F. McCrindle Collection 2010.93.3

INSCRIPTIONS by the artist, lower right, in graphite, *To my friend Wilkinson/ with apologies/J. S. Sargent*; verso: lower right, in graphite, *2473/[two illegible words]2472*; lower right, lightly, *S32/7*

PROVENANCE given by the artist to Sir Neville Wilkinson (according to the inscription); Joseph F. McCrindle, New York; gift to NGA in 2010

FIG. 1
Henry Herbert, 9th Earl of Pembroke, and Roger Morris (architects), *The Palladian Bridge at Wilton House*, 1736 / 1737, Wilton, Wiltshire

IN 1886, SARGENT MOVED FROM PARIS TO London, where he established himself as a fashionable portrait painter. Using unique perspectives, angled viewpoints, and abbreviated compositions, Sargent captured the essence of his subjects. He was honored by the Royal Academy, received commissions for portraits from members of the society elite, and himself was accepted as one of them. Among the many members of the nobility whom he came to know was Sir Neville Rodwell Wilkinson (1869—1940), the last to hold the position of Ulster King of Arms, who had married Lady Beatrix Herbert, daughter of Sidney Herbert, the 14th Earl of Pembroke, in 1903. Sargent became a close friend of the couple, and sometime between 1904 and 1905 he completed this portrait of Sir Neville. The inscription in the lower right suggests that Sargent offered the drawing directly to his friend, apparently as an apology for an unknown transgression. The locale was previously identified as the steps of a Venetian palazzo, but correspondence from Wilkinson's wife confirmed that Sir Neville is shown leaning on the balustrade of the Palladian bridge at the Pembroke family estate, Wilton House, near Salisbury, England (fig. 1).[1] The bridge was built in 1737 by the 9th Earl of Pembroke based on the design of

Andrea Palladio (1508—1580) for a new Rialto bridge in Venice that was submitted in 1554 but not built.

At this point in his career, Sargent no longer used the graphite underdrawing as outline, but instead employed it to jot down the general structure of his composition; he then created the work itself almost entirely with color. Here, shades of blue dominate the composition, not only in Sir Neville's suit but also in many passages that suggest reflections of bright sky and water on the stones of the bridge. The geometric forms and decorative elements of the bridge's architecture create a strong framework for the composition, which allows Sargent to push the boundaries of the medium, both forming and dissolving the stones with color and light. He delights in such repeated ornamental details as the curving lines of the balustrade, the corbeled arches, and the diamond-shaped beams of the ceiling, but he indicates them in the most general, abstract way with loose brushstrokes and flickering light effects. Choosing to place himself at the bottom of the steps, looking up at his friend and toward the roof of the bridge, he plays with the spaces created by the structure and invites the viewer up the steps and into the shadows. In 1892, Sargent had commented on his watercolor techniques in an exhibition essay, writing that "the gift of colour together with an exquisite sensitiveness to impressions of nature has been the constant incentive."[2] The sentiment is illustrated beautifully within this drawing. — JR

1 Ormond and Kilmurray 1998–, 3: 137.

2 Esten 2000, 23.

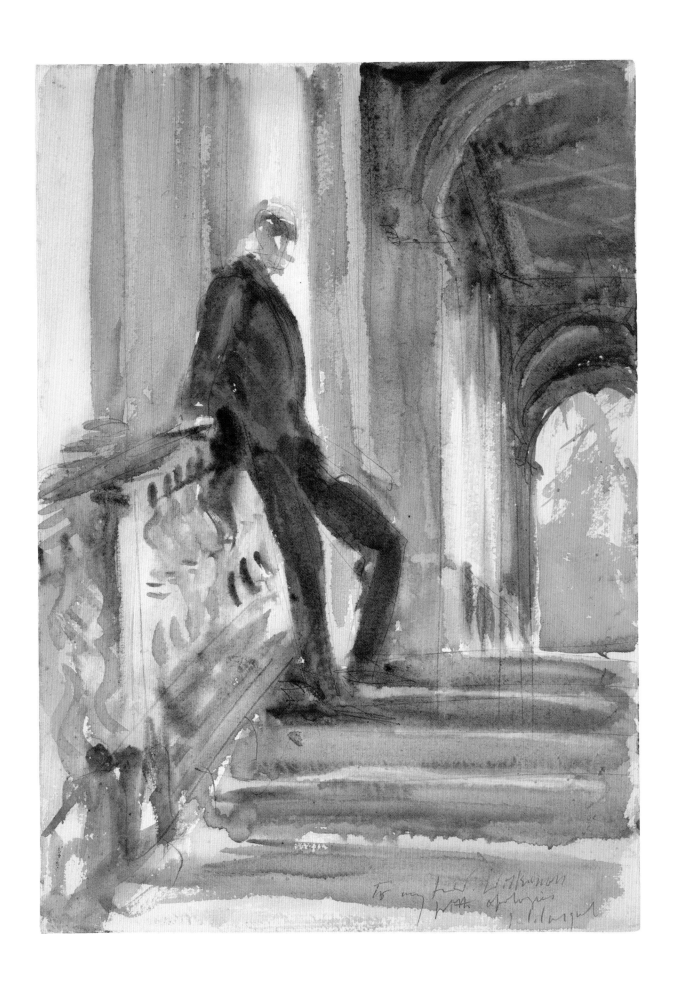

Augustus John

TENBY, PEMBROKESHIRE 1878 – 1961 FORDINGBRIDGE, HAMPSHIRE

61

*Head of a Young Woman
(Virginia Woolf?),*
1895 / 1905

red chalk on wove paper,
357 × 303

Joseph F. McCrindle
Collection, 2009.70.144

PROVENANCE The Rowley
Gallery, Ltd., London;
Joseph F. McCrindle, New
York; Joseph F. McCrindle
Foundation, 2008; gift to
NGA in 2009

BORN IN WALES, AUGUSTUS JOHN MOVED to London to attend the Slade School of Art, where his talent attracted the notice of both professors and classmates. Less than a year into his training, he hit his head on a rock during a diving accident. When he returned to the Slade, he had adopted a bohemian persona that attracted nearly as much attention as his artistic talent. A legend grew up around John's blow to the head, and some of his contemporaries claimed he owed his genius to the accident. He remained a flamboyant personality, pursuing for a period a self-described "Gypsy" lifestyle in a caravan with his wife, mistress, and children, but he went on to a long and illustrious career. A prolific painter, draftsman, and etcher, he was elected to the Royal Academy and awarded the Order of Merit.[1]

This drawing probably dates from early in John's career, when his style was most strongly affected by his training at the Slade, where instructors immersed their pupils in the draftsmanship of the old masters. The insistent diagonal hatching, which appears in a number of portrait studies by John and his fellow students, was a product of this education; an earlier pupil noted that they learned to "draw in the manner of Leonardo and Raphael, a manner that was ridiculed as 'Slade Shading'; it was much older than the Slade."[2] Under his teacher Henry Tonks (1862 – 1937), John later reminisced, he was directed "to the study of the Masters. Rubens, Michelangelo, Rembrandt, Watteau, Ingres . . . I spent most of my spare time in the National Gallery, the British Museum, and other collections, thus loading my mind with a confusion of ideas which a life-time hardly provides time to sort out."[3]

John frequently used red chalk for portrait studies in the late 1890s and early 1900s, a choice that could have been informed by his affinity for the old masters. He made dozens of portraits of women during this time, often using classmates or family members as models. The sitter for this drawing was at one point identified as Virginia Woolf (1882 – 1941), and she does bear a superficial resemblance to photographs of the young author taken in 1902.[4] Woolf was indeed part of John's circle during the first decade of the twentieth century and later recalled 1908 as the beginning of "the age of Augustus John."[5] However, there is no clear evidence that she is the subject of this portrait. — SS

1 For John's life and art, see Holroyd 1912 and London 2004a.

2 Holroyd 1912, 274. For drawings with similar diagonal shading from the early 1900s, see London 2004b, 9, 11, 12, 28. John returned to this style later in a Leonardesque series of portraits of Alexandra Schepler (1906 – 1907).

3 John 1975, 50.

4 The photographs of Woolf (then Virginia Stephen) were taken by George Charles Beresford. See Saywell and Simon 2004, 677.

5 Quoted in Bell 1972, 124.

Ker Xavier Roussel

LORRY-LÈS-METZ 1867—1944 L'ÉTANG-LA-VILLE

62

The Garden, after 1900

pastel on gray-blue wove paper, 325 × 499

Joseph F. McCrindle Collection 2009.70.205

INSCRIPTION signed at lower right, in black pastel, *Roussel*

PROVENANCE Joseph F. McCrindle, New York; Joseph F. McCrindle Foundation, 2008; gift to NGA in 2009

KER XAVIER ROUSSEL, FRENCH PAINTER, printmaker, and decorative artist, is best known for his colorful and lyrical landscapes. After attending the prestigious Lycée Condorcet in Paris, where he met his future brother-in-law and fellow artist Édouard Vuillard (1868—1940), he was admitted to the École des Beaux-Arts in 1886, and two years later he entered the Académie Julian. Soon dissatisfied with these institutions' conservative teachings, Roussel, along with Vuillard, joined a group of equally dis-affected artists who called themselves the Nabis, the Hebrew word for "prophets." Original members of the Nabis included the founder, Paul Sérusier (1863—1927), Maurice Denis (1870—1943), Pierre Bonnard (1867—1947), Paul Ranson (1862—1909), and Henri-Gabriel Ibels (1867—1936). This brotherhood, formed in the spring of 1889, promoted the notion that form and color in art were expressive and independent from the subject matter.[1] Along with exhibiting their art, the Nabis held monthly dinners for which each member dressed in oriental costume and brought an *icône* or picture.[2]

Roussel's early works adhere to the Nabi principles of flat planes of vibrant, unmodulated color enclosed in dark outlines. However, the McCrindle pastel belongs to the period after 1900 when Roussel began to abandon outlined planes of color and reverted to a neoimpressionistic style, in which the broad and clearly visible strokes are suggestive rather than descriptive.[3] The major elements of the garden — trees, shrubbery, and flowers — are merely hinted at by the sweeping lines and masses of the multicolor pastel. Roussel preferred pastel for his drawings not only because of its wide range of color but also for its friability, which allowed him to smudge the forms' outlines and thereby create an effect of hazy atmosphere. Many of his works are populated either with men and women enjoying themselves in the outdoors or with

mythological creatures such as fauns and nymphs; this landscape is unusual in the complete absence of any figures.

The garden landscape depicted here might have been at the artist's country home in L'Étang-la-Ville in the department of Yvelines, just west of Paris. Roussel and his family first arrived there in 1899, after doctors recommended that his ailing daughter Annette would benefit from the country air. After he became successful he built a house there, which he named La Jacannette,[4] a contraction of the names of his two children, Jacques, who died young, and Annette. — CDJ

1 For an excellent overview of prints and drawings by the Nabis, see New Brunswick 1988.

2 New Brunswick 1988, 3.

3 For two good retrospectives on Roussel, see Bremen 1965 and Saint-Germain-en-Laye 1994. A selection of Roussel's work is also included in Paris 1993.

4 London 1981b, in chronology for Roussel.

André Dunoyer de Segonzac

BOUSSY-SAINT-ANTOINE 1884 — 1974 PARIS

63

Three Female Dancers,
1909

pen and black ink with
touches of gray wash on thin
wove paper, 336 × 259

Joseph F. McCrindle
Collection 2009.70.111

PROVENANCE Paule Cailac,
Paris, 1983 (as "Danse
d'Isadora Duncan");
Joseph F. McCrindle, New
York; Joseph F. McCrindle
Foundation, 2008; gift to
NGA in 2009

ANDRÉ DUNOYER DE SEGONZAC WAS
already an established painter when his
interests shifted toward the graphic arts in
the first decades of the twentieth century.
Over the course of his long career, Segonzac
went on to produce a vast number of
drawings, prints, and illustrated books,
including his celebrated etchings for Virgil's
Géorgiques.[1] Though his later works emphasize
landscape, in the early stages of his career
the artist was concerned with the human
form in motion, making drawings of boxers,
cyclists, runners, and other athletes.[2] In 1910
he made a series of drawings of Diaghilev's
Ballets Russes, which in its second season had
taken Paris by storm.[3]

The McCrindle drawing depicts a
performance by another dance troupe
that was thrilling Parisian audiences at the
same time. When Dunoyer de Segonzac
first saw Isadora Duncan perform, he had
already been making drawings of the Ballets
Russes — "these miraculous geniuses of
the dance," as he called them. Even so, he
described her performance as a "revelation."[4]
Duncan, regarded by many as the founder
of modern dance, rejected the formality of
ballet for natural movements. Inspired by
the ancient Greeks, for whom she believed
dance was a sacred art, she wore free-flowing
costumes and danced in bare feet. To elevate
the status of dance, she insisted on classical
accompaniment. Like many artists of the
time, Dunoyer de Segonzac was inspired
by Duncan's dancing, which he considered
truly original and free of artifice. Sitting in
the darkness of the theater, he traced her
movements in pencil, working later from
these sketches to make pen-and-ink drawings
in the studio while humming the music
of Mozart or Schubert "to put me in the
atmosphere and ambiance of her dances."[5]
Several of these drawings were published
around 1910 as *Dessins sur les danses d'Isadora
Duncan* and further enhanced the artist's
reputation.[6]

The McCrindle drawing depicts three
of the six "Isadorables," talented students
from one of Duncan's schools who toured
with her from 1905 to 1920. Here, two of
the girls hold a billowing scarf aloft, while a
third runs toward them as if to pass under it.
All sport the simple tunics associated with
Duncan and her dancers. A more finished
version of this drawing was published by the
artist in *Dessins sur les danses.*[7] The McCrindle
sheet, by contrast, is swiftly rendered with
flowing, open lines that run off the page and
capture the motion of the dance. Though in
the published version Dunoyer de Segonzac
has corrected the middle figure and more
precisely delineated the women's hands and
feet, the McCrindle version is a more lively
work whose fluid rendering echoes the grace
of the dancers' movements. — *JBS*

1 A copy of *Les Géorgiques* (also called *Georgica*), illustrated by
Dunoyer de Segonzac, is in the collection of the National
Gallery (inv. 1948.14.1–51, 1948.14.52–105).

2 Several examples are reproduced in *Dunoyer de Segonzac* 1970,
355–387.

3 For images of the Ballets Russes, see *Dunoyer de Segonzac* 1970,
64–83.

4 *Dunoyer de Segonzac* 1970, 51–52.

5 *Dunoyer de Segonzac* 1970, 53.

6 Los Angeles 1975, 2. For other drawings of Duncan's dances,
see *Dunoyer de Segonzac* 1970, 49–63.

7 See Dunoyer de Segonzac 1910. According to the dealer
Paule Cailac, the McCrindle drawing was published in the
September 11, 1909, edition of *Le Témoin.*

Robert Polhill Bevan

HOVE 1865 – 1925 LONDON

64

Rosemary No. 1, 1915

watercolor with black chalk
and graphite on wove paper
laid down on board, with
a border line by the artist
in black chalk and squared
for transfer in pen and
red ink, sheet 327 × 420,
grid 260 × 356

Joseph F. McCrindle
Collection 2009.70.38

INSCRIPTIONS the squaring
grid numbered along
each margin, in black chalk,
1 to *16*; lower left, by
another hand, in graphite,
H and *29*; verso: lower
right, in graphite, *18407D*
and *C-1006*

PROVENANCE the artist's
studio (atelier stamp
RPB, applied twice);
Davis Galleries, New York;
Joseph F. McCrindle,
New York; Joseph F.
McCrindle Foundation,
2008; gift to NGA in 2009

LITERATURE New York
1970, no. 29

ALTHOUGH HE NEVER ACHIEVED FAME
during his own lifetime, Robert Polhill
Bevan is now considered one of the foremost
postimpressionist painters in Britain. During
his studies at the Académie Julian in Paris
and his extended visits to Pont-Aven in
the 1890s, Bevan fell under the influence
of French artists such as Paul Gauguin
(1848 – 1903), Paul Cézanne (1839 – 1906), and
Paul Sérusier (1863 – 1927). He also learned
lithography at Pont-Aven, making a number
of prints during the first decade of his career,
but pausing for almost fifteen years before
returning to printmaking late in his life.
One of the founders of the Camden Town
Group in 1911, Bevan focused for several years
on the urban scenes favored by many of
the members, specializing in horse markets,
worn-out cab horses, and city architecture.[1]

Shortly before the last exhibition of the
Camden Town Group in 1912, Bevan joined
his friends and fellow members Spencer Gore
(1878 – 1914) and Charles Ginner (1878 – 1952)
for the first time at Applehayes, a farm in
Devonshire.[2] Inspired by the patchwork fields
and distinctive landscape of the nearby
Blackdown Hills, Bevan returned to the area
almost every year for the rest of his life. The
flat patches of tone and blocky foliage of
this drawing and the following one (cat. 65),
as well as the identifiable settings, confirm
that both were made during this period of
his career.

While Bevan's earliest depictions of
the West Country reveal the influence of
impressionist painters, his landscapes quickly
began to demonstrate his admiration for
the postimpressionists: his loose brushwork
and pastel colors gave way to the heavy
contours and geometric patterns seen in these
two McCrindle drawings. The earlier of the
two studies, *Rosemary No. 1* (1915), served as a
preparatory drawing for the first of several
paintings of Rosemary Lane, a tiny hamlet
located a few miles from Applehayes. True
to his typical working practice, Bevan made a

number of studies of this composition.
Two closely related sketches, both watercolors
with crayon, are known and probably
represent earlier phases in the artistic process.[3]
As his former neighbors remembered, the
introverted Bevan roamed the area with
a sketchbook, making his initial studies
in situ.[4] From that point he worked up
increasingly elaborate studies, meticulously
squaring and numbering the final drawing
for transfer to canvas, as seen here. Several of
his colleagues in the Camden Town Group
shared this practice, a technique advocated
by the group's informal leader, Walter
Sickert (1860 – 1942).[5] The McCrindle study
matches the painting quite closely, with the
exception of the addition of a figure and
dog in the foreground of the oil painting,
a decision characteristic of Bevan's working
methods. — ss

1 For an overview of Bevan's career, see Stenlake 2008 and
 Bevan 1965.

2 Coventry 1986.

3 Victoria and Albert Museum, P.29-1963, and sale, Bonham's
 Knightsbridge, March 24, 1999, lot 13 (as *In the Upper Culme
 Valley*). The final oil version of the view, *Rosemary No. 1*,
 was in the collection of the artist's son (Bevan 1965, no. 55,
 reproduced).

4 Stenlake 2008, 136 – 138.

5 New Haven 1980, 4.

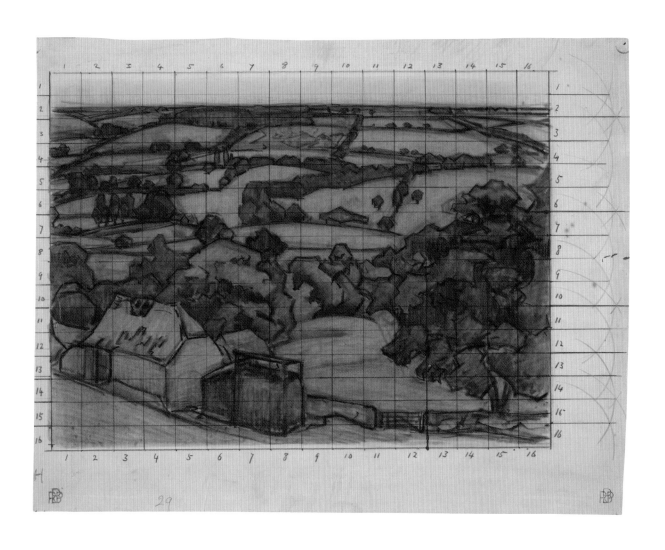

29

Robert Polhill Bevan

HOVE 1865–1925 LONDON

65

Across Bolham Water,
1916 / 1919

charcoal and stumping;
watermark: F J Head & Co
(twice); 335 × 432

Joseph F. McCrindle
Collection 2009.70.40

INSCRIPTION lower left,
in graphite, *37*

PROVENANCE the artist's
studio (atelier stamp
RPB at lower right);
Davis Galleries, New York;
Joseph F. McCrindle,
New York; Joseph F.
McCrindle Foundation,
2008; gift to NGA in 2009

LITERATURE New York,
1970, no. 37

FIG. 1
Robert Polhill Bevan, *The
Plantation* (detail), 1919 / 1922,
charcoal and black chalk
with stumping, Joseph F.
McCrindle Collection,
National Gallery of Art,
Washington, 2009

IN THE SUMMER OF 1916, BEVAN RENTED a rustic cottage called Lytchetts, a few miles from Applehayes. He returned for the next three summers before buying Marlpits, a nearby house, in 1923. It was during his time at Lytchetts that he drew *Across Bolham Water,* a study for a painting of the valley where his rented home was located.[1] Although its simplicity suggests it is an early sketch for the composition, the McCrindle drawing is actually fairly close to the final painting, even down to such details as the positions of the cows and the shape of the cloud. During his summers at Lytchetts, Bevan depicted this particular hillside a number of times from slightly different angles.[2] In charcoal drawings like this and in the black-and-white lithographs he began to produce around this time, he conveyed the myriad greens of the English countryside not only through shades of gray but also through variations in texture.

Although the simplified geometric shapes and heavy contours of Bevan's West Country landscapes recall the work of the French postimpressionist Paul Cézanne, his work remains distinctly English. Joseph McCrindle must have found Bevan's draftsmanship particularly appealing, for he owned a number of his drawings, including renderings of English and foreign landscapes,

studies of horses, and a portrait of the artist's daughter. His bequest to the National Gallery includes a third Bevan drawing, *The Plantation* (fig. 1), a landscape study similar in both purpose and appearance to *Across Bolham Water*. *The Plantation* could have served as a preparatory study for either the eponymous painting of 1919 (private collection) or the lithograph of 1922.[3] It features the same appealing contrasts of tone and texture seen in the earlier drawing, from heavy vertical strokes of foreground foliage to the flat grays of distant fields. Both of these carefully composed charcoal studies must have aided Bevan not only as direct preparation for specific works but also in a more general way, helping him to visualize his landscapes in shades of black and gray as he returned to lithography for the first time in almost two decades. — ss

1 Location unknown, formerly Agnews, London (mentioned in Stenlake 2008, 136, but not reproduced).

2 See for example *Up Bolham Water,* 1918 / 1919, reproduced in Bevan 1965, no. 69; and *West Country Landscape,* sold at Christie's, London, March 3, 1989, lot 307.

3 Both are reproduced in Stenlake 2008, 158 (the print), 159 (the painting).

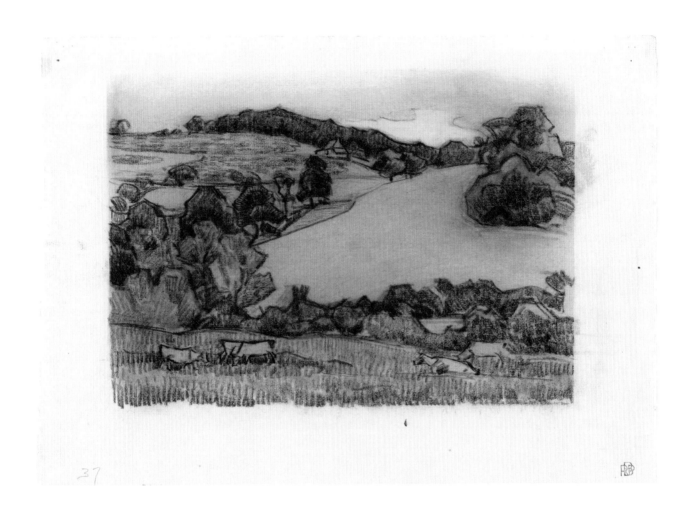

37

Pavel Tchelitchew

KALUGA, RUSSIA 1898 – 1957 GROTTAFERRATA, ITALY

66

Three Studies of a Masked Boy, 1927
verso *Calla Lilies*

pen and black ink with black wash on wove paper, 308 × 242; verso: pen and black ink with touches of black wash

Joseph F. McCrindle Collection 2009.70.232.a/b

INSCRIPTIONS verso: lower right, in graphite, *avec toute mon affection / P. Tchelitchew / 1927*; undecipherable erased inscription lower left and lower center

PROVENANCE Joseph F. McCrindle, New York; Joseph F. McCrindle Foundation, 2008; gift to NGA in 2009

BORN INTO AN ARISTOCRATIC FAMILY and raised in privilege near Moscow, Pavel Tchelitchew showed an early interest in ballet and art. He was forced to flee the Bolshevik Revolution in 1918, when he was just twenty years old, and spent an itinerant young adulthood living and working in Kiev and Berlin. During these years he received some formal art training and achieved considerable success as a stage designer. In 1923 he arrived in Paris, where he settled into avant-garde circles and found early success as a painter.

Influenced by his constructivist and cubist contemporaries, Tchelitchew explored ways of depicting simultaneity — movement through time and space — in his paintings. He also felt a strong tie to the figural art of his early education, especially the work of Mikhail Vrubel (1856–1910) and the Russian symbolists. As a result, Tchelitchew rejected the popular move of the avant-garde toward abstraction. Instead, he became interested in representing simultaneity in the human form.

The recto of the present drawing shows Tchelitchew working on what he called a "laconic" composition. Such compositions consisted of "several figures, contiguous in head and torso, [with] a common set or sets of legs and arms, fewer in number than the figures would normally have, but so arranged that each figure seems complete."[1] In this case Tchelitchew has drawn one torso with too many arms. The figure has two right arms — one holds his chin and the second holds the left arm. The left arm reaches out and grips the hand of its own shadow as if it would run away. Tchelitchew also uses the device of two-color masks — white and black — to suggest to the viewer two different angles of vision. The head at the upper left is nearly cleaved down the center, separated by light and dark, as if it is being pulled into two separate planes. The head at upper right is cocked at an odd angle, and the right side of the face seems to drop away from the left, as if paralyzed. Tchelitchew's ink lines are loose and quick — overlapping and expanding as he experiments with distorting the forms.

On the verso, the study of calla lilies appears to be drawn directly from nature. Here Tchelitchew was primarily concerned with creating the illusion of depth in organic forms. He uses broad areas of light and dark — created by contrasting the paper and the wash — to outline the basic shapes. Wet and dry pen lines carve from the beige background the shapes of the calla lily petals and stems.

The drawings on both the recto and the verso of the McCrindle sheet show a young artist playfully experimenting with new ways to convey depth, space, and time on a two-dimensional plane — a problem that would occupy Tchelitchew for the next thirty years. — *ARJ*

1 Soby 1942, 16.

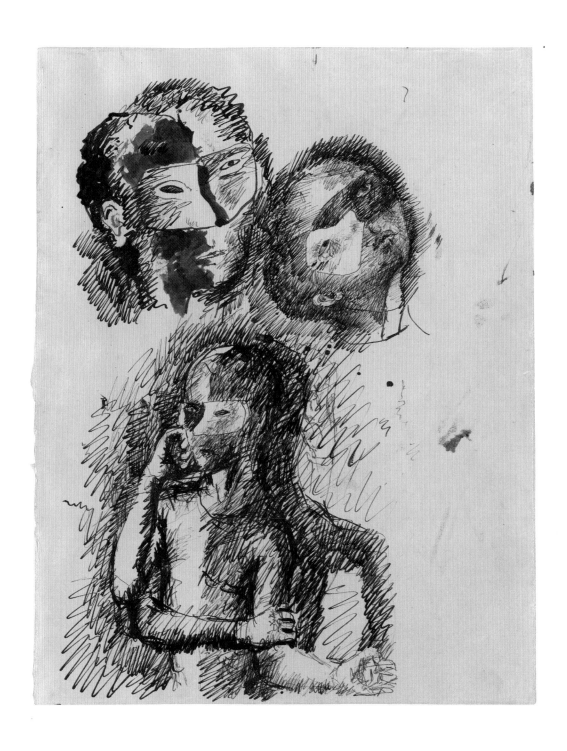

Pavel Tchelitchew

KALUGA, RUSSIA 1898 — 1957 GROTTAFERRATA, ITALY

67

Tree into Double Hand (Study for "Hide-and-Seek"), 1939

pen and brown ink over traces of graphite on tan prepared, canvas-textured "paint paper," 324 × 250

Joseph F. McCrindle Collection 2009.70.233

INSCRIPTIONS signed at lower right, in pen and brown ink, *P. Tchelitchew / 39*; verso: upper left, stamp of the paper manufacturer *Parnassus*

PROVENANCE Joseph F. McCrindle, New York; Joseph F. McCrindle Foundation, 2008; gift to NGA in 2009

FIG. 1
Pavel Tchelitchew, *Hide-and-Seek*, 1940–1942, oil on canvas, Museum of Modern Art, New York

THIS DRAWING IS ONE IN A SERIES OF preparatory studies for Pavel Tchelitchew's best-known painting, *Hide-and-Seek*, 1940–1942. The finished work, a surrealist kaleidoscope of overlapping organic and human forms, was once one of the most famous and popular works at the Museum of Modern Art in New York (fig. 1).[1] It has since fallen out of favor and in recent decades has been consigned to a storeroom.

The artist began the series of studies for *Hide-and-Seek* in 1934 in Sussex, England, with a sketch of a large gnarled tree he encountered on a friend's estate.[2] In subsequent drawings from 1935 to 1939 the form evolved into what Tchelitchew referred to as a "metamorphic composition" or double image. On first impression this work appears to be a straightforward brown-ink drawing of a tree. Upon closer examination the viewer deciphers two simultaneous objects in the same form: the original tree and two interconnected human hands — the first hand points up, its five digits forming the branches, and the second hand points down with fingers bent back, forming the roots. This drawing depicts Tchelitchew's early conception of *Hide-and-Seek* as a "double-hand" composition; in later drawings and the final painting, the bottom hand, or root section, is formed by a human left foot.

The metamorphic composition is a device that recurs throughout Tchelitchew's

body of work. He assigns the beginning of his interest in this device to a childhood toy — a box of wooden puzzle cubes. The puzzle cubes make six different images using the six sides of each cube. To put together each image the child must select the correct side of each cube and piece together the puzzle. In a 1961 interview Tchelitchew said, "I could play for hours with these cubes, and each time I had completed one picture I remained mentally so very much aware of the five other possible pictures concealed within the one which I had composed that I could visualize them as if I were actually seeing them all at the same time, through the one picture which was there before my eyes." He went on to say, "There you will find the key, I suppose, to my whole conception of art as a kind of science of metamorphosis, I mean as a magic which can transform any visible object into a whole series of other objects."[3]

As with the puzzle cubes, Tchelitchew is interested here in a mysterious relationship between the objects contained in a double image, which need not have a logical connection in the viewer's mind. Rather, he is especially concerned with "the moment of pause between two states of being, the interval in a metamorphosis when the prince who is turned into a toad is no longer a prince and not yet a toad."[4] In double images such as this one, and especially in *Hide-and-Seek*, Tchelitchew was expecting the viewer to bring "a human element of curiosity roused by the mystery of the composition which derives much of its life from this human effort to understand and solve it as a riddle."[5] — *ARJ*

1 Inv. 344.1942, oil on canvas, 199 x 215 cm.

2 See Soby 1942, 32. For several of the drawings, see Soby 1942, 80–81.

3 Roditi 1961, 107.

4 Roditi 1961, 124.

5 Roditi 1961, 124.

Wyndham Lewis

AMHERST, NOVA SCOTIA 1882 – 1957 LONDON

68

Froanna Reading, 1936

pen and black ink on wove
paper, 267 × 377

Joseph F. McCrindle
Collection 2009.70.155

INSCRIPTIONS signed at
lower right, in pen and
black ink, *W.L. 1936.*; lower
left, in graphite, *6653*

PROVENANCE Leicester
Galleries, London; Joseph
F. McCrindle, New York;
Joseph F. McCrindle
Foundation, 2008; gift to
NGA in 2009

AT THE BEGINNING OF THE TWENTIETH
century, Wyndham Lewis founded the vor-
ticist movement in England and sought to
relate art and literature to industrial progress.
In 1914 he published the first issue of *Blast:
Review of the Great English Vortex*, a publication
that announced the new art movement in
a manifesto vehemently attacking Victorian
values. As the leader of this first avant-garde
movement in England, Lewis pioneered
compositional geometric abstractions. With
an almost limitless imagination, he found
success in both writing and the visual arts;
within his drawings he developed a particular
skill for using partial contours drawn with
a finely controlled pen to suggest complete
volumes and forms.

In 1930 Lewis wrote *The Role of Line in Art*,
which reflected the artist's commitment to
drawing technique.[1] He was an extremely
talented draftsman, whose fluency of line
and ability to create a whole composition
with the most sparing use of his pen are
beautifully illustrated in this drawing.
Through a loosely formal construction —
with only a series of arches and curves
defining the figure — the artist captured the
grace of his female subject, the concentration
in her face, the pose of her arm, and the
tilt of her head, as well as the weight of the
book she reads. The image floating on the
bare sheet, with little shading and the most
nebulous sense of space, encompassed Lewis's
modern vision of art that was created in
response to contemporary life.

In this serene and elegantly simple
study, part of a group of drawings Lewis
completed of his wife during 1936, Lewis
depicted his wife Gladys (1900 – 1979),
nicknamed Froanna, in a private moment
of reading. Froanna can be identified by the
blouse, hairstyle, and wedding band she wears
throughout the series.[2] She was eighteen years
younger than the artist, marrying him in
1930, when she was thirty and he was forty-
eight. Throughout the 1930s Lewis was very
protective of his wife, to the extent that many
of his friends did not even know he was
married. She remained in the background of
his public life, but was his artistic muse and
devoted caretaker and companion through
his various illnesses and financial difficulties.
The artist's tender regard for his partner is
captured here in the delicate touches that
define so beautifully and purely the features
he knew so well. — JR

1 See Lewis 2007.

2 See London 2004c, 74.

Paul Cadmus

NEW YORK 1904 – 1999 WESTON, CONNECTICUT

69

Don Windham, 1941

pen and black ink over
graphite on wove paper,
304 × 241

Joseph F. McCrindle
Collection 2009.70.65

INSCRIPTIONS signed
and dated at lower right,
in pen and black ink,
Cadmus — 1941; lower left,
Don Windham

PROVENANCE Midtown
Galleries, New York;
Joseph F. McCrindle,
New York; Joseph F.
McCrindle Foundation,
2008; gift to NGA in 2009

A NATIVE OF NEW YORK CITY, PAUL
Cadmus trained at the National Academy
of Design and the Art Students League and
was greatly influenced by the social realist
painters Reginald Marsh (1898 – 1954) and
Kenneth Hayes Miller (1876 – 1952). His
realist tendencies and virtuoso draftsmanship
were further honed during travels to Europe
and through his employment with the Works
Progress Administration in the 1930s. He
was fascinated by Italian Renaissance painting
and in the 1940s took up painting exclusively
in egg tempera, an old-fashioned and pains-
taking technique.

Cadmus painted very few commissioned
portraits in his career, but he did sketch and
paint portraits of many of the people in his
closest social circle. By 1941, the date of the
present drawing, Cadmus was an established
artist at the center of a group of writers and
artists that included Lincoln Kirstein, George
Platt Lynes, and George Tooker. Cadmus
met Donald Windham (1920 – 2010) in 1939,
shortly after Windham arrived in New York
from Georgia, age nineteen and a struggling
writer. He would find his first critical and
financial success collaborating with Tennessee
Williams on the Broadway play *You Touched
Me!* in 1945. In his career Windham wrote five
novels and many essays and short stories,
but he is best known for publishing his
correspondence with Tennessee Williams,
Truman Capote, E. M. Forster, and Alice B.
Toklas, and for writing his memoirs about his
friendships with them.

In the 1940s Cadmus and Windham
were roommates, romantic rivals, and artistic
collaborators.[1] In spite of their sixteen-year
age difference, the two men shared similar
creative philosophies. Both greatly admired
the English novelist E. M. Forster and
his humanist philosophy that emphasized
personal relationships. Both would later
befriend Forster and dedicate works to him.
At a time when open homosexuality was
not accepted, Cadmus and Windham, who
were gay, did not shy away from homosexual
content in their work. As a result both
encountered negative critical attention and
were never wholly accepted by the artistic
and literary establishment.

In this sympathetic portrait Cadmus
defines the contours of Windham's youthful
face and distinctive curly locks with the
delicate lines and meticulous, sensitive strokes
that are characteristic of his drawings and
his paintings in tempera. This sketch is one
of at least three drawn portraits of Windham
done by Cadmus in 1941.[2] The following
year Windham would pose for the artist
group PAJAMA, a photographic collective
consisting of Cadmus, Jared French, and
Margaret French.[3] Both the photographs and
this drawing are evidence of an early kinship
between lifelong friends. — ARJ

1 See Williams 2006, 370 – 371; and Williams 1986, 345.
 Cadmus also illustrated the frontispiece for a limited
 edition of Windham's short story, "Servants with Torches"
 (privately printed, 1955).

2 One sketch is illustrated in Williams 2006, 357. Another is
 illustrated in Windham 1985, 31.

3 Two photographs are illustrated in *Collaboration* 1992.

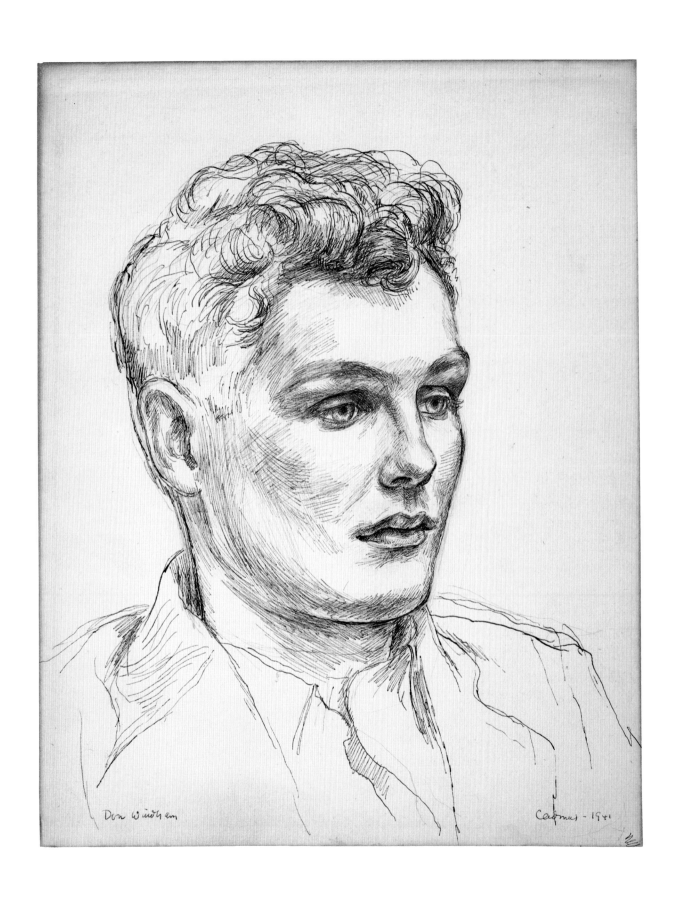

Don Windham Cadmus - 1941

John Piper

EPSOM, SURREY 1903—1992 FAWLEY BOTTOM, BUCKINGHAMSHIRE

70

An Elaborate Stage Design with Arches and Statuary, after 1953

watercolor, gouache, pen and black ink, black chalk, distemper, and graphite with collage on wove paper; watermarks: N 1953 and ENGLAND (Whatman paper); 378 × 578

Joseph F. McCrindle Collection 2009.70.193

INSCRIPTIONS signed at lower right, in graphite, *John Piper*; notes at center left, in graphite, *On backing/Not open to eye*, and center right, *On backing/Not open to/eye*; verso: upper left, in graphite, *78* (circled)

PROVENANCE Brian Sewell, London, 1977; Joseph F. McCrindle, New York; Joseph F. McCrindle Foundation, 2008; gift to NGA in 2009

IN THE EARLY 1930s JOHN PIPER WAS devoted to abstract painting and, as a member of the avant-garde Seven and Five Abstract Group alongside Ben Nicholson, Barbara Hepworth, and Henry Moore, established himself as a major figure in modern British art. This abstract period informed much of Piper's later work, as the use of bold color and the fracturing of the the picture plane came to assume a much larger role in his aesthetic. The artist declared, "the value of abstract painting to me, and the value of Surrealist painting to me are (paradoxically, if you like) that they are classical exercises, not romantic expressions. They are disciplines—even dreams can be disciplinarian—which open a road to ones heart—but they are not the heart themselves."[1]

Best known for his landscapes and architectural scenes, Piper eludes identification with one medium or style because he completed such a wide range of projects. After the 1930s he focused on issues of place and identity by capturing English and Welsh landscapes in his art. In 1938, he embarked on a new genre when he agreed to design the set for a production of *Trial of a Judge* by Stephen Spender at the Unity Theatre in London. Stage design incorporated many of his interests, including especially both music and architecture, and Piper remained devoted to the practice for the rest of his career. Commissions included stage designs for the British composer Benjamin Britten's operas at the Glyndebourne Festival, the Royal Opera House, La Fenice in Venice, and the Aldeburgh Festival.

An Elaborate Stage Design with Arches and Statuary is a preparatory drawing for an unidentified project Piper completed in or after 1953, the date given in one of the paper's watermarks. The light sketches in graphite at the top of the sheet and the notes on both sides reveal the decisions Piper considered when working on his design.

The process he used to bring his ideas to life is remarkably intricate. Starting with a basic, rather flat architectural form painted in bold pinks and salmons, he then brought out some of the sculptural details with extensive touches of white gouache, black ink, and ocher distemper. He also added several statues, some of which were drawn on separate pieces of paper and were then cut out and pasted down in the appropriate niches and spaces of the stage design. Some of the poses were also clarified in the black chalk sketches at the top of the page. Piper was known for transforming traditional stage entrances, building up ornate architectural detail, and enveloping settings with color, thus revolutionizing British theatrical performances. As he demonstrates in this drawing, he was equally innovative in setting down his designs with a remarkably wide range of media and techniques used with great fluidity and panache. — JR

1 From a letter to Paul Nash, January 12, 1943, in Tate Gallery Archives (reprinted in London 1983, 38).

Sidney Nolan

MELBOURNE 1917 – 1992 LONDON

71

Flowers (Paradise Garden), 1968/1970

Ripolin enamel on kaolin-coated paperboard, 304 × 253

Joseph F. McCrindle Collection, 2009.70.177

INSCRIPTION signed at lower right, in Ripolin enamel, *Nolan*

PROVENANCE Joseph F. McCrindle, New York; Joseph F. McCrindle Foundation, 2008; gift to NGA in 2009

FIG. 1
Sidney Nolan, *Paradise Garden* (detail of a grouping), 1968–1970, Ripolin enamel, the Arts Center, Melbourne

HAILED BY KENNETH CLARK AS ONE OF the leading artists of the twentieth century, Sidney Nolan is perhaps Australia's most widely known and acclaimed painter. Extremely prolific, he worked quickly and in series. While best known for his paintings of Australian outlaw Ned Kelly, Nolan considered the monumental *Paradise Garden* (1968–1970; the Arts Centre, Melbourne) to be his crowning artistic achievement.[1] Consisting of 1,336 individual paintings of Australian flowers in 230 framed groups, *Paradise Garden* is an investigation of color and form and a celebration of Australian flora. It was inspired by the rare experience of witnessing the desert in full bloom in 1967: "I saw the flowers springing up in Central Australia after they had lain dormant in the sand for twenty years. The pitiless wasteland throws up this extraordinary garden—like the Paradise Gardens of the Islamic peoples."[2]

In creating *Paradise Garden* Nolan worked at a feverish pace, producing an average of two paintings per day over a two-year period and sometimes finishing a single work in under an hour. In order to produce images so swiftly, the artist exploited the qualities of his materials—Ripolin enamel, a quick-drying gel, and shiny white kaolin-coated paper—to produce realistic depictions with great economy. This ability to pare a subject down to its very essence was characteristic of the artist, who said: "There is no such thing as continuous vision; we are not constructed that way, one flash succeeds another, it is our job to preserve the organic and spontaneous moments of vision."[3] Indeed, Nolan took pains to capture and commit to memory these "spontaneous moments of vision," as his wife related in 1962: "Sidney's manner of looking at things reminded me of a camera click, for he would turn his back on something that particularly interested him, then wheel round for a split second before turning again. I called this the 'quick blick'. . . method of getting memory results."[4]

In the McCrindle drawing Nolan uses vibrant color to depict flowers in full bloom. Though not an exact match, the work relates in form and color to one of the framed groups in *Paradise Garden* (fig. 1).[5] While many of the flowers painted by Nolan can be precisely identified, others simply evoke the flora of Australia. This may in part be attributed to the fact that many of the paintings were produced in London, where he lived after 1953, but also to the lack of specificity in their rendering. In the McCrindle drawing each petal is formed by a single, sweeping stroke of the brush or palette knife. All extraneous detail is stripped away to produce a striking image that borders on abstraction. Nevertheless, the subject is clear and the bright paper shines through the translucent Ripolin much as the sun would illuminate the petals of real wildflowers dancing in the breeze. — JBS

1 As quoted in London 2010, no. 21. For a discussion of *Paradise Garden* and related works, see Rosenthal 2002, 204–219. Several of the paintings were also reproduced along with the artist's poems in Nolan 1971.

2 As quoted in Rosenthal 2002, 207.

3 As quoted in Klepac 2007, 82.

4 As quoted in Klepac 2007, 81.

5 I thank Georgina Pemberton for confirming the subject of this work and Stephen Tonkin for identifying this group of paintings from among the "blossoming" pictures. The *Paradise Garden* paintings correspond to the four stages of plant life; the three others are germination, growth, and decay.

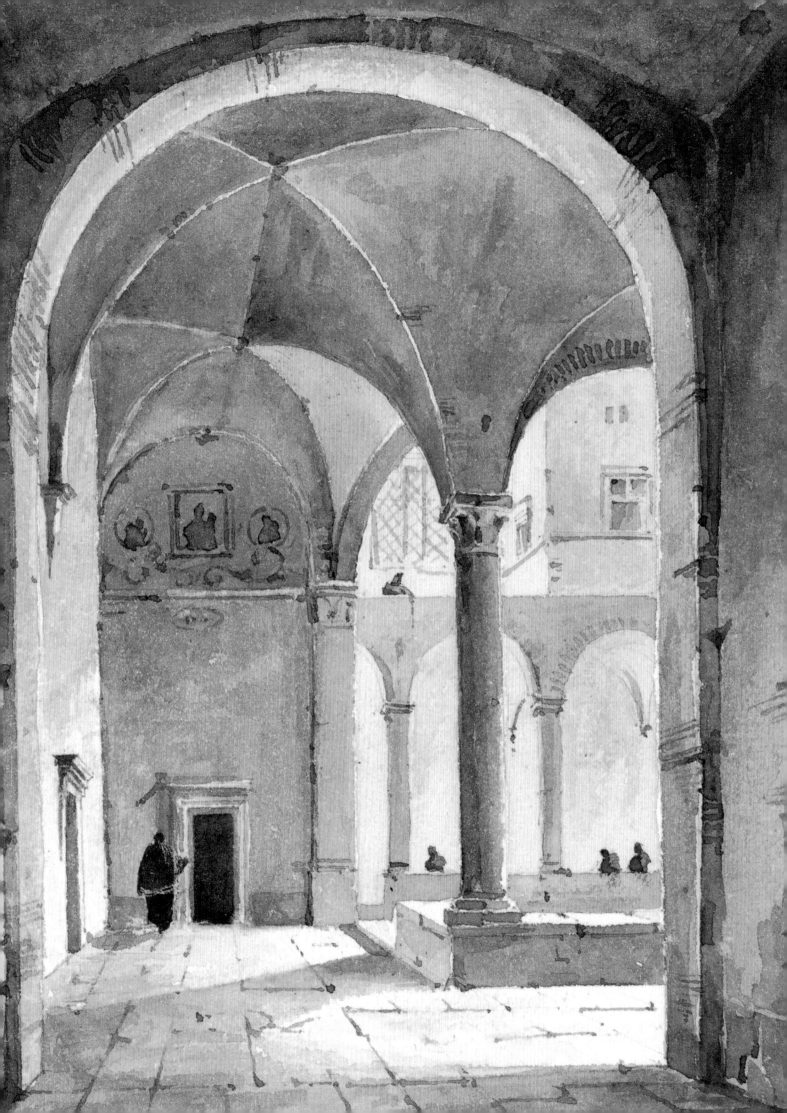

AMERICAN

Ludwig Bemelmans
American, 1898–1962
Notre Dame, Île de la Cité, 1959
watercolor with pen and
black ink on wove paper
271 × 357
Joseph F. McCrindle Collection
2009.70.35

Rockwell Kent
American, 1882–1971
Female Nude (The Artist's Wife), c. 1910
graphite on wove paper
320 × 282
Joseph F. McCrindle Collection
2009.70.145

Rockwell Kent
American, 1882–1971
Two Caricatures, c. 1922
pen and black ink with black wash
over graphite on wove paper
287 × 363
Joseph F. McCrindle Collection
2009.70.146

Rockwell Kent
American, 1882–1971
Study for a Bookplate, c. 1925
black wash with graphite
on wove paper
141 × 215
Joseph F. McCrindle Collection
2009.70.147

John Singer Sargent
American, 1856–1925
Frascati, Architectural Study, c. 1907
watercolor over graphite on wove paper
267 × 371
Joseph F. McCrindle Collection
2010.93.4

John Singer Sargent
American, 1856–1925
*The Calle della Rosa with the Monte di Pietà,
Venice,* c. 1904
watercolor over graphite on wove paper
305 × 457
Joseph F. McCrindle Collection
2010.93.5

John Singer Sargent
American, 1856–1925
A War Memorial, 1918
watercolor and gouache over graphite
on wove paper
365 × 537
Joseph F. McCrindle Collection
2010.93.9

John Singer Sargent (attributed to)
American, 1856–1925
The Piazzetta, c. 1911
watercolor over graphite on wove paper
400 × 505
Joseph F. McCrindle Collection
2010.93.6

John Singer Sargent (attributed to)
American, 1856–1925
Sunlit Wall under a Tree, c. 1913
watercolor over graphite on wove paper
254 × 356
Joseph F. McCrindle Collection
2010.93.8

John Singer Sargent (follower of)
Resting, 1880 / 1890
watercolor over graphite on wove paper
114 × 175
Joseph F. McCrindle Collection
2010.93.1

Moses Soyer
American, 1899–1974
Two Studies of a Woman, c. 1940
charcoal on wove paper
395 × 318
Joseph F. McCrindle Collection
2009.70.217

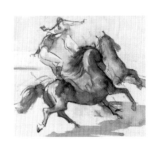

Pavel Tchelitchew
American, 1898–1957
Two Bareback Circus Riders, c. 1930
brown wash over graphite on
wove paper
330 × 378
Joseph F. McCrindle Collection
2009.70.231

Pavel Tchelitchew
American, 1898–1957
Landscape with Bare Trees, 1940
watercolor with pen and brown ink,
heightened with white gouache
on wove paper
315 × 252
Joseph F. McCrindle Collection
2009.70.234

James McNeill Whistler
American, 1834–1903
A Doorway in Ajaccio, 1901
gray wash on wove paper
157 × 91
Joseph F. McCrindle Collection
2009.70.251

William Allan
Scottish, 1782–1850
The Murder of Archbishop Sharpe, 1820
pen and brown ink over
traces of graphite
113 × 201
Joseph F. McCrindle Collection
2009.70.252

Robert Polhill Bevan
British, 1865–1925
The Plantation, 1919/1922
charcoal and black chalk with stumping
342 × 402
Joseph F. McCrindle Collection
2009.70.39

Sir Muirhead Bone
Scottish, 1876–1953
Island of Marmara, 1917
watercolor over graphite on wove paper
138 × 214
Joseph F. McCrindle Collection
2009.70.45

Richard Parkes Bonington
British, 1802–1828
Five Studies of Hunting Dogs
graphite with touches of light gray
wash on wove paper
140 × 206
Joseph F. McCrindle Collection
2009.70.46

Hercules Brabazon Brabazon
British, 1821–1906
Temple of Vesta at Tivoli
watercolor and white gouache over
graphite on brown wove paper
310 × 230
Joseph F. McCrindle Collection
2009.70.51

Hercules Brabazon Brabazon
British, 1821–1906
Palaces on the Grand Canal in Venice
watercolor and gouache over graphite
on tan wove paper
184 × 244
Joseph F. McCrindle Collection
2009.70.53

Hercules Brabazon Brabazon
British, 1821–1906
A Cornfield at Sunset
watercolor and gouache with black chalk
207 × 252
Joseph F. McCrindle Collection
2009.70.54

Hercules Brabazon Brabazon
British, 1821–1906
A Campanile among Ruins
gouache and watercolor over graphite
on gray-green wove paper
258 × 360
Joseph F. McCrindle Collection
2009.70.55

Hercules Brabazon Brabazon
British, 1821–1906
A Landscape with Mountains and a Stream
watercolor over graphite on wove paper
139 × 173
Joseph F. McCrindle Collection
2009.70.56

Hercules Brabazon Brabazon
British, 1821–1906
*The Salute and the Palazzo Ducale from the
Bacino di San Marco*
watercolor and gouache over graphite
on gray-brown wove paper
153 × 223
Joseph F. McCrindle Collection
2009.70.57

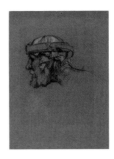

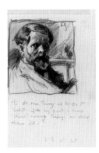

Hercules Brabazon Brabazon
British, 1821–1906
A Gondola Passing under a Bridge in Venice
watercolor and gouache over graphite
on wove paper
232 × 262
Joseph F. McCrindle Collection
2009.70.58

Hercules Brabazon Brabazon
British, 1821–1906
Walls of a North African City
watercolor over graphite on wove paper
112 × 186
Joseph F. McCrindle Collection
2009.70.59

Sir Frank Brangwyn
British, 1867–1956
Head of an Old Man, c. 1908
black and white chalk with graphite on
brown cardboard
370 × 275
Joseph F. McCrindle Collection
2009.70.60

Sir Frank Brangwyn
British, 1867–1956
Self-portrait at Forty-five, 1912
black chalk on wove paper
216 × 140
Joseph F. McCrindle Collection
2009.70.61

British school, 20th century
*Monumental Surrealist Sculptures in a
Landscape*
pen and black ink with watercolor,
gouache, and spattered black ink over
black chalk on brown board
287 × 328
Joseph F. McCrindle Collection
2009.70.24

Alfred Bryan (style of)
British, late 19th century
Days with Celebrities: Mr. Millais, R.A., 1881
pen and black ink on bristol board
385 × 315
Joseph F. McCrindle Collection
2009.70.32

Robert Caney
British, 1847–1911
Lake Scene with Fairies and Swans
watercolor and gouache over black
chalk on blue-green board
174 × 250
Joseph F. McCrindle Collection
2009.70.70

Robert Caney
British, 1847–1911
Flying Monster
watercolor with gray and gray-brown
wash, graphite and white gouache on
light tan board
210 × 303
Joseph F. McCrindle Collection
2009.70.71

Robert Caney
British, 1847–1911
Fantastic Pavilions in a Grotto
pen and black ink with watercolor and
gouache over graphite on wove paper
174 × 239
Joseph F. McCrindle Collection
2009.70.72

Robert Caney
British, 1847–1911
*Underworld Scene with a Man and Woman
Enthroned and Death Standing Guard*
watercolor and gouache with pen and
black ink on wove paper
130 × 190
Joseph F. McCrindle Collection
2009.70.73

Robert Caney
British, 1847–1911
Underwater Scene
watercolor and gouache over graphite
on light tan board
213 × 268
Joseph F. McCrindle Collection
2009.70.75

Robert Caney
British, 1847–1911
*Fantastic Mountainous Landscape
with a Starry Sky*
watercolor and gouache on
gray-blue wove paper
214 × 260
Joseph F. McCrindle Collection
2009.70.76

Robert Caney
British, 1847–1911
"Harold Scene 3 Cathedral
(The relics covered with cloth at centre)"
pen and black ink with watercolor over
graphite on light tan board
171 × 249
Joseph F. McCrindle Collection
2009.70.77

Robert Caney
British, 1847–1911
Incantation Scene from "Der Freischütz"
verso: *An Exotic Locale with Palm Trees,*
Tents, and Canopies
pen and brown ink with graphite on
wove paper; verso: pen and brown ink
with graphite and touches of wash
165 × 223
Joseph F. McCrindle Collection
2009.70.78.a/b

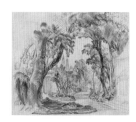

Robert Caney
British, 1847–1911
Castle on a Hill (Set for "Sleeping Beauty and
the Beast"?), 1900?
pen and brown ink with graphite and
brown wash on wove paper
168 × 245
Joseph F. McCrindle Collection
2009.70.79

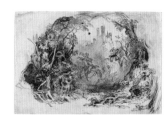

Robert Caney
British, 1847–1911
A Tree-lined Garden Path (Preliminary Design
for "Sleeping Beauty and the Beast"?), 1900?
pen and brown ink with brown wash
and graphite on wove paper
187 × 216
Joseph F. McCrindle Collection
2009.70.80

Robert Caney
British, 1847–1911
A Fantastic Underground Temple
pen and black ink with watercolor and
gouache over graphite on board
251 × 406
Joseph F. McCrindle Collection
2009.70.82

Robert Caney
British, 1847–1911
Stage Set with Paintings and Statues
watercolor and gouache over graphite on
thick wove paper
269 × 365
Joseph F. McCrindle Collection
2009.70.83

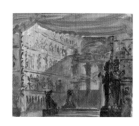

Robert Caney
British, 1847–1911
Interior of an Ancient Egyptian Temple,
c. 1888
watercolor and gouache with pen and
brown ink over graphite on thick wove
paper
373 × 447
Joseph F. McCrindle Collection
2009.70.84

George Chinnery
British, 1774–1852
A Chinese Peasant, 1839
graphite
139 × 121
Joseph F. McCrindle Collection
2009.70.94

John Constable
British, 1776–1837
Portrait of a Clergyman
graphite on tan wove paper
274 × 220
Joseph F. McCrindle Collection
2009.70.98

John Constable
British, 1776–1837
A Seascape with Two Sailboats
watercolor and graphite (in the sailboat
at left) on beige paper
114 × 180
Joseph F. McCrindle Collection
2009.70.99

George Cruikshank
British, 1792–1878
An Unkind Wish, c. 1833
pen and brown ink with watercolor on
wove paper
105 × 163
Joseph F. McCrindle Collection
2009.70.100

Isaac Cruikshank
British, 1756–1810 /1811
A London Character
pen and black ink with black wash and
watercolor on thin card
123 × 59
Joseph F. McCrindle Collection
2009.70.101

George Du Maurier
British, 1834–1896
"The Woman that Was"
pen and brown ink with brown wash
over graphite on wove paper
220 × 236
Joseph F. McCrindle Collection
2009.70.109

George Du Maurier
British, 1834–1896
"Barrington bore it all with exemplary patience,"
1878/1879
pen and brown ink with graphite on
heavy wove paper
220 × 237
Joseph F. McCrindle Collection
2009.70.110

William Etty
British, 1787–1849
Studies of Men Running
graphite on wove paper
333 × 520
Joseph F. McCrindle Collection
2009.70.112

Heneage Finch, 4th Earl of Aylesford
British, 1751–1812
At Tenby, c. 1790?
pen and gray and brown ink with
gray and brown wash and touches of
red chalk over traces of graphite
210 × 247
Joseph F. McCrindle Collection
2009.70.30

Myles Birket Foster
British, 1825–1899
Illustration for Longfellow's "The Rainy Day,"
1850s
pen and brown ink with brown and
gray wash and white and cream gouache
over graphite, with parts of the distant
mountains drawn with a stylus
92 × 85
Joseph F. McCrindle Collection
2009.70.116

Myles Birket Foster
British, 1825–1899
Title Page for "Ellen Seymour"
brown wash and graphite on
wove paper
141 × 88
Joseph F. McCrindle Collection
2009.70.117

Myles Birket Foster
British, 1825–1899
An Evening Landscape with a Distant Cathedral
graphite on wove paper
87 × 154
Joseph F. McCrindle Collection
2009.70.118

Myles Birket Foster
British, 1825–1899
An Evening Landscape with a Hay Wagon
graphite with touches of pen and black
ink, heightened with white gouache on
wove paper
85 × 115
Joseph F. McCrindle Collection
2009.70.119

Myles Birket Foster
British, 1825–1899
An Evening Landscape with Tall Trees
graphite with touches of pen and
brown ink on wove paper
87 × 150
Joseph F. McCrindle Collection
2009.70.120

William Edward Frost
British, 1810–1877
Dancing Woman with a Tambourine
pen and red ink over graphite on wove
paper
178 × 87 (sight)
Joseph F. McCrindle Collection
2009.70.123

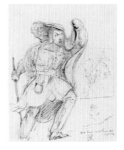

Sir George Hayter
British, 1792–1871
Studies for a Scene from Dante's "Inferno"
pen and brown ink on wove paper
227 × 185
Joseph F. McCrindle Collection
2009.70.137

Thomas Hearne
British, 1744–1817
Furness Abbey, 1777
pen and gray ink with gray wash and
graphite on light tan paper
182 × 272
Joseph F. McCrindle Collection
2009.70.138

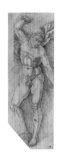
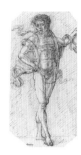

Eric Hebborn
British, 1934–1996
A Naked Warrior with One Foot on a Helmet
(Mantegna imitation)
pen and brown and black ink on
tan paper
299 × 103 (the upper left and lower left
corners cut)
Joseph F. McCrindle Collection
2009.70.139

Eric Hebborn
British, 1934–1996
A Standing Male Nude (Parentino imitation)
pen and brown ink
194 × 101 (all four corners cut)
Joseph F. McCrindle Collection
2009.70.140

Samuel Howitt
British, c. 1765–1822
Two Chinese Pigs
gray wash over graphite on wove paper
62 × 162
Joseph F. McCrindle Collection
2009.70.143

Edward Lear
British, 1812–1888
Tanjore, 1884 / 1885
gray and black wash over traces of
graphite on card
97 × 150
Joseph F. McCrindle Collection
2010.93.27

Edward Lear
British, 1812–1888
Campagna di Roma, 1884 / 1885
gray wash over traces of graphite
on card
94 × 145
Joseph F. McCrindle Collection
2010.93.28

Edward Lear
British, 1812–1888
View of a Bay from a Hillside (Amalfi),
1884 / 1885
black and gray wash with graphite
on card
96 × 146
Joseph F. McCrindle Collection
2010.93.29

Edward Lear
British, 1812–1888
Taggia, 1884 / 1885
black and gray wash with touches
of white gouache on card
95 × 146
Joseph F. McCrindle Collection
2010.93.30

Edward Lear
British, 1812–1888
A Town on a Hilltop (Sanctuary of Lampedusa),
1884 / 1885
gray wash with touches of pen and
black ink on card
98 × 146
Joseph F. McCrindle Collection
2010.93.31

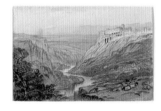

Edward Lear
British, 1812–1888
*Figures Setting out in Canoes from a Palm
Grove (Wady Feiran)*, 1884 / 1885
gray and black wash on card
98 × 147
Joseph F. McCrindle Collection
2010.93.32

Edward Lear
British, 1812–1888
*River Winding through a Rock Formation
(Philae, Egypt)*, 1884 / 1885
gray wash on card
97 × 146
Joseph F. McCrindle Collection
2010.93.33

Edward Lear
British, 1812–1888
*Goats Resting above a River Gorge
(Narni, Italy)*, 1884 / 1885
gray wash on card
96 × 146
Joseph F. McCrindle Collection
2010.93.34

Edward Lear
British, 1812–1888
Mahatta, 1884 / 1885
gray wash touched with white gouache
on card
98 × 146
Joseph F. McCrindle Collection
2010.93.35

Edward Lear
British, 1812–1888
Thebes, 1884/1885
black and gray wash over traces of
graphite on card
97 × 146
Joseph F. McCrindle Collection
2010.93.36

Edward Lear
British, 1812–1888
Avisavella, Ceylon, 1884/1885
gray and black wash with touches of
graphite on card
95 × 146
Joseph F. McCrindle Collection
2010.93.37

Edward Lear
British, 1812–1888
View across a Bay (Monaco?), 1884/1885
gray and black wash on card
98 × 147
Joseph F. McCrindle Collection
2010.93.38

Edward Lear
British, 1812–1888
*Bridge with Mountains in the Distance
(Ventimiglia)*, 1884/1885
gray wash over traces of graphite
on card
99 × 146
Joseph F. McCrindle Collection
2010.93.39

 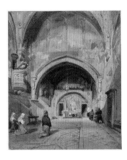

Edward Lear
British, 1812–1888
Napoli, 1884/1885
gray and black wash over traces of
graphite on card
95 × 146
Joseph F. McCrindle Collection
2010.93.40

Mortimer Menpes
British, 1855–1938
*A Letter from Iris Court with Sketches of
Henry Irving*
graphite on wove paper (Iris
Court letterhead)
227 × 176
Joseph F. McCrindle Collection
2009.70.165

Mortimer Menpes
British, 1855–1938
*A Letter from Iris Court with a
Portrait of John Toole*
graphite with watercolor on wove
paper (Iris Court letterhead)
228 × 177
Joseph F. McCrindle Collection
2009.70.166

William James Müller
British, 1812–1845
*Interior of the Church of San Benedetto,
Subiaco*, 1837
brown wash and watercolor over
graphite, with scratching out on
wove paper
250 × 210
Joseph F. McCrindle Collection
2009.70.200

George Romney
British, 1734–1802
Two Studies for a Portrait of the Warren Family
graphite with pen and brown ink on
wove paper
203 × 272
Joseph F. McCrindle Collection
2009.70.201

Thomas Rowlandson
British, 1756–1827
Drovers with a Pair of Rearing Horses
pen and brown ink with watercolor
over graphite
187 × 210
Joseph F. McCrindle Collection
2009.70.207

Thomas Rowlandson
British, 1756–1827
The Fall of Phaeton
pen and brown and gray ink with
gray wash over graphite, corrected in
white gouache, on wove paper
309 × 225
Joseph F. McCrindle Collection
2009.70.208

Thomas Rowlandson
British, 1756–1827
Cavalry Skirmish
pen and black, brown, and red ink
with watercolor
87 × 128
Joseph F. McCrindle Collection
2009.70.209

Robert Smith
Irish, 1792–1882
Figures on a Roman Piazza
graphite
197 × 145
Joseph F. McCrindle Collection
2009.70.214

Thomas Stothard
British, 1755–1834
*Sheet of Studies with Angels and
Cowering Figures*
verso: *Studies of a Sower*
graphite with pen and brown ink and
touches of gray wash; verso: graphite
and pen and brown ink
158 × 290
Joseph F. McCrindle Collection
2009.70.228.a/b

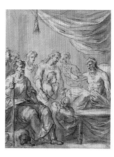

Sir James Thornhill
British, 1675–1734
Isaac Blessing Jacob, 1722
pen and brown and gray ink with
gray-brown wash over black chalk
195 × 160
Joseph F. McCrindle Collection
2009.70.235

Thomas Uwins
British, 1782–1857
The Blind Milton
watercolor with pen and brown ink over
graphite on wove paper
80 × 54
Joseph F. McCrindle Collection
2009.70.227

Theodore von Holst
British, 1810–1844
*Five Male Nudes Gesticulating as a Nude
Woman Enters a Portal*
pen and dark brown ink over graphite
on light tan wove paper
162 × 229
Joseph F. McCrindle Collection
2009.70.247

Raphael Lamar West
British, 1769–1850
*A Seated Male Nude with His Hands Crossed
over His Head*
black chalk on blue paper
535 × 398
Joseph F. McCrindle Collection
2009.70.249

DANISH

Bertel Thorvaldsen (circle of)
Danish, c. 1800
Heroic Male Nude
pen and brown ink
258 × 189
Joseph F. McCrindle Collection
2009.70.236

DUTCH / FLEMISH / BELGIAN

Jan de Bisschop
Dutch, 1628–1671
The Death of Sapphira
brown wash with black and red chalk
on tan paper
308 × 376
Joseph F. McCrindle Collection
2009.70.44

Frans Boudewyns (attributed to)
Flemish, active c. 1720–1766
*A Rocky Landscape with a Stone Tower and
a Waterfall*
red chalk over traces of graphite
190 × 305
Joseph F. McCrindle Collection
2009.70.48

Lieven Cruyl
Flemish, c. 1640–c. 1720
Santa Maria Maggiore, c. 1665
pen and brown ink with touches of
brown wash over graphite on vellum
170 × 306
Gift of Joseph F. McCrindle in memory
of Frederick A. den Broeder
2004.101.1

Dutch school, 17th century
A Scholar Writing
red chalk and graphite on tan paper
201 × 146
Joseph F. McCrindle Collection
2009.70.246

Joris van der Haagen
Dutch, 1615–1669
*Extensive Landscape Seen from the Edge of a
Forest,* 1666
pen and gray and brown ink with gray
wash over black chalk
257 × 404
Joseph F. McCrindle Collection
2010.93.25

Gerard van Houten
Dutch, 1675–1706
Allegory of Sculpture
red chalk with pen and brown and
gray wash, the woman's hair corrected
in white gouache
159 × 101
Joseph F. McCrindle Collection
2009.70.142

Adriaen van Ostade
Dutch, 1610–1685
Two Peasants Drinking
pen and brown ink with gray wash
over graphite
98 × 75
Joseph F. McCrindle Collection
2009.70.180

Félicien Rops
Belgian, 1833–1898
Washerwomen
counterproof of an etching with
additions in pen and black ink, black
and white chalk, and gray wash
343 × 210
Joseph F. McCrindle Collection
2009.70.202

Herman Saftleven
Dutch, 1609–1685
Village Landscape, c. 1648
black chalk with gray and
gray-brown wash
361 × 483
Joseph F. McCrindle Collection
2010.93.24

FRENCH

Herman van Swanevelt
Dutch, c. 1600–1655
A Landscape with a Great Tree
pen and brown ink with brown wash
over graphite on laid paper
49 × 75
Joseph F. McCrindle Collection
2009.70.229
(given with an impression of the
etching by Swanevelt, inv. 2009.70.230)

Hendrik Voogd
Dutch, 1768–1839
A Young Bull Grazing
black chalk on wove paper
sheet 131 × 217, image 122 × 208
Joseph F. McCrindle Collection
2009.70.248

Jacob de Wit
Dutch, 1695–1754
The Four Fathers of the Church
pen and black ink with gray and
brown wash, heightened with white
gouache on brown paper
111 × 182
Joseph F. McCrindle Collection
2009.70.250

Victor Adam
French, 1801–1866
Two Grenadiers
brown wash and graphite with touches
of pen and brown ink on wove paper
Joseph F. McCrindle Collection
2009.70.2

Édouard de Beaumont
French, 1821–1888
*A Middle Eastern Woman Reclining in an
Exotic Setting*, 1844
graphite and stumping with touches of
watercolor on wove paper
sheet 187 × 224, image 126 × 180
Joseph F. McCrindle Collection
2009.70.31

Hippolyte Bellangé
French, 1800–1860
A Seated Soldier
verso: *Detail of a Uniform Jacket*
black chalk on wove paper, cut and
rejoined
228 × 245
Joseph F. McCrindle Collection
2009.70.33.a/b

Hippolyte Bellangé
French, 1800–1860
Figures at a Church Service
verso: *A Robed Man*
graphite with pen and brown ink on
wove paper; verso: graphite
191 × 227 (the lower left corner cut)
Joseph F. McCrindle Collection
2009.70.34.a/b

**Jean Joseph Bernard,
called Bernard de Paris**
French, 1740–1809
Calligraphic Flowers
pen and brown ink with watercolor
299 × 194
Joseph F. McCrindle Collection
2009.70.36

Albert Besnard
French, 1849–1934
Portrait of a Man (Souvenir d'un Passage à Paris), 1878
graphite on card
211 × 142
Joseph F. McCrindle Collection
2009.70.37

Alexandre Bida
French, 1823–1895
An Arab Leaning on a Rail
black chalk, heightened with touches
of white gouache on blue wove paper
242 × 177
Joseph F. McCrindle Collection
2009.70.41

Pierre Bonnard
French, 1867–1947
A Woman Crouching
pen and brown ink over graphite
on an envelope
146 × 114
Joseph F. McCrindle Collection
2009.70.47

Eugène Boudin
French, 1824–1898
Clouds over the Sea
pastel on blue-gray wove paper
116 × 164
Joseph F. McCrindle Collection
2009.70.49

Félix Hilaire Buhot
French, 1847–1898
An Interior with Furniture
verso: *A Gathering in an Interior* and
A Curtained Doorway
graphite on tan wove paper; verso:
graphite with stumping, with another
drawing in graphite pasted sideways
at the bottom
199 × 296; sheet attached on the verso
150 × 98
Joseph F. McCrindle Collection
2009.70.62.a/b

Jean Cocteau
French, 1889–1963
Profile Head of a Woman, 1960
black wash and dry brush on yellowish
wove paper (Santo-Sospir letterhead)
298 × 210
Joseph F. McCrindle Collection
2009.70.96

Henri Pierre Danloux
French, 1753–1809
Two Figures in Classical Dress
verso: *Partial Studies of Figures*
pen and dark brown ink with gray wash
over black chalk; verso: black chalk
188 × 132
Joseph F. McCrindle Collection
2009.70.103.a/b

Alexandre-Gabriel Decamps
French, 1803–1860
Two Draft Horses, 1830
black and white chalk on gray-green
wove paper
320 × 488
Joseph F. McCrindle Collection
2009.70.105

Eugène Delacroix (follower of)
French, 19th century
recto and verso: *Charioteers*
pen and purple-black ink on wove paper
173 × 370
Joseph F. McCrindle Collection
2009.70.104.a/b

Gustave Doré
French, 1832–1883
A Dramatic Scene with a Fainting Woman
graphite with gray wash, heightened
with white gouache (partially oxidized)
on blue wove paper
123 × 84
Joseph F. McCrindle Collection
2009.70.108

Jean-Louis Forain
French, 1852–1931
A Beggar Girl Selling Flowers to a Woman
black crayon with black and
gray wash and touches of watercolor
on brown-blue card
295 × 212
Joseph F. McCrindle Collection
2009.70.115

French school, 18th century
A Procession of the Madonna di San Luca
pen and brown ink with brown wash
over graphite on greenish wove paper,
hinged to a sheet of laid paper bearing
an ornamental border drawn in pen and
black ink with gray wash and graphite
sheet 97 × 154; mount 178 × 249
Joseph F. McCrindle Collection
2009.70.18

French school, 19th century
A Landscape with a River
charcoal with stumping and erasure
249 × 316
Joseph F. McCrindle Collection
2009.70.23

François-Marius Granet
French, 1775–1849
A Cloister
brown wash over graphite, with
touches of scratching out (in the figure
by the door) on wove paper
130 × 107
Joseph F. McCrindle Collection
2009.70.130

Alfred Grévin
French, 1827–1892
A Man and a Woman Swimming in the Sea
watercolor and gouache over graphite
on beige card
182 × 156
Joseph F. McCrindle Collection
2009.70.131

Alfred Grévin
French, 1827–1892
*A Man and a Woman Swimming under an
Umbrella in the Rain*
watercolor and gouache over graphite
on card
178 × 161
Joseph F. McCrindle Collection
2009.70.132

Henri-Joseph Harpignies
French, 1819–1916
A Landscape with Figures Walking along a Path
blue watercolor with gray and black
wash on wove paper
114 × 75
Joseph F. McCrindle Collection
2009.70.134

Léon Lebègue
French, 1863–1944
Nine Studies of a Female Nude
black crayon
290 × 185
Joseph F. McCrindle Collection
2009.70.153

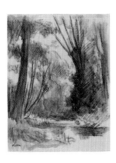

Maximilien Luce
French, 1858–1941
A Forest Glade with a Stream
charcoal with gray wash on wove paper
273 × 215
Joseph F. McCrindle Collection
2009.70.157

Maximilien Luce
French, 1858–1941
A Man and Woman in an Interior
pen and black ink over graphite on
tan wove paper
270 × 208
Joseph F. McCrindle Collection
2009.70.158

Maximilien Luce
French, 1858–1941
A Bridge over the Seine in Paris
pen and brown ink with graphite on
thin card
116 × 159
Joseph F. McCrindle Collection
2009.70.159

Jean-François Millet
French, 1814–1875
Costume Studies
black crayon on brown wove paper
288 × 347
Joseph F. McCrindle Collection
2009.70.167

Victor Jean Nicolle
French, 1754–1826
The Pantheon
pen and brown and gray ink with
watercolor and gouache over red chalk
on wove paper
104 × 138 (oval)
Joseph F. McCrindle Collection
2009.70.176

Victor Jean Nicolle (attributed to)
French, 1754–1826
The Colosseum
pen and brown ink with gray and
gray-brown wash over graphite
295 × 433
Joseph F. McCrindle Collection
2009.70.175

Joseph Ignace François Parrocel
French, 1704–1781
The Stoning of Saint Stephen
pen and brown ink with gray wash
over graphite
344 × 202
Joseph F. McCrindle Collection
2009.70.183

Bernard Picart
French, 1673–1733
A Reclining Male Nude, 1723
red chalk
349 × 494
Joseph F. McCrindle Collection
2009.70.186

Augustin Théodule Ribot
French, 1823–1891
Card Players
pen and brown ink with watercolor and
gouache over black crayon, heightened
with white gouache on card
170 × 224
Joseph F. McCrindle Collection
2009.70.197

Théodore Rousseau
French, 1812–1867
A Landscape with Three Figures and a Dog
pen and brown ink with gray wash
over graphite
67 × 79
Joseph F. McCrindle Collection
2009.70.204

Carle Vanloo
French, 1705–1765
A Seated Male Nude
red chalk on brown paper
488 × 377
Joseph F. McCrindle Collection
2009.70.239

Claude-Joseph Vernet
French, 1714–1789
*Figure Studies, Including One Man Sleeping on
the Ground and Two Men Sawing*
pen and black ink with gray wash
128 × 233
Joseph F. McCrindle Collection
2009.70.240

Claude-Joseph Vernet
French, 1714–1789
Eight Studies of Figures and a Ship at Sea
pen and black ink with brown wash on
greenish paper
134 × 212
Joseph F. McCrindle Collection
2009.70.241

Claude-Joseph Vernet
French, 1714–1789
Ten Men Pulling on Ropes
pen and black ink with gray wash on
pale greenish paper
133 × 213
Joseph F. McCrindle Collection
2009.70.242

Claude-Joseph Vernet
French, 1714–1789
*Quayside Figures and a Length of Rope
Attached to a Bollard*
pen and black ink
130 × 233
Joseph F. McCrindle Collection
2009.70.243

Jacques Villon
French, 1875–1963
Horses
pen and black ink on wove paper
272 × 245
Joseph F. McCrindle Collection
2009.70.244

Adolphe Étienne Viollet Le Duc II
French, 1817–1878
A Rocky Hillside with Dead and Dying Trees
pen and brown ink with graphite on
tan wove paper
275 × 206
Joseph F. McCrindle Collection
2009.70.245

Félix Ziem
French, 1821–1911
A Cove with a Sailboat
pen and brown ink on heavy wove paper
94 × 139
Joseph F. McCrindle Collection
2009.70.254

Georg Raphael Donner
Austrian, 1693–1741
A Reclining Male Nude
black chalk and stumping, heightened
with white chalk and touches of
pink chalk on wove paper washed
dark olive-green
419 × 609
Joseph F. McCrindle Collection
2009.70.106

Jakob Frey
Swiss, 1681–1752
A Sculpture of Saint Benedict in a Niche
red chalk, heightened with touches of
white chalk on brown paper
505 × 275
Joseph F. McCrindle Collection
2009.70.121

George Grosz
German, 1893–1959
A Woman Walking to the Left
graphite on a tan perforated
sketchbook page
207 × 126
Joseph F. McCrindle Collection
2009.70.133

Ernst Ludwig Kirchner
German, 1880–1938
*A Woman Combing Her Hair in Front
of a Mirror*
graphite on wove paper
207 × 162
Joseph F. McCrindle Collection
2009.70.148

Paul Klee
Swiss, 1879–1940
Leiche (Corpse), 1913
pen and black ink
92 × 189 (irregular)
Joseph F. McCrindle Collection
2009.70.149

Erich Mallina
Austrian, 1873–1954
Icarus, 1910
graphite with pen and black ink,
watercolor, and metallic paint
(bronze, gold, and silver)
343 × 211
Joseph F. McCrindle Collection
2009.70.161

Théophile Alexandre Steinlen
Swiss, 1859–1923
Gossiping Women
verso: *Studies of Figures and Heads*
pen and black ink on wove paper
380 × 279
Joseph F. McCrindle Collection
2009.70.218.a/b

Théophile Alexandre Steinlen
Swiss, 1859–1923
A Wounded Soldier and His Comrade
black and white chalk on blue paper
599 × 455
Joseph F. McCrindle Collection
2009.70.219

Théophile Alexandre Steinlen
Swiss, 1859–1923
*L'Aventure du Vieux Doyen
(The Adventure of the Old Dean)*, 1891
pen and black ink and lithographic
crayon with colored crayon and touches
of white gouache on wove paper
image 296 × 251, sheet 365 × 275
Joseph F. McCrindle Collection
2009.70.220

Théophile Alexandre Steinlen
Swiss, 1859–1923
Riders on the Metro
black crayon on textured wove paper
265 × 397
Joseph F. McCrindle Collection
2009.70.221

Théophile Alexandre Steinlen
Swiss, 1859–1923
Sweepers
pen and black ink and blue pencil on
wove paper, partially silhouetted and
laid down on gillot board partly printed
with a reticulated design
315 × 198
Joseph F. McCrindle Collection
2009.70.222

Théophile Alexandre Steinlen
Swiss, 1859–1923
*A Man on a City Street, Surrounded
by Children*
black and blue crayon on wove paper
sheet 322 × 245, image 262 × 181
Joseph F. McCrindle Collection
2009.70.223

Théophile Alexandre Steinlen
Swiss, 1859–1923
A Drunken Man in a Lamplit Street
pen and black ink with blue pencil,
graphite, and scratching out on wove
paper and gillot paper
188 × 216
Joseph F. McCrindle Collection
2009.70.224

Théophile Alexandre Steinlen
Swiss, 1859–1923
The Forest at Courdemanche, 1895
graphite on wove paper
118 × 138
Joseph F. McCrindle Collection
2009.70.225

Johann Friedrich Stock
German, died 1866
View of Muhlendamm, 1834
pen and black ink with gray wash over
traces of graphite, heightened with
touches of white gouache (partially
oxidized) on wove paper
sheet 106 × 156, image 97 × 150
Joseph F. McCrindle Collection
2009.70.226

Eduard Josef Wimmer
Austrian, 1882–1961
Curtain Design
pen and black ink over graphite
on graph paper
148 × 89
Joseph F. McCrindle Collection
2009.70.253

ITALIAN

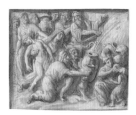

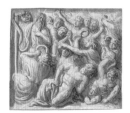

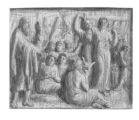

Luigi Ademollo
Italian, 1764–1849
Moses Drawing Water from the Rock
pen and black ink with brown and
gray wash and white and gray gouache
on light tan wove paper
91 × 113
Joseph F. McCrindle Collection
2009.70.3

Luigi Ademollo
Italian, 1764–1849
Moses and the Brazen Serpent
pen and black ink with gray and
brown wash and white and gray
gouache on light tan wove paper
94 × 109
Joseph F. McCrindle Collection
2009.70.4

Luigi Ademollo
Italian, 1764–1849
*Noah's Warning about the Coming Flood
Goes Unheeded*
pen and black ink with brown wash
and white and gray gouache on light
tan wove paper
90 × 114
Joseph F. McCrindle Collection
2009.70.5

Luigi Ademollo
Italian, 1764–1849
The Rod of Aaron Transformed into a Serpent
pen and black ink with gray and brown
wash and white and gray gouache on
light tan wove paper
82 × 109
Joseph F. McCrindle Collection
2009.70.6

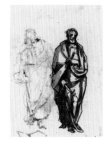

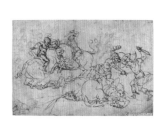

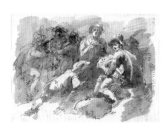

Cherubino Alberti
Italian, 1553–1615
Saints Peter and Paul
pen and brown ink with brown wash
over black chalk
236 × 226
Joseph F. McCrindle Collection
2009.70.7

Cherubino Alberti
Italian, 1553–1615
Two Draped Figures
verso: *Draped Figure with a Staff*
pen and brown ink and black chalk
with brown wash; verso: pen and brown
ink with gray wash over black chalk
238 × 173
Joseph F. McCrindle Collection
2009.70.8.a/b

Giovanni Andrea Ansaldo
Italian, 1584–1638
Soldiers Fighting
pen and brown ink with black chalk
184 × 279
Joseph F. McCrindle Collection
2009.70.68

Giuseppe Bernardino Bison
Italian, 1762–1844
*A Convivial Gathering with a Man
Playing a Hurdy-Gurdy*
verso: *A Monk Reading*
pen and brown ink with brown and
gray-brown wash over black chalk on
wove paper; verso: pen and black ink
over graphite
117 × 162
Joseph F. McCrindle Collection
2009.70.42.a/b

Giuseppe Bernardino Bison
Italian, 1762–1844
Pompeiian Wall Decoration
watercolor and gouache with gray
and brown wash and pen and brown
ink over graphite on wove paper
202 × 175
Joseph F. McCrindle Collection
2009.70.43

Bolognese school, 17th century
View of an Italian Town (after Titian
or Domenico Campagnola)
pen and brown ink
191 × 272
Joseph F. McCrindle Collection
2009.70.22

Ippolito Caffi
Italian, 1809–1866
*The Arch of Titus and the Temple of Venus and
Rome near the Roman Forum*
pen and brown and gray ink with
watercolor over red chalk and graphite,
with later additions of gouache in
the sky
212 × 290
Gift of Joseph F. McCrindle
2009.70.67

Luca Cambiaso (follower of)
Italian, 17th century
Charity
pen and brown ink with brown wash
over traces of black chalk
355 × 260
Joseph F. McCrindle Collection
2010.93.15

Domenico Campagnola
Italian, before 1500–1564
Shepherd Playing a Flute and Leading His Flock
pen and two shades of brown ink over
black chalk on brown paper
152 × 242
Joseph F. McCrindle Collection
2010.93.11

Giulio Campi
Italian, c. 1502–1572
An Ascension and Other Studies
verso: *Venus and Cupid*
pen and brown ink; verso: black chalk
258 × 372
Joseph F. McCrindle Collection
2009.70.69.a/b

Remigio Cantagallina
Italian, 1582 /1583–1656
Two Men
verso: *A Seated Man with a Staff*
pen and brown ink with brown wash
over black chalk
115 × 149
Joseph F. McCrindle Collection
2009.70.87.a/b

Remigio Cantagallina
Italian, 1582 /1583–1656
A Landscape with a Domed Building
pen and brown ink
189 × 260
Joseph F. McCrindle Collection
2009.70.89

Simone Cantarini
Italian, 1612–1648
The Holy Family
red chalk on light tan paper
108 × 176 (corners at upper and lower
left cut)
Joseph F. McCrindle Collection
2009.70.90

Simone Cantarini
Italian, 1612–1648
*A Portrait of a Queen and a Study of a
Woman Seated on a Cloud*
verso: *Sleeping Figure*
red chalk
152 × 193 (the lower right corner cut out)
Joseph F. McCrindle Collection
2009.70.91

Carracci Academy
Italian, early 17th century
The Martyrdom of Saint Lawrence
pen and brown and gray ink over black
chalk, with two irregularly cut and
torn patches attached and drawn with
compositional corrections in pen and
brown ink and black chalk
367 × 268
Joseph F. McCrindle Collection
2009.70.92

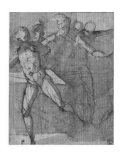

Il Cigoli (attributed to)
Italian, 1559–1613
*Christ Driving the Money Changers from
the Temple*
pen and brown ink with brown wash
over red chalk on beige paper
306 × 250
Joseph F. McCrindle Collection
2009.70.29

Giovanni Battista Cipriani
Italian, 1727–1785
Angelica and Medoro
pen and black ink with brown and
gray wash over graphite
124 × 88
Joseph F. McCrindle Collection
2009.70.95

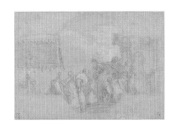

Sebastiano Conca
Italian, 1680–1764
A Bishop Blessing a King
black and white chalk on blue paper
202 × 293
Joseph F. McCrindle Collection
2009.70.97

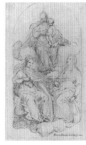

Pietro Damini
Italian, 1592–1631
*The Virgin and Child Adored by Saint Catherine
and Another Female Saint*
pen and brown ink over black chalk
296 × 184
Joseph F. McCrindle Collection
2009.70.102

Ettore Ferrari
Italian, 1848–1929
Trees
pen and brown ink on wove paper
278 × 210
Joseph F. McCrindle Collection
2009.70.114

Florentine school, 17th century
A Youth and a Bearded Man
black and red chalk, heightened with
white chalk
123 × 77
Joseph F. McCrindle Collection
2009.70.27

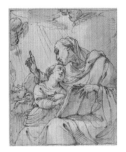

Ubaldo Gandolfi
Italian, 1728–1781
The Education of the Virgin
pen and brown ink with brown wash
over graphite
135 × 111
Joseph F. McCrindle Collection
2009.70.125

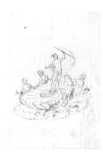

Genoese school, early 17th century
*A Design for a Saltcellar with Venus
Standing on a Seashell*
pen and brown ink over black chalk
290 × 202
Joseph F. McCrindle Collection
2009.70.14

Felice Giani (circle of)
Italian, late 18th century
Allegory of Justice
verso: *Ancient Sacrifice and Head of a Satyr*
pen and brown ink with violet-brown
wash over black chalk on wove paper;
verso: pen and brown ink with brown
and violet-brown wash
225 × 167
Joseph F. McCrindle Collection
2009.70.127.a/b

Luca Giordano
Italian, 1634–1705
Saint Anthony of Padua
black chalk and brown wash
319 × 218
Joseph F. McCrindle Collection
2009.70.128

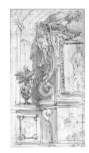

Italian school, 17th century
An Elaborately Sculpted Frame
verso: *An Architectural Study with an Atlantid*
pen and brown ink with brown wash;
verso: pen and brown ink
194 × 113
Joseph F. McCrindle Collection
2009.70.15.a/b

Ottavio Leoni
Italian, c. 1578–1630
Portrait of a Cardinal
black chalk, heightened with white
chalk on greenish-brown paper
(formerly blue)
152 × 108
Joseph F. McCrindle Collection
2009.70.154

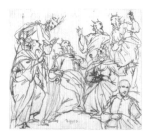

Giambattista Maganza
Italian, 1577–1617
David and the Patriarchs with a Donor
pen and brown ink over graphite
181 × 205
Joseph F. McCrindle Collection
2009.70.160

Agostino Masucci
Italian, c. 1691–1758
Sheet of Studies with Figures, Hands, and Feet
red and white chalk on blue paper
413 × 277
Joseph F. McCrindle Collection
2009.70.162

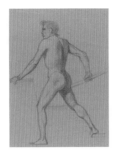

Tommaso Minardi
Italian, 1787–1871
A Male Nude Moving to the Left
verso: *Drapery Studies*
black chalk, heightened with white
chalk on olive-green wove paper
262 × 185
Joseph F. McCrindle Collection
2009.70.168.a/b

Agostino Mitelli
Italian, 1609–1660
Landscape with Ancient Tombs
pen and brown ink with gray wash
on tan paper
170 × 282
Joseph F. McCrindle Collection
2009.70.169

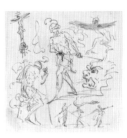

Neapolitan school, 17th century
*Sheet of Studies with a Soldier Drawing
His Sword, a Crucifix, Monstrous Animals,
and Other Figures*, 1625 / 1650
pen and brown ink
138 × 133 (all corners cut)
Joseph F. McCrindle Collection
2009.70.172

Pietro Antonio Novelli
Italian, 1729–1804
The Immaculate Conception
pen and black ink with black chalk
284 × 151 (arched top)
Joseph F. McCrindle Collection
2009.70.179

Giovanni Odazzi
Italian, 1663–1731
Study for a Reliquary Sarcophagus
pen and brown ink with brown wash
over traces of graphite
146 × 213
Joseph F. McCrindle Collection
2010.93.20

Pelagio Palagi
Italian, 1775–1860
A Male Nude Kneeling
pen and brown ink
298 × 211
Joseph F. McCrindle Collection
2009.70.181

Pietro Giacomo Palmieri
Italian, 1737–1804
*Landscape with Cattle, a Goat, and a Resting
Shepherd*, 1774
pen and brown ink on tan paper
249 × 385
Joseph F. McCrindle Collection
2009.70.182

Bartolomeo Pinelli
Italian, 1781–1835
*Two Ancient Warriors Fighting over a
Dead Comrade*
graphite
sheet 220 × 295, image 203 × 267 (oval)
Joseph F. McCrindle Collection
2009.70.187

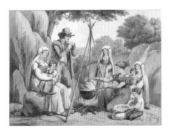

Bartolomeo Pinelli
Italian, 1781–1835
A Peasant Family Cooking over a Campfire
watercolor over graphite on wove paper
239 × 321
Joseph F. McCrindle Collection
2009.70.190

Bartolomeo Pinelli
Italian, 1781–1835
A Peasant Family and Two Donkeys
watercolor over graphite on wove paper
236 × 350
Joseph F. McCrindle Collection
2009.70.191

Bartolomeo Pinelli (after)
Italian, 1781–1835
Four Warriors Supporting Their Dead Comrade,
c. 1811
pen and black and gray ink over
graphite
sheet 304 × 424, image 252 × 313
Joseph F. McCrindle Collection
2009.70.189

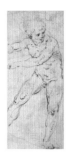

Raphael (follower of)
Italian, 16th century
A Nude Youth
pen and brown ink
155 × 64 (the lower left corner cut)
Joseph F. McCrindle Collection
2009.70.195

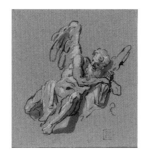

Sebastiano Ricci
Italian, 1659–1734
Chronos
pen and brown ink with brown wash,
heightened with white gouache on
blue paper
116 × 111
Joseph F. McCrindle Collection
2009.70.198

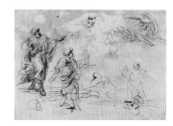

Roman school, mid-17th century
*Studies for a Biblical Scene with God the Father
Appearing to a Bearded Male Figure*
verso: *Two Figures in a Skiff and Two
Horsemen Doing Battle*
pen and brown ink
186 × 260
Joseph F. McCrindle Collection
2009.70.93.a/b

Roman school, 18th century
Two Kneeling Figures with Offerings
pen and black ink with gray wash and
white gouache over traces of black chalk
on blue paper
181 × 264
Joseph F. McCrindle Collection
2009.70.16

Giulio Romano (follower of)
Italian, 16th century
Apollo and Daphne
pen and brown ink on green-blue paper
149 × 104
Joseph F. McCrindle Collection
2009.70.129

Andrea Sacchi (attributed to)
Italian, 1599–1661
Pope Alexander VII
black and red chalk
diameter: 129
Joseph F. McCrindle Collection
2009.70.210

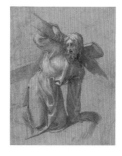

Francesco Salviati (follower of)
Italian, 1510–1563
Christ Falling under the Cross
pen and brown ink with gray-brown
wash and black chalk, heightened with
white gouache on brown paper
129 × 102
Joseph F. McCrindle Collection
2010.93.12

Andrea Semino
Italian, 1526 (?)–1594
*A Palatial Wall Ornamented with Sculptures
and Paintings*
pen and brown ink with brown wash
over black chalk
266 × 411
Gift of Joseph F. McCrindle
1994.9.5

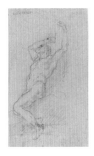

Francesco Solimena
Italian, 1657–1747
A Nude Man Chained to a Rock
verso: *A Seated Nude Man Pointing
to the Right*
black chalk
279 × 166
Joseph F. McCrindle Collection
2009.70.215.a/b

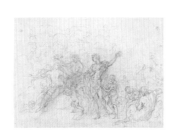

Francesco Solimena
Italian, 1657–1747
The Marriage of Bacchus and Ariadne
black chalk
189 × 266
Joseph F. McCrindle Collection
2009.70.216

Giovanni Battista Tiepolo (style of)
Italian, 1696–1770
*A Standing Man Wearing a Great Coat
and Boots*
pen and black ink with gray wash on
tan paper
197 × 123 (all corners cut)
Joseph F. McCrindle Collection
2009.70.237

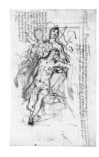

Venetian school, early 17th century
The Pietà, 1600 /1620
pen and two shades of brown ink,
corrected with white gouache
213 × 140
Joseph F. McCrindle Collection
2009.70.19

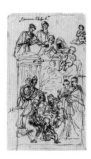

Venetian school, 17th century
*Two Studies for the Madonna and Child
with Saints*
pen and iron-gall ink
201 × 120
Joseph F. McCrindle Collection
2009.70.20

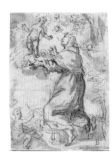

Venetian school, late 17th century
The Christ Child Appearing to Saint Francis
pen and brown ink with gray-brown
wash over red chalk
179 × 130
Joseph F. McCrindle Collection
2009.70.213

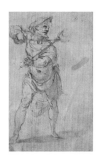

Taddeo Zuccaro (follower of)
Italian, mid-16th century
A Tormentor with Tongs
pen and brown ink with brown
wash over black chalk
172 × 106
Joseph F. McCrindle Collection
2009.70.17

David Davidovich Burliuk
Russian, 1882–1967
The Artist's Wife, 1946
graphite with stumping on wove paper
308 × 257
Joseph F. McCrindle Collection
2009.70.63

SPANISH

David Davidovich Burliuk
Russian, 1882–1967
Self-portrait, 1927
charcoal on wove paper
288 × 198
Joseph F. McCrindle Collection
2009.70.64

Spanish school, 17th century
Eritrean Sibyl
pen and brown ink over traces of
black chalk
147 × 101
Joseph F. McCrindle Collection
2009.70.85

Spanish school, 17th century
Egyptian Sibyl
pen and brown ink over traces of
black chalk
152 × 99
Joseph F. McCrindle Collection
2009.70.86

Spanish school, 17th century
*A Standing Saint Holding a Book and a
Palm Frond*
black chalk, heightened with white
chalk on tan paper
188 × 100
Joseph F. McCrindle Collection
2009.70.174

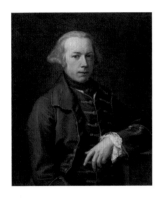

Pompeo Batoni
Italian, 1708–1787
Portrait of a Gentleman, c. 1762
oil on canvas
75.3 × 63.5 cm
Gift of Joseph F. McCrindle
2004.86.1

Abraham Bloemaert
Dutch, 1564–1651
Head of an Old Man, 1625/1628
oil on panel
48.3 × 36.3 cm
Joseph F. McCrindle Collection
2010.93.41

Jan de Bray
Dutch, c. 1627–1688
*Portrait of the Artist's Parents, Salomon de Bray
and Anna Westerbaen*, 1664
oil on panel
78.1 × 63.5 cm
Gift of Joseph F. McCrindle
in memory of his grandparents,
Mr. and Mrs. J. F. Feder
2001.86.1

Niccolò Codazzi
Italian, 1642–1693
The Basilica of Constantine with a Doric Colonnade,
1685/1690
oil on canvas
97.6 × 135 cm
Joseph F. McCrindle Collection
2010.93.42

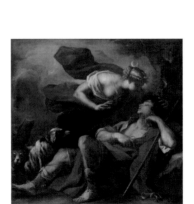

Luca Giordano
Italian, 1634–1705
Diana and Endymion, c. 1675/1680
oil on canvas
149.2 × 164 cm
Gift of Joseph F. McCrindle in memory of
Mr. and Mrs. J. Fuller Feder and
in honor of the 50th Anniversary of
the National Gallery of Art
1991.20.1

Cornelis Jonson van Ceulen
Dutch, 1593–1661
Anna Maria van Schurman, 1657
oil on panel
31 × 24.4 cm
Gift of Joseph F. McCrindle
2002.35.1

Nicolaes Maes
Dutch, 1634–1693
Portrait of a Lady, 1676
oil on canvas
116 × 91 cm
Gift of Joseph F. McCrindle
2001.138.1

Francesco de Mura
Neapolitan, 1696–1782
Alexander Condemning False Praise, 1760s
oil on canvas
76 × 63.4 cm
Joseph F. McCrindle Collection
2010.93.43

Cornelis van Poelenburch
Dutch, 1594/1595–1667
The Prophet Elijah and the Widow of Zarephath, c. 1630
oil on panel
35.6 × 47 cm
Gift of Joseph F. McCrindle in honor of
John Thomas Rowe, Jr.
2004.101.2

Willem Reuter
Flemish, c. 1642–1681
Saint John the Baptist Preaching, c. 1665
oil on canvas
49 × 66 cm
Gift of Joseph F. McCrindle
2004.101.3

John Singer Sargent
American, 1856–1925
Pavement, Cairo, 1891
oil on canvas
48.3 × 58.4 cm
Gift of Joseph F. McCrindle
2006.121.1

Bernardo Strozzi
Italian, 1581/1582–1644
Saint Francis in Prayer, c. 1620/1630
oil on canvas
116.2 × 85.5 cm
Gift of Joseph F. McCrindle
2002.78.1

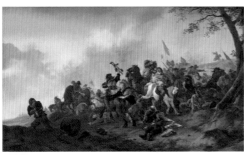

Philips Wouwerman
Dutch, 1619–1668
Battle Scene, c. 1645/1646
oil on panel
48 × 82.5 cm
Gift of Joseph F. McCrindle in memory of
Frederick A. den Broeder
2000.159.1

Abelli 1992
Abelli, Giovanna. "A proposito di Ercole Procaccini." *Arte Cristiana* 80, no. 752 (September–October 1992): 359–368.

Adhémar 1973
Adhémar, Jean. "Les portraits dessinés au XVIe siècle au Cabinet des estampes." *Gazette des Beaux-Arts*, 6th ser., 82, no. 1256 (September 1973): 121–198.

Allgemeines Künstlerlexikon 2005–
Allgemeines Künstlerlexikon. Nachtrag: die bildenden Künstler aller Zeiten und Völker. 4 vols. (ongoing). Munich, 2005–.

Arfelli 1961
Arfelli, Adriana. "Il viaggio del Malvasia a Milano e notizie su Ercole Procaccini il giovane." *Arte Antica e Moderna* 13–16 (1961): 470–476.

Arisi 1986
Arisi, Ferdinando. *Gian Paolo Panini e i fasti della Roma del '700.* 2nd ed. Rome, 1986.

Athenaeum 1905
"Amateur Drawings," *Athenaeum*, no. 4076 (December 9, 1905): 806.

Augsburg 1987
Biedermann, Rolf. *Meisterzeichnungen des Deutschen Barock aus dem Besitz der Städtischen Kunstsammlungen Augsburg.* Zeughaus, Toskanische Säulenhalle. Augsburg, 1987.

Austin 2006
Bober, Jonathan, ed. *Luca Cambiaso, 1527–1585.* Blanton Museum of Art, University of Texas at Austin, and Palazzo Ducale, Genoa. Milan, 2006.

Baldinucci 1845–1847
Baldinucci, Filippo. *Notizie dei professori del disegno da Cimabue in qua.* Edited by Ferdinando Ranalli. 7 vols. Florence, 1845–1847.

Banta 2012
Banta, Andaleeb Badiee. "A Parmigianino Drawing Rediscovered." *Master Drawings* 50, no. 1 (Spring 2012), 49-58.

Baltimore 2005
Fisher, Jay McKean, et al. *The Essence of Line: French Drawings from Ingres to Degas.* Baltimore Museum of Art and the Walters Art Museum, Baltimore; Birmingham Museum of Art, Birmingham, AL; Tacoma Art Museum, Tacoma, WA. University Park, PA, 2005.

Barrett 1988
Barrett, Daniel. "'Shakespeare spelt ruin and Byron bankruptcy': Shakespeare at Chatterton's Drury Lane, 1864–1878." *Theatre Survey* 29, no. 2 (1988): 155–174.

Bean and Griswold 1990
Bean, Jacob, and William Griswold. *18th Century Italian Drawings in the Metropolitan Museum of Art.* New York, 1990.

Bean and Turčić 1982
Bean, Jacob, and Lawrence Turčić. *15th and 16th Century Italian Drawings in the Metropolitan Museum of Art.* New York, 1982.

Bell 1972
Bell, Quentin. *Virginia Woolf: a Biography.* New York, 1972.

Belluno 2005
Scarpa, Annalisa, ed. *Caffi: Luce del Mediterraneo.* Palazzo Crepadona, Belluno, and Museo di Roma, Palazzo Braschi, Rome. Milan, 2005.

Beltrame-Quattrocchi 1969
Beltrame-Quattrocchi, Enrichetta, and Silvana Lazzaro Morrica. *Disegni dell'Ottocento.* Rome, 1969.

Bender 1981
Bender, Elisabeth. "Matthäus Gundelach: Leben und Werk." (PhD diss. Johann Wolfgang Goethe-Universität, Frankfurt am Main), 1981.

Benoit 1994
Benoit, Jérémie. *Philippe-Auguste Hennequin, 1762–1833.* Paris, 1994.

Bevan 1965
Bevan, R. A. *Robert Bevan, 1865–1925: A Memoir by His Son.* London, 1965.

Bjurström, Loisel, and Pilliod 2002
Bjurström, Per, Catherine Loisel, and Elizabeth Pilliod. *Italian Drawings: Florence, Siena, Modena, Bologna.* Stockholm, 2002.

Bohn 2008
Bohn, Babette. *Le 'Stanze' di Guido Reni: Disegni del maestro e della scuola.* Florence, 2008.

Bolten 1969
Bolten, Jaap. "Messer Ulisse Severino da Cingoli, A Bypath in the History of Art." *Master Drawings* 7, no. 2 (Summer 1969): 123–147.

Booth 1981
Booth, Michael R. *Victorian Spectacular Theatre 1850–1910.* Boston, 1981.

Borenius 1938
Borenius, Tancred. *Catalogue of the Collection of Drawings by the Old Masters Formed by Sir Robert Mond.* London, 1938.

Bösel 1996
Bösel, Richard. "L'architettura sacra di Pozzo a Vienna." In Alberta Battisti, ed. *Andrea Pozzo* (Papers presented at "Convegno internazionale Andrea Pozzo e il suo tempo," Trento, Italy, 1992). Milan, 1996, 161–176.

Bremen 1965
Ker Xavier Roussel. Kunsthalle. Bremen, 1965.

Brenner 1983
Brenner, Jan N. *The Early Greek Concept of the Soul.* Princeton, 1983.

Briganti 1962
Briganti, Giuliano. *Pietro da Cortona o Della pittura barocca.* Rome, 1962.

Brighton 1981
Conner, Patrick, and Susan Legouix Sloman. *William Alexander: An English Artist in Imperial China.* The Royal Pavilion, Art Gallery and Museums, Brighton, and Nottingham University Art Gallery. Brighton, 1981.

Briquet
Briquet, Charles-Moïse. *Les filigranes. Dictionnaire historique des marques du papier dès leur apparition vers 1282 jusqu'en 1600.* 2nd ed., 4 vols. Leipzig, 1923. Facsimile eds. Amsterdam, 1968, and New York, 1985.

Buyssens 1991
Buyssens, Danielle. *Les nus de l'Helvétie héroïque: L'atelier de Jean-Léonard Lugardon (1801–1884), peintre genevois de l'histoire suisse.* Geneva, 1991.

Cayeux 1985
Cayeux, Jean de. *Les Hubert Robert de la Collection Veyrenc au Musée de Valence.* Valence, 1985.

Charnon-Deutsch 2004
Charnon-Deutsch, Lou. *The Spanish Gypsy: The History of a European Obsession.* University Park, PA, c. 2004.

Chiarini 2007
Chiarini, Marco. *Teodoro Filippo di Liagno detto Filippo Napoletano, 1589–1629. Vita e opere.* Florence, 2007.

Churchill
Churchill, William Algernon. *Watermarks in Paper in Holland, England, France, etc., in the XVII and XVIII Centuries and Their Interconnection.* Amsterdam, 1935.

Clark 1963
Clark, Anthony M. "Pierleone Ghezzi's Portraits." *Paragone* 14, no. 165 (September 1963): 11–21. Reprinted in *Studies in Roman 18th-Century Painting.* Edited by Edgar Peters Bowron. Washington, 1981, 11–19.

Clark 1967
Clark, Anthony M. "Agostino Masucci: A Conclusion and a Reformation of the Roman Baroque." In Douglas Fraser, ed. *Essays in the History of Art Presented to Rudolf Wittkower.* London, 1967, 259–264.

Clifford 1976
Clifford, Timothy. "Another Clock Painted by Baciccio?" *Burlington Magazine* 118, no. 885 (December 1976): 852, 854–855.

Coburg 1989
Kruse, Joachim. *Johann Heinrich Lips, 1758–1817, ein Züricher Kupferstecher zwischen Lavater und Goethe.* Kunstsammlungen der Veste Coburg. Coburg, 1989.

Collaboration 1992
Collaboration: The Photographs of Paul Cadmus, Margaret French, and Jared French. Santa Fe, NM, 1992.

Corbo 1972
Corbo, Anna Maria. "Benedetto XIV e il Colosseo." *Commentari: rivista di critica e storia dell'arte* 23 (1972): 394–397.

Corpus Gernsheim
Corpus Photographicum of Drawings. An archive of 189,000 black-and-white photographs of drawings in European and American collections taken by Walter Gernsheim, 1936–2008. The images are in the process of being digitized by ARTstor Digital Library, and all of them will soon be available for viewing online.

Coventry 1986
Billingham, Rosalind. *Artists at Applehayes: Camden Town Painters at a West Country Farm.* Herbert Art Gallery and Museums. Coventry, 1986.

Cox 1916
Cox, Kenyon. "The Sargent Water-colors." *Bulletin of the Metropolitan Museum of Art* 11, no. 2 (February 1916): 36–38.

Davis 1982
Davis, Bruce William. "The Drawings of Ciro Ferri." (PhD diss., University of California, Santa Barbara, 1982). Microform edition, University Microfilms International, Ann Arbor, 1982.

Di Giampaolo 1992
Di Giampaolo, Mario. "Balducci o Corenzio? Una ipotesi." In Monika Cämmerer, ed. *Die Kunst des Cinquecento in der Toskana (Italienische Forschungen herausgegeben vom Kunsthistorischen Institut in Florenz, Folge 3, Band 17).* Munich, 1992, 329–334.

Di Giampaolo and Cingottini 2007
Di Giampaolo, Mario, and Donatella Cingottini. "Il Parmigianino: nuovi disegni ed un bozzetto." *Commentari d'arte* 13, no. 38 (2007): 54–62.

Dorati da Empoli 2008
Dorati da Empoli, Maria Cristina. *Pier Leone Ghezzi. Un protagonista del Settecento romano.* Rome, 2008.

Dunoyer de Segonzac 1910
Dunoyer de Segonzac, André. *Dessins sur les danses d'Isadore Duncan.* Paris, 1910.

Dunoyer de Segonzac 1970
Dessins 1900–1970 [de] Dunoyer de Segonzac. Geneva, 1970.

Duplessis et al. 1896–1911
Duplessis, Georges, Georges Rait, Paul André Lemoisne, and Jean Laran. *Catalogue de la collection des portraits français et étrangers conservés au Département des Estampes de la Bibliothèque Nationale.* 7 vols. Paris, 1896–1911.

Edinburgh 1972
Italian 17th Century Drawings from British Private Collections. The Merchants' Hall, Edinburgh. Edinburgh, 1972.

Esten 2000
Esten, John. *Sargent Painting Out-of-Doors.* New York, 2000.

Fagiolo and Marini 1983
Fagiolo, Maurizio, and Maurizio Marini. *Bartolomeo Pinelli, 1781–1835, e il suo tempo.* Rome, 1983.

Farington Diary
Farington, Joseph. *The Diary of Joseph Farington.* Edited by Kenneth Garlick and Angus Macintyre (vols. 1–6) and Kathryn Cave (vols. 7–16). 16 vols. New Haven, 1978–1984.

Fenwick and Smith 1997
Fenwick, Simon, and Greg Smith. *The Business of Watercolour: A Guide to the Archives of the Royal Watercolour Society.* Aldershot, 1997.

Florence 1973
Chiarini, Marco. *Mostra di disegni italiani di paesaggio del seicento e del settecento.* Gabinetto Disegni e Stampe degli Uffizi. Florence, 1973.

Flushing 1985
Faberman, Hilarie. *Hercules Brabazon Brabazon, (1821–1906).* Godwin-Ternbach Museum, Queens College. New York, 1985.

Forberg and Metken 1975
Forberg, Gabriele, and Günter Metken. *Gustave Doré. Das graphische Werk.* Munich, 1975.

García-Toraño Martínez 2009
García-Toraño Martínez, Isabel Clara, ed. *Catálogo de dibujos de arquitectura y ornamentación del siglo XVIII de la Biblioteca Nacional.* Vol. 18. Madrid, 2009.

Gealt and Knox 2006
Gealt, Adelheid M., and George Knox. *Domenico Tiepolo: A New Testament.* Bloomington, 2006.

Genoa 2006
Rossini, Giorgio, and Luca Leoncini. *Caffi e Genova: la percezione del paesaggio ligure a metà Ottocento.* Museo di Palazzo Reale, Teatro del Falcone. Genoa, 2006.

Genoa 2009
Boccardo, Piero, and Margherita Priarone. *Lazzaro Tavarone (1556–1641): 'La vera regola di ben disegnare.'* Musei di Strada Nuova, Genoa. Milan, 2009.

Gibson-Wood 1994
Gibson-Wood, Carol. "Jonathan Richardson as a Draftsman." *Master Drawings* 32, no. 3 (Autumn 1994): 202–206.

Gnann 2007
Gnann, Achim. *Parmigianino: die Zeichnungen.* 2 vols. Petersberg, 2007.

Goldscheider 1996
Goldscheider, Ludwig. *Michelangelo: Paintings, Sculptures, Architecture.* London, 1996.

Göller 1931
Göller, Otto. "Graf Christoph II. Von Fürstenberg und der Maler Matthäus Gundelach." *Die Ortenau. Mitteilungen des historischen Vereins für Mittelbaden* 18 (1931): 99–113.

Graf 1995
Graf, Dieter. *Die Handzeichnungen des Giuseppe Passeri.* 2 vols. Düsseldorf, 1995.

Gray 2011
Gray, Christopher. "The Sidekick in the Spotlight." *New York Times* (July 28, 2011), RE 8.

Grego 1880
Grego, Joseph. *Rowlandson the Caricaturist: A Selection from His Works, with Anecdotal Descriptions of His Famous Caricatures, and a Sketch of His Life, Times, and Contemporaries.* 2 vols. London, 1880.

Grinke 2006
Grinke, Paul. *From Wunderkammer to Museum.* London, 2006

Grove 1996
Turner, Jane, ed. *The Dictionary of Art.* 34 vols. London and New York, 1996.

Harris 1889
Harris, Augustus. "Art in the Theatre: Spectacle." *The Magazine of Art* 12 (1889): 109–112.

Harris 1994
Harris, Ann Sutherland. Review of Frederick A. den Broeder. *Old Master Drawings from the Collection of Joseph F. McCrindle. Master Drawings* 32, no. 1 (Spring 1994): 67–70.

Haverkamp-Begemann 1979
Haverkamp-Begemann, Egbert. "Joos van Liere," in *Pieter Bruegel und sein Welt.* Berlin, 1979, 17–28.

Heawood
Heawood, Edward. *Watermarks, Mainly of the 17th and 18th Centuries.* Hilversum, 1950. Facsimile eds. Hilversum 1957 and 1969.

Hennequin 1933
Hennequin, Philippe-Auguste. *Mémoires de Philippe-Auguste Hennequin.* Edited by Jenny Hennequin. Paris, 1933.

Herdrich and Weinberg 2000
Herdrich, Stephanie L., and H. Barbara Weinberg, with an essay by Marjorie Shelley. *American Drawings and Watercolors in the Metropolitan Museum of Art: John Singer Sargent.* New York, 2000.

Hind 1912
Hind, C. Lewis. *Hercules Brabazon Brabazon, 1821–1906: His Art and Life.* London, 1912.

Hind 1922
Hind, C. Lewis. "Artists Who Matter: IV. Brabazon." *International Interpreter* 1 (May 6, 1922): 148.

Hoetink 1961
Hoetink, H. R. "Heemskerck en het zestiende eeuwse spiritualisme." *Bulletin Museum Boymans van Beuningen* 12, no. 1 (1961): 12–25.

Hollstein
Hollstein, F. W. H. *Dutch and Flemish Etchings, Engravings, and Woodcuts, c. 1450–1700.* 72 vols. Amsterdam and elsewhere, 1949–2010.

Holroyd 1912
Holroyd, Sir Charles. "Alphonse Legros: Some Personal Reminiscences." *The Burlington Magazine for Connoisseurs* 20 (February 1912): 273–276.

Holroyd 1996
Holroyd, Michael. *Augustus John.* New York, 1996.

Hoopes 1970
Hoopes, Donelson F. *Sargent Watercolors.* New York, 1970.

Houbraken 1718–1721
Houbraken, Arnold. *De Groote schouburgh der Nederlantsche konstschilders en schilderessen.* 3 vols. The Hague, 1718–1721.

Humfrey 2007
Peter Humfrey. *Titian: The Complete Paintings.* Ghent and New York, 2007.

Hustin 1893
Hustin, Arthur. *Constant Troyon.* Paris, 1893.

Illustrated Bartsch
Straus, Walter, gen. ed. *The Illustrated Bartsch.* 165 vols. planned. New York, 1972–. Expanded and illustrated edition of Adam von Bartsch, *Le Peintre-Graveur.* 21 vols. Vienna, 1803–1821.

Ivanoff and Zampetti 1980
Ivanoff, Nicola, and Pietro Zampetti. *Giacomo Negretti detto Palma il Giovane.* Bergamo, 1980.

James 1994
James, Roel. "Van 'boerenhuysen' en 'stilstaende dinghen.'" In *Rotterdamse Meester uit de Gouden Eeuw.* Edited by Nora Schadee, Rotterdam, 1994, 133–141.

John 1975
John, Augustus. *Autobiography.* London, 1975.

Klepac 2007
Klepac, Lou. "Nolan, Ripolin and the Act of Painting." In Pearce, Barry. *Sidney Nolan.* Art Gallery of New South Wales, Sydney; National Gallery of Victoria, Melbourne; Queensland Art Gallery, Brisbane. Sydney, 2007, 79–85.

Koszinowski and Leuschner 1990
Koszinowski, Ingrid, and Vera Leuschner. *Ludwig Emil Grimm: Zeichnungen und Gemälde.* 2 vols. Marburg, 1990.

Kurz 1955
Kurz, Otto. *Bolognese drawings of the XVII & XVIII centuries in the collection of Her Majesty the Queen at Windsor Castle.* London, 1955.

Le Claire 2010
Master Drawings, no. 26. Le Claire Kunst. Hamburg, 2010.

Legouix 1980
Legouix, Susan. *Image of China: William Alexander.* London, 1980.

Leone de Castris 2001
Leone de Castris, Pierluigi. *Polidoro da Caravaggio. L'opera completa.* Naples, 2001.

Lewis 2007
Lewis, Wyndham. *The Role of Line in Art with Six Drawings to Illustrate the Argument.* Edited by Paul W. Nash. Witney, 2007.

London 1960
Carlo Labruzzi (1748–1817): An Exhibition of Fine Watercolour Drawings of the Appian Way, John Manning Gallery. London, 1960.

London 1961
Exhibition of Old Master Drawings. P. & D. Colnaghi & Co. Ltd. London, 1961.

London 1962
89th Annual Exhibition of Water-Colours and Drawings. Thomas Agnew & Sons, Ltd. London, 1962.

London 1964
The Sir Anthony Blunt Collection. Courtauld Institute Galleries. London, 1964.

London 1974
A Collection of Drawings and Paintings by Johann Jakob Frey, 1813–1865. Maltzahn Gallery Ltd. London, 1974.

London 1977
Old Master and 19th Century Drawings. P. & D. Colnaghi & Co. Ltd. London, 1977.

London 1978
Maison, Stefanie. *Gerhardt Wilhelm von Reutern, 1794–1865, Drawings and Watercolors.* Hazlitt, Gooden & Fox. London, 1978.

London 1981a
Life and Landscape in Britain, 1670–1870. Thomas Agnew & Sons, Ltd. London, 1981.

London 1981b
Pierre Bonnard, Ker-Xavier Roussel, Édouard Vuillard: Drawings, Watercolors and Pastels. J.P.L. Fine Arts. London, 1981.

London 1983
John Piper. Tate Gallery. London, 1983.

London 1985
Noakes, Vivien. *Edward Lear, 1812–1888.* Royal Academy of Arts. London, 1985.

London 1996
Wilton, Andrew, and Ilaria Bignamini, eds. *Grand Tour: The Lure of Italy in the Eighteenth Century.* Tate Gallery, London, and Palazzo delle esposizioni, Rome. London, 1996.

London 2000
Bambach, Carmen C., et al. *Correggio and Parmigianino: Master Draughtsmen of the Renaissance.* British Museum, London, and The Metropolitan Museum of Art, New York. London, 2000.

London 2004a
Jenkins, David Fraser, and Chris Stephens. *Gwen John and Augustus John.* Tate Britain. London, 2004.

London 2004b
John, Rebecca. *Augustus John, Master Works from Private Collections, 1900–1920.* Hazlitt Holland-Hibbert. London, 2004.

London 2004c
Klein, Jacky. *The Bone Beneath the Pulp / Drawings by Wyndham Lewis.* Courtauld Institute of Art Gallery. London, 2004.

London 2010
Sidney Nolan: Across Continents. Agnew's Gallery. London, 2010.

Longarone 1986
Manfio, Carlo, ed. *Omaggio a Pietro Gonzaga.* Centro culturale Longarone. Longarone, 1986.

Los Angeles 1975
The Graphic Art of André Dunoyer de Segonzac, 1844–1974: A Tribute. Grunwald Center for the Graphic Arts. Los Angeles, 1975.

Los Angeles 1995
Gilbert, Barbara C. *Henry Mosler Rediscovered, A Nineteenth-Century American Jewish Artist.* Skirball Museum, Los Angeles, and Cincinnati Art Museum. Los Angeles, 1995.

Lugano 1989
Pier Francesco Mola, 1612–1666. Museo Cantonale d'Arte, Lugano, and Musei Capitolini, Rome. Milan, 1989.

Lugt
Lugt, Frits. *Les Marques de collections de dessins et d'estampes.* Amsterdam, 1921. *Supplément,* The Hague, 1956. Available online at *http://marquesdecollections.fr.*

Macandrew 1980
Macandrew, Hugh. *Catalogue of the Collection of Drawings in the Ashmolean Museum III, Italian Schools, Supplement.* Oxford, 1980.

Manchester 1983
Clarke, Michael. *The Draughtsman's Art: Master Drawings in the Whitworth Art Gallery.* Whitworth Art Gallery. Manchester, 1983.

Marconi et al. 1974
Marconi, Paolo, Angela Cipriani, and Enrico Valeriani, *I disegni di architettura dell'Archivio storica dell'Accademia di San Luca.* 2 vols. Rome, 1974.

Mariette 1851–1860
Abécédario de P. J. Mariette et autres notes inédites de cet amateur sur les arts et les artistes. Edited by Philippe de Chennevières and Anatole de Montaiglon. 5 vols. *Archives de l'Art français,* vols. 2, 4, 6, 8, 10. Paris, 1851–1860. Facsimile edition, Paris, 1966.

Mason Rinaldi 1984
Mason Rinaldi, Stefania. *Palma il Giovane. L'opera completa.* Milan, 1984.

Méjanès 2006
Méjanès, Jean-François. *Hubert Robert.* Milan, 2006.

Merz 2005
Merz, Jörg Martin. *Pietro da Cortona und sein Kreis. Die Zeichnungen in Düsseldorf.* Munich, 2005.

Milan 1988
Mena Marqués, Manuela, ed. *Disegni italiani dei secoli XVII e XVIII della Biblioteca Nazionale di Madrid,* Palazzo Reale, Milan; Museo Civico Archeologico, Bologna; Accademia Spagnola di Storia, Archeologia e Belle Arti, Rome. Madrid, 1988.

Modena 1959
Modena, Silvana. "Disegno di maestri dell'Accademia Ambrosiana (prima parte)." *Arte Lombarda* 4, no. 1 (1959): 92–122.

Montauban 1999
Vigne, Georges, and Marie-Hélène Lavallée. *Les élèves d'Ingres.* Musée Ingres, Montauban, and Musée des Beaux-Arts et d'Archéologie, Besançon. Montauban, 1999.

Moore 1893
Moore, George. *Modern Painting.* London, 1893.

Müllerschön and Maier 2002
Müllerschön, Bernd, and Thomas Maier. *Die Maler der Schule von Barbizon: Wegbereiter des Impressionismus.* Stuttgart, 2002, 332–340.

Muraro 1967
Muraro, Maria Teresa. *Scenografie di Pietro Gonzaga.* Venice, 1967.

Musella Guida 1982
Musella Guida, Silvana. "Giovanni Balducci fra Roma e Napoli." *Prospettiva* 31 (October 1982): 35–50.

Neilson 1987
Neilson, Nancy Ward. "The Procaccini: Various Ways of Drawing." In *Dal disegno all'opera compiuta: Atti del convegno internazionale.* Edited by Mario di Giampaolo. Perugia, 1987, 133–142.

Nesselrath 1993
Nesselrath, Arnold. *Das Fossombroner Skizzenbuch.* London, 1993.

New Brunswick 1988
Boyer, Patricia Eckert, ed. *The Nabis and the Parisian Avant-garde.* Jane Voorhees Zimmerli Art Museum. New Brunswick, NJ, 1988.

Newcome 1982a
Newcome, Mary. "Santa Maria in Passione: Decorations in a Side Chapel, Convent and Oratory by Tavarone." *Antichità viva* 21, nos. 5–6 (1982): 30–37.

Newcome 1982b
Newcome, Mary. "Prints after Domenico Piola." *The Burlington Magazine,* 124, no. 955 (October 1982): 608–618.

Newcome Schleier 1990
Newcome Schleier, Mary. "Drawings by Tavarone in Berlin." *Jahrbuch der Berliner Museen* 32 (1990): 203–207.

New Haven 1974
Pillsbury, Edmund, and John Caldwell. *Sixteenth-Century Italian Drawings: Form and Function.* Yale University Art Gallery. New Haven, 1974.

New Haven 1980
The Camden Town Group. Yale Center for British Art. New Haven, 1980.

New Haven 2007
Paul Mellon's Legacy: A Passion for British Art. Masterpieces from the Yale Center for British Art. Yale Center for British Art, New Haven, and Royal Academy of Arts, London. New Haven, 2007.

New Hollstein 1993
Veldman, Ilja M., compiler. *The New Hollstein. Dutch & Flemish Etchings, Engravings and Woodcuts 1450–1700. Maarten van Heemskerck.* Edited by Ger Luitjen. 2 parts. Roosendaal, 1993–1994.

New Hollstein 2000
Sellink, Manfred, compiler. *The New Hollstein. Dutch and Flemish Etchings, Engravings, and Woodcuts, 1450–1700. Cornelis Cort.* 3 parts. Edited by Huigen Leeflang. Roosendaal, 2000.

New Hollstein 2001
Sellink, Manfred, and Marjolein Leesberg, compilers. *The New Hollstein. Dutch & Flemish Etchings, Engravings and Woodcuts 1450–1700. Philips Galle.* Edited by Manfred Sellink. 4 parts. Rotterdam, 2001.

New York 1970
Robert Bevan. Davis Galleries. New York, 1970.

New York 1983
William Stanley Haseltine: Drawings of a Painter. Davis & Langdale. New York, 1983.

New York 1985
Johann Jakob Frey (1813–1865): A Swiss Painter in Italy. Wheelock Whitney & Company. New York, 1985.

New York 1992
An Exhibition of Master Drawings. Colnaghi, New York and London. Florence, 1992.

New York 2005
Logan, Anne-Marie, and Michiel C. Plomp. *Peter Paul Rubens: The Drawings.* The Metropolitan Museum of Art. New York, 2005.

Nice 1977
Rosenberg, Pierre, and Marie-Catherine Sahut. *Carle Vanloo, Premier peintre du roi (Nice, 1705–Paris, 1765).* Musée Chéret, Nice; Musée Bargoin, Clermont-Ferrand; Musée des Beaux-Arts, Nancy, 1977.

Nolan 1971
Nolan, Sidney. *Paradise Garden: Paintings, Drawings and Poems.* Introduction by Robert Melville. London, 1971.

Nuremberg 1992
Schoch, Rainer. *Meister der Zeichnung. Zeichnungen und Aquarelle aus der Graphischen Sammlung des Germanischen Nationalmuseums.* Germanisches Nationalmuseum. Nuremberg, 1992.

Olson 2001a
Olson, Roberta J. M. "An Album of Drawings by Bartolomeo Pinelli." *Master Drawings* 39 (Spring 2001): 12–44.

Olson 2001b
Olson, Roberta J. M. Review of Anna Ottani Cavina, *Felice Giani, 1758–1823 e la cultura di fine secolo. Master Drawings* 39 (Winter 2001): 425–430.

Orlandi 1719
Orlandi, Pellegrino Antonio. *L'abecedario di pittorico: Dall'autore ristampato corretto e accresciuto di molti professori e di altre notizie spettani alla pittura* Bologna, 1719.

Ormond and Kilmurray 1998–
Ormond, Richard, and Elaine Kilmurray. *John Singer Sargent: Complete Paintings.* 6 vols. planned. New Haven, 1998–.

Ormond and Pixley 2003
Ormond, Richard, and Mary Pixley, "Sargent after Velázquez: the Prado Studies." *The Burlington Magazine* 145, no. 1206 (September 2003): 632–640.

Ottani Cavina 1999
Ottani Cavina, Anna. *Felice Giani, 1758–1823, e la cultura di fine secolo.* 2 vols. Milan, 1999.

Paris 1993
Nabis, 1888–1900. Galeries Nationales du Grand Palais, Paris, 1993.

Paris 2001
Branchini, Valentina. *Paysages d'Italie: les peintres du plein air (1780–1830).* Galeries Nationales du Grand Palais, Paris, and Centro internazionale d'arte e di cultura di Palazzo Te, Mantua. Paris, 2001.

Paris 2009
Brugerolles, Emmanuelle, and Camille Debrabant. *L'Académie mise à nu: L'École du modèle à l'Académie royale de Peinture et de Sculpture.* Carnets d'études 15. École nationale supérieure des Beaux-Arts. Paris, 2009.

Paris 2011
Gady, Bénédicte. *Pietro da Cortona et Ciro Ferri.* Musée du Louvre. Milan, 2011.

Parker 1956
Parker, K. T. *Catalogue of the Collection of Drawings in the Ashmolean Museum, II: Italian Schools.* Oxford, 1956.

Pascoli 1730–1736 [1992]
Pascoli, Lione. *Vita de' pittori, scultori, ed architetti moderni.* Edited by Valentino Martinelli. 2 vols. Rome, 1730 and 1736. Reprint Perugia, 1992.

Percy 2000
Percy, Ann. "Drawings and Artistic Production in Eighteenth-Century Rome." In Edgar Peters Bowron and Joseph J. Rishel, eds. *Art in Rome in the Eighteenth Century.* Philadelphia Museum of Art. Philadelphia, 2000, 461–467.

Pignatti 1963
Pignatti, Terisio. "Drawings by Bison in Udine." *Master Drawings* 1, no. 3 (Autumn 1963): 56–57.

Pigozzi 2001
Pigozzi, Marinella. "Dall'anatomia agli Esemplari: L'immagine scientifica del corpo, i Carracci e gli esemplari di primo Seicento." *Artes* 9 (2001): 5–40.

Pittaluga 1971
Pittaluga, Mary. *Il pittore Ippolito Caffi.* Vicenza, 1971.

Popham 1971
Popham, A. E. *A Catalogue of the Drawings of Parmigianino.* 2 vols. New Haven, 1971.

Princeton 1977
Rubin, James Henry, and David Levine. *Eighteenth-Century French Life-Drawing: Selections from the Collection of Mathias Polakovits.* The Art Museum, Princeton University. Princeton, 1977.

Princeton 1982
Kaufmann, Thomas DaCosta. *Drawings from the Holy Roman Empire 1540–1680: A Selection from North American Collections.* The Art Museum, Princeton University; National Gallery of Art, Washington; Museum of Art, Carnegie Institute, Pittsburgh. Princeton, 1982.

Princeton 1991
Frederick A. den Broeder, *Old Master Drawings from the Collection of Joseph F. McCrindle.* The Art Museum, Princeton University; Krannert Art Museum, University of Illinois, Champaign-Urbana; The Frick Art Museum, Pittsburgh; University of Michigan Museum of Art, Ann Arbor; Duke University Museum of Art, Durham, NC. Princeton, 1991.

Promey 1999
Promey, Sally. *Painting Religion in Public: John Singer Sargent's Triumph of Religion at the Boston Public Library.* Princeton, 1999.

Prosperi Valenti Rodinò 1995
Prosperi Valenti Rodinò, Simonetta. *Disegni Romani dal XVI al XVIII secolo.* Rome, 1995.

Prosperi Valenti Rodinò 1997
Prosperi Valenti Rodinò, Simonetta. "Ciro Ferri nel Taccuino." In *Pietro da Cortona e il disegno.* Edited by Simonetta Prosperi Valenti Rodinò. Milan, 1997, 189–261.

Réau 1955–1959
Réau, Louis. *Iconographie de l'Art chrétien.* 6 parts in 3 vols. Paris, 1955–1959.

"Reutern" 1894
"Gerhardt von Reutern," in *Baltische Monatsheft* 41 (1894): 295–312; 333–374; 494–511. Abridged reprint of *Gerhardt von Reutern. Ein Lebensbild, dargestellt von seinen Kindern und als Manuskript gedruckt zur hundertjährigen Gedächtnisfeier seines Geburtstags.* St. Petersburg, 1894.

Richmond 2007
Hargraves, Matthew. *Great British Watercolors from the Paul Mellon Collection at the Yale Center for British Art.* Introduction by Scott Wilcox. Virginia Museum of Fine Arts, Richmond, and The State Hermitage Museum, St. Petersburg. New Haven, 2007.

Rizzi 1976
Rizzi, Aldo. *Disegni del Bison.* Bologna, 1976.

Robertson 2008
Robertson, Clare. *The Invention of Annibale Carracci.* Milan, 2008.

Roditi 1961
Roditi, Edouard. *Dialogues on Art.* New York, 1961.

Roethlisberger 1987
Roethlisberger, Marcel. "Landscapes by Francesco Allegrini." *Master Drawings* 25, no. 3 (Autumn 1987): 263–269.

Rome 2003a
Le Pera Buranelli, Susanna, and Rita Turchetti. *Sulla Via Appia da Roma a Brindisi: le fotografie di Thomas Ashby: 1891–1925.* British School at Rome. Rome, 2003.

Rome 2003b
Roma 1850: Il circolo dei pittori fotografi del Caffè Greco. Musei capitolini, Palazzo Caffarelli, Rome, and Maison européenne de la photographie, Paris. Rome, 2003.

Roosevelt 1885
Roosevelt, Blanche. *Life and Reminiscences of Gustave Doré.* New York, 1885.

Rosenthal 2002
Rosenthal, T. G. *Sidney Nolan.* London, 2002.

Rubinstein 1984
Rubinstein, Ruth. "The Renaissance Discovery of Antique River-God Personifications." In *Scritti di storia dell'arte in onore di Roberto Salvini.* Florence, 1984, 257–263.

Ruby 1999
Ruby, Louisa Wood. *Paul Bril: The Drawings.* Brussels, 1999.

Ruggeri 1982
Ruggeri, Ugo. *Disegni lombardi.* Milan, 1982.

Saint-Germain-en-Laye 1994
K. X. Roussel. Musée départemental de Maurice Denis-Le Prieuré. Saint-Germain-en-Laye, 1994.

San Francisco 1992
Marc Simpson, Andrea Henderson, and Sally Mills. *Expressions of Place: The Art of William Stanley Haseltine.* The Fine Arts Museums of San Francisco. San Francisco, 1992.

San Francisco 2006
Rand, Richard, Antony Griffiths, and Colleen M. Terry. *Claude Lorrain—The Painter as Draftsman, Drawings from the British Museum.* Legion of Honor, Fine Arts Museums of San Francisco, and Sterling and Francine Clark Art Institute, Williamstown. New Haven, 2006.

Sanguineti 2004
Sanguineti, Daniele. *Domenico Piola e i pittori della sua 'casa.'* 2 vols. Soncino, 2004.

San Severino Marche 1989
Nesselrath, Arnold, ed. *Gherardo Cibo alias Ulisse Severino da Cingoli: disegni e opere da collezioni italiane.* Centro studi Lorenzo e Jacopo Salimbeni per le arte figurative, San Severino Marche. Florence, 1989.

Sarasota 2006
Boorsch, Suzanne, John Marciari, et al. *Master Drawings from the Yale University Art Gallery.* The John and Mable Ringling Museum of Art; The Blanton Museum of Art, University of Texas, Austin; Yale University Art Gallery. New Haven, 2006.

Saywell and Simon 2004
Saywell, David, and Jacob Simon. *Complete Illustrated Catalogue: National Portrait Gallery.* London, 2004.

Schapelhouman 1989
Schapelhouman, Marijn. *Nederlandse tekeningen omstreeks 1600 / Netherlandish drawings circa 1600.* Amsterdam, 1989.

Schulz 1978
Schulz, Wolfgang. *Cornelis Saftleven: 1607–1682, Leben und Werke.* Berlin, 1978.

Simon 1989
Simon, Robert B. "Doré in the Highlands." *The Journal of the Walters Art Gallery* 47 (1989): 53–60.

Soby 1942
Soby, James Thrall. *Tchelitchew: Paintings, Drawings.* New York, 1942.

Spalletti 1991
Spalletti, Ettore. "La pittura dell'Ottocento in Toscana." In Enrico Castelnuovo and Carlo Pirovano, *La Pittura in Italia. L'Ottocento.* 2 vols. Milan, 1991.

Spencer 1973
Spencer, Charles, ed. *The Aesthetic Movement 1869–1890.* London, 1973.

Spina 1983
Spina, Annamaria Negro. *Giulio Parigi e gli incisori della sua cerchia.* Naples, 1983.

Stainton 1982
Stainton, Lindsay. "London. Covent Garden Gallery. Carlo Labruzzi." *The Burlington Magazine* 124, no. 952 (July 1982): 462, 465–467.

Staunton 1797
Staunton, Sir George. *An Authentic Account of an Embassy from the King of Great Britain to the Emperor of China . . . Taken Chiefly from the Papers of His Excellency the Earl of MacCartney.* 3 vols. London, 1797.

Stenlake 2008
Stenlake, Frances. *Robert Bevan from Gauguin to Camden Town*. London, 2008.

Storrs 1973
The Academy of Europe: Rome in the 18th Century. The William Benton Museum of Art, The University of Connecticut. Storrs, 1973.

Storrs 1974
British Drawings and Watercolors: A Selection from the J. F. McCrindle Collection. The William Benton Museum of Art, The University of Connecticut. Storrs. 1974.

Stuttgart 1979
Geissler, Heinrich. *Zeichnung in Deutschland, Deutsche Zeichner 1540–1640*. Staatsgalerie Stuttgart, Graphische Sammlung. 2 vols. Stuttgart, 1979.

Utrecht 1964
125 jaar Centraal Museum Utrecht. Utrecht, 1964.

Veldman 1974
Veldman, Ilja M. "Maarten van Heemskerck and Hadrianus Junius: The Relationship between a Painter and a Humanist." In *Simiolus: Netherlands Quarterly for the History of Art 7*, no. 1 (1974): 35–54.

Venice 1979
Perocco, Guido, ed. *Ippolito Caffi 1809–1866, raccolta di 154 dipinti di proprietà del Museo d'arte moderna Ca' Pesaro*. Museo d'arte moderna Ca' Pesaro. Venice, 1979.

Venice 1990
Mason Rinaldi, Stefania, ed. *Palma il Giovane 1548–1628: Disegni e Dipinti*. Museo di Correr, Venice. Milan, 1990.

Viatte and Monbeig Goguel 1988
Viatte, Françoise, and Catherine Monbeig Goguel. *Dessins toscans XVIe aux XVIIIe siècles*. Musée du Louvre. Cabinet des dessins. Inventaire générale des dessins italiens, 3. 2 vols. Paris, 1988.

Virgilio 1980
Virgilio, Carlo. *Vedute Mediterranee di Johann Jakob Frey*. Rome, 1980.

Vitzthum 1965
Vitzthum, Walter. Review of *The Sir Anthony Blunt Collection* [London 1964]. *Master Drawings 3*, no. 4 (Winter 1965): 405–407.

Voss 1924
Voss, Hermann. "Über Francesco Allegrini als Zeichner." *Berliner Museen 45*, no. 1 (1924): 15–19.

Wark 1975
Wark, Robert R. *Drawings by Thomas Rowlandson in the Huntington Collection*. San Marino, 1975.

Washington 1978
Carlson, Victor. *Hubert Robert, Drawings and Watercolors*. National Gallery of Art. Washington, 1978.

Washington 1980
Olson, Roberta J. M. *Italian Drawings 1780–1890*. National Gallery of Art, Washington; Minneapolis Institute of Arts; California Palace of the Legion of Honor, San Francisco. New York, 1980.

Washington 1990
MacAndrew, Hugh. *Old Master Drawings from the National Gallery of Scotland*. National Gallery of Art, and Kimbell Art Museum, Fort Worth. Washington, 1990.

Washington 2011
Chapman, Hugo, and David Lachenmann. *Italian Master Drawings from the Wolfgang Ratjen Collection 1525–1835*. National Gallery of Art. London, 2011.

Williams 1986
Williams, Tennessee, and Albert J. Devlin, eds. *Conversations with Tennessee Williams*. Jackson, MS, and London, 1986.

Williams 2006
Williams, Tennessee. *Notebooks*. New Haven, 2006.

Windham 1985
Windham, Donald. "The Hitchhiker." *Christopher Street 101*, vol. 9, no. 5 (1985): 30–34.

Wyss 1996
Wyss, Edith. *The Myth of Apollo and Marsyas in the Art of the Italian Renaissance: An Inquiry into the Meaning of Images*. Newark, 1996.

Zerner 1969
Zerner, Henri. *The School of Fontainebleau: Etchings and Engravings*. London, 1969.

Zurich 1990
Bircher, Martin, and Gisold Lammel. *Helvetien in Deutschland: Schweizer Kunst aus Residenzen deutscher Klassik, 1770–1830*. Städtische Galerie zum Strauhof, Zurich, and Hällisch-Fränkisches Museum, Schwäbisch Hall [Germany]. Zurich, 1990.

INDEX

Albites, Felice | cat. 40

Alexander, William | cat. 42

Allegrini, Francesco | cat. 18

Balducci, Giovanni | cat. 9

Bevan, Robert Polhill | cats. 64, 65

Bison, Giuseppe Bernardino | cat. 44

Bolognese, 17th century | cat. 13

Brabazon, Hercules Brabazon | cats. 56, 57

Cadmus, Paul | cat. 69

Caffi, Ippolito | cat. 47

Caney, Robert | cats. 54, 55

Cantagallina, Remigio | cat. 16

Cibo, Gherardo | cat. 5

Doré, Gustave | cat. 50

Dunoyer de Segonzac, André | cat. 63

Ferri, Ciro | cat. 21

French, mid-18th century | cat. 32

French or Italian | cat. 7

Frey, Johann Jakob | cat. 48

Genoels II, Abraham | cat. 26

Ghezzi, Pier Leone | cat. 28

Gonzaga, Pietro | cat. 41

Gundelach, Matthäus | cat. 10

Harpignies, Henri-Joseph | cat. 53

Haseltine, William Stanley | cat. 52

Heemskerck, Maerten van | cat. 3

Hennequin, Philippe-Auguste | cat. 37

Italian, possibly Florentine or Roman, late 16th or early 17th century | cat. 6

Italian, 17th century | cats. 12, 14

Italian, late 17th or early 18th century | cat. 25

Jode the Elder, Pieter de | cat. 15

John, Augustus | cat. 61

Labruzzi, Carlo | cat. 36

La Fage, Raymond | cat. 23

Lear, Edward | cat. 51

Lewis, Wyndham | cat. 68

Lips, Johann Heinrich | cat. 38

Lugardon, Jean Léonard | cat. 46

Marot the Younger, Daniel | cat. 27

Masucci, Agostino | cat. 31

Mola, Pier Francesco | cat. 17

Nolan, Sidney | cat. 71

Northern Italian | cat. 4

Novelli, Pietro Antonio | cat. 34

Palma il Giovane, Jacopo | cat. 11

Panini, Giovanni Paolo | cat. 29

Parmigianino | cat. 1

Passeri, Giuseppe | cat. 24

Piola I, Domenico | cat. 22

Piper, John | cat. 70

Polidoro da Caravaggio | cat. 2

Pozzo, Andrea del (circle of) | cat. 30

Procaccini il Giovane, Ercole | cat. 19

Reutern, Gerhard Wilhelm von | cat. 45

Robert, Hubert | cat. 33

Roman, late 18th or early 19th century | cat. 39

Roussel, Ker Xavier | cat. 62

Rowlandson, Thomas | cat. 43

Saftleven, Cornelis | cat. 20

Sargent, John Singer | cats. 58–60

Smith, John "Warwick" | cat. 35

Tavarone, Lazzaro | cat. 8

Tchelitchew, Pavel | cats. 66, 67

Troyon, Constant | cat. 49